SEVENTEEN BLACK ARTISTS

Also by Elton C. Fax

CONTEMPORARY BLACK LEADERS

Seventeen Black Artists

Elton C. Fax

ILLUSTRATED WITH PHOTOGRAPHS

Dodd, Mead & Company

NEW YORK

For all those who, with and without acclaim,
have chosen to run the course

ISBN: 0-396-06391-8
Library of Congress Catalog Card Number: 72-165671

Printed in the United States of America
by The Cornwall Press, Inc., Cornwall, N. Y.

Foreword

When I lived in West Africa one of my pastimes was writing down and collecting slogans painted on the lorries that, driven with reckless unconcern, go jolting and bumping along roads in Nigeria and Ghana; "Abide with Me," "Sea Never Dry," "Let Them Say." My favorite is, "Sweet Are the Uses of Adversity." This adage came to mind as I read the life stories of these black men and women.

Elton Fax is that rare artist who is capable of making important statements equally well with words as with paints. He has listened with deep understanding to seventeen colleagues as they related their life stories. The fact that these perceptive and creative men and women were at ease in opening their lives is a tribute to his standing among them. He has indeed traveled the same road, paid the same dues, and shared the same paradoxes. With a discerning ear, he has captured the essence of their tales and chronicled them in a manner that reveals clearly so many aspects of the black experience.

I smiled sadly as I read about Faith Ringgold's frustrations during job hunting expeditions in the New York City public school system. These are classic vignettes that have been played out over the years. Benny Andrews is a product of rural poverty, and his achievement is inspiring testimony to

perseverance and fortitude. His urban contemporary, John Torres, a witness to gang fights and city violence, demonstrates similar determination in the pursuit of his artistic career. A dramatic exemplification of triumph over seemingly insuperable odds is portrayed in the experiences of Charlotte Amévor.

Early in their careers these seventeen unique individuals recognized the necessity to develop a high degree of personal discipline if they hoped to achieve creative fulfillment. They realized there is no substitute for long hours of painstaking labor in their craft. They also learned that jealousy and insensitivity as well as generosity and kindness are not limited to any single ethnic group. All rarely wavered in the pursuit of their goals even when faced with personal crisis or social obstacles.

The recollections of these artists, the young and not so young, provide the backdrop on which Elton Fax has deftly sketched in the prevailing historical events which shaped their lives and destinies. Surely a message is embodied in the tableau. It has urgent meaning for this and succeeding generations of young black people who may have to confront soul-destroying forces in their society.

Elinor Des Verney Sinnette
Librarian

PREFACE

If you are looking for a story loaded with fashionable cocktail party clichés about art and the people who produce it, this will not be to your liking. What you will find in the following pages is no esoteric critique. It is instead the story of seventeen sensitive human beings, what they have to say about the world they know, and why they say it in the way they do.

Like their many counterparts all over America, these seventeen people do not float pleasantly about in a benign vacuum. On the contrary (and with the exception of Elizabeth Catlett Mora, who lives and works in Mexico) they toil in an environment that is harsh, abrasive, and downright hostile to most of its artists. It is an environment that, while taking great pride in the efficiency and speed with which it wages war, does business, and conducts outer space explorations, has not (in its nearly two centuries of existence) established a meaningful, nationally supported program of the arts. The closest we ever got to that occurred in the 1930's when the Roosevelt administration created the Federal Theatre and the Federal Art Projects that provided work for artists during the Depression. When Pearl Harbor was bombed in 1941 the nation went to war against Japan, and the arts projects went out of existence. Individual artists who have "made it" in the

popular sense of the term have had to do so without federal help.

Ours is an environment that constantly reminds its people of their blessings, particularly that great blessing of freedom. Most artists are painfully aware of their freedom to (at best) be exploited by clever entrepreneurs who, dictating what artists must produce for them to sell, succeed too often in misrepresenting artists to their special public. At the very worst, artists are affronted, insulted, and generally taken for granted by sizable portions of the public at large.

Artists, for instance, are asked to give of their skills in a manner that is shameful in its sheer arrogance. People who would never dare to ask an engineer, a physician, or a lawyer to work for nothing will ask an artist to do so. And they will assume an attitude of hurt surprise when the spunky artist refuses. "Difficult" and "temperamental" are the terms applied to artists who will not be misused by those who have never learned that the skilled craftsman in the arts devotes time and energy to the development of his discipline and deserves the same respect accorded the surgeon or the bridge-builder.

It is not unheard of for artists to surrender up to 50 percent of their earnings to those who "represent" them. Moreover, artists are asked to donate their creations to causes of various sorts. They are expected also to furnish (at their own expense) photographs of their works for publication in organs that produce a profit for everyone concerned with them other than the artists whose donations transform a routine venture into an exciting one. In such instances the artist is assured that the publicity that accrues to him will pay him many times over for his "cooperation." Ha! This writer, for one, has yet in forty years of such cooperative ensnarements to uncover any solid truth in that rosy promise!

Such is the environment through which *all* artists in this country struggle. And in the patriotic traditions of "free

enterprise" and "rugged individualism" each must fend for himself as best he can. The seventeen of whom I write here are no exception. Indeed, their situation is more acute since they are forced to tote an added barge and lift an extra bale for being black. What I mean is that they are black in that special and terrible and *magnificent* sense of what it is to be black in a climate charged with white racism. And because of white racism the experience of black people becomes a unique one for them.

Travel and contact have taught me that man's experience is universal and that no human experience dwells in a vacuum. I know, therefore, that what white racism imposes upon black people, it imposes also upon other nonwhites. But it doesn't stop there. White racism is destructive to whites also, especially poor whites. The poor white, however, has difficulty in recognizing that his experience relates to that of nonwhites, largely because he has been deluded into believing he belongs to the "superior" race. To him nonwhites do not count for much since they are merely the "niggers," "spics," "slopeheads," and "gooks" of society. What an effective job white racism has done in separating the poor white from the reality of his own miserable and unhappy experience!

When I speak of the "magnificence" of the black experience, I speak of the simple, uncluttered state and spirit of the man who soars above the meanness of the rejections and denials thrust upon him. He is that man who can face his oppressor and calmly say to him, "Because of you and, yes, in spite of you, too, *I am a man!*" When he is an artist that simple declaration becomes a thing of shining splendor.

But every man who suffers does not face his torment with that kind of dignity, and all black men (even those in the arts) are not made of giant stuff. Some would prefer not to be black, and their reluctance to carry that extra load is, in purely human terms, understandable. One hears the declara-

tion, "I want to be an *artist,* not a *black* artist." Rejection of the "black" label suggests that those who reject it have been convinced there is something not really clean or valid in being simultaneously black and an artist. But even as they deny their unique black experience, their denial in no way negates or diminishes the potent truth of it.

Artists, like all other human beings, neither feel, nor see, nor think alike. They shouldn't. And if one is to survive as a truly creative force, he dares not seek to silence or obscure from view other artists who do not see as he sees. The role of the artist is creative rather than destructive. His knowledge of life teaches him that one man's exposure to adversity will drive him to look inward toward those strengths that proclaim his manhood to *him.* Another man, under the same stimulus, will be driven to seek escape from that which is inescapable, even as he recognizes the futility of his flight. Knowing this, the true artist, surely one of the freest of individuals, will not seek to violate the freedom and individuality of others.

The artists I have selected to write about here have more in common than race. Each is an excellent craftsman, having demonstrated a professionalism of performance acquired only through study and hard work. Their collective devotion to the disciplines of their craft is no less arduous than their devotion to the themes they individually (and collectively) pursue as black artists. Each is, in his and her own way, a representationalist, doubtless because each feels that he can speak most forcefully in that style and manner. Benny Andrews expresses his feelings about style in this way.

"I like much of abstract art and I have no quarrel at all with it. Every artist has to work in his own way, no matter what his creed or his particular style. Color has nothing to do with that. But as for me, I have to work just as you see me working now."

While Eldzier Cortor, Jacob Lawrence, Charles White, and John Wilson, to mention but four, work almost entirely

with black subject matter, John Torres, Norma Morgan, and Benny Andrews do not. Still, all of the artists in the following pages show in what they do a profound cognizance of the black experience. And these artists share another common trait. They are seventeen *undefeated* men and women. Bloody they may sometimes be, but they are quite unbowed. Indeed one finds in their strongest efforts a surging triumph over the environment; and one must bear in mind that this group is but a segment of a larger group of similarly motivated black artists working in America today. During the course of this narrative I will have the opportunity to mention many of them.

One more thought about those in this book. They come from all areas of this nation of ours and from varying backgrounds and home influences. Four are women, one of whom has chosen to become a citizen of the Republic of Mexico. As they step forward to unfold their lives, much of what they are as individuals reveals itself. Far more than that, however, their lives reveal much about America—the beautiful and the not so beautiful. Those revelations, forged and tempered in the fires of the artists' creativity, emerge in related statements at once angry, caressing, and disturbingly handsome.

Elton C. Fax
New York City

ACKNOWLEDGMENTS

The first of these goes to my friend and fellow writer Lindsay Patterson for suggesting this book and for believing that I could do it. To each of the seventeen artists written about I am deeply grateful, not only for the time, patience, and enthusiasm they exhibited in granting taped interviews but for furnishing such splendid photographs of their works to accompany the text. In this regard special thanks belong to Betty, Pancho, and David Mora who were my hosts in Mexico City. Others deserving special thanks are Hazel Biggers for helping with the story of her husband, John; Ethel Morgan for filling in significant details in the life of her daughter, Norma; Agnes Perry for similiar help in preparing the story of her brother, John Torres; Gwendolyn Lawrence, not only for her contribution to the section on husband Jacob, but for reminding me to include Earl Hooks in this narrative.

I am also indebted to Benjamin Horowitz for detailed information on recent achievements of Charles White. To the Atheneum Publishers and Mrs. James Weldon Johnson; Harper and Row; Harcourt Brace, Jovanovich; Farrar, Straus, & Giroux Inc.; The Associates In Negro Folk Education; and Othello Associates Inc.; I am grateful for permission to quote from the works of James Weldon Johnson, Gilbert Osofsky, Horace Cayton and St. Clair Drake, Roi Ottley, Alain Locke, and Paul Robeson respectively. And to W. E. B. DuBois I am indebted for quotes from *Black Reconstruction*.

To the Schomburg Collection of the New York Public Library I extend thanks with particular gratitude to Cora Eubanks, Jean Hutson, and Ernest Kaiser. I am grateful also to Elinor Sinnette for her sensitive foreword and to Anne Judge for her critical reading of the manuscript and checking of galleys. To my editor, Allen Klots Jr., I extend thanks for those qualities as an editor and a man that make working with him such a joy. And to the beautiful typing of the manuscript credit belongs to my devoted partner, Betty, without whose able help my part in this undertaking could never have moved with such smooth efficiency.

Contents

Foreword v

Preface vii

 I. THE FORERUNNERS 1

 II. ELIZABETH CATLETT 14

III. JOHN WILSON 32

 IV. LAWRENCE JONES 48

 V. CHARLES WHITE 63

 VI. ELDZIER CORTOR 79

VII. REX GORELEIGH 95

VIII. CHARLOTTE AMÉVOR 112

 IX. ROMARE BEARDEN 128

 X. JACOB LAWRENCE 146

 XI. ROY DE CARAVA 167

XII. FAITH RINGGOLD 188

XIII. EARL HOOKS 203

xiv. JAMES E. LEWIS 219

xv. BENNY ANDREWS 236

xvi. NORMA MORGAN 253

xvii. JOHN BIGGERS 267

xviii. JOHN TORRES 283

Index 300

Chapter I

THE FORERUNNERS

It should never be forgotten that in America the Negro is having his second rather than his first career in the fine arts." Black, Rhodes scholar, philosopher, and art historian, Alain Locke is the author of that statement. It appears in the opening passages of his book *The Negro in Art,* published in 1940, and it is entirely accurate. The west coast and equatorial regions of Africa, from which the bulk of captive slaves were brought to American shores, did produce the finest examples of African art. And there were artists among those manacled slaves.

But manacles diminish the flow of creativity, and slaves were manacled in mind and spirit as well as in body. Frightened slaveowners saw to that. Learning quickly and often sadly the intense rebellion in slaves, the masters devised every conceivable means of holding that rebellion in check. Punishments for even the slightest deviations from tightly set routines were harsh and cruel, and slaves who informed upon their recalcitrant brothers were rewarded by grateful masters.

Tribal members were separated and mixed with others whose languages they could not speak. In that way their effectiveness in plotting insurrections was diminished. And to make communication even more difficult the slavemasters

split families, separating husbands from wives and mothers from children.

Religious ceremonial rituals that the captives had observed in Africa were strictly forbidden in the land of the enslaver. In fact the slavemasters saw to it that their human property found a new ritual in Christianity—Christianity *as interpreted by the masters*. In no case did that interpretation condemn the institution of slavery. It sought, instead, to justify it and to make the slave believe that his unhappy lot was but the inevitable fulfillment of divine prophecy.

What happened to the carver of ceremonial figurines and masks in his new and repressive environment was that he did not, indeed dared not, practice his traditional ancestral crafts. And here again Alain Locke makes a perceptive observation.

Stripped of all else, the Negro's own body became his prime and only artistic instrument, so that the dance, pantomime, and song became the only gateway for his creative expression. Thus was the American Negro forced away from the craft arts and the old ancestral skills to the emotional arts of song and dance for which he is now so noted.

In spite of romantic myths about Africans and their descendants, all of them are not expert singers and dancers. Many slaves were more adept as craftsmen in iron, wood, and leather—as relics of the American colonial structures in New Orleans and in Charleston, South Carolina, attest. The decorative wood carvings, iron grill, and other metal works, along with weaving, were creative manual skills of which ruling whites were not afraid. They symbolized nothing overtly mystifying and threatening, and they were of utilitarian worth. In a society that had not yet entered the era of industrial mechanization, such crafts were indispensable.

American painting and sculpture of the revolutionary period, derivative of that of Europe, were faithfully imitated by the few black artists permitted to do them. Records show

that perhaps one of the first was Joshua Johnston, a portrait painter, who operated studios in and around Baltimore, Maryland, between 1796 and 1824. That he was a free person is indicated by his listing in the city directory of Baltimore. Slaves were never so listed in that city. Johnston's work, reminiscent of Charles Peale's and designed to please his sitters, reflected their bland and ingrown mode of plantation life.

Since it was not common prior to the 1800's for artists to portray black people seriously and with dignity, few such portrayals exist. Race chauvinism veered white artists away from such a course, and the black artist, eager for commissions, dared not risk offending his white clientele. Scipio Morehead, a black painter of Boston during the late 1700's, painted allegorical canvases. So it came as a bit of a surprise when, in 1785, Baltimore artist G. W. Hobbs painted a splendid pastel portrait of Richard Allen. A young clergyman, Allen was later to become the first bishop of the African Methodist Episcopal Church. Then, as is often true today, the black church exerted a tremendous influence in the black community.

With the coming of the early 1800's formal portraits of free and affluent blacks were painted by black artists Julien Hudson of New Orleans and William Simpson of Boston. Meanwhile, two other black painters of unusual talent were attracting attention in New England. One was Edward N. Bannister, born in 1828 in St. Andrews, New Brunswick. The other, a native of New York State, was Robert Duncanson.

While Duncanson, a landscapist and figure painter, worked in the style of the literary romantics, Bannister, himself a landscapist, was the painter of poetic realism. A founding member of the Providence, Rhode Island, Art Club, Bannister steadfastly refused to leave America to study in Europe. Duncanson studied in Edinburgh and later lived in Italy where, before insanity and death overtook him in Detroit, he

had sought escape from racism at home. "I am not interested in color, only paint," he often snapped. Duncanson did, however, in 1848 paint the family of black Bishop Daniel Payne.

Four years after Duncanson died, Bannister's huge land-scape, "Under the Oaks," took a medal of the first class at the Philadelphia Centennial Exhibition. The canvas was later sold for fifteen hundred dollars, a good price in those days for the work of a living American painter.

Not so fortunate was Eugene Warbourg, a New Orleans-born stonemason turned sculptor. Warbourg's portraits and religious statuary for white clients did not ward off en-counters with racism. At twenty-seven he fled to Paris. Nine years later he died in Rome.

Then came Edmonia Lewis. She was half-Indian, half-African, and attractive in a boyish way. Most of all, she was wild and thorny. Today Edmonia Lewis would be regarded as no worse than thousands of young offbeat rebels. But in the mid 1850's, the Ohio in which she grew up had little understanding or tolerance of forthright young "swingers" when they were white. What chance did Edmonia Lewis have of breaking the rules and getting away with it? Nothing on record, however, indicates that this black orphan girl made any effort to be discreetly inconspicuous.

Some abolitionists felt they should help her find soul salva-tion and learning, so they placed her in Oberlin College. While there the fiery fifteen-year-old Edmonia was accused of murder in the poisoning mystery of two white classmates. The publicity and ugly local sentiment stirred by the bizarre case induced abolitionist William Lloyd Garrison to come to the girl's defense. As soon as she was acquitted, Edmonia left Ohio for Boston.

There she began to study clay modeling with Edmund Brackett. Within a short time, and with the brashness so typical of her, she opened her own studio. The rebellious

nature of Edmonia Lewis was still very much in evidence, for the sculptures she produced marked a departure from what any other black artist had deigned to attempt.

As has been mentioned, the mode was to cater to (and certainly never to disturb) the notions whites liked to entertain of the passivity and good nature of blacks. Edmonia Lewis wasn't catering. She modeled a medallion of John Brown and a bust of Col. Robert Gould Shaw, certainly two controversial figures of the mid-eighteen hundreds. Brown had led an ill-fated insurrection of slaves at Harpers Ferry, Virginia, for which he was hanged in 1859. Shaw gave his life four years later leading the first black fighting unit, the Fifty-fourth Massachusetts Infantry Regiment, in the Civil War.

With what she managed to get from the sale of copies of the Shaw portrait, Edmonia went to Rome to study with Harriet Hosmer. There in 1867 she produced "Forever Free," a two-figure carving in white marble symbolizing the meaning to black people of the abolition of American slavery. That carving, though not a great work of art, may be properly called the first piece of widely publicized "propaganda art" by a black American. Edmonia Lewis was not yet through.

Again, recalling her father's people, she produced "Hagar" and "The Death of Cleopatra," the latter often regarded as her most outstanding achievement in sculpture. Other works, "The Marriage of Hiawatha" and "Charles Sumner," came from her hand as tributes to her Chippewa mother and to those abolitionists whom she had come to respect and love.

In her forty-five years of life, Edmonia Lewis made a significant contribution. By claiming her right to be herself she charted a new course for black artists. No longer did they need to confine themselves to turning out pleasant, innocuous themes that whites could accept without feelings of guilt. Now they were free. And they could thank a troubled, lonely, and sensitive woman for their liberation.

Meta Warrick Fuller and May Howard Jackson, coming

behind Edmonia Lewis, moved resolutely in the pursuit of
their craft. Both were Philadelphia born and trained during
the last quarter of the nineteenth century. While Mrs. Fuller
studied in Paris, Mrs. Jackson chose to remain at home and
do portraits of black Americans. The latter's style, untouched
by contact with Europe's ateliers, prompted Alain Locke to
say of her in his *Negro Art: Past and Present,* "It was be-
cause of her more American experience, no doubt, that she
was the first to break away from academic cosmopolitanism
to frank and deliberate radicalism." This comes through
clearly in May Howard Jackson's portrait of Kelly Miller,
black scholar and educator of Howard University.

In a different vein, Mrs. Fuller's splendid execution of
such figure studies as "The Wretched" (1903) reflected the
suffering of a woman clearly aware of the horrors of slavery.
And it is worth noting here that of the four foremost black
artists of the latter part of the nineteenth century, three were
sculptors—and women.

Henry Ossawa Tanner, born 1859 in Pittsburgh, Pennsyl-
vania, was to become one of the most accomplished American
painters of his time. Though he acquired training in America
and Europe, fame came initially to him in France. Against
the wishes of his father, a rigid, Methodist minister, the
youth became an outstanding student of Thomas Eakins at
the Pennsylvania Academy of Fine Arts.

For a short time, following graduation, Tanner taught at
Atlanta's Clark College. He even tried to earn a living as a
photographer, but the going was not easy. As he shared the
rigors of the Southern black experience, Tanner made
sketches and paintings of the life around him, and from those
expressions of love for his people came at least three par-
ticularly moving canvases, "The Thankful Poor," "The
Banjo Lesson," and "Savings." But the pressures of living
black in the South, plus the Methodist orthodoxy into which
the elder Tanner had immersed his family, had created in

the young artist a zealous desire to paint biblical scenes. To serve that end, Tanner sold his work at sacrificial prices, netting him enough to get abroad.

He was thirty-two when he arrived in Paris to do further study with Laurens and Constant. At the end of six years he was on the periphery of the broad mystical style that characterizes his most celebrated works. "The Raising of Lazarus" won a gold medal at the Salon in Paris, and his name was established. Tanner then made the first of a series of trips to Palestine in search of local color for the biblical themes he began to paint. Though he exhibited and won honors in both Europe and the United States, he chose to live and die in self-imposed exile. His life ended in Normandy in 1937.

A generation later, Cedric Dover, in his book *American Negro Art,* was bitterly critical of Tanner for failing to become the "Negro genre painter of exceptional power" his talents promised. Dover, a Eurasian of East Indian ancestry, must certainly have known the suffocating effects of racism well enough to understand Tanner's desire to escape them. Dover's harsh criticism, however, not of Tanner's artistry but of his choice of subject matter, revealed no such understanding. A far more astute and sensitive view of Tanner had been rendered earlier by Alain Locke in his *Negro Art: Past and Present.*

But for his enforced exile and the warrantable resentment of race as an imposed limitation, Tanner would have undoubtedly added a strong chapter to American regional art in treating Negro types with as much mastery and more intimate understanding than came from white contemporaries like Winslow Homer, Wayman Adams, and Robert Henri.

As a postscript it should be said that fuller recognition at home did come to Tanner through two exhibitions (1967 and 1968) at New York's Grand Central Galleries. And in 1970

he was installed in the Hall of Fame by the then newly formed Black Academy Of Arts And Letters.

Another black painter of the nineteenth century whose talent nearly rivaled that of Tanner was William Harper, born in 1873 in Canada and trained at the Art Institute of Chicago. Harper was a landscape painter who lived only twenty-seven years. Yet the sixty-odd paintings and sketches he had done in Brittany, southern England, and Mexico, and which the Art Institute presented in a 1910 Memorial Show, revealed a creative imagination equaled by few of his time.

The year was 1899. Little did fifteen-year-old William E. Scott of Indiana and nine-year-old Nancy Prophet of Rhode Island dream of what lay ahead. They and others would soon be caught up in a dramatic movement in New York involving black American artists.

THE TWENTIETH CENTURY

Interest in black American artists was heightened directly and indirectly by European recognition of the beauty of African art. Ceremonial carvings from West and Equatorial Africa that had previously been taken to Europe by missionaries as curios were now eagerly sought by Europe's collectors.

When a huge collection of bronze castings and ivory carvings salvaged from the looted city of Benin reached the museums of London, Berlin, and Vienna, excitement in art circles ran high. Europe's most brilliant young artists, headed by Picasso, Matisse, and Modigliani, recognized the true symbolism and aesthetic value in the imaginative and highly developed carvings. Ecstatic with pleasure and admiration with their discovery, they began to incorporate the African-conceived forms and patterns in their own works. And a new era in European art took form.

Brash, rich, young America was not to be upstaged. Though it had not made the new discovery, it did have its

own variety of home-grown "Africans," and since they were right at hand, why not encourage the artists among them to be productive? The time, it seemed, was ripe for such a move. Certainly the music created by black Americans was evidence not only of their talent in that direction but also of an art form that the nation could now call its own. Black Americans were also beginning to show up in serious pictorial representation. Artists Winslow Homer, Robert Henri, George Bellows, Maurice Sterne, and Julius Bloch had tried to present the black Americans as something other than happy-go-lucky buffoons. Nor was their effort without its effect. But they were by no means alone. Significant and related events were beginning to take place simultaneously within the black intellectual community itself.

In 1921 a dapper, aggressive, young black man, fresh from Syracuse University, strode on the campus of Washington's Howard University with the announcement that he was there to establish an art department. His name was James Vernon Herring. From what he later told this writer, that announcement evoked gales of laughter that must have been heard all the way to Baltimore. The derision came not from the students but from administration and some faculty members who should have known better.

The official indifference to the arts that pervades our country obtains to an even exaggerated degree in some black colleges and universities. Many black administrators, like many white administrators in education and industry, are heavily endowed with authority over art and lightly endowed with an understanding of what it is. With philistine attitudes and a determination to appear "practical" in the eyes of white-dominated boards of trustees, they become super-efficient at keeping the arts programs "in their proper perspective." The exceptions are rare indeed.

That was what faced young Herring a half century ago, and what still faces many black artist-educators today. But James

V. Herring, no ordinary man, rose to the challenge. Brushing aside the ridicule with sharp and salty rejoinders of his own, he created at Howard University the first bona fide art department in any black college or university of this country. Moreover, within nine years he had established the first art gallery there on the ground floor of the Andrew Rankin Chapel. James A. Porter, James Lesesne Wells, Lois Mailou Jones, and Alonzo Aden were early members of the art department.

Along with the more humanistic approach of some white American artists to black subject matter, the writings of Alain Locke, and the creation of the center at Howard University, a movement had ignited in New York. America's largest city was caught up in the excitement of the free-spending, roaring twenties. The "discovery" of the Negro was the "in" thing to be embraced—a vogue certainly no alert publisher would be caught ignoring.

The publishers of *The Survey Graphic,* a far better than average magazine, issued its now famous Harlem number. They asked Alain Locke to edit it and they asked Winold Reiss, a Norwegian-born artist, to illustrate it. So strikingly executed were the Reiss illustrations and portraits of black personalities that they lured a young black teacher from Kansas to New York City. The new arrival was Aaron Douglas, trained at the University of Nebraska and possessed of keen intelligence and an unusual imagination. For two years, from 1925 to 1927, Douglas was the pupil of Reiss. And when James Weldon Johnson's book of sermons in verse, *God's Trombones,* was published in 1927 with illustrations by Aaron Douglas, the young black artist was thrust into national prominence.

Langston Hughes's *The Weary Blues* and *Fine Clothes for the Jew* were high on the readers' lists then. Satirist George S. Schuyler was writing brilliantly for *The American Mercury,* and Claude McKay's *Home to Harlem* was a best seller. The

so-called "Negro Cultural Renaissance" in Harlem was slip-
ping into high gear. For black painters and sculptors the
"Renaissance" held a special significance. They had found a
promoter.

William E. Harmon was a white businessman and philan-
thropist. He had declared that the recognition of the artistic
achievements of black Americans was of as much benefit to
white Americans as to blacks themselves, and he used some
of his money to promote that idea. The Harmon Foundation,
therefore, made its first effort in the direction of encouraging
black artists in 1926.

Nineteen artists from various parts of the country re-
sponded to the Foundation's call to send samples of their
works to the Nassau Street offices in New York City. Among
them were painters Palmer Hayden and Hale A. Woodruff,
who won the $400 gold and $100 bronze awards, respectively.
The following year forty artists submitted works, and prizes
were taken by painters Laura Wheeler Waring, William
Edouard Scott, John W. Hardwicke, and by sculptor Sargeant
Johnson. New York's International House displayed the
works of all the artists in that first formal Harmon exhibition.

Within ten years the number of participating artists more
than tripled. Sculptors included May Howard Jackson,
Nancy Prophet, Meta Warrick Fuller, Leslie G. Bolling,
Richmond Barthé, Augusta Savage, Marion Perkins, Ramos
Blanco, Henry Bannarn, and William Artis. Among the more
seasoned painters were O. Richard Reid, Edwin A. Harleston,
Aaron Douglas, Allan Freelon, Albert Alexander Smith,
Malvin Gray Johnson, William H. Johnson, Archibald J.
Motley, and Ellis Wilson. Younger artists Charles H. Alston,
E. Simms Campbell, Samuel Countee, Beauford Delaney,
William Goss, Rex Goreleigh, Lois Jones, Vivian Key, Robert
Pious, James A. Porter, Donald Reid, and James L. Wells
gained their first audiences, too, through participation in the

Harmon exhibits. Recognition also went to an able young art photographer, James E. Allen.

With the collapse of the stock market and the ensuing Depression of the 1930's came an end to the Harlem Renaissance. But the exhibits of the Harmon Foundation continued through the first half of the 1930's. Whatever reservations some may have had about the work of the Foundation and its director, Mary B. Brady, all agreed upon one thing. With the exception of the then more limited Howard University Art Gallery, the Foundation had done more to promote Afro-American artists than any other group at that time. Beyond that, its insistence upon excellence of performance in those works it showed and rewarded with prizes set a tone for what was to follow.

The nation was deep in economic gloom when the Works Progress Administration (W.P.A.) Federal Art projects were born in the 1930's. Black artists, no less than whites, needed work. Some of those who were on the projects and who are firmly established now are Romare Bearden, Robert Blackburn, Selma Burke, Margaret Burroughs, Claude Clark, Samuel Brown, Zell Ingram, Eldzier Cortor, Ernest Crichlow, Hughie Lee-Smith, Norman Lewis, Vertis Hayes, Charles Sebree, Charles White, and Elton Fax.

In Philadelphia there was the gifted young painter, Claude Clark, who established an unusual rapport with the wealthy and eccentric Albert C. Barnes. Clark teaches presently at Merritt College in Oakland, California, and he is represented in most major showings of black artists' works. There was the time when Barnes permitted only a few people other than students to look at his unusual collection of African and modern art at Merion, Pennsylvania. Claude Clark was one of the few. Since the middle 1950's the policy set by the late Mr. Barnes has relaxed, and Clark continues to maintain a relationship with the Barnes Foundation that began in 1939.

But the individual of the 1930's who would bring the

rawest and most original expression of the black experience to art was a Harlem schoolboy named Jacob Lawrence. His story forms one of the chapters of this book.

The anxieties of the Depression surrendered in 1941 to other anxieties as the nation leaped into World War II. Nor did the swift transition from Depression bust to wartime boom diminish the cynicism of the black masses in America's slums. For them, discrimination in defense plants and in the armed services was nothing new. Indeed it was their accumulated cynicism, aggravated by the hostile intransigence of white America, that lit the fuses throughout black ghettos during the 1950's and 1960's.

The works of some black artists reflected this feeling in their choice of subject matter directly related to the black experience. Others, by studiously avoiding it, were in a strangely ambivalent and tormented way giving testimony not merely to their lot as black Americans, but to the sick state of their nation. For, make no mistake about it, no one escapes untouched. All Americans are, to one degree or another, contaminated by the viruses of our national ills, not the least of which is racism.

Although this narrative will focus upon seventeen individuals, it speaks in some way for and about all contemporary black artists. For all have this one thing in common. They are compelled, whether or not they care to admit it, to wrestle with racism as they struggle to practice their profession.

One catches, however, a tantalizing glimmer—the merest glimmer—of hope. It is possible that black creativity can direct this country to a state of spiritual and emotional health. But it must be given a hearing. Certainly, the men and women written about here, whose lives and experiences are so vital a part of America, are illuminating a way.

Chapter II

ELIZABETH CATLETT

She is a tall, strongly built, femininely attractive woman whose warm earthiness puts one immediately at ease. Her voice is surprising. Its deep contralto resonance suggests the traditional blues singer she might have been had she chosen to go that way. As it is, what Elizabeth Catlett does is, at its core, as basic and as moving as any blues ever performed. The same spirit haunts her conversation as she speaks with a bittersweet pride of her forebears.

My mother's parents were both slaves, and they were young when emancipation came. My grandfather helped build railroads in North Carolina and earned enough money to buy a farm. He had eight children—four boys and four girls. All the girls went to Scotia Seminary, now Barber-Scotia College; and all the boys went to Biddle, the Presbyterian school, now Johnson C. Smith University.

My father's mother never knew her parents. She only knew her uncle, a free man, who was a barber in Washington, D.C. So when my father's mother was emancipated, her uncle went to Virginia to bring her to Washington by train. And do you know what? *They made him pay for every seat in the railroad coach in which they rode!*

Such was the quality and character of Virginia racism. But if the laws and customs of the Old Dominion State were un-

duly harsh to black people, following the Civil War and well
into the 1900's, attitudes in the nation's capital were little
better. On Saturday, July 19, 1919, a group of white soldiers,
sailors, and marines, on leave in Washington, perpetrated an
unprovoked attack upon black civilians in the city's south-
west section. Infuriated by what they had seen of black men
in the uniforms of the armed forces, the servicemen, heavily
reinforced with whiskey, resolved to "put the niggers back
in their proper place."

The next day, not satisfied that they had done enough, the
same aggressors, joined by sympathetic white civilians, ex-
tended the attack. They seized their victims from trolley cars
and from private vehicles, pummeling many into uncon-
sciousness. One man was severely beaten in front of the
White House, while a total of three hundred were wounded
by an assortment of deadly weapons.

A third attack, planned for Monday, never came off. The
white invaders of another large black section of Washington
were greeted by a hail of bullets. Before the pungent cordite
lifted, six men—four white and two black—lay dead. The
Washington "riot" suddenly came to an end! Tiny Alice
Elizabeth Catlett and her brother listened openmouthed as
they heard family and neighbors talking about how their
people refused to be slaughtered like cattle for no reason
other than being black. The lesson was by no means lost on
the children.

Their father had died before Alice Elizabeth was born.
He had been one of Booker T. Washington's teachers of
mathematics at Tuskegee Institute before coming to teach
in the Washington public schools. In his spare time he
played music and did a bit of wood carving. His widow lived
with her children in the home built by her father-in-law in
the nation's capital. Like similar homes of the area, it was
typical of the relative comfort and security of Washington's
black middle class.

Because Elizabeth's mother had to work all day, she would leave her baby daughter with a neighbor until she returned home. This prepared the child for getting into kindergarten early. By the time Elizabeth reached the fourth grade she was put in the opportunity class where French and algebra were taught. But the teacher of that class died suddenly and Elizabeth's experience with her replacement was not particularly happy. She did, however, manage, with help from her older brother, to get through the Lucretia Mott Elementary School with a good record, enhanced by her unusual skill at drawing. "I always wanted to be an artist, but for a long time I thought I was going to be a painter," she recalls.

At Dunbar High School, Betty—everyone was calling her that now—was not only excelling in soap carving and painting but was also doing well in her academic courses. So as graduation neared she looked about for a first-rate professional art school. The only one in Washington admitting black students was the then young and burgeoning Art Department at Howard University, under the direction of James V. Herring.

Betty, with a cousin living in Pittsburgh, Pennsylvania, felt she could go there and get better training at Carnegie Institute of Technology. Losing no time, she filed an application for a testing at the famed steel-city school. Carnegie Tech just as promptly instructed her to report to the school, where she would be spending a week taking their competitive examination tests. Betty was elated. She arrived as scheduled and entered the competitive classes where, along with others, she eagerly executed her assignments.

"I was the only black kid there, and each day we students would vote on those things we felt were the best," she says.

Though a lot of the kids never earned any recognition at all, I'd constantly get citations from the others on my work. You can always tell what you are doing. So I thought that in spite of what my cousin's neighbors and friends had been saying about how

Carnegie Tech had never before had a black student in art, I was one of the best possibilities for entering the art school that year.

On the day the candidates were hanging their work for review by the faculty, Betty overheard a remark. "It's too bad she's a Negro, isn't it?" one teacher said to another. Disturbing as it was, Betty would not let herself believe that her race would prevent those teachers from dealing honorably with her. Washington, where she lived, and North Carolina, where she had visited, were the South, and she had expected to encounter racism *there*. But Pittsburgh was the *North,* and racism could not, in her opinion, exist that far above the Mason-Dixon line. She returned to her cousin's home confident that she had done quite well in the tests.

The curt letter of rejection that reached Betty a couple of days later was a cruel shock to her. Northern-style racism coated with sugary deception was even more bitter to the taste than that of the South. She was crushed. Back in Washington, her wise and experienced mother calmly suggested that Howard University was always available. And that is where Betty Catlett matriculated as a student of design.

While she was a student at Howard, the Depression-induced Works Progress Administration (W.P.A.) Federal Art projects came into being during the early 1930's. Two of Betty's teachers, James L. Wells and the late James A. Porter, helped her and another particularly gifted student, Henry Hudson, get on the payroll. It was the first time Betty had ever earned any money outside of working during the summers at the swimming pool. "I was silly—I didn't do the work I was supposed to do. The money went to my head, and they fired me," the artist states in her typically candid manner.

Meanwhile, she did become seriously interested in mural painting, particularly the painting of Mexico's Diego Rivera, whose works were reproduced in books used by Professor James A. Porter. Little did Betty Catlett realize how closely

her life would later be tied to Mexico and to the art of its great contemporary masters. With no hesitancy she transferred from the course in design to painting and was later graduated from Howard University with honors.

Finding work during the Depression was not simple, especially for an artist. However, through an aunt living in Durham, North Carolina, Betty learned of a job in that city. For two years she taught art to four seventh grades, taught all the art in high school, and supervised art in eight elementary schools. Her salary, in tightly segregated North Carolina, where pay for black teachers and white teachers was unequal, was a paltry fifty-nine dollars per month. But that was not all that marked the difference between Durham's black and white schools. Materials available to white schools were not given to black schools, and the latter were overcrowded with disturbed children whom the authorities had labeled "delinquent." But the so-called "bad" boys and girls did not irritate Betty nearly as much as did the black class structure in Durham.

There she discovered the identical corrupt deportment among the affluent black elite one finds among whites of the same class and inclination. Many of their marriages were strictly for material advantages, and their exploitation of the poorer blacks was, in some instances, more ruthless than that of whites. "Why, I'll never forget," she says, "the time my boy friend suddenly announced that he was marrying a gal who owned a lot adjacent to his. He was planning to open a gas station and her lot was important to his venture."

Betty laughs in her deep throaty way. She continues: "You know when I first went to Durham I had an apartment. But I soon moved in someone's house as a roomer because some men would creep up the fire escape at night and knock on my window. It was quite a disagreeable situation."

But such social annoyances were, from Betty's viewpoint, secondary to other things that were happening in Durham.

During her second year a group of young black teachers had persuaded Thurgood Marshall, then an N.A.A.C.P. attorney, traveling in the area, to advise them how to go about equalizing salaries of black teachers. Hers had been raised to seventy-nine dollars a month during her second year. Attorney Marshall's advice to them was to make a test case, using a teacher employed by the state of North Carolina and not by the city of Durham. Betty, quite willing to be used in the test, was, as a city-employed teacher, ineligible. It was understood and agreed that the state Teachers' Association would have to vote for such a test case and put up the money to cover the salary of the teacher, who would surely be fired by the state while the case was being presented.

The president of the association was a black man, Dr. Shepard, who was also president of North Carolina State College for Negroes. Betty was certain he would be anxious to help the black teachers get a raise. "That's how naïve I was," she wryly recalls.

That's when I began to find out how crooked things are. When the resolutions were read, ours wasn't among them. And when I stood up to protest, Dr. Shepard and his supporters among the teachers told me to "shut up and sit down." When I refused to do that, the first thing I knew, two guys were hustling me out of the meeting! I got a real education in Durham.

It didn't take Betty Catlett long to realize that teaching in North Carolina under those circumstances was not for her. Why not go north to add to her study? she reasoned. Since the University of Iowa's Art Department had Grant Wood and it did not have a tuition fee for out-of-state students, she chose it over several others.

Betty was met in Iowa at the railroad station by a group of black students. Assuming that she would be living in the women's dormitory, she asked them where it was. Their reply was a burst of bitter laughter. "What old dormitory?" they

mocked. "Where'd you say you come from? Girl, don't you know we don't live in the white folks' dorm here?" So they good-naturedly drove Betty around the black section of town until she found a place to stay. Many areas of the North, she was beginning to learn, had their racist hang-ups.

On the credit side, however, Betty found at Iowa the disciplined work that she needed for growth. Grant Wood, a master carpenter as well as a master painter, insisted that his students learn their craft thoroughly. In all things Betty found him just and honest. In contrast to Howard University, where a heavy emphasis was placed upon socializing, Betty discovered that the training she was getting practically demanded that she do strong things in a strong medium. She turned to sculpture—not mere modeling in clay, but cutting in stone.

At the end of two years at Iowa she received her Master of Fine Arts degree—actually the first ever earned at the university. Since doctorates in fine arts are awarded in art education and art history, hers was the highest degree one can earn as a practicing artist. Grant Wood was elated. Betty's stone sculpture of a mother and child was a beautifully executed thesis, and he was justly proud of her achievement.

But the head of the department was not at all pleased. A man who prided himself on his ability to place each graduate student in a first-rate job, usually at the college level, his feeling toward Betty was clearly seen in the job offer he presented to her. "The day he called me in he offered me a job teaching art in a junior high school in Saint Louis—*if I could teach music too*," she says. "I told him not to worry about me, I'd get a job. The same man then told me I couldn't get an M.F.A. degree even though I'd been there for two years."

To keep her from being awarded Iowa's first M.F.A. degree, the director "arranged" to have a similar degree given simultaneously to his teacher of sculpture. Actually this

maneuver of the director served a double purpose, as it was also a reward to the sculpture teacher for running the art department for two years while the director was expending his energies elsewhere.

But visual accomplishment—or lack of it—is clearly seen and understood by one's professional colleagues. To Betty's classmates the sculpture teacher's thesis, hurriedly thrown together in cast cement, suffered visibly beside her carefully carved work upon which she had spent several months. It was not a question of superior versus inferior talent, but one of careful and loving craftsmanship versus the lack of it. So when all of the director's efforts to demoralize the gifted, young black woman failed, she left Iowa with her M.F.A., a greater knowledge of sculpture, and a more profound understanding of human behavior. The year was 1940.

For a brief time Betty taught art education at black Prairie View College in Texas. She remained there until some white toughs in Houston tried to demolish a car in which she and friends were riding, and that finished her with the Lone Star State. Her next job was at Dillard University in New Orleans. There she headed the art department. Her predecessor, painter Vernon Winslow, had been fired by the president for hanging the painting of a female nude where it could be seen. Betty went to Dillard, however, with a reputation that commanded respect. Indeed, she was bringing prestige to the school, for she had entered her master's thesis, "Mother and Child," in the national show of Chicago's American Negro Exposition of 1940, and it had won first prize for sculpture. Miss Catlett was therefore at liberty to do a little daring experimentation.

First, she brought live models into the school and set up a class in life drawing. "Everybody found some reason"—she laughs—"to knock on our door that day. I told my students that I wouldn't be surprised if President Nelson wouldn't be

next, and sure enough he knocked, stuck his head in, and asked if we needed anything!"

Next, with the aid of a white teacher at Dillard, Betty was able to circumvent a city ordinance and get a group of black students into a local museum to see one of the biggest Picasso retrospective shows ever presented in this country. The museum, located in a city park, did not bar black visitors. But the city park did. Blacks were not to set foot in it. The plan was to have Betty's students bussed to the door of the museum and then step from the bus directly into the building. It worked. In fact, arrangements for that visit were so carefully made that confounded white museum visitors were turned away in droves. Miss Catlett and friends had effected what one might delicately term a shadowy cultural coup of sorts in the Crescent City.

Her next unorthodox move was to demand twelve months' salary for twelve months' work instead of the ten months' pay she had been getting. She might have made it had there not been a change of administration. Dillard's new president, Albert Dent, was in Betty's words "more interested in making his white board of directors feel good" than in developing high scholastic standards or a deep appreciation of what art really means. If his teachers and students had to go wanting, then so be it. Betty, disgusted with the changes at Dillard, left for New York.

The year she spent in Manhattan was a highlight of her life. To begin with, she lived with Dorothy and Kenneth Spencer, an exciting experience in itself, since Kenneth was a magnificent baritone singer, one of the regulars at Barney Josephson's famed Café Society Downtown. Fellow performers included folk singers Josh White and Hudie (Leadbelly) Ledbedder; jazz pianists Hazel Scott, Mary Lou Williams, and Teddy Wilson; singer, Billie Holiday; and boogie woogie pianists Pete Johnson, Albert Ammons, and Mead Lux Lewis. Betty came to know all of them both on stage and

offstage. She also came to know the remarkably gifted French refugee sculptor, Ossip Zadkina, with whom she studied in Greenwich Village. Zadkina's influence upon her was so strong that one finds his use of convex and concave forms in sculpture appearing from time to time in the current Catlett creations.

Betty's visit to New York was followed by a six months' stay at Hampton Institute, where she worked closely with Viktor Lowenfeld. There she met one of Lowenfeld's talented young black students, John Biggers, from Gastonia, North Carolina. While at Hampton, Betty remembered also an especially serious young black art student of hers at Dillard. Her name was Samella Sanders, and through Lowenfeld, Miss Sanders received a full scholarship, enabling her to move ahead with her development.

A trip to Atlanta University followed the Hampton visit. Hale A. Woodruff, who was heading the Atlanta University Art Department, listened closely as the young woman sculptor explained to him the advantages of offering purchase prizes at each annual Atlanta exhibit. Recalling how splendid art works exhibited at Dillard had received prizes and had been returned to the artists following the shows, Betty was conscious of the need of the black universities to acquire works. Her meeting with Woodruff marked the beginning of Atlanta University's permanent art collection. The South was exciting in that some constructive things were beginning to happen in a few black colleges. But the lure of New York was even greater to Betty Catlett, who returned there to work in the George Washington Carver School in Harlem and to make use of a Rosenwald Fellowship.

Although the Carver School was cited by a congressional committee against subversion, a number of gifted and responsible Harlem citizens lent it their support. Painter-writer Gwendolyn Bennett was its dynamic director, and Norman Lewis, who would later become an outstanding American

abstract painter, was one of the teachers. Painter Ernest Crichlow was another; and artist-photographer Roy De Carava was one of the young students. Betty Catlett, whose experiences had conditioned her not to be fearful of controversy, became one of the Carver School's ardent promoters.

Not only did she talk it up in the community, but she swept its floors and taught classes in sculpture and how to make a dress. Then came a renewal of her Rosenwald Fellowship. She had planned to do a series of sculptures, paintings, and prints on black women, and to get the project going she would have to give up the hectic activity of New York. Besides, she was beginning to feel the hot breath of the political witch-hunters on her neck. In was 1946 when Betty arrived in Mexico City with her husband Charles White.

In view of the direction of twentieth-century Mexican history and Mexican art, it seems fully consistent with her bitter personal encounters at home that Betty would choose Mexico as a place to live and work.

From 1884 until 1911 the dictator Porfirio Diaz had ruled the Republic of Mexico. Stern and effective, Diaz crushed incipient revolts, diminished banditry, and shrewdly played aspirants to political power against one another. In that way his presidency remained assured and supreme. Material prosperity for the privileged grew rapidly as foreign capital poured into Mexico and her resources were exploited mainly by foreigners. Railroads, highways, and telephone lines increased under the Diaz regime, and the interests of the few had never been better served. Meanwhile, the oppressed Indians lost their communal lands as education stagnated and talk of democracy amounted to little more than mocking phrases. Finally Diaz was seriously challenged.

A revolutionary idealist named Francisco Madero rose against him, and in the struggle Mexico was thrown into turmoil. But Madero, not sufficiently strong to hold the country together, fell before the reactionary Victoriano

Huerta. Now Mexico really began to seethe. Other revolu-
tions led by Venustiano Carranza, Francisco Villa, and
Emiliano Zapata sprang up. Villa and Zapata were finally
subdued but only after United States-Mexican relations were
strained by the entry into Mexico of a United States expedi-
tionary force sent to hunt Pancho Villa down. After eleven
frustrating months of trying, the force, led by General John J.
Pershing, returned home, its mission incomplete. Finally,
after seven additional years of uprisings and internal discord,
"strong man" Plutarco E. Calles took over the presidency
from 1924 to 1928. And Mexico took another backswing
toward political and social conservatism.

Meanwhile, in 1922, new schools, libraries, and the build-
ing for the new Secretariat of Public Education were going
up in Mexico; painter Diego Rivera returned home from
Europe; David Siqueiros was called home from Rome; and
Orozco, painting such canvases as "Death," "The White
House," and "Driftwood," had not yet painted his fresco for
the National Preparatory School. It was in March of 1923,
when Diego began the first of a series of a hundred and
twenty-four frescoes for the Ministry of Public Education,
that modern Mexican mural painting was born. This was the
first of Diego Rivera's great frescoes, and it was to consume
four years and three months of his energies.

A decade later, in 1934, Lázaro Cárdenas, a man of Taras-
can Indian descent, became Mexico's president. Unprece-
dented reforms, based upon the constitution of 1917, swept
over the Republic. Cárdenas seized large private landholdings
and distributed them among small farmers. He nationalized
the railroads; and foreign holdings, especially oil and land,
were expropriated. Moreover, he made a drive against illit-
eracy, especially among the Indians. When United States
capitalist interests in Mexico, that had been displaced by
the Cárdenas reforms, called for official United States curbs
on Cárdenas, Franklin D. Roosevelt established instead his

Latin-American "Good Neighbor Policy." Roosevelt saw
hemispheric solidarity as more important than the capital
losses, great as they were, of private interests.

At the same time that American voters were sending Roose-
velt to Washington to heal the nation's desperate economic
illness, Diego Rivera was being called to New York City by
Nelson A. Rockefeller to paint frescoes in the newly erected
Rockefeller Center. The resultant painting and the contro-
versy that ensued will be treated in greater detail in the fol-
lowing chapter. But the publicity that Rivera and other
eminent Mexican muralists received in this country was not
lost upon our own artists. It was especially significant to those
black artists whose entire life style, from 1619 to the present,
was attributable, from their point of view, to the same kind
of human oppression that great Mexican artists were paint-
ing about. That, as much as anything else, is what drew
Elizabeth Catlett to Mexico. "I first worked in The Esmer-
alda, for there are studios there, and I studied terra cotta
sculpture, building it up directly as they've been doing in
Mexico since pre-historic times!" The artist explained. "And
I did woodcarving with José L. Ruiz, a *wonderful* man. Then
I went to the Taller de Gráfica Popular where they let me
work as an associate, then as a foreign visitor, and finally as a
member."

It was at the Taller that Betty met painter and print-
maker Francisco (Pancho) Mora, a sensitive man of Tarascan
Indian heritage, from the state of Michoacán. In a relatively
short time she became La Señora Mora, having divorced
Charles White.

Exciting things were happening at the Taller. Its members
had been given individual cash advances from the Associated
American Artists in New York to begin production of a
special album of five hundred or so prints depicting life in
Mexico. The artists with their advances fanned out over
various parts of the Republic to make sketches from which

they would later work as they completed their prints at the Taller. Pancho Mora went to Pachuca, in the state of Hidalgo, to sketch in the silver mines. It was a collective project in which the artists consulted together, worked together, criticized the work as it progressed, and finally assembled it. Because of Betty's excellent training and strong draftsmanship, she became an immediate and valued member of the team that produced the handsome album. She discovered, among other things, that it is quite possible for artists to work collectively, as do actors, and still retain their individuality.

During the early years of her residency in Mexico, the United States Information Agency, through the Benjamin Franklin Library, presented a special televised program, "La Musica U.S.A." Betty, with her warm contralto, was chosen to sing a Negro spiritual. The program director wanted her to sing *Swing Low, Sweet Chariot,* but she held out for *Steal Away,* since that was a "code song" used by slaves to signal how, when, and where escaping slaves would route their getaway. After a little bickering she was able to carry her point, and the U.S.I.A. was pleased with her work.

"They promised that I'd be doing a lot of that sort of thing for them but I never heard from them anymore," she says.

Meanwhile I had offers to sing in night clubs in Mexico City but Pancho didn't care for the idea and I never pursued the offers. Besides we had three small sons and between looking after our home and keeping up with my print-making, there wasn't time for anything else. As it stood, I began to have a few problems I hadn't counted upon.

During and following the period of Senator Joseph R. McCarthy, Betty was, in her own words, "harassed because of my former political connections and because my husband, Pancho, was working in the interest of Mexico's railroad

workers." The Moras were not alone. During a week of riots thousands of persons were arrested in Mexico: Cubans, Germans, Yugoslavs, United States citizens, and a few Mexican nationals. Betty was suspected and accused of "talking to students." "So I decided," she says, "that in order not to be constantly harassed I would become a Mexican citizen, which I did."

In 1959 Betty took an examination to teach sculpture at the art school of Mexico's National University and she passed it. Without hesitation she received her appointment, the school's first woman professor of sculpture. But she met with opposition in the beginning. The male members of the faculty were not at all friendly, particularly when Betty, because of her superior training and credentials, was named head of the department. That meant they were answerable directly to her. Male ego and the cherished *machismo* were being challenged by a woman, an unheard of thing in Mexico!

"They refused at first," she recalls, "to come near me or to have anything to say to me about the business of the school. But I cooled it and waited patiently, for I knew my experience would carry me through it. After all, I had won a couple of major prizes here and I had exhibited all over the world with the Taller and they respected that."

Betty was quite right. The Taller was held in high esteem by graphics groups elsewhere, including Puerto Rico, Canada, Japan, China, many Latin-American countries, and the U.S. Sure enough, in a relatively short time the men, as they observed her controlled efficiency mingled with a genuine warmth and love for humanity, put aside their hurt pride and began to work with Betty. They have been doing so ever since.

With her sons well out of their babyhood, she resumed her work in the round, carving in wood and stone. Winning a couple of prizes in the Atlanta University shows, Betty

entered her sculpture in Mexico's first biannual show, where it took a major award. In the following Biannual, 1962, she repeated the achievement and one of her students also won a prize.

Meanwhile, she had been invited in 1961 to give the keynote address before a gathering of black American artists at Howard University. In her typically independent fashion Betty paid her own way, except for fifty dollars given her by the group. Before going to Washington, however, she went first to see her friend and colleague, sculptor Marion Perkins. "I was glad I had made that decision," she says, "because poor Marion died shortly afterward."

Betty made a particular point of getting to New York while in the country. Her experience with the leading black artists there, all of whom knew her, was a shocking disappointment. Obviously afraid of being associated with, and possibly punished for their association with, a "radical sister," they reneged. Not one, she took the trouble to telephone, with the exception of Ernest Crichlow, had the time, and more important, the courage, to see her.

At the conference in Washington, Betty found that all of the big-name, and even moderately successful, black artists were conspicuous by their absence. Again Crichlow did make the trip from New York. Others there, who were working alone and obscurely in black Southern colleges, as Betty herself had once done, represented painters, sculptors, and printmakers. Edwin Wilson, Eugenia Dunn, and James Lewis were among them, and here they were experiencing the rare thrill of sitting together. Here, in summary, is what Betty recalls of her remarks to them.

I tried in my address to stress that it was no longer necessary for the black artist to prove that he was as good as the white artist. The job now is to look into our black communities for inspiration—to work for our black people—and to show the link between our struggle and that of other similarly warped and op-

pressed peoples. We no longer, if we are artists, need to prove our-
selves technically any more than our singers need to learn the
European classics first and then sing spirituals. We will be neither
free nor effective until we can reverse that procedure. So let us get
on with creating the best art possible for the liberation of our
beautiful black people.

Between 1941 and 1969 this artist took eight prizes and
honors, four in the United States and four in Mexico. It is
worth noting that her four United States awards came
through competitions with black artists exclusively. The four
Mexican awards were for excellence in Mexico's general and
unsegregated competition. In 1966 she executed a bronze,
nine-foot figure, "Olmec Bather," for the National Poly-
technic Institute of Mexico. And "Reclining Woman" was
shown in Olympic Village in 1968. Indeed, someone had
stolen the latter at the end of the Olympic games, though it
was finally recovered and returned to the artist.

"La Maestra," as her students and colleagues respectfully
refer to her, lives happily with Pancho, her painter husband,
and their youngest son, David, in their comfortable modern
home in a quiet section of Mexico City. David is a student at
the National School of Plastic Arts. Their son Francisco, Jr.,
is a student of music in Boston, and Juan is studying cine-
matic art in Czechoslovakia.

That the lady is honored in her adopted country is ob-
vious as one visits Mexico's Museum of Modern Art and finds
her exquisite and strongly carved figure, "Woman," occupy-
ing a prominent place in the spacious court. Her linoleum
cut "Malcolm X Speaks for Us" won the acquisition prize of
the National Print Salon. And her exhibition in July of 1970,
titled The Black Experience and composed of sixteen sculp-
tures and twelve prints, won critical Mexican praise.

When Mexico City's leading artists are assembled for a
televised discussion, Betty Catlett is among them, and her
comments are listened to with respect. She continues to teach

and to produce her own creations, with the encouragement
of her husband and of her critical admirers in Mexico. How-
ever integrated she has become in the life of current Mexico
(and she is thoroughly immersed in what is happening there),
Betty never loses touch with what is taking place in the United
States. She goes out of her way to learn what the latest de-
velopments are in America's black community and she ex-
hibits here whenever she gets the opportunity.

Though classified now as a "foreigner" by our Depart-
ment of State, she is no stranger to that part of our country
that knows and respects her. "My point of view about life and
art," she says, "has grown out of my experience. A woman
critic here once told me that whenever I do Mexicans in
sculpture they always turn out to be black. There's no doubt
a lot of truth in what she said. My art does, after all, speak
for both my peoples."

Chapter III

JOHN WILSON

ONE DAY DURING 1950 Betty Catlett Mora and her husband, Pancho, had a surprise visitor. He was John Wilson from Boston. With his bride, Julie, Wilson was in Mexico on a John Hay Whitney Fellowship. An excellent painter and printmaker, whose prize-winning works had been shown in the Atlanta and other national shows by black artists, John's art was well known to Betty. She and Pancho gladly introduced him to their group at the Taller de Gráfico Popular. For John Wilson and the members of the Taller it was a mutually fitting introduction. For Wilson, alone, it marked a giant step from the confines of Boston's black community called Roxbury to one of the most esteemed art workshops of the hemisphere.

John's parents, Reginald and Violet Wilson, were born in what was then British Guiana. With the ambition typical of many island people, they came to the United States seeking what they were certain would be a better opportunity for themselves and for the family they were planning. Their reason for leaving Guiana was that, like most of the Caribbean islands, their homeland was plagued by a rapidly increasing population vying for limited land resources.

Between 1838 and 1917 nearly half a million East Indians

were brought into the Caribbean as indentured laborers. More than half that number went into British Guiana alone. Those who were brought between 1850 and 1920 came from a society in India where marriages were made permanent by Hindu custom. On the plantations of the West Indies their traditions meant nothing to the planters, whose only interest was in getting as much work out of them as possible. Nevertheless, the East Indians, through a common language and religion, rebuilt, in both Guiana and Trinidad, a way of life based upon that they had left in India. Their racial and cultural identification with India firmly intact, the Asian recruits to the Caribbean were rarely cordial toward black Guianans.

So it was Indian clanishness added to the growing shortage of elbow room that induced Reginald and Violet Wilson to seek a new life in the United States. Once here, however, they experienced a feeling of mixed elation and disappointment. While there was no East Indian faction to contend with, there was white racism that prevented technically trained Reginald from getting work commensurate with his skills. He took a job wrapping packages. When the stock market crashed in 1929 he was, in the classical tradition of blacks and other nonwhites in America, among the first to be fired.

This came as a severe blow to Reginald Wilson, who had grown up under the British colonial system that shrewdly allowed a few men of color to aspire to and occupy positions of a higher level. Because he and his wife had never accepted the assumption that whites are superior to blacks, they never passed such sentiments on to their children. In fact, Reginald Wilson's humiliation at having to accept work beneath his skills, during an era of American prosperity, rendered him particularly receptive to the stirring black nationalist exhortations of Marcus Garvey.

Garvey, coming from the West Indies to the United States

in 1916 and finding much disillusionment among the masses of black Americans, rose quickly to a position of powerful national leadership during the 1920's. His United Negro Improvement Association, with a well-knit division in Boston, attracted many followers. "My father was one of the most ardent of them," John reminisces.

There were five Wilson children, four boys and a girl, all born in Roxbury. The girl was the oldest and John, coming next to her, was born in 1922. "There was a smaller black population in Roxbury then," Wilson says.

They were mostly second and third generation families who felt that their living *Bahston* somehow accorded them a full share in the city's liberal traditions. How they squared that with their ghetto existence is a mystery. At the same time I don't ever remember living in a neighborhood where there weren't white people within four or five blocks of us. While I don't recall blacks who lived in white areas, there was always a sprinkling of whites in ours.

John Wilson's analysis of the racist character of Boston of the 1920's and 1930's is sharp, incisive, and brief.

This show of token neighborhood integration of the races kept the black-white conflict from being so obvious. There was less consciousness then of the oppression of black people simply because it wasn't officially recognized as—say—was the highly publicized persecution of Jews in Europe. Inequities were explained away by declaring that since people in the north were free to do as they pleased, the black person's not making it was due to his individual ineffectiveness. Blacks and whites accepted that kind of dictum. The Civil Rights Movement (that contribution of Martin Luther King, Jr.) that swept the whole mess from under the rug, was not a part of things.

The elementary school John attended was in the very heart of Boston's black community. Ninety percent of its pupils were black, yet not one black teacher occupied a classroom. Never in his life did John Wilson have a black teacher.

He was made particularly conscious of the fact, as his father, verbalizing the Garvey philosophy, talked constantly at home of the need among black people to develop their own resources and their consciousness of their own worth.

So John found himself caught between having to swing with the lie that democracy was working and that he could go as far as his talents would take him, and the grim counter-evidence that democracy wasn't really for you if you were not white. There was yet another facet to his bewilderment. Nothing that his parents ever said or did indicated that they accepted *or that he should accept* the inconsistency and the limits it placed upon blacks. "I think," he says, "that many West Indians take that tack and that explains in part how and why I became an artist."

He doesn't remember when he did not draw or do something related to creative expression. Never did his parents discourage him. And that has special meaning to John Wilson, who learned early that the one thing for which one was punished—severely punished—was for breaking tradition.

The newspapers, especially the black papers, were full of harrowing tales of black men who stepped out of line and challenged the white man's advantage. And this applied not only to those who, in stepping out of line, committed unlawful acts. It applied equally to those who insisted upon being granted their rights guaranteed by the Constitution. The pictures of individual blacks set upon by white mobs for daring to try to vote in certain areas of the South were indeed graphic. The same held for pictures of the black family in the North that dared buy and then occupy a home in a hitherto white neighborhood. Those graphic pictures, John discovered, were designed to serve as a grim warning to others who might be tempted to follow suit.

"I got the message all right," Wilson admits. "And I'm not so sure but that getting the message had much to do with steering me in the direction of a personal introspective self-

expression in the arts. Humans tend to resolve these kinds of things by making personal statements."

The Boston public schools, like most public-school systems, conducted an unimaginative and sterile art program. Young John Wilson was able to ride above its mediocrity because his teachers wisely would not interfere with children whose involvement in their own creativity was complete. Actually teachers took pride in showing John's work all over the school. That stimulated him to do even more. With his ego thus inflated in school, and then at home by admiring parents who showed his creations to every visitor, John became art oriented at an early age. A simultaneous bout with rheumatic fever that curtailed strenuous activity served to confine most of his energies to creative experimentation.

At Roxbury Memorial High School, where John excelled in all art activities, he became editor of the school newspaper. It was almost a foregone conclusion that any opportunities extended to students so gifted would be extended to John Wilson. Almost, that is, but not quite.

The Boston public schools, in conjunction with the Fine Arts School of the Boston Museum, selected talented high-school students for special classes in art at the Museum school. Classes met on Saturdays and their purpose was to prime those who wanted to pursue art professionally. Those selected for the classes were made ready to compete for scholarships to the Museum school. John Wilson was never selected for membership in that Saturday class, though others in his school, whose art achievements fell behind his, were. He speaks about that experience every so often.

Though I was upset about this I didn't feel quite sure enough in my suspicions to say anything about it. After all, this was not a thing proper *Bah*stonians discussed openly in those days, and my teachers were all quite proper people. Besides, I was able to get over my initial bitterness because of what came along by way of unexpected help from a source outside the school.

There was the neighborhood Roxbury Boys' Club to which John would go regularly after school. The big attraction for him was the art class, headed by a couple of young men, Peter Dubanowitz and Bill Halsey. John became a fixture of the Club and the art class. Dubanowitz and Halsey, both graduate students at the Boston Museum school, saw the boy's talent and after working with him for a year or so made a proposal. With John's consent they would take a portfolio of his work to the school and see if they could get a scholarship for him. The young artist needed no coaxing.

The Boston Museum school agreed without qualification to admit Wilson on a full scholarship for a year's trial. And he was admitted upon graduation from high school without having to take the usual entrance examination! Reflecting upon it now, John says: "As is true of so many of our folks I got in by the back door—which is the way most exceptional black people in our society get on the track of status and success. You usually get in by the back door because of the benevolence of some kindly white individual."

His tone grows cold and scalpel-edged.

Officially you're washed out—destroyed as an individual, for that is what the establishment had in mind for you, anyway. Anyone of my generation or older who made it had to be helped by some white person who took exception to what the establishment had in store for them. So you were given your individual chance for which you were supposed to be grateful. Ha! Maybe my art teacher in high school, who never recommended me for the Saturday Museum class, rationalized that he was doing me a favor by not exposing me to the harsh realities of the artist's life. And in that sense he thought of himself as being a good black parent to me!

John, now sixteen years old, was in the Boston Museum school with little or no way of fully apprehending the social implications of what was happening to him. But he knew he was black all right, and he was determined to play the game

of "fulfilling myself in spite of what whites had expected of me." Moreover, he felt he had absolutely nothing to lose but his obscurity. He was, and still is, genuinely grateful to Dubanowitz and Halsey, for he knew they were motivated by a sincere desire to see that he was not robbed of a chance he deserved. Still, John had a sense of growing bitterness toward the white world that made their kind of sincere benevolence necessary.

At the Museum school he discovered a world completely different from the one he had known in grammar and high school. The one familiar sight was that of schoolmates from Roxbury Memorial High who had come in by way of the Saturday classes. Seeing them was no surprise to John. Nor, from their honest youthful viewpoint, was his presence there any great surprise to them. What began to disturb John was that, to use his own words, "the sense of tradition and pattern that one gets with everyday contact with the black community was lacking at the Museum school."

Moreover, even though he was an outstanding student all the way through (having his full scholarship renewed each year), he knew he'd have one rough time earning a living as a painter. The white boys and girls faced that reality, so what more could *he* expect. Behind this uncertainty was that other reality, the Depression. The Wilsons had been forced to go on welfare. Yet not once did either parent suggest that their Johnny would not find a way, just as the handful of success-ful white artists had found theirs. But John had secret mis-givings. As he looked about Roxbury and found no black artists sustaining themselves by their art, he wondered if he had made the right choice. Did he dare believe he could prevail? He wondered. And his doubts induced him to post-pone that inevitable confrontation with himself for as long as possible. At least he could postpone it until he had com-pleted his course, thanks to his parents' faith and to a most unusual teacher.

Carl Zerbe was a teacher not only of art technique but of those basic principles of living every individual needs to know. He is a man whose social conviction contributed much to John Wilson's development as a person. During John's second year at school the United States declared war on Japan. Suddenly the scarcity of work that had clouded the twelve years prior to 1941 gave way to a war boom as defense plants with thousands of jobs to offer sprang alive around the nation. John saw an opportunity to leave Boston for Washington, where he could be trained for work in lithography. The prospect of earning unheard-of wartime money was tempting indeed. Keenly conscious of the struggle his father had been having, John viewed this as his chance to be immediately helpful. He talked it over with Carl Zerbe.

Zerbe didn't think highly of the idea. He pointed out how easy it is when one is young to be lured from an immediate objective, particularly if money or the lack of it becomes a consideration. "No, John, you have too much to give—too much to say later—to run off course now, possibly never to return to the thing you are in." As an incentive to his remaining at the school, Zerbe practically guaranteed young Wilson a fellowship good for a year of study in Europe upon completion of the course. That did it. John proceeded to complete his two remaining years with no further thought of quitting.

Still there was that nagging question of how to earn a living after he returned from Europe. Through his conversations with Zerbe he knew that most artists teach in order to eat and stay alive. But there were no black art teachers at the Museum school, and if the Boston public-school system employed any he had never encountered them. At that moment John knew more clearly than ever how important it is to the minority group student to see someone, to whom he can personally identify, doing the thing he wants to do.

The onus of failure is always on you when nobody sees you as an active participant. People wonder what is wrong with

you. Maybe you can't do it, after all, and that's why nobody ever sees you doing it. With that in mind and with his self-confidence buttressed by a fine and sensitive teacher, John Wilson went ahead and completed his course at the Boston Museum school.

An arrangement between Tufts University and the Boston Museum school permitted art students to take academic studies leading to a degree. John, realizing how valuable a degree would be in seeking employment, investigated the program at Tufts. He had received the traveling fellowship as promised by Zerbe but was unable to use it immediately because of the war in Europe. So it seemed reasonable, inasmuch as he had been exempted from the draft, to pursue his studies at Tufts. Three months after receiving the bachelor's degree in education he took off for Europe in the autumn of 1947.

John went directly to Paris. For the first time in his life he had a sense of being at ease with his thoughts. And he began to put his thoughts together in some semblance of meaningful order. To begin with, the four years spent in art school had meant development not only in the techniques of the craft but a development of his beliefs. The familiar ghetto of Roxbury, like any other restricted area, was reassuring only as long as one remained in it. Reflecting verbally upon what moving outside of Roxbury meant to him, Wilson says:

When I left the ghetto for the outside world I was able to look back with some sort of perspective on what had happened to me there. My contacts outside were with people more socially developed than I, and they introduced me to political and social movements in which I became involved.

Through Carl Zerbe's teaching I became aware of socially conscious painters—Daumier, Picasso, Roualt, Shahn, Groz, and the Mexican painters Rivera, Orozco, and Siqueiros. You can't look at the great Mexican muralists without being conscious of their expressions of revolution against the evils of existing social orders.

So, along with looking and listening I began to read. I read
Marxist philosophy and I read the *New Masses*. When I read
Richard Wright's *Uncle Tom's Children,* man, I flipped! I re-
alized that there had been a lot of pretending—pretending that
America was a great and good and generous place where anybody
could make it by pulling himself up by his bootstraps. Orozco's
paintings told it like it *was!* So did the stories of Richard Wright!

It was this contact with the writings and paintings of
modern masters that awakened the Wilson consciousness to
the breadth and intensity of human anguish and unspoken
bitterness. He made a trip to Dartmouth College to have a
look at the Orozco murals in the library. Then John took a
long hard look around him. How cooperative and conducive
events of the day were in evoking this kind of harsh expres-
sion! In June of 1943 a mob of whites in Detroit attacked
black citizens in a conflict that left thirty-four dead and seven
hundred injured. Ugly stories from the European and Pacific
areas of war told of racial clashes between black and white
United States servicemen. It was common knowledge that
black troops did the bulk of war's drudgery while white
troops did the bulk of the shooting. Yet black men who
weren't shooting died along with the others under deadly
enemy fire.

These were the things John Wilson felt needed to be
articulated by the black artist for the black masses. He began
his segment of it by making a series of drawings based upon
the stories of Richard Wright, before going to Europe. "It
was then that my life began to make sense," he says.

The thoughts and attitudes he held in Europe had, of
course, been shaped by all the foregoing experiences and
events.

In Europe I deliberately avoided contacts with white Ameri-
cans, partly because I wanted to learn the languages; but mainly
because it always took me a while to meet a compatible white
American. Most of them took a long time to cut through the fact

that you were black and not a stereotype but an individual. In Europe your acceptance as an individual is far more direct.

The artist smiles as he contemplates his companionships in France and Italy. He didn't try to do too much drawing on the spot but tried to absorb as much of the atmosphere as he could.

Six months after arriving in Paris I went to Italy and there I met young Italian writers, a few of whom have done some important things since. They usually assumed I was from Africa, for their stereotype American is harder and less "simpatico."

He laughs at the irony of his being a stereotype in his own country, while not being readily associated with the European's American stereotype.

John found that while studying in France with Leger and hobnobbing with writers and artists constituted an essential part of what art is, it did not show him what to do with his own art as an American who happened also to be black. So John began to ponder how he could create for himself a way of painting what he had to say of the black experience that would be as soulful as black music. He saw black Americans as completely cut out of painting, not merely in terms of numbers of images in painting but also in terms of a kind of treatment that attempted to interpret the black man's living reality. Richard Wright had successfully interpreted black reality in his writings. Why couldn't he do the equivalent in his drawings and paintings?

Upon returning from Europe, John's Alma Mater, the Boston Museum school, offered him a teaching post, which he promptly accepted. But he continued to be haunted by what he had seen on slides of the murals of the contemporary Mexicans. Standing before Orozco's famed panel—"Still Born Education"—at the Dartmouth library had stirred memories of what Wilson had heard and read of the great draftsman's other works in Mexico. Moreover, hadn't he and other artists

read with intense interest Diego Rivera's set-to with the clergy
in Detroit? Hadn't they been conscious of his later rift with
the Rockefellers in New York, hastily mentioned a few pages
back in the section on Betty Catlett?

What actually took place was that even before he could
complete the painting of his controversial frescoes for the
garden court of the Detroit Museum in 1933, Diego was in-
vited by Nelson A. Rockefeller to paint frescoes in New York.
The wall on the ground floor of the new R.C.A. building at
Radio City was his. After a year of correspondence Diego
moved into Radio City and began to paint, in March of 1933.
The plans he had submitted to the architect and to Nelson A.
Rockefeller, then executive vice-president of Rockefeller
Center, Inc., were clearly and unmistakably anticapitalist.

Rivera's interpretation of the Rockefeller "New Frontiers"
theme was as follows: 1) Science dominates and destroys the
gods. 2) Tyranny is liquidated. 3) The workers, both rural
and city, inherit the earth and machinery is controlled by the
worker. 4) The union of worker, soldier, and peasant with
the worker as the leader. 5) The implication that capitalism
bred war, crisis, and unemployment. Bertram Wolfe states in
his book, *The Fabulous Career of Diego Rivera,* that Diego
submitted that plan along with sketches to Mr. Rockefeller.
Rockefeller approved both.

When the nearly finished mural revealed the figure of
Lenin joining the hands of a black and a white worker, the
press reacted quickly. *The New York World Telegram* for
April 24, 1933, carried a story headlined: "RIVERA PAINTS
SCENES OF COMMUNIST ACTIVITY AND JOHN D., JR., FOOTS
BILL." Whether or not Mr. Rockefeller suffered a flutter of
heart is uncertain. But he did have a *change* of heart. Would
Rivera substitute an anonymous head for that of Lenin? It
seems that that part of the sketch had not been as clearly
delineated as in the finished fresco. "No!" was the artist's
reply. The frescoes were promptly covered with huge

stretched canvases, and Diego was paid in full and asked to abandon the project.

Demonstrations, pro and con, picketed the premises. Artists, intellectuals, liberals, and radicals supported Rivera. Businessmen with previous plans for Rivera murals canceled them. The pro-Rivera forces were sufficiently strong to induce the Rockefellers to pledge in a statement quoted in the *New York World Telegram,* May 12, 1933: "The incompleted fresco of Diego Rivera will not be destroyed, nor in any way mutilated, but . . . will be covered, to remain hidden for an indefinite time. . . ." Six months later, however, at midnight, Saturday, February 9, 1934, workers were set to work and they quickly reduced the murals to dust. Eleven-year-old John Wilson living in Boston was not destined to see the stormy creation until he visited Mexico where the artist had repainted it.

Later, as a young man, he came to know that when Rivera was paid in full, according to contract, he was deprived of the possibility of appeal to our courts. Our law recognizes those rights as may be settled in cash, but it does not recognize the artist's rights in work for which he has been paid. The law in Mexico gives the artist the right over the integrity of his work, even when it is sold, and no change may be made in it without his consent. Here a fabulously wealthy man may buy up art treasures, destroy them at will, and no one can stop him. The thought, a chilling one to artists, heightened John Wilson's desire to go to Mexico and see the kind of creativity he and his countrymen are not allowed to look upon here.

In Mexico, after working along with Betty Catlett, Pancho Mora, Pablo O'Higgins, and other members of the Taller de Gráfica Popular, John turned his attention to fresco. The walls of the Ministry of Education and the main stairway of Mexico City's National Palace afforded the chance to study Diego. Orozco could be seen in the Supreme Court building, and Siqueiros, on the walls of the Chapaultepec Palace. John's

admiration for Orozco and Siqueiros knew no bounds. Why not join one of the fresco workshops, he thought. The idea of painting with pigments mixed with water and applied directly to wet plaster was intriguing. There is a permanency about the fresco, for once it dries it can be removed only by tearing out the plaster into which the pigment has sunk.

"Our workshop project experience," he says, "required that each student design and execute a fresco mural."

A simple informal courtyard in one of the suburbs of Mexico City provided a practice wall. With the completion of each student's project the plaster was torn out and the wall made ready for the next. I chose as my subject an incident involving Ku Klux Klan terror. To my surprise Siqueiros, himself, came to look at it and ordered that it be kept intact.

John has no way of knowing if his "wall" still stands. "It probably was torn down like the rest of them," he says. "But it was heartening to know that the Maestro, himself, showed such approval of my first effort."

At the end of 1951 John received another grant for extended study in Mexico, this through The Institute of International Education. He and Julie loved Mexico. What a beautiful atmosphere in which to bring their first offspring into the world! Its landscape was so lush—so fertile—its people so warm and human.

"There was a feeling of true camaraderie between my Mexican neighbors and me," he recalls, remembering the day he stopped in a little shop to buy a pair of sandals.

I could speak Spanish reasonably well and as is usual in Mexico the shopkeeper and I mixed conversation with haggling. He was asking twelve pesos for the sandals as a white American entered and priced the same item. The cost went up to thirty-six pesos!

Wilson laughs harshly.

The average Mexican who knows anything about *gringos* has been a *bracero* and he knows damn well that once he sets foot in

the U.S.A., he immediately becomes a "nigger." And he has never forgotten who calls him a "nigger" and who treats him like one.

John and Julie Wilson were made to feel more welcome in Mexico than mixed couples are generally made to feel here. Still, they knew that all she and John and Becky—their first-born, who had never seen her country—were committed to was in the United States. John is quick to admit he does not harbor the illusion that his drawings and paintings will work miracles in bringing about social change. "After all, Daumier did quite a job on the French judiciary and the injustices did not go away." Still, a lot of promising action was taking place north of the border.

While they were in Mexico a mild-mannered, good-looking black seamstress in Montgomery, Alabama, boarded one of that city's buses at the end of a long, hard day. It was December 1, 1954, and her feet hurt something awful. So she sat down and refused to follow custom and surrender her seat to a white man. Yes, she knew the customs of the city but on this day she decided she'd had it. The irate and highly shocked white bus driver had her arrested. Within a short time Martin Luther King, Jr., and Ralph Abernathy were defending Rosa Parks. And the Montgomery Freedom Movement sprang from the loins of a nation pregnant with fear and hate. Two years and many beatings, jailings, and much diminishing revenue later, the United States Supreme Court ordered Montgomery to desegregate its buses.

John and Julie made their move. Home was where the action was and that was where they had to be. They set up housekeeping first in Chicago, then in New York. John did commercial art and taught an evening class in anatomy at Brooklyn's Pratt Institute. Then he secured a teacher's license and with it taught art in the Bronx and in Fushing from 1959 to 1960. Boston University called him then to an associate professorship—a position he presently holds.

John Wilson's honors and awards form an impressive list. Though he no longer lives in Roxbury, he has not forgotten where and how he started. When Elma Lewis conceived the idea for her National Center of Afro-American Artists in Roxbury, she envisioned it as having a strong visual arts program. Following her custom of going to top-flight sources for help, she called in John Wilson, and fellow artist Calvin Burnett, to help set up the program. Wilson, a consultant to the Boston Museum, got busy, and the Museum agreed to underwrite Miss Lewis's visual arts program. Wilson serves on the Center's Board of Directors.

As museum consultant he organized the exhibition of the five black American artists, Romare Bearden, Jacob Lawrence, Horace Pippin, Charles White, and Hale Woodruff, that was seen in the Boston Museum early in 1970. Later in the same year when the Boston Museum presented Afro-American Artists: New York and Boston, John Wilson worked quietly in the background with its organizers, Barry Gaither and Barnet Rubenstein.

Now in his fiftieth year, Wilson continues to work enthusiastically and effectively with young people. They know and respect him as a teacher and an art consultant. But most important of all, he continues to work at his craft. And the art that John Wilson produces is an unfailing reflection of his own profoundly moving black experience.

Chapter IV

LAWRENCE JONES

THE YEAR WAS 1928 and a group of Lynchburg, Virginia, citizens had raised seven hundred dollars to send a local black youth to the Art Institute of Chicago. Betty Catlett was still a student at Washington's Dunbar High School. And in Boston, Massachusetts, the drawings of six-year-old John Wilson were far more forceful and imaginative than those of his second-grade classmates. Lawrence Jones had been born less than a generation earlier in Lynchburg. None of the three young natives of those cities had any way of knowing how closely their personal lives and careers would be matched and woven into a common human fabric.

On Route 29, just south of Lynchburg and two miles north of Altavista, stands a historical marker of the Virginia Highway Commission. It reads as follows:

One hundred yards west of here stands a walnut tree under which Colonel Charles Lynch held an informal court in 1870 for the trial of tories and criminals who were later whipped. This form of summary justice was first used by his brother, John Lynch, founder of Lynchburg. From this crude form of justice evolved the term "Lynch Law." It is claimed that John Lynch first used such methods of summary punishment to rid the neighborhood of escaped slaves.

It must be said, however, in justice to the proud Old Dominion State, that it by no means holds the national all-time lynching record of the nation. Between 1899 and 1918 fourteen other states, including West Virginia, claimed more lynch victims than Virginia, with its modest twenty-four. Only one of those has been reported (by Ralph Ginsberg in his *100 Years of Lynching*) as being in the Lynchburg area. That occurred in Amherst, Virginia, on April 6, 1902. Compared, say, to Mississippi, Lynchburg, the unsavory connotations of its name notwithstanding, was not the worst place in which to be black.

Lawrence Jones's paternal great-grandfather was a slave on the Virginia plantation of a white farmer named Jones. His African name is not known. Indeed the African names of most slaves in the United States were not known even among other slaves. And if they were, they were rarely spoken. Such was the slavemaster's way of controlling his property—of protecting his investment against the perpetuation of African traditions that ran counter to his interests. Masters reasoned that if slaves retained their names, languages, and customs they could more easily enlarge upon the rebellions and insurrections they were constantly plotting. Virginia, a pivotal slave state, was especially troubled by that problem, as the historic Nat Turner rebellion of 1831 attests.

But if Lawrence Jones never learned his great-grandfather's true name, he did learn that he was from the Sudan and that he was a skilled leather-craftsman. Great-grandfather Jones's job on the plantation was that of making saddles, harnesses, shoes, and other useful items of leather. His wife was the plantation's number-one seamstress. As skilled slaves it may be assumed that they were considered prize property and were treated accordingly.

Young Lawrence Jones was the oldest of six boys and six girls. Their father, with a marked aptitude for leathercraft, chose instead a career in music. Lynchburg of two genera-

tions ago typified the spirit of the Old South. There were then, as there are now, the traditional restrictions upon what black people were allowed to do in Virginia. So, following tradition, the Jones children and all other black youngsters attended Lynchburg's segregated schools. Forced "separate and equal" systems of education established in racially segregated segments of our society are not equal. Therefore the grammar school to which Lawrence Jones went could not fully appreciate the significance of his talent for drawing. Even if it could, it was in no position to nurture it.

It wasn't until he reached Lynchburg's Dunbar High School that anyone took serious notice of Lawrence's ability in art. And that notice was conceived and born of a selfish need. As is typical of black Southern high schools, there was no art department as such at Dunbar. Lawrence Jones's presence in the school was a welcome windfall to its teachers. Since they themselves could not draw as well as he and were reluctant to expose their lack of skill to student ridicule, they quickly seized upon the young artist's skills and used them to the fullest extent.

"I became the official artist for the entire school—doing all the charts, sketches, and blackboard decorations usually required in the school program," Jones recalls. Lawrence Jones was learning early how easily the exploitation of the artist is taken for granted even by otherwise well-meaning daily associates.

The year was 1927, and four hundred miles away in New York City recognition and admiration of another kind was being lavished upon gifted black artists, writers, and musicians. It was the movement described in the first chapter as the "Negro Cultural Renaissance in Harlem." As has been mentioned, one of the prime figures of the movement was black poet, teacher, and one-time United States consul to Venezuela and Nicaragua, James Weldon Johnson. Here, in

part, is how Mr. Johnson describes the period in his book, *Black Manhattan.*

Toward the close of the World War, there sprang up a group of eight or ten poets in various cities of the country who sang a newer song. The group discarded traditional dialect and the stereotyped material of Negro poetry. Its members did not concern themselves with the sound of the old banjo and the singing around the cabin door, nor with the successions of the watermelon, possum, and sweet potato seasons. They broke away entirely from the limitations of pathos and humor. Also they broke away from use of the subject material that had already been overused by white American poets of a former generation. What they did was to attempt to express what the masses of their race were then feeling, thinking, and wanting to hear.

Among those new poets to whom Johnson referred were Claude McKay of Jamaica in the Caribbean, Countee Cullen, Langston Hughes, and Mr. Johnson himself. And there were novelists. Rudolph Fisher (*The Walls of Jericho*), Walter White (*The Fire in the Flint*), W. E. B. DuBois (*Dark Princess*), George A. Schuyler (*Black No More*), and Jessie Fauset (*Plum Bun*) were published and avidly read. The Lafayette Players, a Harlem-based group, were presenting new black themes in the theater, and as has been stated in Chapter I, black painters and sculptors were being presented by the Harmon Foundation. By 1927 the Harlem Cultural Renaissance was reaching its zenith.

James Weldon Johnson's *God's Trombones* was published by Viking Press in 1927, the very same year that Mr. Johnson came to Lynchburg to speak at the Dunbar High School. How fitting that the black poet, Johnson, would appear as the guest of a school named for the black poet Dunbar. Because of jim-crow laws and customs barring black guests from Southern hotels, Mr. Johnson stayed at the home of a local poet, Mrs. Anne Spencer. There young Lawrence Jones

was introduced to the celebrated writer from New York. The memory of that meeting is still quite clear to Jones.

"Mrs. Spencer had told me to bring some of my drawings along; and when Mr. Johnson saw them he immediately declared that I should be given an opportunity to study art upon completing high school."

But where was a poor, or even a wealthy, black boy to study art in or near Lynchburg? Even with the endorsement of a James Weldon Johnson, Virginia's jim-crow laws and practices would not permit it. Lawrence Jones had to look elsewhere. He chose the Art Institute of Chicago. Now there was still the matter of money to consider. For a poor black family of fourteen the expense of such a venture was unthinkable. But interested black and white citizens of Lynchburg had been moved to get together and help.

One has to understand the South, particularly the state of Virginia, to appreciate fully the attitude that guided the action of those select citizens. Historically Virginians have regarded themselves as the aristocracy of the Old South. That holds as much for many black Virginians as it does for whites whom the blacks were emulating. Virginians do have a heritage in which they may take reasonable pride.

Establishing the first permanent English settlement in America at Jamestown was indeed a remarkable achievement. The obstacles of 1607 were formidable, to say the least. Seventeen years later Virginia became a royal colony, the first in English history. By 1641 three fourths of its 7,500 settlers had come as indentured servants or apprentices. About 250 of them were blacks and the first of them had arrived in 1619 on a Dutch ship. But in the very beginning blacks arrived, not as slaves, but, like the whites, as indentured servants.

Only a few of the freeholders of the colony were of high lineage. They, along with the merchant class from whom came the First Families of Virginia, controlled the govern-

ment. From 1690 to the American Revolution, Virginia, with tobacco as one of its chief resources, expanded economically and territorially. With this came an increase in slavery and the influx of more blacks.

Progressive Virginia and Massachusetts led the opposition to the policies of George III that preceded the Revolution. Moreover, of the first twelve presidents of the United States, seven, from Washington to Zachary Taylor, were Virginians. Although Virginia was the chief battleground of the Civil War and was impoverished by it, under Governor Francis Pierpont it escaped the worst horrors of the Reconstruction. White supremacy was indeed restored by a new state charter of 1902, displacing the Reconstruction constitution of 1868. Yet while agriculture had recovered somewhat from the devastation of war, and farm tenancy became an accepted part of the economy, agriculture never gained a strong hold. Industry, particularly that related to tobacco products and textiles and coal mining, began to grow. Then during World War I another Virginian, Woodrow Wilson, was installed in the White House.

So the progressive white element of Lynchburg of the 1920's was certainly not loath, in view of the state's relatively liberal heritage, to help a talented and well-mannered black boy get an out-of-state education. Who knows what he might accomplish? After all, some must have nostalgically recalled, that other illustrious black Virginian from Richmond, Bill (Bojangles) Robinson, had made it to the top, and he had done it with no education at all! So the whites raised five-hundred dollars and the blacks two-hundred dollars, and with that help Lawrence Jones was encouraged to help himself. True, seven hundred dollars was a lot of money to receive as a gift, but it was not enough to cover full expenses for even the first year. On his own and with no relatives to greet him at the other end of the journey, Lawrence came north where he landed in Albany. There, in spite of the economic slump,

he found work as a busboy, for with such a job one can always count on eating. Finally, with the Depression holding the nation in an icy grip, Lawrence set out for Chicago.

Chicago, 1932! What a contrast to easy-going Lynchburg with a total population of not more than 40,000. Why, there were 230,000 in the Chicago black metropolis alone! St. Clair Drake and Horace Cayton, in their two-volume study, *Black Metropolis,* state that the Chicago black belt evolved into the black metropolis between the close of World War I and the beginning of World War II. The fifty or sixty thousand blacks who had come to the city during the great migration had no intention of returning to the South. Despite bombs and riots they insisted upon a place to live within the city. Moreover, they insisted upon room for friends and relatives who followed them north, and for the children who would be born in the midwest metropolis. By 1925 the city had resigned itself to the fact that a rapidly growing black community was there to stay. Blacks had secured a firm foothold in Chicago.

Though black Chicagoans had to fight block by block to get housing during World War I, they had no trouble getting jobs. It is true that after the war a minor depression had cut into the gains black women had made in the garment industry. Besides that, the use of blacks to break a stockyard's strike was at once a passport to them in that industry and a guarantee of their having won the bitter antagonism of Italian, Irish, and Polish workers. Another recession in 1924 resulted in another employment setback for blacks. But by 1925 a postwar boom ensued and racial conflicts subsided. The building of skyscrapers and factories vied with the nefarious and equally well organized machinations of the gangsters who were reaping a harvest in illegal booze.

With the crash of the stock market in 1929 the bubble of profiteering burst with a terrifying suddenness. During the first two years of the Depression hundreds of black Chicago-

ans, unable to pay their rent, faced evictions. And great turbulence of an unexpected nature, which shall be described more fully in the following chapter, permeated the black community.

That was the Chicago that greeted Lawrence Jones upon his arrival in 1932. He found a place to live in the black metropolis and registered as a regular student at the Art Institute of Chicago. It was perfectly natural that he would want to live in the heart of black Chicago. He had, after all, spent his formative years in segregated Lynchburg. What did it really matter to him if white Chicago did not want blacks hanging around the fashionable Loop area, commiserating with them over hard times? Black Chicagoans had their own metropolis within a metropolis, where they could exist with as much relaxation as the Depression would permit. There Lawrence Jones was to absorb the human sounds and smells that would provide the incentive for the serious study he was about to undertake.

The Institute is one of America's highly respected professional schools. At least three black students had distinguished themselves there prior to Jones's entry. They were painters William Edouard Scott and Archibald J. Motley, and sculptor Richmond Barthé. As a student of drawing, painting, and illustration, Jones came to know fellow students Charles White, Frank Neal, and Eldzier Cortor. This was the period of the first administration of Franklin Delano Roosevelt, and with it came the establishment of the government-sponsored Federal Art Project of the Works Progress Administration.

Popularly known among artists as "The W.P.A.," or simply "The Project," the program provided temporary work for artists, roughly between 1934 and 1940. Easel painters, printmakers, muralists, and sculptors were put to work at subsistence wages to produce works that were installed in public buildings. Art centers where interested persons could study without charge were established in many

American cities. Chicago was one of those cities with an active W.P.A. art program, and her black artists, traditionally the last to be hired in private industry, benefited greatly from the nondiscriminatory government program.

Lawrence Jones and other gifted young artists were able, as students, to derive benefits from the project. Meanwhile, the quality of Lawrence's work won scholarships for him during his entire period of study at the Art Institute.

At the same time a local art activity in which Jones had a part was beginning to germinate along Chicago's South Side. A group of black citizens of the Chicago business world responded to the trend initiated by the government. More conscious now than they had been in the past of the burgeoning talent around them, they worked along with the black artists to establish the South Side Community Art Center. Claude Barnette of the Associated Negro Press, with his wife, actress-singer Etta Moten, were among the sponsors. Others included Pauline Kigh Reed and Earl B. Dickerson. Among the artists were Bernard and Margaret Goss, Marion Perkins, and Lawrence Jones. The Center did become a reality in 1938. Its location at Michigan Avenue and Thirty-ninth Street designated it as Chicago's first black community art center.

It was 1936 when Lawrence Jones, having completed his course at the Art Institute, went on to New Orleans to Dillard University as an instructor in art. During his three years at Dillard he applied for and won a Rosenwald Fellowship to study in Mexico. When Jones left Dillard in 1940, his place at the New Orleans school was eventually filled by Betty Catlett. He had preceded her to Dillard by four years and was about to precede her to Mexico by six years.

In Mexico City Lawrence Jones quickly found his way to Paul (Pablo) O'Higgins. Pablo O'Higgins is a gifted Californian who has been totally adopted by the Mexican art community. His name was, and is, synonymous with the

influential Taller de Gráfica Popular, and there Lawrence studied the art of wood and linoleum engraving. Lawrence discovered that the Taller was visited by many of Mexico's leading artists. Among them were Diego Rivera and José C. Orozco, who were not at all hesitant to talk informally with the artists, even offering criticisms and suggestions as they felt inclined. "My year and a half at the Taller was in many, many ways a great experience for me," recalls Jones.

The paintings and drawings of the distinguished triumvirate—Rivera, Orozco, and Siqueiros—captured and held Jones's attention even as they would later arrest the attention of Betty Catlett and John Wilson. Lawrence Jones could look at those angry Mexican masters' works and relate them to his own life. As he studied them he could recall the humiliation of black material poverty occasioned by white moral poverty in his own native Lynchburg. He could see them both, separated in a way that held blacks to be morally responsible for their own condition, which they had not initiated. So if the black schools of Lynchburg were not as large, airy, fresh, clean, well equipped, and well staffed as white schools, the lacks, it was said, were due entirely to *black* inferiority and deficiency.

Blacks, it seemed, always had to be led by whites who knew the right way. And the right way held that a black boy with talent was not to be allowed to use what facilities Lynchburg and its environs offered its similarly gifted white youth. A special dispensation had to be made. In this particular instance the decision was to take up a collection with which to send a youth out of his home state to study. As well intentioned as the gesture may have been, and as quickly as it was accepted, the fact remains that the recipient could not help but be made conscious of it as another facet of his dehumanization. For in a social order that constantly stresses the virtues of individual effort and the just rewarding of that effort, anything less becomes tainted and stigmatized. And it is so

branded—by the same social order that sees fit to bestow special bounty upon those it cannot bring itself to treat fairly. *No amount of rationalizing changes that fact.*

That is why Betty Catlett would not beg for admittance to Carnegie Tech, even though she knew she had earned her right to go there. It is also why she chose to teach in Texas and in New Orleans following her graduate work at Iowa University. Those were her choices. And she made them after turning her back upon the job in St. Louis offered by the racist head of Iowa University's Art Department. The latter experience would scarcely have been more harrowing than the ones she chose. Still, she had the satisfaction of navigating her own ship through troubled seas. And that is what being a man or a woman is all about.

It explains the harshness of John Wilson's laughter as he explains, with genuine affection for the two young white teachers at the Roxbury Boys' Club, how black Americans so often have to go through the back door in order to get anywhere near the national feasting table.

These three black artists, each with an experience to which he or she felt compelled to address himself or herself before the world, could view the work of the revolutionary Mexican painters with an understanding as old as mankind. Take a good look at Betty Catlett's mother and child pieces or her female figures, and you will find in them not one bubble of sugary fluff. Look hard at John Wilson's black people. Then look at Lawrence Jones's prize-winning triptych, "Past, Present and Future," and you will find more than the artist's emotional affinity to Orozco. There you find an affinity to a whole segment of humanity everywhere that feels and understands the common experience of the oppressed.

From Mexico, Lawrence went to Georgia to teach art at Fort Valley State College. One of his students was a sandy-haired rural youth named Benny Andrews, of whom a great deal more will be said later. But Jones was not long at Fort

Valley before being drafted into the army in 1942. He was
sent to Fort McClelland, Alabama.

"There," he says, "I was eventually relegated to a unit that
prepared silk-screen illustrations used in the military training
program. Our department also prepared a few propaganda
posters and I did some murals for the service club at Fort
McClelland."

In 1946, upon his discharge from the army, Jones returned
to teach at Fort Valley, where he stayed until called to head
the art department at Jackson State Teachers' College in
Mississippi in 1949. A visit to Cuba, meanwhile, during the
regime of the dictator Batista, brought him into contact with
the lady who later became his wife and mother of their only
daughter.

Mississippi! The very mention of the name evokes, in
some, feelings of stark terror and revulsion. In others it sug-
gests the honeysuckle-scented manners and traditions of a
grand and courtly era. Most Americans, who know Missis-
sippi merely through hearsay, wonder what is wrong with
the mentality of black people who choose to live there. Why,
they wonder, has voting been so difficult for Mississippi
blacks? Is it because Mississippi breeds a particularly super-
vicious type of white whose "natural hatred" of blacks is
greater than that found anywhere else in these United States?
Not quite.

Nearly a century ago black voters were prevalent in Missis-
sippi. Under a military government set up following the
Civil War, forty black men sat in the first Mississippi Recon-
struction Legislature of 1867. During the following year six-
teen blacks sat among the one hundred members of the Black
and Tan Convention. It was at that convention that a consti-
tution extending voting rights to black and white alike was
drawn up. Blacks not only voted, they were the majority of
the Mississippi electorate. Hiram Revels, Blanche K. Bruce,
and John R. Lynch represented Mississippi in the United

States Senate. The Mississippi State Senate had five black members. A study of the records of those black representatives reveals they were not the loud-mouthed ignoramuses the propagandists opposed to their presence said they were.

Alarmed white Mississippians, conscious of their former treatment of slaves, feared retribution and a complete take-over by blacks of the state's economic resources. One newspaper, *The Yazoo City Banner* for July 31, 1875, declared editorially that "Mississippi is a white man's country and by the eternal God, we'll run it." White terrorist gangs then began to roam the countryside. Through tricky legislation blacks were denied the vote, and by the late 1800's and early 1900's additional new laws made any form of civil and social equality of blacks and whites in Mississippi a thing of the past. Other Southern states picked up the Mississippi strategy. The rash of brutal lynchings that followed were designed to deter any blacks from ever again challenging the political and economic supremacy of whites. Though the terrorist methods were effective for a number of years they, too, were destined to be challenged by their former victims.

When Lawrence Jones arrived in Jackson, Charles and Medgar Evers had already defied local custom by attempting to vote in Decatur. Even though life seemed to be moving along in the usual unhurried fashion of the region, and the work Jones was doing at Jackson State seemed to follow a repetitive pattern, Mississippi was in for some radical changes. The writer well recalls the summer of 1950 when he was called to Mississippi's Alcorn College to do a special job in arts and crafts with black teachers from various Mississippi counties. Dr. Jesse R. Otis, who was then Alcorn's president, recounted the remarks of one of the members of his white trustee board.

We were trying to get a sum of money from the state for some project we felt was necessary, and there was a lot of bickering as

to the advisability of their giving us the money. Finally one of the trustees told the group that they may as well go ahead and authorize it, because it wouldn't be long before Mississippi Negroes would be attending the state's white colleges anyway.

Lawrence Jones has not only seen a few of those changes, he is an active participant in them. When, on September 30, 1962, a mob of screaming white hoodlums tried unsuccessfully to prevent James Meredith from being admitted to the University of Mississippi, a major change was in the making. Eight years later not only was Meredith graduated but other black students were currently attending "Ole Miss." Two of them are students in a course on the Art of Black Americans taught by Lawrence Jones. Mr. Jones also teaches drawing at the University of Mississippi as he himself works for his master's degree there.

That "Ole Miss" would employ two black teachers in 1970 (there is another, Miss Jenette Jennings) is not inconsistent with the remark made twenty years earlier by that trustee at Alcorn College. Lawrence Jones cannot, however, in view of his experience, have any illusions that Mississippi is about to lead the nation in taking blacks to its bosom. How well aware he is of the as yet untouched areas of racist resistance to change. Early in May of the very year he went up to "Ole Miss," Jackson police, following the Mississippi tradition of terrorizing blacks, created havoc on the campus of Jackson State College. Asserting that they had been fired upon by snipers, the police opened a barrage of gunfire, lasting thirty seconds, into the women's dormitory. Two students died. Although intensive federal investigation that followed cast some serious doubts upon the police insistence that they had fired in self-defense, no action has been taken against them.

It is that kind of black experience that motivates the pictorial statements of quiet, soft-spoken Lawrence Jones. He will never mount a rostrum, raise his fist, and scream "Off the Pigs!" That is neither his medium nor his style. He

speaks, instead, through his painting, and the eloquence of
his voice has been heard and acknowledged where it means
a great deal to him. In 1963 he was awarded first honorable
mention for oil painting in the Atlanta University Annual
Show. He later won the second award in the regional show of
the Emancipation Proclamation in New Orleans. When the
same show was held in Chicago, Jones won the first place
blue-ribbon award along with the Dr. Karl Douglas trophy
for his triptych painting, "Past, Present and Future."

One of Jones's news releases includes the following:

Although he has never hung a painting in his present home
community's Municipal Art Gallery, but has been told to "come
in the back door," of that gallery, Mr. Jones is coming in the
front door of many of the nation's more important museums.

The Municipal Art Gallery's loss is, happily, another's
gain. Lawrence Jones knows he needs not be anybody's back-
door artist.

Chapter V

CHARLES WHITE

FOR LAWRENCE JONES, the city of Chicago became a vital stopover on the way to a career. To Charles White, Chicago was similarly related, with one important addition. It was also home. White was born there in 1918. An allusion has already been made in the preceding chapter to a serious racial confrontation in Chicago following World War I. Here, briefly, is what took place.

The black migration from the South to Chicago created a need for migrant housing. And most of the newcomers were poor, rural people, barely able to pay for more than the meanest accommodations. Because of the great demand, prices were astronomical and housing generally substandard. Real-estate brokers, black and white, were taking advantage of the shortage. As more blacks herded in, whites fled to better areas, while the black belt widened with alarming rapidity. Some whites reacted violently to the relentless tide of onrushing blacks. They threw bombs at homes newly occupied by them and at the homes of realtors who negotiated the deals.

St. Clair Drake and Horace Cayton report in Volume One of *Black Metropolis:*

From July 1, 1917 to March 1, 1921, fifty-eight such bombs were tossed. This conflict over space often came to a head where Negroes and whites met in public places—at the beaches and playgrounds and in the public schools. Particular resentment was manifested against Negroes who frequented beaches that white people had come to think of as their own. Yet throughout this period, despite tension in the areas peripheral to the Black Belt, there were also adjusted neighborhoods in other sections of the city where Negroes and whites maintained their neighborly relations and where no hostility was evident.

Nevertheless, on a hot July day in 1919 the Chicago riot was touched off at a bathing beach. A black boy swam across the imaginary boundary separating white and black users of the Twenty-ninth Street beach and a group of white boys began to stone him. In the melee that followed, the black boy was drowned. Word that a black youngster had been murdered by white spread through the black belt, igniting five days of rioting. The fighting ceased only when the state militia took over and thirty-eight people lay dead, while five hundred sustained injuries. Property damage was estimated at a quarter of a million dollars, and over a thousand were left homeless. Charles White was barely fifteen months old.

His parents, Charles and Ethel Gary White, were among those Southern migrants to Chicago between 1914 and 1918. Perhaps they had been encouraged by the editorial of October 7, 1916, in *The Chicago Defender,* written by its Georgia-born publisher, Robert S. Abbott. Here was Abbott's advice to his black Southern readers:

Turn a deaf ear to everybody. . . . You see they are not lifting their laws to help you. Are they? Have they stopped their Jim Crow cars? Can you buy a Pullman sleeper where you wish? Will they give you a square deal in court yet? Once upon a time we permitted other people to think for us—to-day we are thinking and acting for ourselves with the result that our "friends" are getting alarmed at our progress. We'd like to oblige these un-

selfish (?) souls and remain slaves in the South, but to their section of the country we have said, as the song goes, "I hear you calling me," and I have boarded the train singing, "Goodbye, Dixie Land."

However they may have been motivated to seek refuge from Southern economic and social tyranny, Charles White, Senior, a Creek Indian, was convinced he had no future in Dixie. Within eight years after their only son was born, Charles died, and when his widow's second marriage failed, she decided she and her son could go it alone. The way for them was not easy.

"I grew up in Chicago very, very, poor," the artist relates.

We lived in the only house on our block that was heated by an oil stove. My mother had been a domestic worker since she was eight. My father worked in the steel industry and finally ended up as a post-office worker. From the time I was seven I never wanted to do anything but paint.

A drawing Charles had made at age seven while his father was still alive, showing a landscape barren of human or animal life, is reflective of his child's view of a desolate world.

Ethel White, a hard-working domestic, hopeful for a career in music for her son, bought him a violin and sent him to a teacher. But Charles's greater interest in drawing and painting revealed itself early and with an unshakable persistence. He attended the Saturday art lectures for gifted schoolchildren of Chicago—lectures followed by the assignment of a theme which each child executed during the week. On the following Saturday citations were awarded the best efforts and Charles was a frequent recipient.

Following his mother's example, Charles read a lot. He found a great reading discovery in Alain Locke's *The New Negro*. One will never accurately estimate the value of such an inspiring work in lifting the morale of poor black youth seeking self-respect. In Charles White's case it led him into

truancy from dull classroom routine to the more exciting public library and the halls of the Art Institute of Chicago. He was fourteen and he had learned show-card painting well enough to sell his work to neighborhood shopkeepers. In this way he was able not only to help his mother but to help himself by meeting others engaged in the same work.

It was at this period that a brilliant young black cartoonist from Saint Louis was selling his drawings to some of the nation's top humor magazines. His name was Elmer Simms Campbell. Campbell lived in Chicago during the late 1920's. His growing success, that eventually made him famous in the 1930's to readers of *Esquire* magazine, was already familiar to readers of the black press all over the nation. Naturally Chicago's black artists knew about Campbell. Inspired by his success, Charles White and his contemporaries formed a club whose aim was to pool enough capital to send one of its members to the Art Institute for one session each week. Then they would assemble and the rest of the group would be taught by that member all that he had learned during his session at the Institute. It was a cooperative effort that worked well.

Things did not, however, go well for Charles at school. Because nothing he had been reading on his own about the achievements of black people was mentioned by his white teachers, he began to question openly this lack in the program. "Sit down, White!" the teachers ordered. "What are you trying to do—start trouble?" Such an approach merely increased the youth's anger. Finally he became too withdrawn to communicate with any faculty member other than his teachers of art.

They encouraged him to enter his work into competitions leading to admission to art school, and he did just that. To his great joy he won two such competitions. But when he showed up, first, at the Chicago Academy of Fine Arts, he was informed by the flustered officials that "some mistake"

had been made. The same thing happened at the Frederick
Mizer Academy of Art. Charles White's rage drove him
deeper into truancy and he might have become a rudderless
street thug had not the urge to continue drawing held him
on a more even keel.

While he was still at Englewood High School, an entry of
his in a nationwide drawing contest won first prize, and the
National High School Weekly asked to buy the drawing.
With the prestige and encouragement that followed, Charles
remained in high school for an extra year to make up for the
academic deficiencies occasioned by his rebellion. That day
in the spring of 1937 when he received word that his applica-
tion for a scholarship at the Art Institute was accepted was
the happiest he had ever known. Because he was desperately
poor and needed money Charles worked at two jobs along
with his studying. And with his particularly intense desire
to learn he was able to complete two years of work at the
Institute in half the time.

Meanwhile he had come to know the group of young black
artists in Chicago. They included Charles Sebree, Eldzier
Cortor, Charles David, Bernard and Margaret Goss, and
Archibald J. Motley. A particularly strong influence upon
young White's drawing and painting at this period was
painter Mitchell Siporin, whose distinctively sculptural han-
dling of planes he adopted without apology. In addition to the
Depression painters he began to hobnob with the writers
Willard Motley, Richard Wright, and Gwendolyn Brooks.
Two others with whom he came in close contact were dancer
Katherine Dunham and a young photographer from Kansas
named Gordon Parks.

So stimulating was the association with these young black
creative artists that Charles White was moved to make his
own personal statement. Now he would answer those teachers
who had silenced him in high school when he wanted to
speak about the black heroes they had never heard of. And

he would also comment upon what it was to be black, and hungry, and desperately tired, and even more desperately angry.

The mural White painted in 1939 and 1940 for the George Cleveland Branch of the Chicago Public Library was a jolt to American traditionalists accustomed to those virginal ladies in cheesecloth that had become the accepted symbols of most wall paintings. Nor did he intend that his drawings and easel paintings should titillate banal expectations. They didn't. At twenty-one Charles White's strong and commanding style was beginning to attract critical attention.

In 1941 he was awarded a Julius Rosenwald Fellowship of two thousand dollars for a year's work in the Deep South. Though White had lived with black Southern migrants in Chicago all his life, this was the first time to see and feel the region from which his own parents and their parents had come. He found that much of the violent behavior of Southern whites toward blacks that had precipitated the great migrations had begun to abate. Whereas in 1921 the number of persons lynched by mobs totaled sixty-four, the total for 1941 was five. But jim crow was very much alive, as the young Chicago-born artist was to see from the moment he entered the South. Black railroad passengers rode the jim-crow cars close to the engine and baggage room and they were not generally served in the dining cars. They entered and exited through doors marked "colored" and when they traveled by bus they rode in the rear seats.

Black people were never addressed by whites as "Mister," "Missus," or "Miss." When not called by their first names, and if they were elderly, they were addressed as "aunty" and "uncle." Black teachers and educators were all "professors" and "doctors," particularly to white merchants, whose eye to business was no less sharp than their determination to maintain Southern social traditions. Black patrons did not eat

meals in white restaurants that did not provide "special" (and less attractive) dining facilities for blacks.

The only blacks to enter Southern hotels were those entering through their service areas. *Never* was a mixed couple seen walking arm in arm along a Southern street. That was the South to which Charles White was making his initial visit. And though he committed a few embarrassing blunders before adjusting to its regional mores, he found a quality there that he hadn't found in Chicago. It was not to be found, however, among the sophisticated city folks whose warmth and vibrancy had already been chilled by their mode of harsh urban living so imitative of that of struggling whites. He found it among the simple, hard-working, hard-drinking, hard-playing black Southern masses. And as he worked in Louisiana, and later in Virginia, he was gratified to capture that direct and honest quality of their life in the drawings and paintings he made of them.

In New York City, meanwhile, various gallery showings of the works of selected black artists were being planned through the efforts of astute Edith Halpert, director of the Downtown Gallery. Her purpose was to let the art-conscious New York public know what a wealth of talent there was among black artists. Charles White was one of them. But on the day the show was to open, December 7, 1941, the disaster at Pearl Harbor changed the plans of practically every American. White was seen later, however, in two shows during the following year at the New York A.C.A. Gallery and the Art Institute of Chicago. Though his name was being remembered by critics, there was a special project he had begun and was determined to complete in the South.

In preparation for that Charles worked for a semester at the Art Students League in New York, studying the technique of tempera and fresco painting. His time there with Harry Sternberg was profitably spent, and at the end of the term he went back South to Hampton Institute in Virginia. There,

under the enthusiastic eye of Viktor Lowenfeld, who headed the art department, White began the actual work on an eighteen-by-sixty-foot tempera mural. He called it "Contribution of the American Negro to Democracy."

In a pictorial arrangement singularly powerful for a twenty-five-year-old painter, White commented upon the contributions of such historic (and revolutionary) black figures as Crispus Attucks and Peter Salen of the American Revolution and slave insurrectionists Nat Turner and Denmark Vesey. In addition Charles included the modern-day black leaders Booker T. Washington, George Washington Carver, Paul Robeson, and Max Yeargan. Again he had replied to those who were seeking to ignore, by their silence, the facts of American history. Critical praise of the work was quickly forthcoming and Charles White's work began to gain national recognition.

Meanwhile the military draft that caught Charles up in its sweep did not hold him in the army long. After a short hitch in the camouflage division he was detailed, along with his outfit, to help control the flooded Ohio and Mississippi rivers. While so engaged he was stricken with pleurisy and had to be hospitalized for three years. Tuberculosis, the dreaded "White Death" that had cut down so many residents of the black ghettos of American cities, had seized him too. And little wonder. In Chicago between 1939 and 1941 the death rates from the disease as recorded in a report by Dorothy J. Liveright were 45.4 for whites and 250.1 for blacks. None of the other four cities in that report came close to matching that death figure for Chicago's blacks!

But Charles White was luckier than most. Aided by early detection and first-rate care in a Veteran's Administration Hospital, he recovered in time to hold his first one-man show in New York City in September 1947. Critics characterized his work as revealing "a mature, powerful, and articulate

talent" and as having "force and conviction." Sales increased, and Charles decided he wanted to go to Mexico.

In Mexico City he found the Esmaralda School of Sculpture and Painting and the Taller de Gráfica Popular much to his liking. Indeed, he attended the Taller simultaneously with talented Elizabeth Catlett (who had become his first wife). Contact with Mexico's leading artists was inevitable. Charles quickly saw the relationship between the social realism of Diego Rivera, Pablo O'Higgins, and David Siqueiros, and what he had been doing at home. And because he felt the need to be as strong in black and white as in color, he began to work in graphics. In this area he found great inspiration in the woodcuts of Leopoldo Mendez.

Returning to the United States, White served as artist in residence for a time at Howard University before illness and domestic difficulties descended upon him. Again he was hospitalized for a year, and his foundering marriage ran aground. For a while it looked as though he might not make it, but he pulled through again and went back to New York and to his work.

The city was alive with artists, writers, and performers who were devoting much of their time to combatting social and political injustice. Among them was the scholar Dr. W. E. B. DuBois. Others in the arts included Rockwell Kent, Jacob Lawrence, Ernest Crichlow, Walter Christmas, Langston Hughes, Shirley Graham, Ruth Jett, Lorraine Hansberry, Kenneth Spencer, Ossie Davis, Ruby Dee, Paul Robeson, Harry Belafonte, and Sidney Poitier. Charles White came to know them all. Moreover his work would be influenced by their opposition to what they collectively believed was not good for humanity at large, and black peoples in particular. Here, in part, is what had been taking place, for instance, in Paris.

During April of 1949, eighteen hundred delegates from sixty-nine countries to the World Congress of Partisans for

Peace assembled in Paris. They listened as Dr. DuBois, co-chairman of the American delegation, insisted that the basic cause of world conflict was the continued and planned exploitation of millions of blacks in Africa and other parts of the world, and declared:

The colonialist spirit in America left millions of black serfs who could not be removed to colonies and yet could be held in forced labor only by nullifying the democratic Constitution on which the United States is founded. To-day in the United States fifteen million such citizens are still in semi-slavery and form part of an internal colonial system.

The DuBois address stated prophetically that—

War may be threatening in Europe and America, but its seeds are being sown in Africa where British, American, French, and Belgian wealth is trying to rebuild an old world economy on slave labor which will continue to compete with the best paid labor in the world.

He named two democracies, the Union of South Africa and the United States, as leaders in the fight to re-enslave human labor. His condemnation of the Union of South Africa was terse and harsh. Of the faults of his own country he sadly noted that they are what they are because "The United States is too new to be wise; too impatient to be intelligent; too rich to be humble; and too boastful to have good manners."

Other black Americans who spoke at that conference were singer-actor Paul Robeson and writer Shirley Graham, who was later to become Mrs. DuBois. Miss Graham told the delegates that the black mothers of the United States, in their unenviably bottom-rung status, were unwilling to feed their sons to another war.

But it was Robeson whose statements, as quoted by the American press, drew the heaviest official American fire. He had flown into Paris from London on the opening day of the Congress. Among other things he said (as reported by P. L.

Prattis of the *Pittsburgh Courier,* April 30, 1949) that the
only time he had ever felt like a human being was when he
was in the Soviet Union. As to what he said about the atti-
tude of black Americans toward a war with the Soviet Union,
the following statement was made by Robeson in testimony
before the House Committee on Un-American Activities on
June 12, 1956.

It was 2,000 students from various parts of the colonial world,
from populations that would range from six to seven hundred
million people, not just fifteen million. They asked me to address
this [Paris] conference and say in their name that they did not
want war. That is what I said. There is no part of my speech in
Paris which says that fifteen million Negroes would do any-
thing. . . . But what is perfectly clear today is that 900 million
other colored people have told you they will not [go to war with
the Soviet Union]. Is that not so? Four hundred million in India
and millions everywhere have told you precisely that the colored
people are not going to die for anybody and they are going to
die for their independence. We are dealing not with fifteen mil-
lion colored people, we are dealing with hundreds of millions.
However, I did say in passing, that it was unthinkable to me that
any people would take up arms in the name of an Eastland to go
against anybody, and gentlemen, I still say that. I thought it was
healthy for Americans to consider whether or not Negroes should
fight for people who kick them around.
What should happen, would be that this U.S. Government
should go down to Mississippi and protect my people. That is
what should happen.

So highly charged with emotion was the general American
attitude toward Robeson as a result of the negative type of
press reporting of his Paris remarks as to make of him a
pariah among his own countrymen. White and black Ameri-
cans who had been lauding his virtues suddenly began to hate
Paul Robeson. Charles White did not join them. Indeed, he
was so outraged by the tactics of Senator Joseph McCarthy
and his House Un-American Activities Committee that he

did a tribute to Robeson that was published in Hungary in 1958 at a time when the great singer's recordings could scarcely be purchased in his homeland. Charles White's reaction reflected his own understanding of what the black experience really was. His creations, without losing any of their basic power, were beginning to take on a new look.

During the middle and late 1940's such works as "Woman of Sorrow," "Blues Singer," "Soldier," "Songs," "Sojourner," "John Brown," and "Open Gate," (all done between 1947 and 1949) were handled in a heavy manner. They suggested the blues singing of Ma Rainey and her incomparable protégé, Bessie Smith. White, in his thrusts at injustice, had borrowed the broadsword used by the angriest of his Mexican colleagues.

But from 1950 on he took to the rapier. And with parries more reminiscent of the singing of the immortal Billie Holiday, he began to say what was on his mind in a manner distinctly that of Charles White. It was during this period that he produced the first of his well-known portfolios. Published in 1953 by the New Century Publishers of New York, it was called, simply, *Portfolio of Six Drawings—The Art of Charles White*. Included in it are "The Harvest," "Walk Together," and "Work," and each is a superb interpretation of black working people. The portfolio today is a collector's item.

A year in Europe revealed to Charles and Frances White (he had by this time remarried) how well known his work was there, through the distribution of reproductions from his originals. Invitations to visit the Soviet Union, Czechoslovakia, and Poland and to speak in those countries were in contrast to the refusal of Alabama and Louisiana galleries to permit his entry even as his works hung on their walls. As was true of Betty Catlett and John Wilson, White's acceptance in foreign lands was natural and untainted by the sickness of American racism.

Returning home he found the demand for his work greater

than it had ever been. Atlanta and Howard universities pur-
chased White drawings, as did the Whitney Museum in New
York. One-man shows and participation in group shows be-
came more frequent, and the drain on Charles's health began
to show again in 1958. Something had to be done quickly, so
he and Frances moved to Altadena, a suburb of Los Angeles,
where, having adopted two children, they have established
their home. That the move was a wise and productive one is
evident in Charles White's subsequent output.

How closely his drawings reflect what black Americans are
experiencing at a given moment in their current history is
clearly seen as one studies the White portfolios. This is par-
ticularly true of the last three: *Portfolio 10,* (1961), *Portfolio
6—I Have a Dream* (1964), and *Wanted Poster Series* (1967).
The first of them, *Portfolio 10,* reflects significant happenings
of the decade of the 1950's. It gave us "Southern News—Late
Edition," "Birth of Spring," "Go Tell It on the Mountain,"
and "Let the Light Enter." These four drawings clearly
symbolize black awareness of, and reaction to, the revolution
that was to transform the face, at least, of the South.
"Mayibuye Afrika" from the same portfolio recognizes the
significance to black Americans of the emergent nations of
the sub-Sahara Africa. Finally, "Awaken From the Unknow-
ing" is an eloquent admonition to "learn, baby learn"; and
"Move On Up a Little Higher" is an extension of the same
thought.

The second Portfolio, *I Have a Dream,* gives expression to
black disenchantment and hope of the 1960's as voiced by
the martyred Martin Luther King, Jr. The *Wanted Poster
Series,* the most recent of Charles White's portfolios, resur-
rects the relentless stalking of the hunter and the furtive
stealth of the hunted. But does it refer merely to a shameful
passage of history involving escaping black slaves and their
pursuers? Or does it bear equal reference to an equally
shameful passage of present-day history in which the pursued

are declared to be a threat to the peace and security of a free nation? In view of the incisive past commentaries of Charles White, one needs not strain as he seeks a reasonable answer.

Not only do Charles's portfolios speak of the people they portray, they speak also for them. And they speak for the people in a living, meaningful way since they are so widely shared through the distribution of prints. Scores of people who identify in one way or another with the black experience as Charles White expresses it have come to know something of the man. No one has to tell them that here is a man who understands what it is to work like hell for substandard wages. They can see that he knows the country blues and what they mean to those who play and sing them. It isn't necessary that someone explain the agony of the wartime drawings to an ex-GI, who happened also to be black. Nor does the earthy, rugged, and ever so tender love of the mother in White's drawing called "Guardian" need to be rhapsodized by critics long on verbiage and short on simple, honest feeling. People who know these things recognize them instantly when they look at White's work.

It should never be forgotten as we look at the life of Charles White that we are looking not at a man "born with a fantastic gift" but at one who has studied long and hard. The adage that talent such as his is 90 percent perspiration and 10 percent inspiration may well apply. And as one looks about at some of the young, undisciplined expressions of "feeling" and "soul," one knows that heart alone will not do the job required by both heart and mind.

Charles White is a first-rate draftsman who has taken the time and, yes, the pains, to learn his craft. He knows how to draw! More than that, he understands the use of drawing, that it is not an end unto itself but a means to a bigger and far more encompassing end. During a period of the evolution of modern American art such as we have been experiencing for the past quarter of a century, it has taken a great deal of

courage for an artist like White to hold fast to his convictions while the more fashionable practitioner flitted from one fad to another.

It must have been especially gratifying to him when in 1962 the professional magazine *American Artist,* in its Silver Anniversary Issue, ran an illustrated story on him titled, "The Remarkable Draughtsmanship of Charles White." Of all the praise any artist receives none is more heartfelt than that coming from his peers. The layman knows what he likes. The professional knows what is sound. Both recognize and respond to the power of Charles White.

The middle and late 1960's brought further recognition and honors. Charles won the Gold Medal at the International Art Show in Germany. During the same year the University of Syracuse announced the establishment of a Charles White Collection that would make information related to his career and work available to students and art historians. The following summer *Ebony* magazine broke precedent by running a Charles White drawing on its August 1966 cover. *Ebony*'s use of Charles White's drawing titled, "J'accuse! No. 10" was precedent breaking in more than one way. First, in selecting a cover honoring the black woman, *Ebony* dispensed with its usual full-color photograph. The drawing was executed in black and white. That was not all, however.

The monthly magazine, one of the nation's most successful, and certainly the slickest of black periodicals, has never made a secret of its projection of the middle-class American image. It bears down heavily on the successes attained by the black persons it writes about. *Ebony*'s success stories make it clear to readers that those it features in its pages have won the acceptance and the praise of whites who are in control of most things. If the story subjects earn a lot of money and live in opulent surroundings, so much the better. Normally *Ebony*'s covers exude the spirit of the magazine's interior contents. But the August 1966 cover was different.

The Charles White heads of eleven black women of vary-
ing ages and personalities made no effort to proclaim material
success or to exploit the legendary sexuality of the black
female. Here was a serious and an honest interpretation to
which masses of black American women could honestly
relate. If there is one word that amply defines what this
drawing says that word is "dignity." Indeed, the term may
be aptly applied to all of Charles's drawings, and it came as
no surprise when in 1967 a collection of them was assembled
in a handsome book titled, *Images of Dignity*. The above
mentioned cover design for *Ebony* is one of the images from
that book.

The honors that have come to Charles White are as de-
served as they are numerous. Since the publication of *Images
of Dignity,* he has been cited by the city of Los Angeles for
his cultural contributions—the first artist in that city's history
to be so recognized. He was named to the executive board of
the Black Academy of Arts and Letters; the Metropolitan
Museum of Art bought all of his drypoint etchings; and the
Whitney Museum bought "Sarah" and "Maternity" from
the *Wanted Poster Series*. It is obvious that here is an artist
who is getting some of the recognition he has earned while
he is still around to receive it. Finally, here, in part, is what
Charles has said about his own work.

My work strives to take shape around images and ideas that
are centered within the vortex of the life experience of a Negro.
I look to the life of my people as the fountainhead of challenging
themes and monumental concepts. I strive to create an image that
all mankind can personally relate to and see his dreams and ideals
mirrored with hope and dignity.

There again is that word—"dignity." How fittingly it ap-
plies to the work of Charles White.

Chapter VI

ELDZIER CORTOR

THE SPECTACULAR SETTLEMENT of black migrants in Chicago just before World War I was not without historic precedent. The Pottawattomie, an Indian tribe of the early 1800's, were the indigenous inhabitants of the prairie that became Chicago, and they had a saying about the very first of the territory's new settlers. "The first white man to settle in Chickagou," the Indians wryly commented, "was a Negro." They were referring to French-speaking Jean Baptiste de Saible.

Described as a handsome black man of French-African descent, de Saible opened the prairie frontier by building a home, poultry house, smokehouse, bakehouse, and dairy. He also maintained a barn and two stables. The Pottawattomie traded with him, while French and English explorers rested themselves and their horses at his quarters as they traveled through the area.

From about 1790 until 1796 de Saible maintained his homestead and business before selling out to an Englishman, John Kenzie, and moving on to Peoria. Legend has it that the first marriage consummated in Chicago, the first white child born there, and the first election held there, took place in the home Jean Baptiste de Saible had built.

Nearly a hundred and twenty years later that prairie wilderness became the Midwest site of factories, skyscrapers, and bustling humanity. Following the tradition of de Saible, of fugitive slaves, and of black freemen, John and Ophelia Cortor brought their infant son, Eldzier, to Chicago. They were certain that in 1916 they could do better there than they had been doing in Richmond, Virginia. At least their son would get a better education in Chicago than they, themselves, had obtained in Dixie.

The Cortors found a place to live in the famed South Side, where Eldzier was enrolled in a predominantly black elementary school.

"I recall hearing my father talk about the street fighting between black and white when he'd come in the house from work," says Eldzier, referring to the riot of 1919 and to subsequent racial clashes that occurred during his childhood. He similarly recalls the growing feeling of black group solidarity occasioned by those clashes. It was that solidarity of which Drake and Cayton wrote in the following passage from *Black Metropolis.*

On eight square miles of land a Black Metropolis was growing in the womb of the white. Negro politicians and business and professional men, barred by color from competing for the highest prizes in Mid-west Metropolis, saw their destiny linked with the growth of Black Metropolis. Negroes were making money in steel mills, stockyards, and garment factories, in the hotels and kitchens, on the railroads, and in a hundred other spots. "Why," the leaders asked, "should these dollars be wasted in riotous living? If white men are so determined that Negroes must live separate and apart, why not beat them at their own game?"

Black Chicagoans of the 1920's assumed, therefore, a stance of black nationalism. If white folks wanted to keep their stores, churches, and places of public accommodation untainted by black intrusion, let them. If white physicians and dentists didn't want to treat black patients, so what? And if

white pleasure seekers could find no fun in any public place admitting blacks, why not let whites have their fun places to themselves. Black folks' money certainly didn't have to be spent where it would make white folks unhappy. Blacks would establish their own places of business and pleasure. And black money, earned in white industries, would be spent as far as possible with black entrepreneurs. Constant encouragement in this reached the black masses through the pages of the black press.

The Cortors were avid readers of the black press. Between *The Chicago Defender* and *The Chicago Bee,* two black weeklies, they kept up with what was happening to and within the black metropolis. Young Eldzier, who always liked to draw, was inspired to draw even more as he read and looked at the cartoons. Nowhere in the comic sections of the white press was the black man portrayed as anything other than a lackey or a buffoon. "Mushmouth," a black stooge in *Moon Mullins* by Frank Willard and a clownish black stableboy called "Sunshine," who appeared in Billy DeBeck's, *Sparkplug,* were typical. Both destroyed in black readers' consciousness any sense of pride in blackness.

But there was "Bungleton Green," who appeared weekly in *The Chicago Defender.* And while Bungleton's behavior was quite a match for his name, he, at least, was not a white man's lackey. Eldzier loved the strip. Someday, he thought, he, too, would make people react to his drawings as he reacted to "Bungleton Green." Moreover, his parents were friendly with Catherine Irving, editor of *The Chicago Bee,* and Mrs. Irving was forever urging Eldzier to keep up his drawing. She had given him a watercolor set when he was young. Eldzier cherished it so much he made it last until he began his studies at the Art Institute of Chicago.

"I attended Medill Junior High School on the West Side of Chicago," he says.

The West Side was what is now called the "ethnic" side of Chicago, with its Mexican, Italian, and Polish populations. We were entering the Depression then and everybody was in the same boat. My folks had had a grocery store on the South Side and when we moved to the West Side we were, for the first time, living with people other than blacks. This was the area where Willard Motley lived and from which he drew inspiration for his novel *Knock on any Door.*

John Cortor's limited formal education had not deterred him from an ambition to be independent of the kind of existence common to most black, Southern migrants to Chicago. He refused to be a drone for a white boss. In addition to his little grocery store, he ran a modest electrical business. And he was a sportsman of sorts, too, roaring about on a motorcycle and even, at one period, flying a small plane. As a private pilot, John Cortor was quite in the spirit of the times. Bessie Coleman and Hubert Fauntleroy Julian were both firing black imaginations with their spectacular exploits in aviation. Because John Cortor prided himself upon being a "self-made and practical man," he saw little future for his son in art. Why, he wondered, did Eldzier have to be such an impractical dreamer? Couldn't he see that the only way to make it was by plain, hard hustling at every turn?

But Eldzier had to go his own way, and he found encouragement in school. A Miss Wilson, who was his art teacher, had been a fellow student of Elmer Simms Campbell. "Simms," as has been mentioned, was beginning to be very successful as a cartoonist, and his sparkling drawings appeared regularly in the nation's leading humor magazines. Since this was something no other black artist had hitherto achieved, young Campbell had fans in every black community across the country. Through Miss Wilson, Eldzier began a correspondence with Campbell which, though it never led the former into professional cartooning, provided a needed stimulus at a critical time in his life. There was yet

Elizabeth Catlett

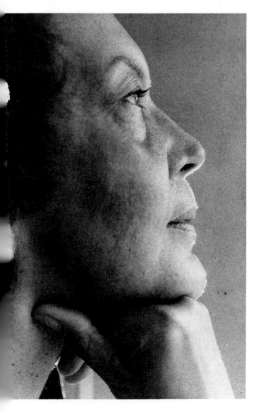

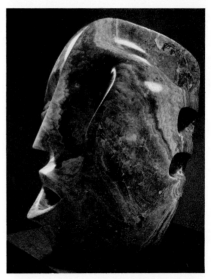

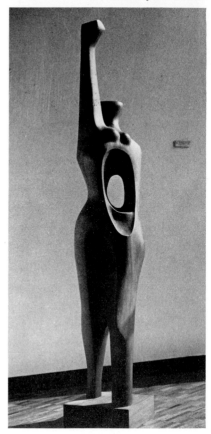

ABOVE RIGHT: *"Singing Head"*
(Brown marble) 1970

RIGHT: *"Homage to My Young*
Black Sisters" (Cedar wood) 1968

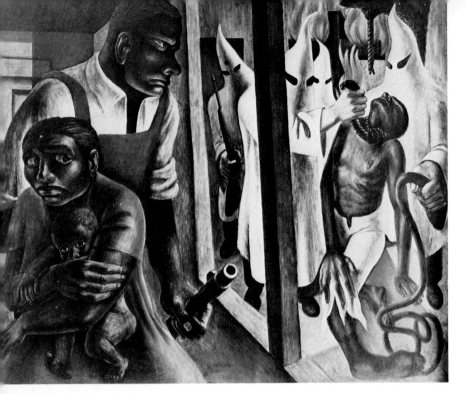

"Incident" (Fresco Mural, Mexico) 1952

John Wilson *"Mother and Child" (Oil) 1970*

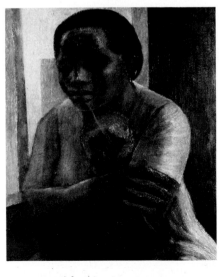

"Environment #V," 1969

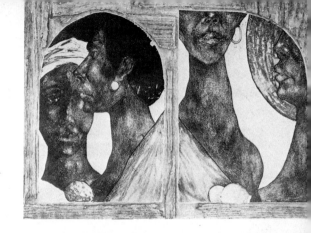

"L'abattoir #III"
(Intaglio-etching)

Eldzier Cortor

Rex Goreleigh. Making a Serigraph print

"The Tomato Picker" (Serigraph print)

"Village Drummers"

"Determination"

Charlotte Amévor, 1971

Romare Bearden

BELOW: *"She-ba"*
GEOFFREY CLEMENTS

GEOFFREY CLEMENTS
ABOVE: *"Gospel Song"*

Jacob Lawrence

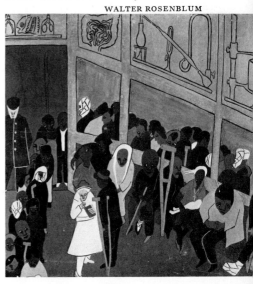

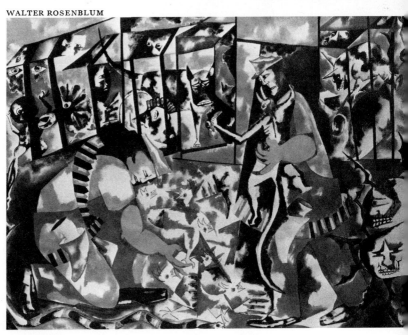

Roy De Carava

SHERRY DE CARAVA

"Hallway"

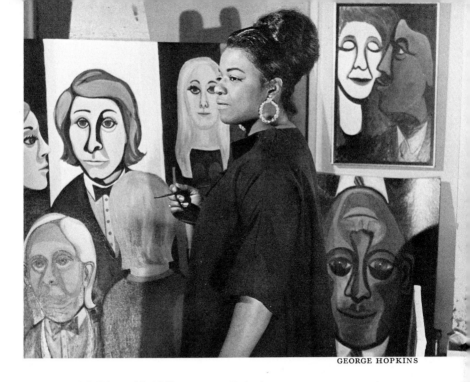

ABOVE: *Faith Ringgold, 1967;* BELOW: *Painting*

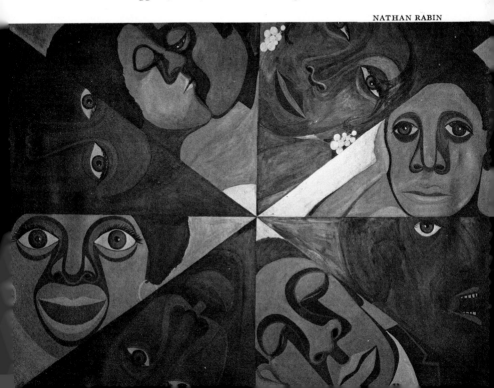

ABOVE: *Earl Hooks*

RIGHT: *"Head of a Girl" (Ceramic sculpture. Wheel thrown and hand built.)*

BELOW: *"Bird Form" (Branch vase. Wheel thrown ceramic decoration. Scrafitto through glaze.)*

LEFT: *James E. Lewis*

BELOW LEFT: *Broadway Median Strip Sculpture. (Brass fountain sculpture with play of water about its base and through the center top. Ashanti-Oriented design relating to geometric Ashanti gold weights.)*

BELOW: *Life-size portrait of Judge William Hastie*

Benny Andrews

MARY ELLEN ANDREWS

"Teacher" (Oil) 1965

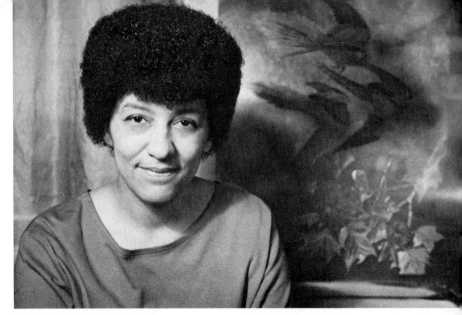

Norma Morgan

"Rock Urchin" (Watercolor painting)

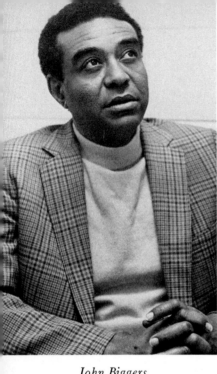

John Biggers *Drawing by John Biggers*

LEFT: *"The Anvil" (Vermont marble) 1964. Collection: J. Shatnoff, New York City;* RIGHT: *John Torres*

another black teacher who was important to Eldzier Cortor. He speaks warmly of her: "She was Miss Kemp, our science teacher. Now Miss Kemp was the kind of soul sister who knew how to handle us black kids, especially when we stepped out of line." Cortor laughs heartily.

She'd keep the class in after school, dismissing the white kids one by one. And when *we* were the only ones left—about twenty or so of us—Miss Kemp would sit back in her chair and give us what we deserved as only a black woman knows how. We were her "family" and she let us know we were never to violate the family code of decency and honor, particularly when "outsiders" were present. I don't believe any black kid in that class ever forgot Miss Kemp.

With the full weight of the Depression on the nation, everyone was affected in some way. John Cortor's businesses suffered and his reversals forced him to take Ophelia and Eldzier back to the predominantly black South Side. When Eldzier entered Englewood High School he found, in contrast to what he had known in junior high, the cleavage between black and white was considerably wider. Reasons for it had more to do with events than with a difference of location.

During the prosperous 1920's Chicago's black community, as has been stated, established many businesses of its own. Two of them were banks, one founded by Southern-born Jesse Binga. Mr. Binga's story, straight out of the Horatio Alger tradition, was that of the poor country boy who made it in the big city. In thirty-five years he had risen from Pullman porter to banker via the real-estate speculator's route. His predictions for the future of black businesses in Chicago were most glowing indeed.

No one, least of all enthusiastic blacks, paid any attention to the dire warnings that all was not economically well with the nation. Especially ignored by blacks was that handful of local Communists who insisted that the hollow prosperity

was doomed to collapse and that black and white workers needed to "unite." Even the respected black *Chicago Defender* was not taken too seriously when, early in 1929, it sounded the following warning in its January 29 edition:

Something is happening in Chicago and it should no longer go unnoticed. During the past three weeks hardly a day has ended that there has not been a report of another firm discharging its employees, many of whom have been faithful workers at these places for years.

With the sudden economic crash that followed, Jesse Binga's bank was the first to close its doors in July 1930. Not at all surprisingly, his black depositors had been among the first to lose their jobs. Within a few months all the other banks in black Chicago shut down. And black people, hungry and faced with evictions, began then to listen to the Communists they had heretofore ignored. The latter were vociferously supporting the defense of nine black Scottsboro, Alabama, boys accused of raping two white women of questionable character. As evictions of black families occurred in Chicago, neighborhood unemployed councils, organized by Communists, rushed to the scene to replace the families' goods in the houses and flats from which they had been removed. They were joined by other blacks, who though far from being Communists, were in full sympathy with the action the Communists had so strategically initiated.

During one such demonstration, on a hot August day in 1931, police, confronted by an angry crowd of five thousand or so black demonstrators, fired shots. Three fell dead. Within a matter of a few hours leaflets, calling for the death penalty for the "Murderers of the Workers," were circulating throughout black Chicago. The corpses of the victims, lying in state at the Odd Fellows Hall of the black belt, were reviewed by eighteen thousand sympathizers and curiosity seekers. A black and white honor guard stood over the re-

mains, and thousands of blacks and whites joined the procession to the cemetery.

White Chicagoans at large were aghast. They had expected a demonstration of blacks, but they were not prepared for a protest staged by blacks and whites together! That constituted a threat of doubtless "foreign" origin that menaced established American law and order. City officials hastily called black conservative and not so conservative leaders into a huddle in which they discussed ways of avoiding another race riot—or, worse still, a "Bolshevik revolution." They lost little time getting their program together.

The first positive step out of the mess was the immediate suspension of the Renter's Court and all eviction proceedings. Both city and state then began the laying of relief plans that marked the first serious attempt to face Chicago's economic crisis. And while the city at large benefited as a result of the demonstration in its black community, white resentment of blacks in general was easy to find. It was certainly apparent in many areas of Englewood High School where Eldzier Cortor was a student.

Eldzier recalls that except for his history teacher, Mr. Wilson, most of the teachers there melted into a pattern of negative grayness.

But Mr. Wilson bore down heavily on such things as the *Bill of Rights*. We had to *read* for his class, and we had to relate our reading from books and newspapers to what was currently happening. And, man, that exerted a profound influence upon me—one that I was to recognize even more clearly later in life.

Through Mr. Wilson's teaching Eldzier began to think in political terms. In fact he even began to draw political cartoons, not for publication, but to satisfy a need for self-expression in that direction. And he chose cartooning because, as he phrases it now, "I thought painting was not for a mere mortal like me but for the Gods, whose talent reached heights I never dreamed of achieving." Eldzier thought a

great deal about the West Side where the family had previously lived and he compared what he had felt there with what was happening to the South Side. Life was less pretentious and more real on the West Side, he recalls.

The opening of the Royal Theatre, for instance, was for him at once a spectacular and a disappointing South Side experience. "I'll never forget that opening," he says.

There was the huge staircase and the chandelier—the orchestra rising out of the pit—gold clocks—the whole works. There was Dave Peyton conducting the Overture to *The Flying Dutchman,* and Sammy *somebody* seated at the organ—all of it in pure imitation of what the whites were doing. The performers, however, like Buck and Bubbles, and Cab Calloway, and Ethel Waters— now *they* were *real!* What they conveyed as performing artists, I, too, hoped I would someday convey in my cartoons.

Eldzier Cortor continued with his drawing and his other studies in the new school setting. Meanwhile, another sensitive and gifted black boy had entered Englewood High School. His name was Charles White.

Eldzier left day school and went to work in his father's electrical business, continuing with high school at night until he finished. Following that he began attending evening classes at the Chicago Art Institute, still intent upon being a cartoonist. But night classes weren't enough and in 1935 he enrolled as a regular day student. The decision brought him in contact with a teacher who was to point a course from which he would never deviate.

Miss Blackshire was a white Texan, with a knowledge and a love of African sculpture. During the year that Eldzier was one of her students, she took the class on several trips to the Field Museum to study the African art. Miss Blackshire told her students why African carvings differed in treatment from those of Europe. She then had them make drawings from African masks and figurines so that they could acquire a feeling for the forms. As Eldzier Cortor recalls his teacher and

those museum visits, he says: "Like most Southerners, Mrs. Blackshire was forthright and direct in her dealings with blacks. Southerners, as a rule, don't go out of their way to jive us, you know, and you quickly know where you stand with them. This lady constantly encouraged me, even to the point of buying a few of my things. It was through contact with her that I came to appreciate the true meaning of art history, composition, and life drawing."

Cortor then relates how Miss Blackshire went to the office in his behalf to secure scholarship aid for him, and how it was she who made him know that painting was a very attainable thing for *him*. "But it was her enthusiasm for African art," he recalls, "that really got to me. That was the most important influence of all in my work, for to this day you will find in my handling of the human figure that cylindrical and lyrical quality I was taught by Miss Blackshire to appreciate in African sculpture."

At twenty-two Eldzier, completely on his own now, found work as an easel painter on the W.P.A. art project. It was 1937 and the canvases he painted of life in the surrounding slums were placed, according to the provisions of the project, in the public schools of the area. Equally exciting as seeing his work so used was Eldzier's contact with other talented black artists and writers of Chicago.

"The Motley brothers were there and so was Richard Wright, Margaret Walker, and Horace Cayton," he reminisces.

The South Side Community Art Center had been founded and young Cortor was one of its teachers. And as has been previously stated, the Center attracted all the black artists in various fields to its program of building a community consciousness of what black theater, dance, literature, painting, and sculpture could mean to every black resident. Eldzier formed close friendships at this period. One was with Horace Cayton, co-author of *Black Metropolis,* from which I have

already several times quoted. It was Horace Cayton who stirred the young painter's interest in a colorful and historic area of the southeastern seaboard, the Sea Islands.

After two years on the Chicago easel project Eldzier applied for and was granted a Rosenwald Fellowship. Because he was not drafted into the military service, he was free to go to the Sea Islands to do a series of drawings and paintings of the life there. The Sea Islands' history, made vivid to him by Horace Cayton, provided Cortor with just the kind of inspiration his own Chicago experience had prepared him to understand and respond to.

During the Civil War the Sea Islands around South Carolina, Georgia, and northern Florida took on a unique character. The entire South had counted on using its slaves as an auxiliary labor force in the conflict with the North, and as the war intensified, had even considered using them as troops. At the very outset of the war, some of the more astute slaves fled north. That action created panic among Southern planters who issued dire warnings to other slaves of the incredibly wicked character of the Yankee. Yankees, they declared, could never be relied upon to treat fugitive blacks well. The slaves listened and many bided their time. Then as the Northern armies moved into the South, and the war became very real, two inevitable things happened.

The first was that the oncoming Northern forces discovered that slaves, instead of fleeing with their masters, waited and sought refuge with the invading army. The second was that the Yankee army, no less than its Southern counterpart, saw the wisdom of, themselves, making military use of the abandoned slaves. Such action paved the way to the latter's freedom, though that was never the intention of the Union Army.

W. E. B. DuBois, in *Black Reconstruction,* writes: "When W. T. Sherman occupied Port Royal in October 1861, he had no idea that he was beginning emancipation at one of its

strategic points." DuBois further reports the mistreatment of slaves by the Northern soldiers they joined. Still they kept coming. Says DuBois: "They increased with every campaign, and, as a final gesture, they marched with Sherman from Atlanta to the sea, and met the refugees and abandoned human property on the Sea Islands and the Carolina coast."

Those refugee slaves had left the plantation not because they no longer wanted to work but because they no longer wanted to work as slaves. Indeed, with few animals or implements to help them clear up the Island lands, neglected for three years, the new inhabitants, with federal help, worked hard. General Saxton eventually settled thirty thousand in the area. More than half of them became self-supporting within a year. A measure of their achievement at one place alone is indicated in the following Saxton quote, as recorded by DuBois:

To test the question of their forethought and prove that some of the race at least thought of the future, I established in October 1864 a savings bank for the freedmen of Beaufort district and vicinity. More than $240,000 had been deposited in this bank by freedmen since its establishment. I consider that the industrial problem had been satisfactorily solved at Port Royal, and that, in common with other races, the Negro has industry, prudence, forethought, and ability to calculate results. Many of them have managed plantations for themselves, and show an industry and sagacity that will compare favorably in their results—making due allowances—with those of white men.

Eldzier spent a year on the Sea Islands. While there he learned that until 1930 the Sea Islands people had had little contact indeed with people of the mainland. He learned also that if you want to get along well there you don't go around calling the people "Geechies" and laughing at their mode of speech. Cortor liked the Sea Islands. "To find such an area within the continental United States," he says, "had great

meaning for me, and the work I did there was purchased by Howard University through James V. Herring."

Back in Chicago, Eldzier saw an exhibition of paintings and heard a series of lectures at the Chicago Art Institute that would exert yet another influence upon his work. The show, from the collection of the Louvre, included works of the classical French painters David, Corot, and Delacroix. Their paintings entranced Cortor because, in his words: "They incorporated good craftsmanship and everyday subject matter into an *epic* style of painting. This was lacking in my own work and I felt I would want to paint my own choice of subject matter in the same way." With that objective in view, Eldzier set out for New York in the 1940's to pursue further study. There he would come to see and know New York's two major black communities—Harlem, and Bedford Stuyvesant across the river in Brooklyn.

American entry into World War II created much needed employment, following the Depression. Between 1940 and 1944 another wave of black migrants went north to find work in urban industrial areas. Sixty thousand arrived in Chicago alone. While work there was abundant, as it was in other major cities, the old bugaboo of housing still plagued them. Even with the demand for labor climbing to a record peak, it became necessary for the President to establish in June 1941 the Fair Employment Practices Committee. Discrimination in war production plants had to be curbed. The following year James Farmer founded CORE, the Congress of Racial Equality, in Chicago. And in the spring of 1943 Harlem became the scene of a riot in which six lives were lost. Such was the general atmosphere at the time in the nation's two leading black communities.

In spite of the difficulties, national and local, Eldzier found New York not only to his liking but much to his advantage. He found greater personal sponsorship there than he had encountered in Chicago, which accounts for his declaration

that "I did my best work in New York for an uninterrupted year of painting in the late 1940's." While in New York he applied for and won a Guggenheim Fellowship for travel and painting in the West Indies.

Cuba, with its sizable black and mestizo population, was Eldzier's first stop. From Cuba he went to Jamaica and from there to Haiti, where he spent the longest time. Quickly learning the Creole patois, he taught drawing and painting at the Haitian Centre D'Art. Two years in the West Indies gave Eldzier a chance to study the cultures first hand and to observe the ways in which they differed. Returning to Chicago in 1953 he painted and showed his work until the magnetic pull of New York could no longer be ignored. Back east in the nation's largest city Cortor found that significant changes had been taking place throughout the national art scene. His observations of those changes, and how they influenced the attitudes and behavior of the gallery owners and dealers of his experience, evoked these crisp comments.

This change in art "styles" affected me a great deal. Painting had become abstract and because I held fast to my own style I lost heavily. One gallery in New York put my paintings away in a closet. The reason why I know that is through some museum people from Chicago. They went to look at some work I had left at a New York gallery and they later relayed the story to me. When they asked to see my paintings the gallery people declared at first that they didn't have any.

With a little prodding, however, the gallery was prevailed upon to dig up what they had put away in a closet. And when they showed my canvases to the group from Chicago they showed them upside down, an obvious slur since I don't paint in the style that permits my things to be shown inverted. A lot of time and care had gone into that work and the gallery had hidden it away for more than a year. Now here is the pay-off. When I got it back in my own hands and sent some of it out to exhibits, some of those canvases took prizes!

Eldzier Cortor firmly believes that successful contact with galleries becomes as much an exercise in personal social rapport as anything else. "If they like you, you'll make it with them," he says. This most human of man's traits—the business of dealing generously with those who please us—is especially significant in the lives of black artists who, in America, have to grapple also with racism. Any artist, black or white, who finds it easy to ooze social charm will make it more easily. But every artist who is black and competent does not necessarily charm others to the same degree. Nor should he be expected to, the variations in human nature being what they are. But people like to have their feathers smoothed and gallery directors are, after all, just people.

One gets the impression from Eldzier Cortor that while he is outwardly gentle and mild mannered he will not easily compromise his principles. He obviously prefers to earn his way through hard, honest work minus all the little stunts and exercises people use in currying favor with those who happen to be in power at a given moment. He doesn't say that and he doesn't need to. The clean, stubborn directness one sees in his work certainly emanates from deep inside the man himself. Like it or not, one is bound to respect it.

No gallery handles Eldzier Cortor's paintings, though he is affiliated with the Associated American Artists print gallery in New York. He finds contact with the A.A.A. most helpful. Prints are, after all, less expensive than paintings. And their greater volume of sales offers the artist a wider market than Cortor could normally find for the large epic canvases he paints.

As difficult as he finds the existence of the painter who maintains his integrity, Eldzier will not consume himself in bitterness. What and how he feels about the entrance upon the scene of younger artists is summed up in a simple sentence: "When I was coming along I recall how easily the older fellows were dropped for the newer and younger ones."

Although he is no faddist leaning upon opportunistic thrusts and parries to keep his name alive, Eldzier's work has been consistently seen and honored for the past three and a half decades. His participation in group shows extends from a Chicago show in 1936 at the South Parkway Y.M.C.A. to the impressive 1970 showing of black New York and Boston artists at the Boston Museum. He is the recipient of several awards. They include the Carnegie, The Bertha Aberle Florsheim, The William H. Bartel, and the American Negro Exposition awards.

As was true of the four artists whose stories precede his in this study, Cortor also found his way to Mexico during the 1950's. Eschewing the cosmopolitan atmosphere of Mexico City, he chose a small town in the state of Jalisco, close by Mexico's second largest city, Guadalajara. There he lived within the shadow of the famed asylum for the orphaned and the aged, called Hospico Cabañas.

The Orozco frescos, "Man of Fire," painted inside that dome between 1938 and 1939, have been labeled by Justino Fernandez "one of the greatest works of art history and the most impressive to be found in America." Like his black fellow artists before him, Eldzier comprehended Orozco's forthright anger. That was no doubt one of the many things he and Betty Catlett and Ernest Alexander talked about when the three of them got together in Mexico City to exchange ideas.

Upon returning to New York, Eldzier went ahead with painting that which he believes in and appreciates above all else. "Here I work with what's around me," he says, "though sometimes I reach back for something out of my memory. I work with what I know—what I understand—even if it's just a head. Everything doesn't have to be an epic, you know." He recalls an appointment not long ago with the A.C.A. Gallery in New York. "The man looked at my paintings as though they were much too foreign for his taste. But I cer-

tainly couldn't—or I actually *wouldn't*—run back to the studio
to produce something I thought he'd like."

Cortor received an unexpected mention in a novel by
Sinclair Lewis that gained a measure of popular acceptance
during the late 1940's. It was *Kingsblood Royal* published in
1947 by Random House. Because the author was dealing
with the racial theme he did not fully understand, it was not
one of his great achievements. At one point in the story the
principal figure contemplates what it might be like to be
black. To be black, he thought, would require that he have
on his wall either a portrait of Ethiopia's Emperor, Haile
Selassie, or a painting by Eldzier Cortor. The artist's smile is
tinged with cynicism as he comments upon the reference.

The author of *Kingsblood Royal* obviously felt that a Cortor
painting hanging in a "white" black man's home, would auto-
matically relate that man to the black experience. I, that artist,
am not too sure if Sinclair Lewis was trying to make fun or if he
was trying to say the "in" thing, or if he meant to pay a compli-
ment. One thing is certain. He didn't understand the black ex-
perience at all.

Chapter VII

REX GORELEIGH

REX GORELEIGH is thirteen years Eldzier Cortor's senior; and he grew up, not in Chicago, but in Pennsylvania. That they were later to share a common experience in Chicago is attributable to the capricious and unifying nature of the black experience.

You meet with Rex Goreleigh in his modest but comfortable Princeton, New Jersey, home, called The Studio on the Canal, and the ease with which he receives you recalls the manner of the European continental gentleman. With Rex the manner is not fraudulent. You can know this man for thirty-five years and you will find that his approach to you rarely varies. He has a way of blending an innate dignity with a full and often tortured human experience. Together they create the image of the debonair bon vivant.

But you look away from the man himself, study the paintings he has done and hung around him, and there you see the man *inside* the soft voice and the suave manner. The compositions contain none of the furious Orozco thrusts nor are they drenched in hues suggesting the abject hopelessness of Siqueiros. Yet each speaks with an honest and brilliant clarity about one of the most shamefully exploited of all labor groups in this republic—the migrant farmworkers. Although

95

the artist has reveled in the attention paid gifted black Americans by adoring Europeans, he has not forgotten who and what he is.

The twentieth century was only three years old when Rex was born in a small town near Philadelphia, Pennsylvania. One detects a distant quality in his voice as he speaks of his earliest years.

I don't talk too much about my childhood because I try to forget many things that happened then. There was a closeness between my mother and me, though we weren't always able to be together. Ours was a home with no father present, you know. In fact, I saw my father for the first time when I was about nineteen and my mother had been dead then for five years. [A reflective pause] So I was raised by relatives, especially by my grandmother—that is—when my mother and I couldn't be together.

Rex's mother, Henrietta Goreleigh, was a domestic worker. There were times and places where her son could and could not share her tenuous "sleep-in" quarters, and that resulted in his attending nine different elementary schools. He did, nevertheless, manage to finish grammar school at fourteen. Two of those elementary schools were predominantly black with black teachers, and the others were predominantly white. Rex gained something of value from each.

Because he was small and not of a pushy, aggressive nature, he stood on the sidelines and watched other boys play ball, hoping that they would invite him in. They didn't. One day, however, as a ball was hit in his direction on the sidelines and he speared it with one hand, the two teams quickly began to vie for his participation. From that experience Rex learned that one cannot expect others to take his abilities for granted. One has to *show* what he can do.

Attending schools with children of well-to-do white families, Rex found, was both advantageous and disadvantageous to him. He benefited from the day-to-day contact with

those whose home environments encouraged reading and inquisitive exploration into things that attract all children. And because they were materially secure and their neighborhoods free of poor families who could be considered a "threat" to the status quo, Rex encountered little or no overt racism among them. A lone black child whose mother was a domestic servant scarcely constituted a "problem." Still, the knowledge within him of the differences that separated him from his schoolmates revealed itself, for instance, in his speech. Rex stuttered. It was his stuttering, in fact, that drove him into art.

"I began at an early age," he recalls, "to show a leaning toward drawing, I would say about eight or so. My stuttering made drawing come easy to me; because no one clearly understood my conversation, I turned to drawing as a means of making myself clear. Eventually I lost the speech impediment but the drawing stuck."

Rex drew everything around him that captured his fancy—the teacher at the blackboard, kids throwing spitballs, the surrounding Pennsylvania farmlands and their people. It wasn't long before he, like Lawrence Jones, began to do the drawings needed around the school. He drew with such ease it surprised him that everybody couldn't, or wouldn't, do likewise. "Drawing," he says, "is such a natural mode of self-expression—like whistling or humming. It's a wonder more of us don't make use of it." So with the joy he derived not only from drawing but from the special attention it focused on him, Rex did well in grammar school. High school was a far less pleasant experience.

To begin with, his mother had died just as he was about to enter and he was left, more or less, on his own. There were relatives close by, but his contact with them had been none too close. They lived in the country and scrounged for an existence as best they could. Rex and his mother, by contrast,

lived more comfortably—if a bit uncertainly—with the suburban families for whom Mrs. Goreleigh worked. The two vastly different life styles roused the envy of Rex's country cousins to the point where there was little communication between the two family factions. Since turning to his relatives was quite unthinkable, Rex tried going to school by day and working to support himself at night. Finding that far more taxing than he had imagined it would be, he began to drift away from school. Finally, in confusion and disgust, he left for Philadelphia.

There Rex did find an abundance of work in local hotels. During the summer he had easy access to the nearby resort town of Atlantic City, where tourist spending was traditionally heavy, and beach-hotel work easy to attain. A breakthrough for him came in 1918. With a little money he had saved, Rex set out for Washington, D.C., where he entered Howard Academy to continue with his studies. Shortly thereafter, with the changing of the curriculum, students at the Academy were transferred to Dunbar High School. Rex Goreleigh found himself there in the company of youngsters who would later distinguish themselves in various ways. Among them were Edward Kennedy (Duke) Ellington, Mercer Cook, and Montague J. Cobb.

For two years Rex was a completely self-supporting student at Dunbar High School, where he dreamed of preparing for the study of medicine. "Doctors always lived so well, you know," he chuckles. But with money running low and no one to look to for support, he soon abandoned the idea, and with good reason. Few people anywhere were more snobbish than provincial, black, middle-class Washingtonians of the post World War I era. Because they placed heavy emphasis upon money, family pedigree, "a nice appearance" (meaning fair skin and straight hair), they weren't likely to be kind to an obscure, black, nappy-haired boy with no visible family and no money. Proud, sensitive, Rex Goreleigh read them per-

fectly, and packing his few belongings, he caught the next northbound train leaving Union Station.

"I was eighteen when I arrived in New York City," he says.

One of my main reasons for wanting to get there was that I had seen and heard the famed Lafayette Players when they performed at Washington's Howard Theater. How I admired the stage craft of Abbie Mitchell, Edna Thomas, Inez Clough, Frank Wilson, and Charles Gilpin! And I had read of the career of the great Ira Aldridge who went on to London to win fame as a Shakespearean actor. The theater was where I belonged and New York was the port of entry. It didn't take me long to get a bread and butter job.

With more youthful adoration than knowledge of the theater, Rex spent all the time he could spare at the rehearsals of the Lafayette Players. After his work was done he would go and listen and watch, and later, talk with the artists. He speaks poignantly of it now.

Once in New York I began to see what hard lives those performers endured. One fellow in particular, who played romantic leads, fell into the trap of narcotics. And when I spoke to members of the group about joining them they were cordial but not too encouraging. They were far more realistically aware than I of the rigid requirements of the theater and of my lack of experience in it.

It didn't take Rex too long thereafter to discover that even though he had the desire and had done a little amateur acting in Pennsylvania, he would not find fame or fortune in the theater. As a personable, cleancut young man who spoke and dressed well, he had relatively little trouble finding and holding jobs that brought him in direct contact with the public. He served, for instance, as a receptionist for a motion picture company, a rarity in the early 1920's. The firm wanted to train him in the Spanish tongue and send him to work in its branch in Mexico City. Rex chose instead to take a job as

waiter in a smart hotel. It was while there that his attention was drawn to an unusual art exhibit that opened in New York.

Mention has already been made of the Harmon Foundation and the part it played in presenting the works of the Afro-American artists to the public. The show that Rex Goreleigh attended at the International House was the very first of the Harmon art exhibitions. It was in perfect keeping with the period of the "Negro Cultural Renaissance" that produced the writers Claude McKay, Taylor Gordon, George S. Schuyler, and Wally Thurmond. It produced also the quartette of great black showmen, Noble Sissle and Eubie Blake, Flournoy Miller and Aubrey Lyles, whose musical *Shuffle Along,* was making theater history in America and London. Rex was quite familiar with all of the aforementioned. But this was his first contact with black artists of the brush. Here was something he had always done so naturally.

"I stood before those paintings and I wept," he says,

not in sorrow but in joy—joy that at last artists of ours like Hale Woodruff and Palmer Hayden were gaining some recognition. This was the turning point for me. Not many days later as I waited on a party, I handed them a menu upon which I had previously made a few marginal sketches. They wanted to know why I wasn't in art school, and realizing I was wasting a precious opportunity, I arranged at once to take private instructions in drawing during my free hours. In a short time I moved on into working in color.

It was the spring of 1933, and Diego Rivera was in New York painting his controversial frescoes in Rockefeller Center. Diego was a guest at the hotel where Rex waited on table, and it was inevitable that they would meet. The great Mexican, with his compassionate understanding of the Indian peon, was no less understanding of the young black waiter who wanted to paint. Diego urged Rex to come as often as he wished to Rockefeller Center to watch him work. Besides

that, when Rivera took an apartment in Greenwich Village, Rex was a visitor there, as well as being among the invited guests at the opening of the Rivera show at the Museum of Modern Art.

"I would say that this meeting with Diego and his constant encouragement were *the* things that put me on the road to becoming an artist," Goreleigh declares.

Meanwhile, barely thirty, Rex had held his first show at the Anderson Gallery. He was studying privately with the Italian painter Xavier Barile, and he was becoming acquainted with the outstanding black artists of New York. When Hale Woodruff went off to Europe on his Harmon award, a group of black artists, including Aaron Douglas, Augusta Savage, Jacob Adams, and Gwendolyn Bennett, gave him a send-off party. Invited also were three younger artists, Zell Ingram, Oliver Harrington, and Rex Goreleigh. That social gathering marked Rex's initial meeting with the Harlem group. He was to get to know them more intimately later through the W.P.A.

When the art projects of the W.P.A. got under way in New York, Rex, inspired by his recent contact with Diego Rivera, applied for work and was hired as a mural assistant to Ben Shahn. Murals were being planned for high schools, prisons, and hospitals of the New York area. The project to which Shahn was assigned was for the city prison at Riker's Island. But Rex wasn't with Shahn very long. A black W.P.A. art teacher in Harlem had been taken with a sudden illness and Rex was called upon as a replacement.

Utopia Neighborhood House, in the very heart of Harlem, was a community center serving young people of all age groups. A private social service agency, Utopia House, with added financial help from the city of New York, was a boon to poor black families during the Depression years. Their children were fed and instructed in the arts and crafts while parents, who had work, could go about it without wondering

if their children were roaming the streets. It was the kind of place that held a special significance for Rex Goreleigh. How thoroughly he, as the child of a working mother, could have enjoyed and benefited from such an opportunity! With that kind of consciousness he was able to bring to his work an abundance of practical understanding.

During his stay at Utopia House Rex was painting on his own and he was beginning to move about in genteel, down-town, social circles. He groomed himself immaculately. And since his experiences as the son of a domestic servant and as a waiter had taught him that monied whites were only human beings, he was quite at ease in their company. They in turn found his manner pleasing and engaging and they frequently invited him to join them and their guests.

On one such occasion at the home of a Greenwich Village patron who owned one of his paintings, Rex happened to remark that he hoped to get to Europe some day. "Are you serious about that, Rex?" one of the guests asked. When Rex replied that he had never been more serious in his life, he was assured that it could be arranged for him. And it was. In addition, another admirer saw to it that Rex's wardrobe was appropriately completed. Within a few weeks, Rex Gore-leigh, having secured a leave of absence from his work-relief W.P.A. job, was on the high seas. Destination? Paris!

"Man, I discovered I had planned that trip so well I was one of the few people aboard ship who knew exactly where he was going, at what hotel I'd be staying, and in whose studio I'd be studying!" Rex still roars with laughter think-ing about it.

In Paris he quickly fell in with the artists and jazz *aficio-nados* of the day. Rex studied and worked with DeLauney and he became a favorite of the painters who were intrigued with his sense of color and his easy-to-meet personality. Georges Braque was one of the group, and though Rex ad-mired Braque tremendously, he never tried to emulate the

Braque abstractions. He laughs now as he thinks about it. "They all kidded me about my abstinence from pure abstraction, but they tolerated me with the understanding one finds among truly creative people."

Rex had left New York in May 1935 with the understanding that he would have to be back within six months in order to be reinstated on his job. He would have to hurry to make it. But who hurried away from Paris during the 1930's? So he spent his six months there, and because he had promised friends from Germany and Finland that he'd drop by to see them, he visited those countries too. For three weeks he sketched in Germany and he painted for three months in Finland. Rex was the only black person in Helsinki at the time, and excited and friendly Finns insisted that before leaving he must meet their prize exhibit, who lived in a nearby town. That turned out to be a black expatriate American who had become a railroad engineer and was doing quite well.

A black former dancer from New York, Roy DeCoverly, was living in Denmark and writing for the Danish press at the time of Goreleigh's visit. Because the two had known each other in New York, Rex took time out to visit his friend in Denmark. Finally, with canvases carefully rolled in a bundle and sketches packed flat for the return trip home, he arrived in New York in the spring of 1936—six months late and extremely happy.

Reinstatement to the Art Project under such circumstances was not easy. However, Rex went downtown to headquarters in King Street as anxious to talk about his adventures as to seek reassignment. Someone occupying an inner office, upon hearing his voice, called, "Is that Rex Goreleigh out there?" Before Rex could answer, the caller was outside shaking his hand and assuring him that there was a place waiting as soon as he could return to work. He was promptly sent to take over a class at the Y.M.C.A. in Harlem.

The success of the Art Project in New York City had stimu-
lated official interest in the establishment of art centers in
other areas of the country. Washington subsequently revealed
its program to expand the establishment of centers to smaller
American cities. The plan called for having the government
supply directors, staffs, and equipment, while the selected
local communities contributed the locations for such centers.

New York City was a source from which personnel would
be drawn. Two thousand of its artists were screened, and of
that number sixty-eight were selected to go out of the city on
that assignment. Four of the number were black. Two, Nor-
man Lewis, now an outstanding abstract painter, and Rex
Goreleigh, were paired off and sent to establish the art center
for blacks in tightly segregated Greensboro, North Carolina.
Two others, Sara Murrell and Ernest Crichlow, were ordered
to nearby Raleigh, North Carolina. White artists directed
simultaneously to the same cities were assigned to set up
"white" art centers.

The idea was that the federal government would fund
these experiments in their initial stages, and after a given
time the communities themselves would take them over.
Each artist agreed to spend a certain number of weeks in the
community to which he was assigned. If, at the end of that
period, he chose to sign up for extended service, he could do
so until the time limit, set in advance by Washington, had
been reached. At that point, the government's sponsorship
would end, the artist would return home, and local communi-
ties would take over from there. That, of course, is what took
place in Greensboro—with one exception. Rex Goreleigh
remained in North Carolina. What kept him there was his
quiet and unexpected marriage to a charming widow, Martha
Sebastian.

Mrs. Sebastian, the widow of a prominent local physician,
was a librarian. It was the public library of which she was in
charge that had been selected as the location for the art

center conducted by Rex Goreleigh and Norman Lewis. Mrs. Sebastian was impressed by Rex's poise, and it was not long before they were married. For a brief time he taught at Palmer Institute in nearby Sedalia. It was there that Rex, in a new setting, decided that he would need a broader academic education. His wife agreed with him and between them they agreed that he would pursue further study at the University of Chicago. The year was 1940.

Between work at the University and outside employment as an art coordinator in an advertising agency, Rex was enlarging upon an already rich experience. His wife, Martha, kept busy meanwhile between working in Greensboro and getting to Chicago to visit with her husband.

It was inevitable that in Chicago Goreleigh would get to know the famed South Side Community Art Center at whose opening Mrs. Franklin Delano Roosevelt had officiated.

"When the Center closed for lack of funds, the black community formed a committee to keep it alive," he recalls.

Monied people of the community like Claude Barnette and his wife, Etta Moten, to mention but two, rallied to the task of saving the Center. They asked me to be its director. I accepted, much to the chagrin of many local artists, who regarded me as an "outside intruder."

From 1944 until 1947 Rex Goreleigh directed the course of the Center. Among local artists who showed there were Charles White, Eldzier Cortor, and Charles Seabree. "We also invited artists outside Chicago to show," says Goreleigh.

One of them was a young North Carolinian named John Biggers. He had come to Chicago to paint a mural for one of the local black-owned banks and it fell to my lot to appraise his design and to designate where it would be installed. We showed the mural at the Center before installation. I also recall that Ellis Wilson and Hughie Lee-Smith were other nonlocal artists we presented at the Center. We worked in quite an atmosphere, you know. Every Saturday night we used to listen to a tall, young,

jazz pianist and his two partners playing a smooth brand of jazz directly over our Center. His name was Nat "King" Cole.

A writers' group was formed at the South Side Center, headed by a woman Rex had met at the University of Chicago. She was Marjorie Peters, a white free-lance writer, who came to know and be known by young local black writers such as Gwendolyn Brooks. The Peters' group would meet with another writers' group headed by Richard Wright. Together they established a lively group rapport. And all the activities were made known to the community at large by that pair of local scholars and columnists, St. Clair Drake and Horace Cayton.

At the end of three years as director of the Center, Rex received an unexpected offer from an unexpected place, Princeton, New Jersey. There a group of Princeton University professors, along with members of the Jewish and Quaker communities, wanted to form a racially and religiously integrated organization that would serve the cultural needs of Princeton. In looking about for someone to coordinate and direct the program they came upon, among others, the name of Rex Goreleigh.

"Lord knows, I didn't want to go to Princeton," reminisces Goreleigh, recalling how black Americans had long ago nicknamed New Jersey "The Georgia of the North." What on earth, Rex wondered, did he need to go to Jersey for, and to Princeton, of all places? Wasn't Princeton where Woodrow Wilson, no champion of black men's rights, had taught? Was it not the home base of a rich white man's school that had shown little disposition up until that time to break from its racist traditions? Besides, Rex could see himself being slowly sucked into a possible lifetime career as a nonpainting executive in art programs.

Hell! He wanted to *paint* because he was a painter! He'd been painting and showing consistently since 1932 and had gained some recognition as a painter. Surely there would be

more to come if he only continued with his craft. Besides, the offer looked like a massive hoax—a trick. Why would they choose him, who had the least impressive paper credentials? Was this another of the white man's way of cunningly selecting a sacrificial goat in the carrying out of another of his nefarious schemes? This time maybe he was purposefully choosing a black goat.

All of these thoughts ran through Goreleigh's mind before he began to laugh at his own fears. What was he being afraid of? Who had asked him to come to Princeton anyway? The simple truth was that he was one of several candidates approached. All the others doubtless had far more impressive academic qualifications than he. After all, Princeton was an academic community and it would be looking for an academic man for such a post. So why not relax and let Princeton worry about its problems of up-South racism.

But Rex Goreleigh was the man Princeton wanted. Martha felt it would be a good move, if he'd take it, for they could establish their home in the North. So Rex moved on to Princeton in 1947.

I still had misgivings about Princeton, though I must say the people who asked me to come did give me full support. I had hoped in the beginning to enroll at the University and complete the studies I had begun at Chicago. But the work load was too heavy to permit that.

And a work load it certainly was. The job called for the creating, directing, and administering on an all-arts program. It was one that would include people of all faiths and financial circumstances. Poor blacks who wanted to participate were given scholarships. Knowing how faithful hard-working black Americans are to their churches, Rex wisely went to the black ministers to enlist their aid in stirring their membership to participate. "Response was slow," he recalls.

The black community could not see the relevance of the Prince-
ton Group Arts program to their specific problems. Then we had
another kind of initial opposition from the local "Y." Even
though it had no real arts program, the "Y" felt is had a monop-
oly on such activity, so they didn't help us.

In the midst of solving some of the early problems, tragedy
struck. Martha was involved with her son in an automobile
collision in North Carolina. They were on their way to
Princeton with Rex's paintings for a showing there and they
never made it. Martha's son's injuries were serious. Hers were
fatal.

With his bereavement to live with, Rex plunged headlong
into the work awaiting him. "I was the first to bring such
artists to Princeton as William Warfield, Marion Anderson,
and Louis Armstrong," he says,

We had many things going here—a chorus, little theater, creative
writing, painting, and sculpture. One thing in my favor was my
ability to wear pressure well—to move easily among people.

And here I believe my childhood experiences in the *kind* of
white setting I was placed in helped me. Oh, I knew I was poor
and black, but as one can see from the details of my childhood
I was not harassed by insecure whites. I therefore didn't feel the
need to be constantly damning "whitey" even though I was thor-
oughly familiar with the patterns of racism right here in Prince-
ton. And even though I had strong misgivings about the job, I
decided that once I said I'd do it, I'd proceed with producing the
best I could.

Princeton Group Arts ran for six years with Rex Goreleigh
in the director's chair.

"When it closed, people came to my home to see if I would
continue to remain and conduct an art class. My answer was
to open this present Studio-on-the-Canal. We've been here
since 1955."

Here at last was the opportunity to function as a practicing
artist and simultaneously to offer courses of instruction on his

own terms. Starting with a small group, the Studio-on-the-Canal quickly grew from a single room in Rex's home to the occupation of the entire adjacent garage building. It still continues to function at the same site. Of its aims, Director Goreleigh has this to say:

Here at the Studio we do more than provide a place for the dilettante to come and dabble. We do provide solid instruction that will permit the participants to move ahead seriously with the art of painting. Our teachers have to be known for their achievements as artists if we hope to attract and hold the serious student. We hope that I'll be able to retire from teaching the Monday class and devote all of my time to painting.

Indeed, Goreleigh began almost at once to resume serious painting.

There is a tiny community within fifteen miles of Princeton called Roosevelt, that had been the home site of artist Ben Shahn. During the Depression the federal government built houses there for the garment workers from New York who were settling in the area. And not long ago the Roosevelt Board of Education invited Rex Goreleigh to conduct a summer program of arts and crafts for the community. It was an experience that would not only evoke early memories but designate a new direction for the artist.

Though Rex's paintings had always reflected his affinity to life in the black American community (he had lived in Harlem and on Chicago's black South Side), he was not a ghetto painter. Actually, by virtue of his boyhood conditioning and later travel, he had enjoyed periods of respite from the most harrowing and humdrum routines of the ghetto existence. How would he react in a direct and personal confrontation with racism? How had his goings and comings in genteel drawing-room circles affected him? Had Rex Goreleigh forgotten who he was? where he had come from? Had he become just another "Oreo cookie—black on the outside and white on the inside?"

"There was talk of bringing migrant children into the school at which I was teaching," he recalls.

And that was done as planned. But none of those children attended my class in arts and crafts. You see, there was a studio fee of two dollars assessed the parents of each child and no migrant worker could afford two dollars for such a thing. That disturbed me. Then there was another thing that got to me. The migrants' children were not let out of school at the same time other children were using the playing field. That was to prevent social mingling outside the schoolroom itself. I threatened to quit teaching unless they changed both situations, and they did.

Meanwhile, as I was walking in the vicinity one day, I saw the charred ruins of a migrant worker's shack in which two children had died just hours before. This is something no human being ignores and the sketches of the three figures I just showed you— the two women and the man—was the beginning of my comments on the migrant workers.

Rex Goreleigh was soon to discover that any indictment he sought to level at the injustices borne by migrant workers was not going to be well received in certain quarters. Guilty authorities were extremely sensitive to criticism, even when it came from a mild-mannered artist. Senator Harrison Williams did, however, request that Rex lend him six watercolors to hang in his Washington office. Beyond that the New Jersey State Labor Division at Rutgers University, in celebrating its Golden Anniversary of Labor, borrowed the Goreleigh paintings of the migrant workers for an exhibit.

"It was a pleasant social gathering," recalls the artist, "but nothing happened to remedy the evils of the situation. They even showed more of my works on the subject at the Rutgers Labor Building, and still nothing has been done."

Though there has been little encouragement to continue with the series, Rex is not being easily brushed off.

I'm going to keep on painting these canvases and watercolors until I've completed the series—even if there is no request for

them. My hope is that there will be a place in New Jersey where the pictorial record of the migrant worker will be hung. It may be a mural or may not be. But the fact of automation will soon make the migrant worker extinct. Still, the story of his having fed the people of this state during our time is a human document that should be made and placed where it will not be forgotten.

That falls in direct line with the Goreleigh philosophy that his art must be a mode of communicating his feelings to others. Rex Goreleigh is not alone in that. Though more than a generation separates them, Charlotte Amévor, whose harsh and moving personal experience follows, shares that view.

Chapter VIII

CHARLOTTE AMÉVOR

I wasn't three years old when it happened and yet I distinctly remember. My mother was ill and I was being put into a home. I remember screaming in the streets and though I didn't know where I was going, I knew I was going away from my mother.

The speaker shudders slightly before adding, "I still can't pass that block where the Gould Foundation is located without feeling all sorts of chills."

Charlotte Amévor crosses her long shapely legs and gazes momentarily at a vacant spot on the wall. Her husky tones are washed in a sweet sadness as she recalls that very real nightmare of her childhood. But this is not a woman who will permit anyone the luxury of feeling sorry for her. She is no less tough and stubborn than she is talented and warm. Her terrifying memory notwithstanding, Charlotte Amévoy knows how to cope with the rigors of big city life. She has had to learn some hard lessons. She has learned them well; and learning them has made her a purposeful human being.

Charlotte got her first glimpse of the world in New York City's Harlem Hospital on September 17, 1932. Her father, Charles Kimuvu Amévor, was a seaman from what was then the British Gold Coast in West Africa. He had jumped ship and hidden, undetected, in New York's Harlem, for thirteen

years. In the interim he had met and married Charlotte's mother, Marie LaPierre, a native of Martinique.

Charles Amévor was not a lazy man. Finding employment with the Jack Frost Sugar Company, he managed to study for a time at Columbia University. Tall, slender, and with the dignified bearing so typical of West Africans, he was a most attractive man indeed. Women found him very easy to look at and to like. Following the polygamous tradition of his male forebears, he had, in addition to his wife, Marie, several admiring girl friends. One of them, quite unlike the women of his native Gold Coast, became incensed with jealous rage when she learned of Marie and little Charlotte. Without any warning, the spiteful woman told the immigration authorities where they could lay hands upon the elusive Charles Amévor. The immigration officers wasted no time. In a matter of hours they had scooped up their quarry and shipped him back to Africa via London.

Marie was distraught. At first she had no idea where or why her husband had disappeared. Having been brought up in a strict West Indian family setting, she did not know which way to turn. And small wonder. She had barely been permitted out of the house alone until she was seventeen. Marie's naïveté, coupled with her husband's sudden and unexplained exit, were more than she could handle. Left alone with a small child, she panicked and fell acutely ill. And little Charlotte was placed in the temporary children's shelter of the Gould Foundation.

It wasn't long before the social worker found a Harlem foster home for Charlotte with Pauline Rivers, a concert singer. During the child's four years in her home, Mrs. Rivers discovered she had a talent for the piano, and before Charlotte was five, Pauline Rivers had presented her in two public performances. Mrs. Rivers entertained visions of developing a prodigy. A couple of years later, however, Marie was able to take her daughter back home, and what might

have blossomed into a career in music came to an end. Marie, barely able to feed the two of them on the Depression pittance she earned as a housecleaner, could ill afford piano lessons.

Charlotte attended P.S. 157, an all-black Harlem elementary school. She recalls that period in relation to present-day Harlem. "Today, with all the talk about integrated schools, I really feel privileged to have gone to a school where there were all black teachers. They were really 'down with it' as far as we kids were concerned and that was a great thing for us." Charlotte also recalls those black teachers who were not "down with it" and whose indifference was painful to bear. One particularly stinging reminder still lingers with her.

Because they were too poor to buy much that they needed, Marie had taught Charlotte to sew and to make artificial flowers. The child was extremely apt. In fact, she became so good that the day her teacher gave the class the project of making a bouquet of flowers for the principal, Charlotte was in her element. While her classmates struggled with their flowers, Charlotte not only finished hers first but helped others with theirs. Indeed, she made all of Dorothy's roses for her. Charlotte liked Dorothy—so scrubbed, well groomed, pretty, in her fresh new ribbons each day. And Dorothy was a pleasant girl, too, not "hincty" or stuck-up; she was okay with Charlotte, even if she couldn't do anything with her hands.

On the day the class was to present the bouquet to the principal, Charlotte went carefully through her patched clothing to find the best dress she had. After all, as the expert flowermaker in the school she had to look her best for that occasion. She couldn't go before the principal in her shabbiest rags. However, when the teacher designated the girl who would take the bouquet to the office, she called Dorothy, and Dorothy alone. "But—but can't I go—*with* Dorothy to see the principal?" Charlotte implored. "She's my friend." The

teacher tried to be casual. "I'm sorry, Charlotte, but I'm afraid you're not dressed properly for this occasion."

The words struck with a cruel and chilling finality. From that moment on Charlotte's personality changed. She was through trying to play it "their" way and with being a nice acceptable little girl. It didn't pay, she found. Moving to the rear of the classroom, she assumed the role of class clown.

"I performed with a carefully studied shrewdness," she says.

Not once did I fail any of my subjects as I kept things in a constant uproar. Even after another teacher took me to a department store on 125th Street and bought me two middy blouses and ties, I still raised enough hell in class to be considered a border-line problem child.

Charlotte remained just that way all through junior high school. Her popularity with classmates was unquestioned. They elected her class president, not only because she was obviously bright but also because she had nerve enough to disrupt and distract authority. They were all black Harlem youngsters together who shared a common aversion to the white man's authority, especially as it was filtered down to them through his black hirelings.

The routine Charlotte had set in motion remained unbroken except for those rare and inevitable times when she was made to feel "different" from her classmates. Whenever the children were asked by their teacher to tell the class where their parents were born, Charlotte readied herself for battle. As she declared that her mother was from the French West Indies and her father from Africa, derisive laughter and taunts of the others would surely follow.

To Harlem youngsters, whose forebears were born in the United States, anyone from the West Indies was a "monkey-chaser" with an insatiable appetite for monkey hips and dumplings. Coming from Africa meant that one was a cannibal. So Charlotte was mercilessly "put in the dozens" by

the others. When you were "put in the dozens," your parents and their ancestors were verbally scandalized to your face, and you were obligated to fight to redeem their honor and your self-respect. Charlotte, of course, fought with all her combined West Indian and African fervor. After that she was quickly restored to her place of popularity.

In junior high school now, Charlotte was to learn some bitter truths about adult-child relationships. Because she had learned to sew well at home in order to keep a neat appearance on the lowest kind of budget, she was fully alert one day when she saw her sewing teacher inadvertently spoil the cutting of a classmate's material. What bridled Charlotte was the teacher's unwillingness to admit her error. "You'll just have to bring in fresh material," she bluntly told the girl. Knowing what a struggle it was for the very poor to buy anything, Charlotte spoke out in defense of her classmate. The already embarrassed teacher was enraged. In a voice filled with emotion she announced for all to hear that Charlotte Amévor was much too big for her britches and needed to meet her match. A deadly silence descended upon the class for the remainder of that period.

Charlotte lingered after class. The teacher reprimanded her again and tried to dismiss the girl. "I'm not ready to go yet," Charlotte replied. "You've had your say. Now I'll have mine." The teacher sat in stunned silence as Charlotte reminded her of the many undemocratic procedures in the classroom. She cited the pedestal occupied by the teacher and how the teacher often descended from that pedestal to wage war upon children. When the latter showed any sign of retaliating in kind, the teacher would hastily seek the sanctuary of the pedestal. "That is what *you* have been doing right along, but for the past few minutes, at least, you and I have been on equal terms." With those words Charlotte gathered up her books and left.

Within twenty-four hours every other teacher in the school

had been "advised" by the angry sewing teacher to give Char-
lotte Amévor a "D" grade in conduct. They did. When Marie
Amévor was apprised by the school of what had happened,
she and Charlotte, following their custom, talked it over at
home. The girl was honest with her mother, who ruled out
heaping any further punishment upon her daughter. Further
encouragement soon came to Charlotte from her art teacher,
who publicly praised her in class for outstanding work. "Oh,
I clowned a bit in accepting the compliment," she recalls.
"But those words from that teacher went deep and right to
my heart. They, more than anything, were what I needed at
the time."

Charlotte, who loved to draw, had found something other
than clowning and hell-raising that set her apart from others
in school. Still she said nothing to her mother about her in-
terest and involvement in art. It wasn't that she was de-
liberately withholding information, but she honestly didn't,
at the time, think it was important enough to talk about.
"Had I said anything to my mother about art she would have
encouraged and pushed me to the limit. That's the way she
was," Charlotte says. So instead of pressing to take the city-
wide examination for the High School of Music and Art,
Charlotte went on to the academically reputable George
Washington High School. There again her work in art was
outstanding, and it appeared that she would, before gradua-
tion, become one of that school's outstanding art students.
But Charlotte was not graduated with her class. At sixteen
she was pregnant.

From the very outset she ruled out marriage to the fellow
since, as she puts it; "There were already four kids in the
family of my son's father and his mother was very strong. I
had no intention of becoming another one of her children."

Moreover, her own mother, Marie, now a diabetic, put no
pressure on Charlotte to marry. She was quite willing to look
after the youngster while Charlotte worked to support him.

Charlotte got a job at a small but elite studio where stockings were hand painted. She started in as a packer for the firm headed by alert and chic Mrs. Troy, a woman of French-German extraction. Indeed, she worked right beside Mrs. Troy. One day, as they were busy packing together, the latter took a look at Charlotte's hands. "What exquisite hands!" she exclaimed in her accented English. "Have you ever done anything in the arts, Charlotte?" When told of the early piano exploits, and the art work in school, Mrs. Troy immediately transferred Charlotte to the painting division of the studio.

"That was exactly where I wanted to get," Charlotte says. "In fact, I'd been sneaking up there practicing on my lunch hour ever since I had been at the studio. So in six months I was working next to the master painter."

Business slowed down at the studio shortly thereafter, but it was easy for Charlotte to get a similar job at another place. And because Mrs. Troy's standards were so high, Charlotte automatically became the number-one craftsman in the new studio. Her earnings, however, were small. The twenty-eight dollars a week went for the support of three, and there was nothing left to spend on the new styles that appealed to her eighteen-year-old tastes. She would simply have to earn more, and that was that.

It was at this point that Marie made a decisive move. Her diabetes was now advanced and she sensed the gravity of her illness. In one of their woman-to-woman talks she told Charlotte it was time for her to take full responsibility for her child. Within a week, Marie had moved to another address.

"It was strange," Charlotte says, "but I never took a why-are-you-doing-this-to-me attitude toward my mother's decision. I later, of course, realized that she was preparing me to stand completely on my own."

Charlotte left the studio and went to work as an information operator for the New York Telephone Company. By

now she had met a fellow she liked and again she became
pregnant.

This time I tried to abort it and nearly lost my life. I wasn't
interested in marriage for I knew I wasn't ready. For a while the
fellow and I lived together. But he wasn't as strong as I. Though
we both worked I had to find the place to live—to fight the land-
lord. To keep him out of alimony jail with which his wife, from
whom he was separated, threatened him, I took a second job. He'd
been an athlete and wasn't really through playing. So I didn't
want to stand on him. A fellow like that had to have a chance to
grow up. So we separated and I went to live in South Jamaica.

Charlotte worked three jobs. She took care of thirteen
nursery-age youngsters, and was the superintendent of the
building she and her children lived in. At night she worked
at the Ideal Toy Factory. "And I did a lot of art work for
relaxation, but if anyone admired it, I'd throw it away," she
recalls. Her last child, a daughter, was born at this period,
and Marie lovingly took the infant to Washington with her
until Charlotte could afford to care for it properly herself.

Now the going was becoming really rough. At one point
Charlotte approached the New York City Department of
Welfare for help, though she did not ask to be admitted to
its rolls. What she requested was that the department place
her two sons in a foster home until she could earn enough to
take them back herself. The proposal, not in line with existing
policy, was refused. She would have to keep her children with
her and accept welfare. The department found a place for
them to live on West End Avenue. Meanwhile, Marie grew
critically ill in Washington. Charlotte managed to scrape
together enough to go down and bring her mother and baby
home. When the two women and the baby girl arrived at the
Greyhound bus terminal in New York, Marie could make it
no farther. An ambulance rushed her to a hospital and in a
few days she was dead.

With no money for a funeral, Charlotte, following Marie's

foresighted advice, handed the body over for medical re-
search. Gossipy acquaintances wagged malicious tongues to
no avail. "In spite of them," Charlotte recalls, "I came to
know a few princes and princesses of the human race at a time
when I needed such reassurances as they offered." Charlotte
Amévor had hit rock bottom, but at age twenty-two there
was but one direction in which she could go. Up. "I was wait-
ing for my daughter to reach the age of two, so that I could
get her in a licensed day care center so she wouldn't be
buffeted about. The boys, I felt, could take care of them-
selves."

The district Democratic Club had its headquarters across
the street from where Charlotte now lived on West End
Avenue. The year was 1955. There just had to be an oppor-
tunity over there, Charlotte thought. One day, bold with
desperation and toughened by her grim experiences, she
strode into the club. "I came over here to see just what it is
you're doing in this lily-white organization," she announced
in firm and even tones. The white man to whom she spoke
flushed and quickly pointed to the contingent of black Club
workers nearby.

"Oh, I saw them all right as soon as I walked in. But I
don't need to see them or talk with them to be made com-
fortable. When things are as they should be I'm just as much
at home with you as with them."

Tall, good-looking Charlotte was oozing charm, and the
man relaxed. She was introduced to Bill Ryan, who was seek-
ing the post of district leader and who was later to become a
member of Congress. Ryan immediately put her to work for
him.

"They never dreamed I was on relief. My children and I
were clean and neat, for I made their clothes and mine too.
Yes, we were on welfare but we weren't wallowing!"

Charlotte soon became a favorite of the Club workers.
They wanted to know all about her—what college she had

attended—and she told them simply, and with the profoundest truth, that she had received all her education right uptown in Harlem. When she made it known she wanted to practice her typing, they gave her the keys to the Club. That allowed her to use the machines for three hours each day while her two sons were in school and her daughter in nursery school. And when she felt she was ready, Bill Ryan sent her to Tammany Hall and thence to the New York State Unemployment Insurance Office, where she took the exam and passed it. Within days she had a job with the State of New York. The year was 1957.

Gloria Sharpe and Charlotte Amévor worked together in the same office. Gloria had spent thirteen years in Nigeria and she was constantly keeping up with African events, particularly those occurring on that continent's West Coast. By 1952 the Africans of the Gold Coast were no longer colonials of Great Britain. Kwame Nkrumah, who had engineered their freedom from colonial rule, was now their prime minister. Within another eight years he would become their first African president and the territory would be thenceforth called the Republic of Ghana.

The foreign publications on Gloria Sharpe's desk were full of such news, and Charlotte, never forgetting that her father was African, asked to look at them. And though she didn't take her drawing too seriously, she was forever doodling sketches of Africa and Africans. One day, as she looked over one of Gloria's magazines, she came across a picture of an African shading someone with an umbrella. Unconsciously she thought of her father and very audibly she exclaimed, "Daddy!" Gloria, overhearing Charlotte, asked what she was talking about.

"Oh, didn't you know? My father's African." "Oh, really? Where's he from?" Charlotte told her. "That's interesting. What's his name?" "Charles Kimuva Amévor." Gloria's frown indicated she had heard the name before. Charlotte,

meanwhile, described her father from words and pictures
left with her by Marie. Suddenly Gloria sat upright. "I know
him!" she cried, scattering papers in her excitement. Char-
lotte's father, it developed, had been a regular visitor to the
home of Gloria's parents, who were hosts to many Africans
in New York. Moreover, Charles Amévor had proudly in-
vited Gloria's mother to be one of the first to have a look at
his new-born daughter, Charlotte.

Gloria called the Ghana Mission to the United Nations and
spoke with Francis Cann, who asked for pictures of Charlotte,
which he sent, with a news story, to Ghana. Within a month
Francis called Charlotte. He had located Charles Amévor,
and the *New York Daily News, New York Post,* and United
Press International, all wanted stories. It was August 1958
and Charlotte Amévor was making news headlines.

"The following morning Africans began to rain on me,"
Charlotte recalls. "I began to get letters from all over the
world, and of course one of them was from my father." In
addition to urging his daughter to visit him as soon as pos-
sible, Charles Amévor was especially interested in her edu-
cation. How far had she gone in school? That did it. Char-
lotte resolved that, at the very least, she would have to get
her high-school equivalency certificate. And that she did. By
taking a crash course she came out in the upper fifth of the
class. Now she would have to see about getting to Africa.

Ghanaians based in New York made Charlotte all sorts of
offers and proposals. But in her own words: "I was quite
unwilling to go there on my back, though I did find the
Ghana Minister of Finance, Mr. Gbedemah, an extremely
fine man. But Gbedemah couldn't help me at the time."

Charlotte wrote her father that much as she wanted to
see him she wouldn't become a prostitute for the opportunity.
She assured him, however, that she would eventually get to
Ghana, and on terms more to her liking.

Following the news stories, Charlotte secured a job in the

office of Manhattan Borough President Edward Dudley. With
three children to support she took a night job at the School
of Visual Arts. One evening Sy Rhodes, the school's director,
asked her if she ever had done any drawing, and the follow-
ing night she took three of her pastels to show him. Rhodes
immediately offered her the opportunity to attend day classes
at the school—free of charge. But with her family obligations
Charlotte regretfully declined the offer. She simultaneously
took a more lucrative job in the office of The International
Ladies' Garment Workers' Union.

Her middle child, meanwhile, was having emotional prob-
lems requiring psychiatric attention. Charlotte joined him
in obtaining counseling and again her life took another de-
cisive turn. Upon learning of her art work, Charlotte's
therapist insisted upon seeing it. "What do you do with most
of these things?" he asked. "I eventually throw most of them
out with the garbage." "Well," replied the doctor, "you've
got to stop throwing yourself on the garbage heap, for that is
what you are doing each time your destroy your art. Besides
you should be attending art school." Charlotte listened with
great attentiveness.

Her doctor then secured a catalogue for her from the
Brooklyn Museum School, and three weeks later Charlotte
went there and enrolled. In Brooklyn she met another gifted
black artist, Joan Bacchus. Joan encouraged Charlotte to
enter some of her work in the 1964 outdoor Fulton Art Fair
held annually in the Bedford Stuyvesant area of Brooklyn.
There, for the first time, she became acquainted with the
black artists of the borough. Jacob Lawrence, Ernest Crich-
low, Tom Feelings, and Leo Carty welcomed her into the
circle. With this contact and with thoughts of going to Africa
alive in her consciousness, her art began to focus on the life
she knew so well at home and what she hoped to find in
Africa.

Meanwhile, in search of further study, Charlotte chose the

Art Students League of New York where she worked in the class conducted by Edward Lanning. She liked the work and she believed in the instructor, but she found that the course was cutting a deep hole in her small budget. Charlotte was on the verge of abandoning the League when Lanning offered her the monitorship of the drawing class with its tuition free advantages. A few weeks later one of Charlotte's drawings was chosen for the League's catalogue. During the following session she received not only the class section award for drawing but the monitorship of her instructor's painting class. Then came the class section award for painting. It was her teacher, Edward Lanning, who helped her discover the color in black skin and how to explore and interpret that marvelous color range with pencil and pen applied to paper and paint applied to canvas. Now Charlotte Amévor was ready to make that trip to the land of her father and his ancestors.

She had decided that the only way she could get to Ghana without compromising her principles was through sticking with one place of employment long enough to establish a credit rating. Heretofore she had flitted from one job to another as she sought support for her children and herself. Now, with the I.L.G.W.U., she felt she should become more solidly based. She had been with the Union for a while and she was keeping a sharp eye on the airlines' ads. So when, in 1966, the travel agency with whom she was in contact quoted a price she could afford, Charlotte was ready.

The story of her coming had preceded her to Ghana, so a small army of newsmen and officials had gathered at the Accra airport to meet her. "Welcome home, sister!" Charlotte heard it just about everywhere she went. Those who had seen her in New York not long before were curious. "Who brought you here?" they asked, hoping to tie her arrival to threads of some amorous intrigue. "The Chemical National Bank, that's who brought me," was Charlotte's tart reply.

In her father's village of Kedzi near the Togo border, not only were Charles Amévor and family members waiting to welcome her but they were joined by the village chief as well as the chiefs of three neighboring villages.

Charles was in the zenith of his seventh heaven. Attired in slacks and sandals rather than in the traditional cloth, he was the quintessence of aplomb as he held center stage. This was his moment of glory. Eschewing his native tongue, he spoke in English—and through an interpreter. When the latter made an occasional error, he was obliged to restate the phrase to Charles's satisfaction. These were sweet moments for Charles Amévor. Over the years he had borne the insults of neighbors who were convinced that his stories of the wife and daughter he had been obliged to leave in America existed only in his imagination. So now, with his arm protectively around Charlotte, he related the story of his American daughter and of how they were reunited.

There were the parties with dancing in which Charlotte was the chief and honored participant. Half brothers and sisters, cousins, aunts, and uncles, showered her with affection. They listened with wise and appreciative understanding as she told them of her own three children. In Ghana, as in other areas of Africa, there is no such thing as an "illegitimate child." No one there is ever stigmatized because his parents were not married. Charlotte, free, honest individual that she is, and proud of her African heritage, too, refuses here to cringe and conceal the facts of her motherhood. There in the land of her father and his people she didn't even have to think about it. It was Christmas, and there could have been no more appropriate a season for Charlotte's visit to her family in Ghana. Indeed, it was the only family she had ever known.

It was understood, therefore, that she would decline an invitation to a New Year's Party extended her by the Ameri-

can colony there, who thought she might "be homesick." As Charlotte explains it:

I declined, knowing very well that their racist attitudes had not really changed simply because they were on African soil. To them, and this goes even for the blacks among them, my father and his people were still "natives" and we were still half-citizens, or less, in America. That's why they had established themselves a colony there!

No, she didn't need to go all the way to Africa to hear such sentiments expressed. She would be returning home soon enough.

But Charlotte's return to America was more than a return to familiar routines. It was a return also to drawing and painting—this time with a more profound appreciation of what her life had really meant. Now back home she went to dances attended also by Ghanaians. They looked at the particular cloth she wore and they watched her dance. "You have *been* there, sister!" they told her. "You have *been* there!"

She did not pitch feverishly into painting what she had seen and felt but rather let it settle for a while. When she did begin to work, the output was warm and knowing. One black man hearing someone speak of her work remarked, "Oh, do you like what she does? She paints that old ethnic stuff!" Charlotte sees nothing wrong in a black artist's making drawings and paintings about her own people. Admittedly, hers is not protest art.

They talk about the tragedy of the ghetto, and I talk about the good times we had in the ghetto. They talk about "Charley" and I talk about the bourgeois blacks and their socials and their this and their that. Sure, we catch hell in the ghetto, but we also have our good times there too, and why shouldn't I recall that? I have to do what I know, and I have to feel it—otherwise it won't work.

The husky voice vibrates with self-assurance and the animated woman gesticulates as she talks of the works stacked

around her. You look closely at her and see that she is a remarkably youthful thirty-eight. You look again at her paintings and especially at her drawings—those most intimate and candid of any artist's statements. You look and you remember that here is someone who began only recently to know her worth as an artist. Less than a decade earlier as she drew and discarded her work she was simultaneously building and destroying a part of Charlotte Amévor. Her doctor had told her so, and she heeded his advice to stop the destruction.

But there were those things Charlotte could neither escape nor destroy as long as she clung to life. The terror in the city street of the baby girl torn from her mother; the hurt of a schoolchild whose patched clothing was more visible to a myopic teacher than was her talent; the thrill of conceiving and giving birth, with or without the licensed approval of a conforming society; the unflinching surrendering to science of a diseased cadaver, with the knowledge that she had kept for herself a portion of the priceless spirit that had taken its restful flight from that worn-out body; yes and finally, the resolute demand for a chance to work when to give up would have been easier. These were the things to which Charlotte held fast.

And they, holding fast to her, seep into her interpretations on paper and on canvas. Look at them. They say, "I have *lived*, yes, and I am still alive!"

Chapter IX

ROMARE BEARDEN

CHARLOTTE AMÉVOR and Romare Bearden! No two
Harlemites could have seen the same community from more
different points of view. No two Harlemites could have been
nurtured in more contrasting family settings. At the same
time one was being forced into a foster home, the other was
pursuing a course of study at New York University. That
Romare would attend the university was inevitable and un-
contested, just as becoming a foster child was an inevitable
and uncontested reality for Charlotte.

Surely her childhood was more tortured than his. But who
can say that his adulthood, with its highly developed sense
of responsibility to self, to craft, to race, does not have its
own tortured moments. Who knows what he, black by choice,
has been made to feel? Yesterday the brother or sister who
could "pass" enjoyed many of the economic advantages of
the white world and all of the social advantages of the black
one. Today, if the former holds true at all, the latter certainly
does not. Such is the mischievous character of American
racism.

"My father came from Charlotte, North Carolina, and my
mother from Greensboro, though she was raised in Atlantic
City," Romare relates.

When she was pregnant with me, she and my dad went down to Charlotte, where I was born in 1914. Then shortly after my birth they came back to New York City. I was brought up in New York and in Pittsburgh. You see, my grandmother lived in Pittsburgh and I liked being there for short periods because there was more room to play in than in New York City.

Romare Beardon recalls the Harlem of his particular childhood experience: "It was a community, as opposed to the social jungle it has since become. And this was deliberately done," he insists, "to wreck what was a viable community and a haven to which other black people came. When I was a little boy people wanted to be either in Harlem or in Paris— the two most interesting places for one to be."

The heavyset man's blue-gray eyes are alight with nostalgia as he continues:

Sure Harlem had its gangs, The Montanas and the Black Aces. Today we speak of dope addicts. We had them then only we called them dope fiends and they weren't as big a problem as they are today. But there were also the great night clubs—the great athletes. Everybody lived together in Harlem including the poverty-stricken Baldwin writes so eloquently about. Still I think there was in Harlem a sense of community and awareness of other people that's gone now. It was possible out of that type of thing to make an art that came as a natural thing. Now people are trying to establish things here—like The Studio Museum—all because of what Harlem once was. But most of the attempts so far have been hybrid. When Langston [Hughes] and Claude [McKay] were there all the inspiration one needed was right there with them.

The Harlem of 1914 to which Richard and Bessie Bearden brought their infant son, Romare, was by no means a solidly black community. The influx of its black population had begun only ten years earlier when Philip Payton, a poor, young, black, real-estate agent, saw an opportunity and seized it. One of a pair of feuding white landlords, seeking to get

even with the other, turned over a house in West 134th Street to Payton. The enterprising young black man quickly filled the house with black tenants. He then advertised his services in white real-estate journals, presenting himself as a specialist in "managing colored tenements." He founded the Afro-American Realty Company in 1904 and within four years had made and spent several small fortunes. By 1908 the company he founded had collapsed. Of Payton and his enterprises Gilbert Osofsky, in *Harlem: The Making of a Ghetto*, writes as follows:

The Afro-American Realty Company played a significant part in opening homes for Negroes in Harlem. Philip A. Payton, Jr., owned and managed apartment houses and brownstones in sections never previously rented to Negro tenants. His holdings were scattered throughout Harlem from One Hundred and Nineteenth to One Hundred and Forty-seventh Streets. When the company folded, white realtors and mortgagors took over its property but the Negro tenants remained. The new owners continued to advertise the Negro company's former houses in the colored press. The speculations of Philip A. Payton, Jr., led to the downfall of the Afro-American Realty Company, but they also helped lay the foundations of the largest Negro ghetto in the world. . . . By 1914 there were some 50,000 Negroes in the neighborhood.

Still, many of New York's black families lived in the midtown area of the West Sixties. The Beardens lived there with in-laws for a short time prior to World War I. During the war Richard Howard Bearden secured a job in Canada, where he took his wife and child to live before returning to New York to rent an apartment on West 140th Street. The house into which they moved was still being taken care of by a white superintendent, for it was just beginning to "go black." It was not far from Lybia Lot, where in former days trotting races had been held.

Lybia Lot was a great playground for neighborhood children, what with its boulders and streams dominated by a

particularly huge rock on Seventh Avenue. The rock, all of three stories high, covered an entire block and it became the sight of a night club named The Garden of Joy. It was in Lybia Lot that the colorful Hubert F. Julian, whose exploits were equally well known to Chicagoans, built his airplane. Romare and other Harlem boys used to go over to the lot and help "The Black Eagle" install the wire struts in his aircraft. They hoped, along with Julian, that he would be the first man to make a nonstop solo flight across the Atlantic.

Julian's attempt, preceding that of Charles A. Lindbergh, wound up in the marshes of Long Island. Likewise, his parachute jump over New York (the city's first) landed him not in Lybia Lot, as previously planned, but on the El station at Eighth Avenue and 140th Street. Still, as Romare recalls, the luster of Harlem's airborne soldier of fortune was never really tarnished in the eyes of his youthful admirers.

Attractive Bessie Bearden took a job as cashier at the box office of the Lafayette Theater. In such a public and conspicuous spot she was bound to see and know everybody of importance who came to the theater. Conversely, everybody of importance soon came to know and be captivated by Bessie Bearden. She was headed, it seemed certain, for bigger and better things. Her opportunity came through contact with the New York City Democratic party.

For a long time black New Yorkers had been without political power of any kind. In the 1890's, Tammany Hall chief Richard Croker is quoted in *Harlem: The Making of a Ghetto* as stating that political recognition and patronage to Negroes would be granted in "proportion to their works and numbers." At that time political jobs held by blacks were those of street cleaner, assistant janitor, and laborer. The devotion to the party of Lincoln held by most blacks of the day reflected their distrust of the Democratic party, dominated by white Southern racists. But in New York City blacks began to learn something of Republican white racism.

In 1898 James D. Carr, a Rutgers graduate and holder of
an LL.B degree from Columbia University, was promoted by
New York's black Republicans for the office of assistant dis-
trict attorney. The party bosses turned Carr down. Simul-
taneously another black man, endorsed for the office of
coroner, was likewise rejected. Moreover, Republican L. Eli
Quigg rubbed salt into wounded black pride by boasting that
black loyalty to the Republicans was unshakable. He was
doubtless banking heavily upon the fact that Charles W.
Anderson had been elected president of the Young Men's
Colored Republican Club of New York County. From 1890
until 1934 Mr. Anderson worked in the district office of the
Internal Revenue Service. He was indeed a strong figure in
Republican politics in Harlem.

But some black New Yorkers, stung by the arrogance of
Republican leader Quigg, formed, in January 1898, the
United Colored Democracy. That was the nation's first black
Democratic organization and it chose Edward E. (Chief) Lee
as its head. As New York's first black Democratic leader, Lee
became a sheriff, and his successors held even more important
posts. And even though the United Colored Democracy was
scorned by many blacks still faithful to the ghost of Lincoln,
the organization continued to live and gain strength.

In 1921, for instance, Howard-educated Ferdinand Q.
Morton, another black New York politician, was named
chairman of the Municipal Civil Service Commission.
Morton, a Democrat, worked closely with the white Demo-
cratic bosses of Harlem and in the 1930's he was recognized
as New York City's most powerful black political figure.
Again, Gilbert Osofsky, in *Harlem: The Making of a Ghetto,*
writes of the ruthless power of the Morton regime:

He who held the jobs controlled the party. In fact, those who
showed defiance too often and too loud found themselves un-
employed. A clerk in Harlem's municipal court, a superintendent
of Harlem's state employment office, and a New York County

deputy sheriff were suddenly dismissed for "incompetence" after criticizing Morton's leaderships or refusing to contribute ten per cent of their salaries to the U.C.D.

Democratic mayors and county chairmen used Morton as their funnel for patronage to the city's black constituency. Ferdinand Q. Morton was the absolute boss of Harlem—until Fiorello LaGuardia became New York's mayor. Then, true to the cynical code of politicos of all labels, Morton deserted the Democrats for the American Labor party.

It was in the New York Democratic organization of "Chief" Lee and Ferdinand Q. Morton that the charming Bessie Bearden found a place in Harlem politics. That was the period of the legendary roaring twenties, and it was not long before Mrs. Bearden had become head of the Women's Auxiliary of the New York City Democratic party. She moved swiftly. In an incredibly short time she was named assistant collector of internal revenue for New York City, a post she held until her death in 1943. Her husband was employed in the city's Health Department.

Bessie Bearden also headed the New York office of the eminent black news weekly, *The Chicago Defender.*

"Because my mother knew just about everyone in Harlem," Romare recounts, "a lot of folks constantly came in and out of our home. Show people, political figures, and people on the downtown daily press, who depended upon her for statistical information on Harlem, were regular callers."

Then there were the young black artists and writers of the Harlem Renaissance for whom the vivacious Bessie gave parties. Arna Bontemps, Aaron Douglas, and Archibald J. Motley were but three. Young Romare was becoming acquainted early, not only with the social aspects of politics but also with some of the important black creative artists of the period.

Public School 89 and Public School 5 were well known in the Harlem of Romare's youth. The former was at Lenox

Avenue and 135th Street and its kids were tough. Several of its teachers were middle-class blacks, one of whom, Howard Day, lived in the apartment directly under the Beardens. Another, Gertrude MacDougall Ayer, was the guidance counselor at P.S. 89. She later became New York City's first black school principal.

P.S. 5, at Edgecombe Avenue and 141st Street, had a less formidable group of boys in its enrollment. Romare recalls no black teachers there during his youth, but he does recall that the men who taught there used corporal punishment at will. Each class was separated into several divisions. Those in the first three divisions comprised the brightest of each class. With good scholarship, boys at P.S. 5 could get into first-rate Townsend Harris High School, and possibly be graduated in three years. The general academic atmosphere around P.S. 5 was good—what with the presence nearby of the sedate Hebrew Orphanage, whose boys were good students and good athletes.

Indeed, Romare recalls that the atmosphere at P.S. 5 was such as to discourage the boys from reading any morning New York newspapers other than *The New York Times.* But the youngsters, preferring the sensational coverage (with pictures) of the then new *Daily News,* managed to read their favorite paper each morning. They simply opened the tabloid *News* inside the more formidable *Times* and read until they were either through or discovered by an alert

Romare relates:

I had shown no interest in drawing until high school. My interest as a boy was in sports. Nor had I read any more than the average boy about art. I took no art courses other than the mandatory ones either at DeWitt Clinton High School in New York or at Peabody High School in Pittsburgh from which I was graduated. But I did become interested in cartooning during my

last year in high school. You see, my mother wanted me to be
a physician but I wasn't interested in that. I had even majored
in math in high school. In fact I went to New York University
as a math major.

The Depression was on and young Bearden, a student at
N.Y.U., was now art editor of the school's humor magazine,
The Medley. His mother, sadly reconciled to the fact that he
would not become a physician, sought to deter him from a
career in art. But her son, having met E. Simms Campbell
and having become greatly enamored of Campbell's success
as an *Esquire* magazine "regular," was not to be turned
around. He had sold several of his cartoons to some of the
nation's leading humor magazines and he was drawing edi-
torial cartoons for one of the nation's top black weekly news-
papers, *The Baltimore Afro American*.

Bearden pauses to elaborate a bit on that phase of his life.

Another Harlemite, Oliver Harrington, and I used to spend a
lot of time together drawing and submitting our cartoons to the
humor magazines. Ollie's, "Bootsie," became a hit with readers of
another of our Negro papers, the *Courier*, that was published
weekly in Pittsburgh and read by Negroes all over the country.
My own work for the Negro press was done for the *Afro American*
between 1931 and 1935. And I drew in the manner and tradition
of the editorial cartoonist Fitzpatrick, of the *St. Louis Post Dis-
patch*. I was a great admirer of his simple, open, monumental
style.

Romare and E. Simms Campbell then decided upon taking
a course at the Art Students League with George Grosz. "I got
a lot from Grosz," he recalls.

When he first saw me draw he knew I had done cartoons, even as
he had done. But he worked at getting me to say more in my
drawings than I said in cartoons and that led to my decision to
paint. Most of what was done in those days dealt with social con-
ditions—bread lines and such things as that. I began to study
Rembrandt and Daumier, and my first oil painting was done in

the Daumier style. Then I began to meet and know the angry, young black writers, Claude McKay and William Attaway. And I met Jake Lawrence.

Jake had a studio at 33 West 125th Street and I got one right above him. I began to do my first paintings on brown paper— just as Jake was doing at the time. The paintings I did were reflective of what I'd seen so frequently in the south when I visited relatives there.

The studio Romare rented cost eight dollars a month. The landlord had taken all the radiators out of the building and the artists heated their studios with kerosene stoves. Consolidated Edison's office was just across the street and the building superintendent had tapped the main line, giving the building its light without cost to the artists. It worked for a while, but when the flow of current became legitimate, Romare had to hook Claude McKay in on his line until the latter could afford his own.

Reminiscing over those days of struggle as artists in Harlem, Romare recalls what the black experience meant to him then:

Claude McKay was the first Negro to produce a big best seller (*Harlem Shadows*) and he'd gone to Europe. It was a nonfictional work dealing not only with his Harlem experience but with those overseas as well. Claude opened a whole new world to us. Jake? Oh well, Jake [Lawrence] was a young genius, of course, just knocking his things out while I pored over mine.

A warm smile lights his eyes as Bearden recalls his first one-man show:

My first show—my very first show—was not in a fancy downtown gallery. It was given to me by "Ad" Bates up in Harlem. "Ad" was one of the finest wood craftsmen we've ever had. He had a loft workshop at 306 West 141st Street where he presented my show six months after he had shown Jacob Lawrence. That was in 1940.

With the entry of the United States into World War II, Romare found another studio on Harlem's West 125th Street.

This one was in the building housing the famed Apollo Theatre and owned by Frank Schiffman, who knew Bessie Bearden. Romare, single, healthy, and draft eligible, enlisted in the regular army where he served for three years. Luckily he was able to retain his studio even though he was not in New York to use it. Just prior to leaving, however, he made a contact that resulted in his being given an important New York show.

Some time previously, black painter William H. Johnson had taken a lady to young Bearden's studio to have a look at his work. She was Caresse Crosby, one of the famous American expatriates in Paris during the 1920's. She and her wealthy husband, Harry Crosby, had founded the *Black Sun Press*, and they published Hemingway, Kay Boyle, and a number of American writers in Europe. Mrs. Crosby had also introduced Salvador Dali to America.

When she saw Romare's work, Caresse Crosby decided to show a series the artist called "The Passion of Christ," at her Washington Gallery. A few months later Mrs. Crosby took Bearden to Samuel Kootz in New York and introduced him as having had a successful show with her. Romare showed Kootz a few watercolors and many more drawings in colored inks. Kootz liked them.

"Do you have any oils?" Kootz asked. "Sure," replied Bearden, knowing full well he had never done a painting in oils in all his life. A few days later Kootz called and asked Romare to bring in his oils. The brash young artist got some masonite boards, coated them with white gesso, and using oils thin as he had used watercolors, painted rapidly. Then taking a speedball pen, he inserted outlines and accents and took the results in to show the gallery owner. Kootz looked at them and remarked, "I'm giving you a show right away." For Bearden that was an important event since, in his own words: "Very few places then were showing young abstractionists. Kootz wanted to show more of this and he showed

Motherwell, Adolph Gottleib, and Hans Hoffman. This was significant for me since I was meeting artists and making contacts."

While things were developing nicely for Romare Bearden personally, he was fully aware of the tensions building up in the nation's black communities. Moreover, he knew *why* they existed. A fellow Harlemite, journalist Roi Ottley, brought out a book in 1943 while Romare was still in the army. Its title was *New World A-coming* and its revelations startled white America. The following quote from Ottley's book is a sample:

According to the 1940 census there were 5,389,000 Negroes in the labor force, 3,582,000 of which were men. A government survey found that of 29,215 employers in ten war plants in the New York area, only 142 were Negroes. In fifty-six war contract factories in St. Louis, each employed an average of three Negroes. Outside the N.Y.A. and the W.P.A. there were practically no provisions for Negroes in the program of defense employment training, despite the need for manpower and the increasing number of Negroes on the W.P.A. rolls. The United States Employment Service sent out an inquiry to a selected number of defense industries as to the number of job openings and whether they would employ Negroes. More than fifty per cent stated flatly that they would not. Moreover, contrary to the assumption that Negroes are barred only when they seek skilled work, no less than 35,000 out of 83,000 un-skilled jobs were declared closed to Negro applicants.

The conservative National Association for the Advancement of Colored People was outraged. It fired off a wire of protest and appeal to President Roosevelt, who replied perfunctorily that "It is the policy of the War Department [letting contracts] that the services of Negroes will be utilized on a fair and equitable basis." Still, industries handling such contracts refused to budge. It was only when A. Philip Randolph, president of the Brotherhood of Sleeping Car Porters, organized a massive demonstration, "Negro March on Wash-

ington" and threatened to call it, that meaningful action was taken. Mr. Roosevelt wrote Executive Order 8802, creating the Committee on Fair Employment Practices.

Then there was the article written by Mrs. Franklin D. Roosevelt for the October 1943 issue of the *Negro Digest,* and titled "If I Were a Negro." Mrs. Roosevelt counseled patience. If she were a Negro she would accept advances, though she "would not try to bring those advances about more quickly than they were offered." That infuriated most black Americans. But they were really startled when newsman Westbrook Pegler, certainly no Negrophile, had this to say: "If I were a Negro I would live in constant fury and probably would batter myself to death against the bars inclosing my condition."

Such news items, and all that they implied, were by no means lost on Romare Bearden. Though a privileged Harlemite, his awareness had been honed by his experience as an editorial cartoonist for a black newspaper. No artist who does such drawings can possibly assume a stance of impassive objectivity. The very news items that gave impetus to Romare's cartoons were harrowing. They were almost as torturous to him as his mother's death, that struck with sudden force in 1943.

Out of the army in 1945, Romare Bearden returned to a Harlem that had elected Adam Clayton Powell to a seat in Congress. V-E Day, wildly celebrated in New York's Times Square, was greeted quite differently in Harlem. S. W. (Swig) Garlington, writing in the *New York Amsterdam News* for May 12, 1945, observed the following:

The general summary of Harlemites thoughts was: "What's going to happen to the Negro now that we have V-E Day?" Further summarizing the reaction of Harlemites to V-E Day, it was clear that those upgraded during the crucial period would gladly stick to their jobs if the reconversion period did not force them into bread lines. In contrast to D-Day, when the allies

landed in Normandy on June 6, 1944, and Harlemites expressed as much enthusiasm as other racial groups, the general thought on V-E Day was about the future of Negroes. Will they hold the gains made during World War II? That was the question, both expressed and seen between the lines.

Among the Bearden paintings shown at that period were "Factory Workers," "Baptism," and "After Church." Each, especially "Factory Workers," was clearly reflective of the Harlem mood of the day. And it was particularly fitting that those three works should be hung in 1945 at the Albany Institute of History and Art in a show titled, The Negro Artist Comes of Age. Coming of age artistically was more than a phrase for Bearden. Among other things it meant establishing a first-hand contact with the art and the environment of the great pioneer masters gone before. So in 1950 he used his G.I. Bill for a trip to Paris.

"That was one of the great times of my life," he declares.

The first time somebody told me the place I had was Paul Cezanne's old studio, I didn't believe it. I used to look across the street from upstairs and there I'd see where Louis Pasteur had gone to school. All around me were the places where famous French writers, painters, and composers had lived and worked. Paris was so *alive* at that time! G.I.'s were spending freely and French attitudes toward Americans were more tolerant than they later became. I had never seen any city like Paris before!

While many young American painters can scarcely wait to get to Paris so they can plunge into their work, such was not true of Romare.

I never struck a lick at painting in two years, the year I was in Paris and a year after I returned. At first I thought I'd go straight to the Louvre, but it was four months before I got there. And that happened only because I happened to be passing it and my conscience made me enter.

He laughs heartily.

No, I spent my time in Paris having a ball with people! Among
Negro Americans I knew there were the writers James Baldwin,
Sam Allen, Dick Wright, and the painters Paul Keene and Bill
Rivers. Rivers knew everybody in Paris! I soon discovered that
Paris was not the place for a young person to go at that time
because it was too seductive. The parties and everything of the
like were there to lure you away from your work. So when I
returned to my studio on 125th Street I couldn't get myself to-
gether. I kept thinking about Paris—was indifferent to showing
any more with Kootz. I got myself some brown wrapping paper and
shellacked it. I had large photostats made of Grotto, Rembrandt,
and one or two other masters and I copied them on the paper
I had prepared. That helped me and I felt it would aid me in
getting back to painting.

Such did not happen immediately, however. Having a
studio in the building housing the Apollo Theatre brought
Romare in contact with performers and musicians. His
having had violin and piano lessons as a boy encouraged him
to ask some of the musicians around Harlem to show him a
few things about song writing.

"I got the great idea"—he laughs—"of sitting down writing
a hit song and making enough money from it to get back to
Paris. I did actually get a song of mine published, and it
made a little money for me. It was called, 'Seabreeze,' and
Billy Eckstine made a recording of it. So I began to try to be
a successful song writer."

In addition to the assortment of uptown and downtown
"characters" Romare was beginning to cultivate as he sought
success in Tin Pan Alley, there was also a professor at Barnard
College. The gentleman was a frequent visitor to the 125th
Street studio, where he spent hours studying Romare's paint-
ings.

"He invited me to his home for dinner one day," the artist
recalls.

Here he told me of a close friend of his in Germany who was a successful writer in musical comedy, and he asured me that my talent lay in the direction of painting.
He further told me that if I kept fooling around with song writing I'd soon dissipate any meaningful ability I had and I'd never paint again. That stuck with me. I was in the craziest thing with all sorts of self-deluded characters and I could see myself winding up just as most of them. But what really got me back to painting was what one of the characters himself, Archie Poole, told me. "Boy," he said, "you better stick with paintin' 'cause you ain't never gonna be no song writer!"

Romare hadn't shown since 1949 and the 1950's were fast approaching the halfway mark. He had a showing at the Barone Gallery in 1955. A few years later he landed with the Cordier, his show place as of the present, which he describes as "an excellent gallery." Meanwhile, an attempt and its resultant failure led Bearden to yet another mode of expression that is presently synonymous with his name.

Romare gathered a group of black artists, one of whom was Norman Lewis, and he proposed that they could work more effectively jointly than if they continued to work singly. Specifically, he presented them with the identical idea of working collectively that Elizabeth Catlett found and joined upon her arrival in Mexico.

"I was wondering just how we could do it," he explains.

My wife subscribes to *McCall's* and in one issue we saw some photographs of works by Richard Mayhew, the landscape painter. Starting with that I cut some photographs of trees. I tried to get the others to come in on it but they didn' know what I meant. Each was busy doing his own thing.

So Romare began to work alone. He had photostats made of material he intended to use, blew some up fairly large, cut them out and put them together. That is what led to his present way of painting in collage. Most of them relate in some way to the experience of the Afro-American.

What I tried to do in a lot of them was to take themes that were constant in art. For instance, a woman and child was called by the Renaissance artists, "Madonna and Child." Impressionists called it, "The Woman Next Door With a Child." The Africans in their sculpture use it constantly.

One looks at the Bearden collages and finds the railroad train somewhere in many of them. The artist says: "I use the train as a symbol of the other civilization—the *white* civilization and its encroachment upon the lives of the blacks. The train was always something that could take you away and could also bring you to where you were. And in the little towns it's the black people who live near the trains."

The artist points to one he has just finished. It is a cotton field, as he recalls it on one of his visits to his parents' home state.

The idea here is as if it is suspended in memory. Here's a woman and a little child bringing her lunch to the field. And they dominate the composition while the work proceeds back in the field. Even if it has no artistic merit, this is the record of what was, before the coming of the machine. Many of these are my memories of North Carolina. And the train is always coming— symbolizing industrialization. It does not enter as a threat, a definite threat—but it's always there in the background.

You look. You study what you are looking at, and you do see that in these mosaics—like arrangements of photography, drawing, and painting—is indeed a record of what was and what is. They evoke critical acclaim and they sell, two "musts" for any painter who is to be considered successful. Bearden is. So you talk with him about galleries. What do they really do for and to the artists affiliated with them? His answer is unhesitating.

Galleries in general now have to work with what's available— not that they are not nefarious. The young artist comes here and he goes to the gallery to make the scene. No one puts a gun to his head, but he sees what is selling.

What does he think of today's art schools?

The art schools don't, as Grosz used to do, teach the fundamentals of drawing. What they teach is the rudiments of success. Students learn how to do the minimal thing. Now the "Pop" is still good, and the minimal is still "in." The difference is that now all the canvases are so large. Still, Thomas Eakins is still interesting to me because he was one of the first to portray the Negro not in the manner of the sentimentalist or the caricaturist.

To the late nineteenth-century black painter Henry O. Tanner, Bearden offers an apology.

I wrote an article in the 1930's for which I now apologize. Now I realize that he was one of the three or four of America's finest painters, plus being one of the supreme painters of religious subjects of this century. Besides the demand that a people be not robbed of their history, that has led to a resurgence of interest in Tanner, it happens that he was, incidentally, a great painter.

The works of Romare Bearden are not limited to the enjoyment of collectors and those who frequent the galleries that show them. *Time, Fortune,* and *The New York Times Magazine* have featured his collages on their covers. Nor has success "downtown" spoiled Romare Bearden. He has been represented in every major exhibition of the works of black American artists over the past thirty years, and he has helped assemble and arrange such shows.

With Norman Lewis and Ernest Crichlow, Bearden has founded, and the trio directs, the Cinque Gallery on Lafayette Street in downtown Manhattan. Funds for it came through a grant from the Urban Center at Columbia University. The Cinque, named for the leader of mutineering nineteenth-century slaves aboard the Spanish ship *Amistad,* operates nonprofit. It shows the works of ethnic minority group artists under thirty. Works are for sale but the gallery takes no commission. It opened its doors with the showing of drawings and paintings of gifted twenty-four-year-old Mal-

colm Bailey, who, with all his merit, would not easily have found a place to show. The Cinque Gallery is clearly reflective of the views of the three black artists who direct its course.

Romare Bearden has four books to his credit. Two, *The Painter's Mind* and *The Artist's Vision*, treat the study of structure and what vision means in art. He has written a biography of Henry O. Tanner for teenagers, and his most recent book is called *Six Black Masters of Modern Art*. It presents the lives and work of Joshua Johnston, Robert Duncanson, Henry O. Tanner, Horace Pippin, Augusta Savage, and Jacob Lawrence.

You ask Bearden if he cares to comment on young black artists. He does.

You can't speak as a dictator of art or of what art is going to be. You are like a hunter. You can't go out and say, "I'm going to get thus and so." You take what you can find, for art is that kind of a venture. It would seem to me that what the young black painter has that is unique is that he has experiences and a way of looking at them that is unique. It's like what the black man did with the Negro Spiritual. It was the theme of the English hymn done in *his* manner. There is nothing wrong with either form. No one needs surrender that which he has.

Romare Bearden's own life proves the truth of that statement.

Chapter X

JACOB LAWRENCE

IT WAS A GRIMLY humorous incident and it happened during the Depression. Men who have known each other for a long time like to recall such occurrences of their youth as proof of the closeness they still feel to each other. Romare Bearden and Jacob Lawrence, sharing neighboring Harlem studios, were experimenting in materials and methods. Both were painting in tempera and using egg as a vehicle. As the gooey egg medium ripened, their studios began to smell to high heaven, a circumstance not bound to encourage visitors, especially lady visitors. Such a curtailment of the young men's social life could not be tolerated. So they decided to mix the egg with a solution of ammonium chloride.

Ammonium chloride is used in the manufacture of smelling salts, and Lawrence had bought a large container of it. One afternoon Bearden happened to go to his friend's studio just in time to discover him literally trying to climb the wall. "Jake" he chuckles, had opened that can of ammonium chloride and taken a deep whiff of it. "It damn near blew his head off!" How lucky that it didn't. Jacob Lawrence has stayed around long enough since then to have become one of the nation's outstanding painters.

Less than ten years previously, Jake's mother had brought

146

her three children, two boys and a girl, to Harlem. Jacob, Jr., the oldest, had been born in Atlantic City in 1917. Their parents, Rose Lee and Jacob Lawrence, were among the throng of rural black migrants from the south. They settled briefly in Atlantic City before Jacob, a railroad worker, decided opportunities would be greater for him in the coal fields of eastern Pennsylvania. There domestic difficulties began to accumulate, and following the birth of their third child, a daughter, the Lawrences separated. Rose Lee Lawrence moved to Philadelphia with her children. She struggled there until Jake was thirteen. Then, desperate to improve their meager existence, she made another move to New York's Harlem.

"We had," Jake asserts, in his typically untheatrical manner, "the usual problems of poor black families." No truth has ever been more simply understated. The big city's slum areas of the Depression were completely abominable.

Two Harlems greeted the Lawrences. One was the Harlem of the black middle class, the strivers, and the well-to-do celebrities. That was the Harlem of Romare Bearden's experience. The other Harlem, the Harlem of Charlotte Amévor, to which Rose Lee Lawrence and her three children had come in search of a better life, was aptly described by Harlemite Roi Ottley in the pages of his *New World A-coming*. Here in part is what he says of it:

The Depression had driven thousands of Negroes back to the already crowded hovels from which they had emerged during the prosperous twenties. In many of these tenements one toilet served a floor of four apartments; and few had a private bathroom or even the luxury of a common bath. If there was a tub, it usually had been installed in the kitchen. Without exception, the houses were filthy and vermin-infested. Gaping holes in the skylight allowed the winter's cold air to sweep down the staircases, sometimes freezing the toilet flushes for weeks. Coal grates provided the only heat.

Things had come to such a pass that Negroes scoured the neighborhood for fuel, and harassed janitors in the surrounding districts were forced to stand guard over coal deliveries until stored safely in cellars. Many of the destitute were reduced to roaming the streets and to foraging in garbage cans. Harlem's increase in population served to sharpen the problem. In twenty years it had increased sixfold, until the average density of population was two hundred and thirty-three persons per acre as compared with one hundred and thirty-three for the rest of Manhattan. The community had become a vast swarming hive in which two and three families occupied apartments meant for a single family.

Ten thousand and more Negroes lived in basement dungeons, cellars that had been converted into makeshift flats. Packed into these damp, rat-ridden holes, they existed in squalor comparable to that of the Arkansas sharecropper. Floors were of cracked concrete, and the walls were whitewashed rock, water-drenched and rust-streaked. In many cases there were only slits for windows and no partitions to separate the space into rooms. In some there was no running water. Packing boxes were used as beds, tables, and chairs. In winter, rags and old newspapers were stuffed into the numerous cracks to keep out the wind.

Jake Lawrence was never a problem child. He and other nonproblem boys did, however, attend P.S. 89, in Harlem, described by Romaire Bearden as the school most of the tough street kids of the area went to. Nor was Jake ever a typical Harlem street kid, and he explains why:

I'd been used to more space such as we had in Philadelphia. When I played marbles there, we played in large open lots. Here the tenement kids had learned to play in the cramped quarters of the gutters and I wasn't used to that. New York City games took on the character of the environment. Stick ball played in the narrow side streets, with parked cars and manhole covers for bases, was strange and foreign to me. So I withdrew from much of that kind of activity. I was thirteen, and children entering adolescence find it more difficult to adjust than when they are younger.

The activity Jake did begin during his adolescence is one he has never since abandoned. Someone told his mother about Utopia House and she took him there. As has been earlier indicated, the Utopia House program was just the thing poor slum children needed. At lunchtime they could get a hot meal at the settlement house and then return to school. After school they could return to Utopia House and participate in its various activities. The services were without cost to their parents. Jake chose the course in painting.

Recalling his creations at that period he reveals the following:

My first paintings consisted of geometric designs, done from my imagination, with poster paints on paper. I was playing with forms and color with no other thing in mind. Then I began painting masks out of my imagination. It was only later that I began working out of my own experience. I built street scenes out of corrugated boxes—taking them to familiar spots in the street and painting houses and scenes on them, re-creating as best I could a three-demensional image of those spots. And then I began to gradually work freely on paper and with poster color.

That was Jake's initial exposure to art outside of the limited program at school. Utopia House kept him off the streets and kept him from feeling the loneliness of the child unused to the ways of New York City. After two years there he was ready to get about more on his own. Besides, as the eldest of three, he had to look out for the others while Rose Lawrence worked.

Commerce High School on West Sixty-fifth Street enjoyed a good reputation in the 1930's. Its students, drawn from various parts of New York City, were both academically and vocationally inclined. Though Jacob Lawrence entered Commerce High with art as his prime interest, he remembers no one there who offered him any encouragement. "The only black teacher I can recall there," he says, "was an instructor in Physical Education." But luck was with Jake. There were

a number of art programs flourishing in Harlem under the federally sponsored relief projects launched by President Roosevelt. One was located in the library at 135th Street. Augusta Savage directed a studio a block away on the same street. And Charles Alston headed another. The Harlem Art Workshop, on West 141st Street. Jake tried all of them for a while before settling on the studio headed by Charles Alston. He remembered Alston, a Columbia University graduate, as his teacher at Utopia House.

There was another gifted young black painter and sculptor with a studio in the same building occupied by Alston. He was Henry Bannarn. A native of Oklahoma, Bannarn had grown up in Minneapolis. He had been sponsored there by a wealthy white benefactor who saw to it that the talented youth received first-rate training at the Minneapolis School of Fine Arts. Then Bannarn and an unknown photographer, Gordon Parks, set out together for New York during the Depression. Genial "Mike" Bannarn permitted Lawrence and other young artists to work with him whenever they saw fit. His superb training, coupled with a warm, generous personality, added much to the joy of Jake's experience. "So you see," Lawrence asserts, "all of my motivation toward art came from the Harlem community."

Rose Lawrence had strong misgivings, however, about her son's art activities. She felt it would be a nice enough hobby for him to pursue but she was worried. Jake had left Commerce High before entering his senior year, and how that would affect his chances for future employment was a matter of great concern. White boys might get by without finishing high school. Black boys didn't have a chance without a high-school education. Indeed, they scarcely had much of a chance after they obtained one. Besides, there were the younger brother and sister who might very well decide to follow Jake's example.

Mrs. Lawrence need not have been so worried. Jake was

not a young man to stray easily into trouble, and he never minded working.

"I did hold odd jobs in those days," he says. "And I had a good paper route which brought in about half as much each week as most men were earning. Then there were jobs in a laundry and a printer's shop. After that I spent all of my evenings in the art studios." The things Jacob Lawrence began to create during those evening sessions were far from ordinary paintings.

A spindle-legged black child pauses before a dingy meat market. There he gazes hungrily at washed-out chickens dangling behind a steamy plate-glass window. Another child leads a blind man holding a tin cup. They thread their way through the refuse-strewn sidewalk. Cats forage in battered garbage cans and children frolic in the humid filth of a steamy slum. Behind them, dark tenements lean precariously against a leaden sky. The patterns of color are flat and somber, relieved occasionally by stark-white patches of clothing or the colorful patch of a funeral wreath. The artist was recording the Harlem he came to know as a lonely adolescent.

But Jake was to know that other Harlem too. At the studio of Augusta Savage he met not only Harlem painters and sculptors but writers, musicians, and other celebrities. Laura Bowman, Eva Jesse, Leigh Whipper, Alain Locke, Claude McKay, Countée Cullen, Matt Henson, Charles Seifert, and Aaron Douglas were a part of the scene. James Weldon Johnson and Rose McClendon posed for students in Augusta Savage's studio. And a two-year-old prodigy, Philippa Schuyler, whose father, George, was a brilliant writer of the Negro Cultural Renaissance, astounded the group with her vocabulary and poise as she too posed for sketches. Jake Lawrence reminisces over it as the smoke from the cigarette curls lazily around him.

The atmosphere of that area of Harlem was most exciting and wholesome for a young fellow like me. While I didn't realize it at the time, I was greatly inspired and influenced because of my closeness to such personalities. Young black people today talk as though the black experience is something new that they, alone, have discovered. Actually, what is happening now is an extension of what was happening then.

The black history clubs of Harlem of the 1930's provided further inspiration. Professor Charles Seifert, Joel C. Rogers, and Richard B. Moore were but three of the scholarly Harlem residents to whose gatherings interested Harlemites would flock. Young Jake Lawrence was one of them. And it was through such meetings that he became aware of, and intensely interested in, Toussaint L'Ouverture, founder of the Republic of Haiti. The valor and the statesmanship of the former slave had been glossed over by most American historians. Abolitionist and reformer, Wendell Phillips was a notable exception. And his stirring oratorial tribute, "Toussaint L'Ouverture," was brought forth from the recesses of book mausoleums and enlarged upon by leaders of Harlem's black history clubs.

The more young Lawrence heard about Toussaint, the greater became his desire to comment upon him in the way he knew best. But a single painting simply would not do. Toussaint's achievements had been too great to be summarized in one painting. So Jake decided upon producing a series of paintings on Toussaint's life. Research for such a project was obligatory, and here again the young artist was fortunate. He could find just about anything he needed in the Schomburg Collection of the New York Public Library housed on the top floor of the branch at 135th Street near Lenox Avenue.

The Schomburg Collection is the largest collection of literature and artifacts by and about Negroes anywhere in the world. While it was born formally in 1926 in New York,

it began many years before in San Juan, Puerto Rico. There, Carlos and Mary Schomburg, in 1874, celebrated the birth of their son, Arturo. As the child grew he became proudly conscious of his African ancestry. He was so sharply stung by a teacher who declared at school that the black man had no history worthy of recording that he resolved to disprove the statement.

After studying in the Virgin Islands and Puerto Rico, Schomburg arrived in New York at the age of seventeen. He held several jobs before becoming a messenger for the Bankers Trust Company. It was during his twenty-one years with the bank that Schomburg aided in the founding of the Negro Society for Historical Research. By 1922 he was elected president of the American Negro Academy. His collection of literature by and about blacks had grown considerably.

When the collection was brought to the attention of the New York Public Library, it was purchased from Schomburg by the Carnegie Corporation of New York. The price of ten thousand dollars was a bargain. Formal presentation of the material to the 135th Street Branch Library by L. Hollingsworth Wood, of the National Urban League Board, was a gala event. Attended by library and Carnegie Corporation officials, the ceremony marked the confirmation of the now larger, world-famous, and extensively used Schomburg Collection. Arthur Schomburg, himself, was named curator of the Collection in 1932, a post in which he actively served until his death in 1938.

The more than five thousand volumes, three thousand manuscripts, two thousand drawings, and thousands of pamphlets that Mr. Schomburg had personally collected include Toussaint L'Ouverture's original "Proclamation for Freedom." Small wonder that Jake Lawrence would find a veritable gold mine of L'Ouverture information in the files of the famous collection.

"I remember Mr. Schomburg well," he muses.

I was too young to know him as a personal friend, but I recall seeing him and speaking with him there at the library. What an atmosphere he created in that special room of the library during the thirties—what with African sculpture and other items descriptive of our ancient and contemporary culture! And to think of how it has grown since his death—that's the great thing about the Schomburg Collection!

Jake went to work with his reading and other related research. The series of paintings he had in mind had gotten off to a sound start. Meanwhile, he had found a solid supporter and friend, as had dozens of other young artists, in the gifted black sculptor Augusta Savage. Miss Savage quickly saw Lawrence's talent, sincerity, and need for help. In her characteristically generous fashion she tried to get him a job on the W.P.A. Art Project. But Jake was only nineteen and the authorities couldn't hire him. However, when Augusta took him back a little more than a year later, he was hired. That afforded him his first chance to earn a livelihood as a professional artist. It also meant that he could simultaneously be preparing work that would later be shown in exhibitions.

Meanwhile, the Harmon Foundation was becoming aware of Lawrence's unusual talent. Both Augusta Savage and Alain Locke saw to it that Mary Beatty Brady, who directed the Foundation, knew about it. The James Weldon Johnson Literary Guild had already sponsored the young artist's first one-man show at the Harlem Y.M.C.A. It was 1937, and the paintings Jake showed were those he had been doing of life in Harlem. He was working, meanwhile, on his Toussaint series. When the paintings were completed the Catholic Interracial Council requested permission to show them at its Vesey Street headquarters. Father John La Farge, well known for his interest in Harlem, was particularly excited about the series, and was much in evidence at the show's opening.

"That was my first showing outside of Harlem," Jake recalls. It was but the beginning however. The series of sixty

small (eleven by nineteen inches) tempera paintings proved to be a monumental statement. They launched what was to become a phenomenal career.

In 1939 the Harmon Foundation, the Baltimore Museum of Art, and a committee of Baltimore's black citizens planned a unique exhibit for the Monumental City. For the first time in its history, the Baltimore Museum would be host to a showing of the work of the nation's black artists. Thirty-two years later Lawrence recalls that exhibition.

"As far as I can recall this marked the first time a major museum gave over its facilities to an all-black show. And this was in the 1930's when there was little or no talk about 'the black thing' and the pressing need for it to be seen and appreciated."

Art work from all areas of the country was being assembled in New York for that show. Baltimore's committee of black citizens, headed by Mrs. Sarah Fernandis, looked about for representative works by Baltimore's local artists. The offices of the Harlem Foundation hummed with activity and Miss Brady was delighted. She faced a dilemma, however. While most of the artists were to be represented by not more than one or two pieces of work, there was the magnificent Toussaint series of sixty small paintings by Jake Lawrence to consider. Should only a portion of it be shown? And if that were done would not the continuity of the accomplishment be destroyed? When Miss Brady asked this writer what he felt about it, she was told that Toussaint should be shown in its entirety. Obviously Alain Locke, certainly her ablest and closest advisor, felt likewise.

When the show opened in Baltimore, the museum had made special provisions for the showing of the Lawrence paintings. They hung in their entirety in a room set aside especially for them. Jake smiles in recollection of the show. He whispers: "I didn't at the time realize how big a show that was. Why, my participation in it with an entire series

of sixty paintings was the biggest thing that had happened to me up to that time." Jacob Lawrence was a name of which reputable critics were beginning to take careful note. And the artist was barely twenty-one years old!

Between 1938 and 1940 Jake, furthering his explorations in black history, painted the Frederick Douglass and the Harriett Tubman series. Then in 1940, a vision of yet another series, in which his own parents were involved, began to take form in his fertile young mind.

At about the same time, a huge exhibition of the work of black artists was being assembled in Chicago. The aforementioned American Negro Exposition of 1940 presented what Alain Locke called "the most comprehensive and representative collection of the Negro's art that has ever been presented to public view." The show, extending from July 4 to September 2, covered work done between 1851 and 1940. Artists from all parts of the country exhibited and shared in the prizes, and Jacob Lawrence's Toussaint series was a highlight of the display. Back in New York, Jake had already begun work on that series so close to his own parents' experience. He called it, "The Migration."

With the help of a Julius Rosenwald Fellowship he was able to move his migration series along to its conclusion. Again, Jake had chosen to tell his narrative in sixty gouache panels. He linked each to the next by a single descriptive phrase of his own writing. The flat somber earth tones of the paintings, heightened by patterns of black and white and pure primaries, tell the story of the mass exodus of blacks from the South.

Human figures, bent under the burdens of cotton and despair, eagerly sign up with recruiters for free passage north. Their way is often barred by reluctant landowners, but still they keep coming. Once in the North they are caught between wealthy white acceptance of their cheap labor and poor white fear of it. The new frustration and despair, along

with the marginal advantages of the Northern environment, are clearly and powerfully projected in these paintings. They provide a spine-tingling aesthetic experience, even to the uninitiated.

Jacob Lawrence was beginning to hit his stride. Marriage to fellow painter Gwendolyn Knight was doubtless a factor in his development at that period. Meanwhile, Alain Locke had brought "The Migration" to the attention of the late Edith Halpert, owner of New York's Downtown Gallery. Lawrence regards her as "having been one of the most important people in contemporary art in this country, who has done much to encourage young artists." Acknowledging that hers was a commercial gallery, Jake credits her with having created a new climate for black artists among gallery owners.

"With the exception of Carlin in Philadelphia, who handled Horace Pippin's paintings, no other commercial gallery took such an initiative as the Downtown Gallery," he asserts. "Heretofore black artists had to earn their livelihoods as teachers in black colleges and universities.

"So Edith Halpert passed on the idea to many art dealers in New York City of giving showings of black artists," Lawrence continues.

Out of the showings each gallery would select one artist for its regular roster. This was 1941. Gwen and I were in New Orleans and my "Migration" series was selected for showing at the Downtown Gallery.

The show opened on December 6, 1941. Because of what happened at Pearl Harbor on the following day all of the dealers except Edith Halpert scrapped their plans. She stood by her pledge and she took me on. I had been working on my second Rosenwald Fellowship, preparing the series on John Brown. Her letter inviting me to join her gallery came and I accepted, little knowing the true meaning of it. We black artists had had no experience in this and I had no way then of evaluating the offer.

The respect that Lawrence holds for the memory of Edith Halpert is understandable. However, in his typically modest way, he has played down his own importance in Mrs. Halpert's decisive action. It is considerably easier for the outside observer, having less emotional involvement here to recognize the depth of Mrs. Halpert's acumen. Wars come and go. An original and exploitable talent such as Jacob Lawrence's comes along rarely. No shrewd entrepreneur would permit it to slip away—Pearl Harbor or no! Subsequent Lawrence performances and achievements have proved Edith Halpert to have been as astute as she was visionary.

Edith Halpert saw to it that twenty-six of the "Migration" series were reproduced in full color in the November 1941 issue of *Fortune* magazine. Alain Locke wrote the accompanying text. Still the artist and the gallery owner had not yet met.

"I had been a member of Edith's gallery for several months," he recalls, "and had been sending my paintings from New Orleans up to New York before Gwen and I actually saw her."

Back in New York Jake found that "The Migration" would form unexpected personal contacts for him. Jay Leida, who was setting up the film library at the Museum of Modern Art, showed some of the "Migration" paintings to José Clemente Orozco. The great muralist was up from Mexico to do some paintings for the museum, and Leida felt that the two should get to know each other. Reflecting now upon their meeting, Lawrence observes that "although my contact with Orozco was brief, it was most encouraging and it had great meaning to me."

In 1942 another Lawrence series was in the making. The artist called the thirty paintings simply "Harlem," and Edith Halpert showed them between the eleventh and the twenty-ninth of May 1943.

Through close contact with Romare Bearden, Jake had

discovered the casein and gouache media that he was using in place of the poster colors of earlier works. And the paintings were taking on a richness now, though the stark simplicity and power that were his trademark were as yet unchanged. There were no happy paintings, reflecting as they did post-Depression Harlem caught up in the frustrating first months of World War II. The characters Jake Lawrence created for this local drama were disturbingly close at hand. They were the poor, the hungry, the demoralized. Many, like his only sister, were physically ill. There is a poignant irony in the fact that this, the most personal of all his series, would be shown only months before his sister, barely in her twenties, died.

Young men eligible for the military draft were being rapidly inducted into the service and Jake Lawrence was fully eligible. "I became aware then," he says, "of the understanding that exists in the black community. My draft board deferred me twice so that I could take the fullest advantage of my fellowship grants. When I did have to go I entered the Coast Guard service. Most black Navy men at the time were stewards mates and that's what I was."

The *Sea Cloud* was the first vessel on which Lawrence served. A once private yacht converted to use as a weather patrol, its captain was a professional photographer. Because he was sympathetic to Steward's Mate Lawrence, the captain made it possible for Jake to be transferred to a troop transport. There he was given the rating of petty officer, third class, public relations. That enabled him to paint. With that advantage Jake was also able to see his wife once each month, and the paintings he did were shown at the Museum of Modern Art while he was in service. In 1945 he was honorably discharged from the Coast Guard after twenty-five months of service. He immediately applied for and won a Guggenheim Fellowship, with which he painted a powerful and disturbing series on war.

The year 1947 was an auspicious one for Jacob Lawrence. For one thing, Josef Albers had invited him to teach at Black Mountain College in Black Mountain, North Carolina. Recalling that venture, Lawrence says:

This was a milestone for me as it initiated me into the ranks of teacher. It was an experience also for all of us concerned, for this was the South. Most of all, through Albers I came to know something of the Bauhaus concept of art, which, simply put, stresses the design, the theory, and the dynamics of the picture plane. Regardless of what you are doing, form, shape, color, space, and texture become the important things with which you deal.

Other things that happened for Lawrence at this period were that he was asked to illustrate *One Way Ticket,* a collection of poems by Langston Hughes. The six black-and-white drawings for that Hughes collection are the first book illustrations Jake had been commissioned to do. Besides that, he was commissioned, through the Downtown Gallery, to paint for the Container Corporation of America his own concept of the essence of New Jersey. That firm's advertisers were running a series of paintings in *Fortune* magazine. Each artist selected was asked to execute a painting that reflected his impressions of his own home state. Since Lawrence was born in Atlantic City, his impression of New Jersey was printed in full color and run as scheduled.

Things, it seemed, were going beautifully. How could they be more perfect, what with having one's talent and hard work so quickly and widely recognized? To be able to express one's undisguised disapproval of established oppression and to be rewarded for so doing is not the experience of every gifted artist. It certainly had not been the experience of many black artists. And what made Lawrence especially effective and memorable was that success had never went to his head. It wasn't that he was blasé. It's just that the simple unassuming manner that he exhibited as a boy at Utopia House never deserted him as success began to intrude itself into his life.

Not a single trace of the irritation, anger, and bitterness that
motivated his type of art expression ever invaded Lawrence's
public oral statements. He reserved them, instead, for his
painting.

Here, then, was the perfect guest and the perfect host,
young, attractive, gifted. From the point of view of those who
promote art and specifically those who promote its black
practitioners in this country, here was the "ideal repre-
sentative." Jacob Lawrence was sitting pretty, all right, as
fellow artists noted with varying degrees of mingled admira-
tion and envy.

It came as a surprise, therefore, as word filtered through
the art community in 1949 that Lawrence had "suffered a
breakdown." Like most unpleasant rumors the speculations
rose to ridiculous heights. The thirty-two-year-old artist, it
was declared, had been knocked down and out at the peak of
his prime. Other groundless tales had it that he had been
taken with a violent seizure and had had to be forcibly con-
fined. Those who were his closest colleagues and friends
waited for word of Jake's health and progress from his wife,
Gwen. She assured all that Jake was "all right and doing very
well," as a patient at the Hillside Hospital in the Queens
section of New York. Friends let it go at that. They recog-
nized that certain details were matters of concern only to the
patient, his family, and the attending hospital.

If there was surprise at news of Jacob Lawrence's illness,
there was even greater surprise at a news story appearing in
The New York Times Magazine for October 15, 1950. Under
the by-line of Aline B. Louchheim, the story was headlined,
"An Artist Reports on the Troubled Mind." Miss Louch-
heim's text, illustrated with a photograph of Lawrence and
several black-and-white reproductions of his paintings, pro-
vided the best possible advertising of a new Lawrence show.
Scheduled for opening at the Downtown Gallery on Octo-

ber 24, the show would feature ten paintings made during the year Jake spent in therapy at Hillside Hospital.

Miss Louchheim, while alluding briefly to Vincent van Gogh at Saint-Rémy, made it clear that comparisons between the illnesses of the Dutch master and Lawrence were by no means similar. Furthermore the story described Hillside Hospital as the only one of its type "in the East that will take voluntary mental patients regardless of their ability to pay" and that "it also has a high ratio of staff to patients and an outstanding record of recoveries." Dr. Emanuel Klein, who attended Lawrence, had this to say:

Unlike Van Gogh, Lawrence simply had nervous difficulties neither particularly complicated nor unique, which became so much of a burden that he voluntarily sought help. These paintings did not come from his temporary illness. As they always have—and as is true for most real artists—the paintings express the healthiest portion of his personality, the part that is in close touch both with the inner depths of his own feelings and with the outer world.

Jacob Lawrence was back at work as usual in his studio and was again being seen in the old familiar places. What was even more important was that his state of health was considerably improved.

Toward the end of 1960 the Ford Foundation awarded liberal cash grants to five artists. To five other artists it gave each a traveling retrospective show.

"I was one of the latter," says Jacob Lawrence. "Along with the show a monograph was done by Aliene Garrienen and every painting in the show was reproduced. My show opened at the Brooklyn Museum and it traveled for two years." The artist was only forty-three years old.

Time magazine for February 24, 1961, reported on the Lawrence show as it opened at Allegheny College in Meadville, Pennsylvania, the third stop on its long national tour. Said *Time:*

Few painters use so bright a palette or so bold a brush and still achieve so sorrowful a mood. Purplish blues lie alongside acid greens; reds and yellows vie for attention yet do not seem to clash. Nor do the jagged rhythms of the paintings ever get out of control. Tension mounts in Jacob Lawrence's paintings, but the threatened disorder never takes place.

The following year the American Society Of African Culture received a request from the MBARI club of Ibadan, Nigeria, for a showing of Jacob Lawrence. The Society was delighted. This was just the kind of thing it was geared to promote. Jake also was pleased but even more so when he learned that he, too, was to go along with the show, all expenses paid, for ten days in Nigeria. He selected "The Migration" for showing in Lagos and Ibadan.

In Nigeria he met and exchanged views with that country's leading artists. Indeed, what Jake saw in Nigeria so intrigued him that he returned about a year and a half later with Gwen. Together they devoted eight months to observing the African scene and to painting. When they returned to New York they brought not only drawings and paintings they had done, but a fuller appreciation of the then current life of Africa's most populous country.

Jake had by now moved from the Downtown Gallery to the Dintenfass Gallery. In 1963 Terry Dintenfass presented him in a showing of bitter commentaries upon life in America. "Taboo," treating the fantasies Americans entertain about interracial marriage, and "The Ordeal of Alice" were two memorable canvases of the show. The latter depicts a small black Southern schoolgirl integrating a formerly all-white school. As is true of Alice in Wonderland, the child finds herself surrounded by strange creatures.

The difference, of course, is that the creatures in Lewis Carroll's classic are benevolent while those in the Lawrence painting are the quintessence of evil. It is a work symbolizing the nightmarish ordeal of the nine children in Little Rock,

Arkansas, and of all the other black young pioneers in the civil rights movement of the 1960's. Their collective struggle to force this nation to live up to its flowery rhetoric of democracy is embodied in that one painting. Looking at it provides the viewer with an unforgettably disturbing lesson in the sheer ugliness of racist bigotry. And it is the more remarkable since the artist's statement here, not as simply treated as in his earliest works, loses none of its paralyzing force because of its complex handling.

Time magazine commissioned two cover paintings from the brush of Jake Lawrence. The first, a portrait of former Biafra's Lieutenant Odumegwu Ojukwu, appeared on August 23, 1968. The second, of Jesse Jackson, on April 6, 1970. Both are quickly identifiable as Lawrence paintings—which is to say that neither is typical of the week-to-week type of traditional portrait one associates with *Time* covers.

"Painting a portrait for *Time* is a difficult experience," Lawrence declares.

First they have an idea of the subject *they* want projected through the cover, and it is often difficult for the artist to know what that idea is, since the *Time* editors can't explain it. Then they give you loads of photographs, but at best they are difficult to use when you haven't seen the person. The two-dimensional images don't give the artist what the three-dimensional object itself does. Finally, there's the matter of a deadline. Often it's a very short one—as little as two or three days.

Another even more satisfying aesthetic experience was his juvenile picture book, *Harriet and the Promised Land.* Published in 1968 by the Windmill Press, this book, with its handsome illustrations in full color, will doubtless become a collector's item. The publisher, in contracting painters rather than traditional illustrators to provide pictures for his books, is seeking to produce more "arty" results. Lawrence, it seemed to this writer, has gone well beyond that. Choosing a subject he felt would have special appeal to children, he

created works of art as he made the drawings in his individualistic way. While squeamish children's librarians looking for pleasant images will not be drawn to the Lawrence interpretations, art-oriented observers will be far more appreciative of them. Certainly children, for whom the illustrations are actually intended, will love their raw, honest realism. That, thank heaven, is the way children are. Proof of publisher Robert Crouse's satisfaction with the Harriet Tubman illustrations is that he immediately contracted Lawrence to do the illustrations for a new collection of *Aesop's Fables.*

One asks Jake Lawrence to comment upon the black artist today. "The black artist becomes aware of how the cards are stacked against him early in his school experience," he replies.

Good as the people in our black schools have been, they simply have never been given the opportunity to have the experience one gets from teachers in the nonsegregated school. But that is beginning to change for the better. The demands now made by blacks do not always get the results desired. But the black artist must get the same kind of exposure the white artist gets. All black artists will not measure up to the highest standards, but neither do all white artists who do get the exposure.

Lawrence insists also that more young black people should prepare themselves to become not only first-rate art teachers, but also art critics, art historians, and museum curators. He is quick to acknowledge that his fourteen years of teaching at Pratt Institute have meant much to him as a professional artist.

Honors and citations of merit have come to Jacob Lawrence from many parts of the world. Because of the racist climate that pervades the United States, he has achieved recognition as "the nation's foremost black artist"—a phrase that some white reporters use freely, then apologize for using. But Jake Lawrence makes no apologies about his blackness. Indeed, the following remarks he made upon receiving the

N.A.A.C.P.'s Spingarn Medal in 1970 (he was the first artist so honored) clearly shows what being black means to him.

If I have achieved a degree of success as a creative artist it is mainly due to the black experience which is our heritage—an experience which gives inspiration, motivation, and stimulation. I was inspired by the black esthetic by which we are surrounded; motivated to manipulate form, color, space, line, and texture to depict our life; and stimulated by the beauty and poignancy of our environment.

Chapter XI

ROY DE CARAVA

ALTHOUGH THE PUBLIC personalities of Roy De Carava and Jacob Lawrence could scarcely be more divergent, there is a similarity in them as artists. It isn't that they have shared completely identical social lives and careers; for, even with such resemblances as exist in those areas, each man's life and career has run its own course. Nor have their measures of acclaim and acceptance been of equal portion. That is the expected way of man and of the events he conducts. To all who recognize the value of authentic creativity, however, such disparities are no true measures of comparative merit. History teaches that not all contemporary victors are awarded the laurel wreath in their own time. Still, neither swift nor tardy acceptance destroys the validity of true contemporary victors such as Lawrence and De Carava. Each knows his own worth. Moreover, each is profoundly and inextricably attuned to that quality of life that pulls him and his creativity close to the other.

Roy De Carava isn't at all reluctant to talk, and as he warms to the subject his tenor voice rises and falls with the mood of the discourse.

I was born in Harlem Hospital and during all of my elementary and junior high school days I had a facility for drawing. I re-

member that even in kindergarten, perhaps the happiest part of my childhood, I played with blocks and with colors. What was really lacking in my childhood was contact with the arts. That didn't come until I got into high school. Until then I was completely on my own as far as art was concerned. In fact, the only drawing I did outside of the little done in the elementary schoolroom was the work I did on the sidewalks. My *pièce de résistance* was the cowboy I once drew that extended from one side of the street to the other. I got to be the artist of the blacks. In my predominantly Jewish neighborhood, with a sprinkling of Puerto Ricans and blacks, I became their "artist-in-residence."

The De Caravas lived on East 105th Street between Madison and Park avenues, a section now almost wholly Puerto Rican. Roy was nearly ten when his stepfather died, leaving him and his mother completely destitute. They had to seek help from a private charity that looked out for recently widowed women with children. One of the caseworkers, noticing the boy's talent, bought him a watercolor set. That was Roy's first introduction to art material other than the chalk he had used for sidewalk drawings. With this encouragement he submitted a drawing to a "draw me" contest and "won" a course. Roy laughs lightly about that now. "You know that was just a *hustle*," he says. "They tried to get my mother to buy the course but she couldn't afford that. A little later on, though, I won another contest, and my prize was a pair of shoes. Now that was something we really appreciated."

Times were extremely hard for the De Caravas during the Depression.

We never stayed in any one place too long. We had to move frequently—existing as we did on the rim of financial disaster, and dwelling in pocket areas ringed by hostile whites. You crossed into their areas at the risk of a beating. So I was always the new kid on the block. I never had a chance to take roots where there does exist, in poor areas, a history—a tradition. My nomadic mother and I never "belonged" to the area we moved into.

Roy describes himself as a "scary kid," a "loner" who never courted trouble. And as he talks of the terrors of his childhood, he recalls a photograph he took in 1950 when he was thirty-one years old.

It was just the picture of a dark hallway, and it brought me right back to my childhood. That picture, with its lack of space and light, expressed what I felt as a six-year-old but was not able to express then. I forced *everything* out of that print so that the observer could feel what I felt as a kid.

Roy was a standout student in art at Cooper Junior High School. There was no formal art program there. Yet one or two of Roy's teachers encouraged him by keeping him busy making drawings for various projects. Outside of that classroom experience Roy De Carava's world of art was that which came to him through the ads for men's clothing and accessories.

"I really didn't know that there were painters," he admits, "for the art I saw and admired never connected with people who had a purpose in producing it. I became serious about it when I got into Textile High School and took my first course in art appreciation. That opened my eyes to what art was really all about."

As was true of fellow Harlemites Jacob Lawrence and Charlotte Amévor, Roy De Carava's eyes had been earlier opened to the abrasive life of Harlem's poor. The word picture that Roi Ottley presented of Harlem in the early 1930's had been occasioned by the dreadful reality through which the De Caravas struggled. The following is another small portion from Ottley's *New World A-coming*.

Virtually barred from all other sections of the city, Harlem Negroes were forced to pay exhorbitant rents, while landlords relaxed supervision and flagrantly violated the city building and sanitary codes. Compared with twenty and twenty-five per cent of their income generally paid by white families for rent, Negro tenants paid from forty to fifty per cent. Frequently whole families

slept in one room. Envied was the household that had a night worker as a lodger, as he occupied a bed in the day that could be rented again for the night. This was described as the "hotbed." If the family had a bathtub, it too, after being covered with boards, was rented out as a bed.

Discrimination against employment of Negroes had practically closed the doors to many occupations. Generally, the poorer half of the Negro population was living on an annual income that was only fifty per cent of that of the poorer half of the white population. Wage standards had all but disappeared as dispossessed Negro sharecroppers of the South drifted into Northern cities, swelling the total of destitute persons.

With these destitute people teeming into the Northern cities, the relief bureaus were deluged with thousands of demands for food, clothing, and employment. There was bitter waiting and more bitter complaining. In New York, meanwhile, twenty-five thousand Negro families, fifty per cent of Harlem's population, were receiving unemployment relief. By 1933 the total of jobless Negroes in the United States had risen to 1,500,000. In such cities as Chicago, Cleveland, and St. Louis, Negroes made up from forty to fifty per cent of the unemployed population.

That was the Harlem Roy and other black boys and girls left each morning as they went off to high school. There was then, and still is, no high school in Harlem except the specialized High School of Music and Art. Besides, few black boys attended Textile High School when Roy De Carava entered in 1933. That was indeed surprising when one considers that Textile and Haaren high schools came to be known as the "garbage heaps" where black boys and nonacademically inclined white boys were "dumped."

Textile High School had an art department. As Roy puts it now:

But very few blacks interested in art could take it there because they were systematically pushed into "more practical" areas of study. I was a freak to my teachers at Textile High. Some were fawning. Others in their attitudes demanded, "How dare you!"

But there was a Miss Lang there, a young, dedicated, and truly religious Catholic lady. She went beyond the call of duty to help us even to the point of giving us money to buy the things we needed but couldn't afford. Right from the beginning, Miss Lang helped me move ahead.

Moving ahead at Textile High was not easy for black boys. To begin with, its students used two buildings, the main building and the annex. Black students rarely were seen attending classes in the main building. Roy recalls the annex as little more than "a dive with no facilities" worth speaking of. Miss Lang taught in the annex where Roy was enrolled for the first two years. She was, it seemed, the starry-eyed young "white missionary" assigned to bring a little salvation to the young "black heathen" of her class. Obviously she did her job more than admirably. When Roy entered his junior year he also entered the main building—thanks to a lot of dedicated behind-the-scenes work in home missions.

Roy found everything in the main building superior to what he had left—except for the art teacher. She tried and she tried hard, but she found it difficult to be relaxed with nonwhites. Roy did his work well, however, and was one of the school's outstanding art students. He was in line for the coveted four-year scholarship to Pratt Institute awarded the best senior in art. Like Betty Catlett who, in competing earlier for admittance to Carnegie Tech, knew how she stacked up with the others, Roy De Carava, likewise, knew where he stood in relation to his competition. The winners were announced and Roy recounts what happened.

They gave the scholarship to a white boy who had been attending school in the main building "longer" than I had. Then they scurried about and *found* a prize for me. That hurt. I knew and they knew I was the best art student they had that year. Besides, that scholarship would have seen me through four years at Pratt. That's why I had knocked myself out so in order to excel. Well, the "prize" they scraped together for me amounted to twenty-five

cash dollars. I took the money and bought an artist's drawing table with it.

Roy De Carava was eighteen years old. He knew very well what his worth was as an art student and he proved it by passing the stiff competitive city-wide entrance test at Cooper Union. As the lone black student there he was keenly conscious of the varying degrees of racism among both faculty and students. His awareness of the high quality of Cooper Union's first two years of basic instruction was equally keen. Intelligence told him that especially during that period he needed to study and learn the basic disciplines of the craft. With those at his command he would be ready to elect his courses wisely for the final two years. Yet, as fully as Roy De Carvara could appreciate intellectually the thoroughness of the instruction he was getting, he found it all but impossible to ignore emotionally the cold efficiency with which it was dispensed.

"I considered them indifferent—not as teachers—but as *human beings*," he says.

They failed completely to understand my blackness and my need for an understanding that the whites did not have. I am sure that one of my reasons for feeling so "out" of things at Cooper Union was that unlike most of the white students I had no background reserve upon which to draw. The others lived with art. They mentioned names to me I had never heard of. That made me feel "out" of it. We blacks in such situations were culturally deprived and didn't know it!

Roy bore it long enough to acquire those basic disciplines he knew he could not do without. Then, after two years, he left. Meanwhile, word had been filtering through Harlem, and indeed all through New York City's art circles, of the excellent facilities and teaching staff at the W.P.A. art center in Harlem.

The rumors were well substantiated by the facts. The Harlem Art Center, the Federal Art Project's "showcase" in

New York, was the best in the city. Day and evening classes in drawing, painting, etching, lithography, sculpture, weaving, dressmaking, and photography were open five days each week. And they were free of charge. Its instructional staff included Ernest Crichlow, Selma Burke, Robert Pious, Sarah West, Francisco Lord, Robert Blackburn, Bert Jackson, and this writer. And the center's crowning touch was its art gallery, where interesting exhibits were constantly on view. All of it had come about through the efforts of sculptor Augusta Savage, who was the Center's first director. When she retired to an upstate farm, her position was taken over by writer-painter Gwendolyn Bennett.

Someone casually dropped word of the Harlem Art Center where Roy De Carava heard of it, and he immediately went to see it for himself. Roy liked what he saw. He liked even more what he *felt* when he enrolled in its adult evening classes of life drawing and lithography. For one thing he had a feeling of manly independence, since at eighteen he had become his mother's and his own means of support. All through high school he had held after-school jobs. At sixteen he had learned show-card writing so well that he was doing all the signs for the Fox Theater in Brooklyn. He had learned the art from a friend while he was still in school. So as a free-hand brush letterer, Roy was able to earn two or three dollars each evening after school. That, during the Depression, was not bad pay.

Roy's mother, meanwhile, had been employed on the W.P.A. But when Roy became eighteen years old he was allowed, as his mother's sole support, to replace her in a job of his own on the project. He began also to attend evening classes at Cooper Union. During the day he worked for three weeks as a W.P.A. office clerk. The job bored him so terribly he lost no time making his sign-writing skills known to the authorities. They immediately reassigned Roy to the silk-screen poster division of the art project. It was there that he

learned about the much-talked-about art center in Harlem.

If at Cooper Union he had been tight and tense, Roy De Carava was completely at ease at the Center. Because he found students and teachers there so warm and friendly, he spent all the time he possibly could with them. For Roy the Center meant more than just returning to what he calls "my street roots" for inspiration. It meant also that he was breaking away from many of the fellows he had grown up with who, for one reason or another, were going nowhere in a hurry. Harsh as the break was, Roy was realistic enough to know that, rudderless and unprepared as they were for life's gales, they would eventually founder and go under. He certainly could not afford to let them drag him down with them.

As he sought new companionship, Roy found a friend in James Allen, a young photographer from Washington, D.C., who had come to Harlem and set up a studio. Allen had won a Harmon Award for his work and he was well known both inside and outside the community. His dapper mode of dress and suave European manner initially irked Roy.

Jimmy Allen struck me at first as being a snob, but after a time I grew to respect him and his aspirations. Jimmy clung close to his middle-class values and he was a fine craftsman if not an artist. I appreciate now what he did in introducing me to Alain Locke.

Scholarly Alain Locke, at first meeting, was even more of a shock to Roy than Allen had been. Where on earth did *he* come from? the young artist wondered. Street kids have a way of looking askance at erudite persons, especially erudite males. Since the former usually have little or no understanding or appreciation of scholarship, they simply don't respond quickly to scholars. But Roy knew how to listen when Dr. Locke spoke. And to his great surprise he discovered that the distinguished man was not only a "regular guy" but one very much in his corner when and where it counted most.

Meanwhile, as a student at the Harlem Art Center, De

Carava was doing excellent work. A particularly striking
creation he produced there was a lithograph. One night while
walking home from school he passed through a block where
the area's least attractive and poorest paid whores stood as
seductively as they could, soliciting from their grimy door-
ways. There was nothing novel in the scene for Roy, who had
been through there hundreds of times. On this night however
he happened to glance at one woman in particular. He will
never, he declares, forget what he saw.

She looked like she'd been through many wars—face battle
scarred and wine puffed. It hurt me to see the pain in that
woman's face. And I carried that hurt with me to the sketch pad
and the litho stone as I went deep inside myself to pull the in-
terpretation out. That drawing was a real breakthrough for me,
emotionally and artistically. It was important that I did not dis-
card my feelings in this instance since the popular concept of art
is that it must always portray beauty. So who wants to see an
ugly prostitute? But in a more profound sense the woman was
not ugly, but merely the reflection of the ugliness that created her.

Young De Carava had become conscious of the *individual
in relation to his environment.* Further consciousness of the
Harlem environment and what it meant to its poor majority
inhabitants was recognized by those who worked at the
George Washington Carver Art School. The Carver School,
located on 125th Street near the Harlem Art Center, had its
own staff and its own style. Noted for its left-of-center politi-
cal viewpoint, it, too, provided the opportunity for the study
and practice of the arts without charge to students. Roy De
Carava, anxious to learn from, and practice in, as many
sources as were available, studied there between 1944 and
1945. At the Carver school he met and developed an ap-
preciation for the strong talent and the warmth of Betty
Catlett. There also he came to recognize what he believes to
be the responsibility of the black artist as spokesman for the
voiceless masses of the black community.

The advent of World War II disrupted many plans, including a few of Roy De Carava's. His brief span of military service at Camp Claibourne, Louisiana, was what he calls "a destructive experience." He was let out with a medical discharge. With his skill as a display and show-card artist, Roy sought a job in advertising. But the agencies weren't about to let a black artist into so lucrative a field. He had to settle for a job making drawings for nameplates to be used on machinery. A little later he found work as a draftsman for army manuals.

De Carava did not let the routine of commercial work consume his creative powers. He continued to paint and to make silk-screen prints, and for two years he exhibited with the New York Serigraph Society of which he had become a member. Meanwhile he had been using a camera as a means of quickly recording pictorial data which he would then translate into drawings and prints. Without realizing it he was stepping into a new and a wonderous career.

It was in 1947 that I became seriously interested in photography as an art form. And I hadn't been taking pictures long, before I began to be a successful photographer—successful in the sense that I was taking good photographs, better than my paintings—more at the level of that lithograph I had done of the whore.

The first camera Roy bought was an Argus, for which he paid nineteen dollars. He built all his enlargers and he never had one minute of formal instruction other than that he gathered from reading and studying alone. Between 1947 and 1949 Harlem offered the young artist with a camera a wealth of subject matter. Roy took roll after roll of film in Harlem. Finally he was ready for his first show.

In the course of his travels, De Carava had come to know crusty Mark Perper, who operated the Fourty-fourth Street Gallery. Perper knew art. He himself was a good painter, and when he looked at Roy's array of Harlem photographs he

decided they would have to hang in his gallery. Pleased as Roy was, he knew nothing about evaluating his pictures or about hanging a show. So in the small Forty-fourth Street Gallery he put up one hundred and seventy-five photographs. Perper looked at the four walls covered with pictures. Saying nothing to Roy, he went to the telephone and called his friend Homer Page. "Homer, I want you to come over here and look at something."

Homer Page came and he looked. Then he made Roy take every picture down and together they began to select pictures for the show. They worked through the night and when they were done they had sixty pictures back on the walls. The remaining one hundred and fifteen were put well out of sight. Page, himself a professional photographer, felt there were still too many pieces for that small gallery but he was sufficiently impressed with their quality to let them remain. Then Homer Page and Mark Perper did that magnanimous thing that white men with important contacts have done over the years for each other, but that few ever do for black men. They issued a special invitation to the renowned Eugene Steichen to come and have a look at Roy De Carava's photographs.

Roy's surprise was immeasurable. After all, he had been in photography but two years! But the real shocker for him came with Steichen's enthusiasm for what he had to show. Here was one of the world's masters of the art of photography expressing enthusiasm for the photographs of a young black unknown. That was not at all in character with Roy's previous experience with whites.

Steichen was completely sincere. He stunned Roy by suggesting that he apply for a Guggenheim Fellowship and by saying that he, Eugene Steichen, would sponsor him. Today Roy quite frankly admits there were two things about that meeting with Steichen that shook him. "First, I didn't know at the time how important Steichen was in photography and

how weighty his sponsorship was. Then, as is true of so many young, black, impoverished artists, I clung to my pride, and, lets face it, to my fright!"

Roy began to think of all the reasons why he shouldn't bother to apply for the Guggenheim Fellowship. Only nine photographers before him in twenty-three years had received such a grant. There was the business of writing a plan, writing letters, and "begging" people to sponsor him. Why should he go through all that in addition to what he'd already been through? Mark Perper sensed the reasons for his young friend's reluctance and he kept needling and prodding until Roy took positive action. He asked Jacob Lawrence, Romare Bearden, librarian Dorothy Homer, Homer Page, and Eugene Steichen to sponsor him. He had previously approached his old friend Alain Locke for sponsorship, but Locke, ill and crotchety, was not in his most approachable mood.

True, the older man genuinely liked Roy De Carava and thought highly of his talent. It was none other than Locke who had previously seen to it that De Carava's work had appeared on the covers of *The Crisis* and *Opportunity* magazines. Indeed it was through Dr. Locke that most young black artists went in quest of grants.

Locke was an institution. Tradition held that he was the number one instrument through which doors were opened for gifted black artists. So it irked the former Rhodes' scholar that Roy would ask him *and* the eminent Eugene Steichen to be his sponsors. Obviously Dr. Locke had the feeling of being upstaged, a situation that simply was not supposed to occur. He was snappish when De Carava asked for his sponsorship. Roy, proud and sensitive, would neither beg nor cajole, choosing instead to do without. Meanwhile, the Countée Cullen Branch of the New York Public Library presented a second one-man show of the De Carava photographs.

Roy got the Fellowship. His grant of thirty-two hundred dollars marked the first of its kind awarded a black photog-

rapher. He took leave of absence from his job as a commer-
cial artist, realizing that what he wanted to do would require
his full time and energy. By now he owned a second-hand
Leica, since he had decided long before the Fellowship came
that the seriousness of his effort demanded first-rate equip-
ment. To that he added another camera and a better enlarger.
And since he was going to photograph black people of Harlem
he did not have to leave the city.

"I had a ball during that year!" Roy recalls. He was, never-
theless, shocked to discover that what he did was not received
with what he was certain would be a show of marked public
acclaim. To begin with, most people could not understand
why Roy wanted to photograph black people. Then he was
faced with the question of how to cash in on what he had
produced. It would have been easier had he been white. As
a white photographer he would doubtless have sought out a
different Harlem, one that more closely conformed to the
stereotype most whites held and still hold of the area. But
Roy De Carava knew Harlem as few white men ever do. One
exception was Richard Lincoln, a white reporter who worked
in Harlem. Writing in the *Amsterdam News* for May 10,
1952, the very year Roy was working on his Guggenheim
award, here in part is Lincoln's view of Harlem in a story
headlined:

CRIME WAVE? WHO'S SPEAKING?
 I am white. I am a regular reporter for *The Amsterdam News*.
I get around Harlem. Since I live about twenty blocks below
110th Street, I suppose I am what this article refers to as a "down-
towner." Still, I have been in and around Harlem since 1936,
when I attended high school in the area. More recently, as a
reporter, I have had occasion to be in and out of innumerable
houses, churches, pubs, offices, meeting halls, restaurants, night-
eries, and, yes, police precincts in the community. I have walked
through the streets wide and well lighted, and streets dark and
rather narrow.

In all that time, I have not been robbed, rolled, mauled, cheated, attacked, or insulted. Nor have I ever been filled with especial fear as I crossed from one side of 110th Street to the other on my way uptown—unless, that is, I was crossing against the lights. Now although it would be unjust to the community to say it had no distinctive features, I have never found crime to be one of them. Naturally, if I spent all my time at the Twenty-eighth Precinct, I might get that impression.

There are slums in Harlem, falling ceilings, and rats and broken stairs and families crowded into tiny rooms. Nobody likes to live in them. Never once in all the tenements I have visited have I come into contact with anyone except human beings who want a decent dwelling, a decent job, a decent life.

Richard Lincoln's Harlem bears a strong resemblance to Roy De Carava's. That, doubtless, is why neither found a popular market in the most lucrative places. Roy's photographs went unwanted and unused, except for the four that appeared in Steichen's *The Family of Man*. De Carava tried another tack. He opened a gallery which he called The Photographers' Gallery. Located on West Eighty-fourth Street, the gallery was dedicated to the belief that photography is an art that people should buy. It presented excellent work for sale and in the two years of its existence, the gallery received excellent reviews. Though it was a first-rate venture it suffered the handicap of being a pioneer. Moreover it suffered because of racism. Roy's partner was white and female.

One day in the interim Roy asked Langston Hughes if he would like to see his pictures of Harlem. Langston, who loved and lived in Harlem, was delighted at the suggestion. One look at the pictures and the poet was all excitement. "Man, we gotta get you a *book!*" he exclaimed. De Carava was pleased but more restrained. "But man we can't get a book with this. I've been trying to get a book of this stuff for two years!"

It was the mid 1950's and publishers were being very cautious with black material. Langston, full of faith in Roy's

material, took it around for the publishers to look at anyway. Finally, Simon and Schuster agreed to make a book of it—if Langston would write the brief text. So *Sweet Flypaper of Life* took form and was born in 1955.

Sweet Flypaper, a slender work of ninety-eight pages, was hailed as one of the best fifty books of the year. Certainly it was ahead of its time, well received by the public, but barely advertised at all by the publisher. Not one of the three bookstores in Harlem was notified by the publisher of its availability, and Roy himself had to place copies in those stores. In spite of such handicaps it sold out its twenty thousand paperback copies, and three thousand hardback copies were done as an afterthought for libraries. Needless to say, *Sweet Flypaper of Life* made no money. It was, however, reprinted in 1967 by Hill and Wang.

Throughout the 1950's Roy held on to his job in commercial art. In 1959 he decided to go all out as a free-lance photographer. Only a couple of years previously he had been shown in a group exhibition at the Museum of Modern Art. The show, Seventy Photographers Look at New York, was a hit. Roy had proved his ability, so why shouldn't he take the plunge. He did, and he found the water deep and rough.

But for a few jobs given him by Harry Belafonte, he might well not have been able to endure it. The high-sounding phrases proclaiming the lack of discrimination in the arts notwithstanding, Roy found the doors leading to important things slammed and bolted tight. In 1959, for instance, there weren't enough black photographers employed outside the black press worth mentioning. *Life* magazine had Gordon Parks, and he was *it;* the symbol of fair play for all the other black photographers scrounging for bread. The big money in photography is in advertising and fashion. Not one black lensman was in either field. Roy joined the American Society of Magazine Photographers because he wanted to be in a

professional organization whose members were recognized professionals earning a living at their profession.

Once in the organization he found it riddled with racism, and Roy spoke openly to the membership about it. Reluctantly a few admitted the fact of discrimination. They formed a committee to "investigate," and while the committee members were, themselves, not bad individuals, they were powerless to move the group. Nothing came of their "investigation," and the truth about color prejudice in the field goes marching on. Black photographers work in big studios, all right, but they work, ironically enough, in the darkrooms. Their names never appear on anything official and they are not likely soon to have their own studios. Excellent as they are as technicians and behind-the-scenes assistants, that, precisely, is where they have been safely stashed—to stay!

Roy De Carava found such conditions sickening and thoroughly intolerable. In 1964 he prodded the A.S.M.P. to sponsor a meeting of black photographers. At first the group balked, indignantly declaring that such sponsorship would constitute (of all things) discrimination! Finally they consented. Of the more than two hundred black photographers called, fifty or so responded. Their meeting was a fiasco, as Roy's account attests.

It was a fiasco because of the influence over the others of, who happens to be successful. I had gone to see, hoping that he would use his influence to help us. He assured me he'd meet with us and when he showed up I was glad to see him. As soon as we had all assembled I quickly established my position, namely that discrimination had been keeping black photographers out of the broad field and in particular out of the most lucrative areas. Without batting an eyelash, retorted that my statement was not so. "If you're good you can make it," was his assertion. He then proceeded to intimidate several members of the group by reminding them of personal favors he had done them and of their need to be grateful and "reasonable." With such tactics and his reputation, he was

able to mesmerize the majority of the group into silence on the very issues we had previously agreed necessitated the meeting. In fact, they began to look to him for help, sincerely believing it would come their way. That's just how hungry they were for recognition.

I walked out of the meeting in disgust and was gratified to find that five or so walked out with me. They did so because our guest had overplayed his hand and they had seen through him. At one point of the meeting the guest had turned to me and cajoled, "Now, Roy, you know your claims of discrimination are not true. *You* make good money!" When I replied that my earnings during the previous year were a mere four thousand dollars he sputtered in disbelief, muttering that he'd have to see that something was done to correct that. I said simply, "No thank you." I have concluded that this man after talking over my invitation with others at his own level, was instructed to be there as their representative as well as his own. He and they want the situation to remain as is. Meanwhile he will continue to do well for himself with things just as they are.

With the handful of young black photographers who walked out of that meeting with him, Roy founded the Kamoinge workshop. The name, a Kikuyu word meaning "a group effort," suggests the purpose of the group—to work together at the job of developing and promoting the talents of black photographers.

Back in 1961 Roy had begun to work for *Sports Illustrated* as a free lance. Six years later he went into a contractual arrangement with them and his work has appeared regularly in their pages. He says that he brings as much truth to his work as the editors permit him to. What he photographs and what the editors select for printing do not always add up to the same sum total. Editors select those pictures that illustrate the story and generally fit their editorial policy. He does, however, find *Sports Illustrated* decent to work for. Having also done work for other publications, Roy has his own feel-

ing about publications that refuse to employ black photographers on the grounds that they lack professional experience.

I have learned that no man is born walking, talking, reading, and building bridges. They all have to learn to do such things. The same is true of photographers, black and white. I have seen how white photographers develop. They are hired, they make mistakes, but they are allowed to grow on the job. Anyone, black or white, who insists that black photographers have to go into a job better prepared than that, are catering to racism—nothing less!

In a personal vein Roy clearly remembers when *Look* magazine was approached by the National Urban League about hiring a black photographer. He went in to apply and found the red carpet and all the trimmings awaiting his arrival, for *Look* was well aware of him and his work. The interview could not have been more friendly and pleasant. When *Look*'s reply reached Roy he learned that he was "too *old*." He had to laugh. "I had reached the tottering age of forty-two!"

De Carava believes that the black person has an affinity with photography just as he has with jazz. He contends that the person whose life is devoted to the elemental task of surviving is forced by circumstances to be more realistic and more truthful than the person who isn't. The black man, in this instance, has to "read" the white man accurately and swiftly. If he doesn't, his chances of surviving the latter's tyranny are considerably diminished. Because he deals with the immediacy of his life's irregular pattern by meeting unorthodox demands with improvised answers, the black man finds jazz and photography suited to his instincts.

Jazz, in its most exciting form, is an art of musical improvisation. It is an *immediate* creation. Photography is likewise immediate. The photographer must be there with his camera, and his subject must be there. And when the three meet in harmony at precisely the right instant, the photographer's

art is conceived. Gestation and birth take place later in the darkroom.

But the ultimate element linking jazz, photography, and the black creator is the element of reality. Jazz music emanates from the reality of the musician's life experiences. In photography there is the undeniable reality of the thing from which the lens and the film take their image. Those realities eagerly welcome the embrace of the ungilded reality of the black man's experience in a hostile racist environment. That sums up a significant De Carava belief.

The year 1969 was especially meaningful to Roy De Carava. Cooper Union invited him, its former student, to teach a course in photography. A bit earlier, however, the Metropolitan Museum of Art in mid-January opened an exhibit of images and sounds that it called Harlem on My Mind. Covering the period between 1900 and 1968, the exhibit purported to give a realistic and balanced picture of the community. Roy De Carava and Bruce Davidson were asked to contribute photographs to the exhibit. Each had reservations.

They were far from sure of the depth of understanding of, and feeling for, Harlem on the part of those who were putting the show together. So each asked to have his own work hung in a room to itself as individual pictorial statements relative to Harlem. The Metropolitan Museum balked. If De Carava and Davidson wanted to show they would have to to conform to the Museum's and Allon Schoener's format and directions. Bruce Davidson wavered and went along with the Museum.

On the bitter cold night Harlem on My Mind opened, without the De Carava photographs, Roy was outside picketing the Museum. His placard read: THE FOREIGNERS REVEAL THE REAL NITTY GRITTY. In a statement later in *Popular Photography,* here is what De Carava said:

It is evident from the physical makeup of the show that Schoener and company have no respect for or understanding of photography, or, for that matter, any of the other media that they employed. I would also say that they have no great love or understanding for Harlem, black people, or history.

The criticism was as deliberate and thoughtful as it was valid. Later, in an interview with A. D. Coleman for the April 1970 issue of *Popular Photography*, De Carava freely acknowledged that he knew he wasn't loved by the white photographic community. He gave as his reason the fact that he had refused to become their grinning, castrated, yes-man. "But I *am* loved by the black photographic community," he concluded, "and that's what really matters to me."

The black community, at large, who may or may not know a single thing about the art of photography, likewise loves and respects what Roy De Carava stands for. So also do many honest and sensitive whites. Eight months after the opening of Harlem on My Mind, they had a chance to show the depth of that love and respect. Edward Spriggs of the Studio Museum in Harlem mounted an exhibit of one hundred and eighty De Carava photographs titled Thru Black Eyes. Mr. Spriggs, the restrained and articulate executive director of the Studio Museum, called it, "one of the most important photo shows of our time." He was not alone. *The New York Times* accorded it rave reviews, and one photographer who knows De Carava's work well remarked that "Roy could have put together ten shows this size. Some of his strongest pictures are missing—things I kept expecting to see just never turned up. But that's the way Roy wanted it."

Thru Black Eyes was not hung by Roy De Carava as evidence of his virtuosity. He selected what he felt his people in Harlem would recognize and respond to as meaningfully interpretive of their daily life. As A. D. Coleman reported, in his aforementioned essay in *Popular Photography*,

The exhibit probed the sub-surface far more exhaustively than the Metropolitan Museum of Art's monumental disaster, Harlem on My Mind, in which De Carava was conspicuous by his absence.

But it was the reaction of Harlem itself to the Studio Museum show that must have been heart-warming to its native son. They came singly and in groups, the young, the old, those trained to know art and those who know only what they like. And they stood quietly before the work of a man who believes that the black photographer must make full use of his art. By full use he means more than the negative use of propaganda that damns the opposition. Roy means also that positive use of his art that enables it to speak to and for black people in a way that enriches their lives and lifts them to a level of true dignity.

Here indeed is a rare man and a rare artist. He summarizes his feeling about himself and his work in the least complicated terms.

You should be able to look at me and see my work.
You should be able to look at my work and see me.

Those who take the trouble to look do see. And what they see, in the parlance of all the nation's Harlems, is that *Roy De Carava has really gotten himself together.*

Chapter XII

FAITH RINGGOLD

There is a general feeling among lots of school people—too many of them—that art is not for kids who are academic minded. In addition to that there was the feeling when I was a child in school that art was not for black kids.

The speaker is a teacher of art at New York's Brandeis High School Annex. She also lectures at Wagner College and Bank Street College for Teachers, and she knows what she is talking about. Faith Ringgold has to know her business thoroughly. To have arrived where she is, she has had to hurdle the double barrier of sex and race.

I was Harlem-born and during my childhood things in Harlem were quite different from what they are now. Harlem was just beginning then to be a frightening place to be. But I had a strong mother and father, who were very strict and strong on education.

As Faith speaks in her crisp, clear manner, you are aware of a self-assurance mingled with a keen intelligence characteristic of many people of West Indian origin. You ask if her family has roots in the Caribbean islands and she rocks with laughter.

"No-ooo, honey. My folks come from Africa by way of Jacksonville, Florida!" She lapses momentarily into the re-

laxed speech pattern black brothers and sisters slide into
when they feel at ease with one another. You reply that the
immediate point of origin makes little difference, and she
laughs even harder. Close to the surface of Faith Ringgold's
well of scholarship, wisdom, and creativity lies an earthy
sense of humor. It is that as much as anything else that has
enabled this unusual woman to laugh at herself. She is capable
of yet another kind of inner laughter of equal intensity. That
she reserves for those white people who, meeting her for the
first time, often lose their composure.

Andrew and Willie Posey Jones had real ambitions for
their three children, of whom Faith was the youngest. Poor
as they were, they lived respectably, what with the steady
income Andrew Jones brought home from his job as a sanita-
tion worker. His wife, Willie, made all her children's clothes.
Today she is a recognized fashion designer, but thirty or
more years ago few people in this country had ever heard of
a black fashion designer. The very idea was offbeat, even
to blasé New Yorkers.

Because of the gangs in Harlem and the constant danger
and temptation they present to youngsters, Mrs. Jones walked
her children to and from school daily. It mattered little how
much the others laughed at them, the Jones children had an
escort as they entered and left school. It may have had its
trying moments for them, but it also kept them out of mis-
chief. Moreover, they were made to know the significance of
school. The classroom became the most important thing in
their lives, next to home. Their mother saw to that.

Although the Jones family lived on West 140th Street, the
children attended Public School 186 on 145th Street between
Amsterdam Avenue and Broadway. Faith laughs again as she
recalls that period of her elementary schooling.

My mother had her own open enrollment program in which
she enrolled us where *she* thought we should go. So we climbed
that hill on 145th Street every day to get to Public School 186.

There were a lot of immigrants from Europe with the same ambition for their kids, so in that regard we were in harmony with our schoolmates. The big deterrent came later when drugs took over and made addicts out of a lot of black kids. But since the schools were mostly white, there weren't large numbers of us who went that way then.

Faith never, during her grammar-school days, dreamed of being an artist. In the third grade she used to do blackboard murals, one of which she remembers to this day. It dealt with the war of the American Revolution and she used the illustrations from the textbook as a guide.

"I noticed that all the soldiers in the book were white, and the only black people were the little boys eating watermelon," she says.

I didn't like that and I mentioned it to my mother when she came to the school at lunchtime to escort me home. Mother, who knew there had been black soldiers in that war, spoke to the teacher and my mural underwent some changes. I kept the watermelon eaters in but I made some of the soldiers black.

Faith loved history class. In addition to drawing she was a good academic student. She was so good in fact that in junior high school she was a math tutor to slower pupils. But art was what she loved and it pleased her that she was the artist of her class. However, she noticed that in junior high school she was pulled out of any special art class she wanted to attend and given, instead, some academic chore. That alerted Faith Jones to the every-day attitude toward the bright child who preferred to draw. Such a child was discouraged by the teachers. Art, they believed, was for those they considered too dim-witted to do anything else. Such an attitude holds that one never has to work hard at being an artist since it is a "God-given-gift" requiring no mental effort. Many teachers actually believe that myth.

Junior-high-school students in New York who so desire may take the competitive tests for entrance to the city's specialized

high schools. The High School of Music and Art, established during the administration of Mayor Fiorello LaGuardia, is one such school. Not only does it admit children with special aptitudes for music and art, but it demands that those students be well above average in general academic studies. Faith Jones qualified as a girl who should have taken the entrance test. Her ability in art was as recognized as her academic ability. Certainly she had been exploited for all she was worth by every teacher in her school who ever needed a drawing. Yet no one told Faith when or where the tests would be held. When she did finally hear about it she was already enrolled in another school.

Getting into the "right" high school had great meaning to conscientious Harlem children and their parents. For many years, because of unstable family situations and all of the ills accruing therefrom, many children of the area have never adjusted to the school program. Teachers assigned to Harlem regarded the community as the "Siberia" to which they could be banished for displeasing a superior. Most Harlem teachers during Faith Jones's childhood were white. In all her years as a student she, like John Wilson of Boston, never had a black teacher.

Many teachers in Harlem automatically assumed that most black students would not do well in an academic high school. Guidance counselors invariably and indiscriminately shunted them off to vocational high schools unless alert parents intervened. Even so, the vocational schools would often bar black boys from such areas of specialization as gas and Diesel engines and aircraft. Their defense for such actions was that industry and the unions would never admit blacks even with the training. Such were typical of the "benevolent crimes" committed against Harlem schoolchildren by representatives of the city's system of education.

In Faith's case, however, the crime was one of omission. Because nobody at her junior high school thought she, a

bright black student, should be studying art, she was allowed to miss a chance that could have placed her in one of New York's finest high schools. Faith has never forgotten that negligence.

"George Washington High School in 1945 maintained high academic standards," she recalls.

It was also very racist—very bad for blacks. The paper and the yearbook they published were completely closed to black student contributors who wanted to draw or write. Judge Hubert Delaney's daughter had been graduated several years before my time, and her father demanded representation of black girls in the school's activities. He did force a change in the traditions, though I can still see that traditional lily-white procession of girls led by those wearing Martha Washington wigs.

She was in her senior year at George Washington High when Faith, with excellent grades in all her subjects, decided to be an artist. Although her mother expressed disappointment, Faith had already set her sights on Pratt Institute. Fees at Pratt, however, are high, and with an older sister at New York University the family could not afford to have two girls enrolled in expensive schools. Faith had to settle for the College of the City of New York located in Harlem close to the grammar school she had attended as a child.

My earliest impression of C.C.N.Y. is that of seeing these hordes of young men, mostly white, coming up out of the subway at 145th Street and Saint Nicholas Avenue. As my mother walked us to and from our school nearby I would ask her who they were. No one ever dreamed of the day when women would be going to the liberal arts school of City College. Women went to Hunter College!

Faith is correct. Though one of her daughters now attends the liberal arts school at City, women in 1948 were limited to attending the school of education. When Faith filed application at City College she told the authorities she wanted to work for the bachelor of fine arts degree. They replied that

she would have to settle for a bachelor of science in education, and she turned to Hunter College. But Faith didn't really like Hunter and she returned to City, resigned to prepare for a career as an art teacher. Removed as it was from her original plan of training for a professional career in art, the choice was better than nothing.

Male chauvinism was rampant at C.C.N.Y. when Faith entered. As she puts it today, "The idea there was that this is a man's school—a superior institution of outstanding men; and that meant white men!" But there were black men at City College too. And the fact that they got through there meant that they had produced. Of those whom Faith remembers there was Alvin Hollingsworth, a gifted artist, and a brilliant scholar who currently hosts a weekly TV art series in New York. Al Sargeant was there, as was Andrew Donaldson, now a district superintendent for New York City schools. Donaldson had preceded Hollingsworth at C.C.N.Y., as had Charles E. Allen, presently a department chairman and supervisor. But the enrollment of a few such outstanding black males neither dissolved racist attitudes nor prepared a rosy bed for Faith Jones.

During her freshman year Faith was surprised to receive the lowest possible passing grade in drawing. It irked her because she had been given no indication by the teacher that he considered her work just barely passing. When she asked him about it, he replied that in his opinion she plainly and simply could not draw. On the other hand the teacher of painting had suggested that her proficiency in drawing was interfering with her progress in painting. Later, the drawing teacher did apologize to Faith for his error in judgment.

I knew from that day on that my study of art, alone, was going to be a struggle. And to this day when someone asks me if I think so-and-so has real ability I reply that I don't know. What I look for in a student is stick-to-it-ive-ness. If he has that then I feel certain he'll do something of worth. But I reject this business of

brushing off a conscientious student because what he is doing does not appeal to me personally. I must say that no one at C.C.N.Y. did anything to stimulate me creatively.

Faith took more than twice as many credits in art than in education at City College. Actually, though her degree reads "Bachelor of Science," her major preoccupation at college was with art. She was graduated in 1955 and licensed to teach art in any New York City high school. In the interim she had married, had her first child, and returned to finish college three years later than originally planned. That worked decidedly to her advantage inasmuch as her added maturity was just what she needed on her first teaching assignment.

She was Mrs. Faith Wallace now, assigned to Public School 136 in Harlem, a junior high school for girls. Public School 136 is a notoriously difficult school. It was tough thirty years ago, what with lesbianism and the unhealthy relationship between some of the girls and the police. Still, many thoroughly decent Harlem girls have gone through that school wholly unspoiled by its less savory characteristics. One of its illustrious graduates is Miss Ruby Dee, certainly one of the distinguished ladies of the American theater. Faith worked at 136 for one year before deciding that it simply was not her type of school situation. By this time she and her husband had separated and she saw every good reason to unload all her troublesome problems at one time. Casting them out of the way, she embarked upon a new start.

With a license authorizing her to teach in high school, Faith set out to do just that. But being placed was no easy thing for her. To begin with, everybody in the field reminded her that the pressing need was for teachers at the lower grade level. That, she soon discovered, was true. White teachers found placement easier in the lower grades. And then, of course, there were the persistent reminders from black friends in the teaching profession that black teachers in New York's high schools were rare. Faith knew they were right. Still she

could not, or would not, believe that in a city the size of New York there was not *one* place where her services were needed.

She haunted the Bureau of Art until they at last suggested three places. Two were in Brooklyn and the third was in the Bronx. Each was having severe behavioral problems. In following through on the Bureau's suggestions, Faith discovered that making appointments on the telephone to see the principals was easy. After all, she had easily passed the oral part of the test given by the city's licensing board. And when a black candidate in New York City achieved *that* a few years ago, he or she could easily have qualified for radio announcing on any of the major networks.

"Why, yes, Mrs. Wallace, we need an art teacher. Please get in to see us as soon as you can." That was the tone—before they saw Mrs. Wallace. "The first person to greet me was shocked," she says, laughing. "And when he or she would go off to bring in the chairman of the art department I braced myself for another expression of shock. Result: no job."

Before she went out to Tilden High School, Faith had a frank talk with the principal of Public School 136. Laying her case straight across the board to him she asked a special favor. "I understand and *you* understand that there are few black teachers in high school and the chances of my getting in are slim—even though my license qualifies me for that job."

Then, without a trace of hesitancy, she posed her question: "Will you promise me that when the principal calls you from Tilden you will give me a good reference and not cop that old plea about how badly you need me here?"

The principal of Public School 136 promised. She laughs. "I guess the poor man was glad to get rid of me, but in all fairness to him he was a good man. He could have stopped me cold and he didn't."

A less understanding reception awaited Faith at Tilden High School. The principal, obviously surprised, made no

verbal committal about the vacancy but immediately went to his telephone and called the chairman of the art department at the latter's home. The art chairman happened to be mowing his lawn. "Get over as soon as you can," the principal urged in low, excited tones. "I've got someone here for that art job." The principal never mentioned a thing about Faith's color or sex but the urgency in his voice brought the chairman to the school in a remarkably short time.

"The man came puffing in the office with the grass still clinging to him," Faith recalls. "In his confusion he denied there was an opening in his department even though he had previously stated by phone not only the need but the urgent need for a teacher."

Faith Wallace was furious. She wasted no time arguing with the two befuddled men but went straight back to the Bureau of Art. There, in a quiet manner, she made it known that she was ready to forego the quest for a job and devote her time and energy to exposing the situation. The choice, she let them know, was theirs. They could either give her the job for which she was professionally and legally qualified or they would have to answer charges of rank discrimination. And she would make the charges public.

At that particular time the civil rights movement was rising to its crest. News stories and pictures were appearing in periodicals all over the nation and Northern communities were especially sensitive about being publicly tied to charges of racism. Faith Wallace knew that. She was quite willing, if pushed any farther, to do a little pushing of her own.

Though she had revealed no details, her battle had been well planned even before she had begun to experience any trouble. Her mother, from whom she had learned to stand fast, was ready to give her daughter and two grandchildren full support for as long as it might be needed. The officials at the art bureau were convinced that this young black woman was not bluffing. They immediately sent her to John

Jay High School in Brooklyn, where she was greeted by the
chairman of the art department, Max Greenberg. His first
words to Faith were, "Come in. You're hired!" That is the
kind of man Greenberg was—no frills, no wasted words or
motions.

In New York City's high schools there are only a certain
number of slots for teachers in a special subject area. The
opening at John Jay High School in Brooklyn was for a
teacher of mechanical drawing in the industrial arts depart-
ment. Because there weren't enough teachers of the subject
to fill all the slots, Faith was asked to teach mechanical draw-
ing for one period each day. She carried that along with her
other art courses. Max Greenberg, who himself was an alum-
nus of C.C.N.Y., knew the kind of preparation Faith Wallace
brought to his school. During that first year Faith herself
came to know how well trained she had been.

Max Greenberg had heard all about the trouble Faith had
been through before she came to work for him. One of the
first suggestions he made to her was that she prepare herself
to take the supervisory examination.

"He was the first person ever to say such a thing to me," she
asserts.

And he encouraged me in every way, constantly blocking the in-
cidents, or would-be incidents, of racism so prevalent in most of
the public schools of New York.

There was, for instance, the problem of who the black teacher,
or teachers, in such a white-dominated situation would eat lunch
with. Max would create the atmosphere in which we could all
move and be relaxed. Our approaches to art were so different
and yet I had such respect for him. Max Greenberg was a sensitive
and kind and beautiful man.

After four years at John Jay, Faith left to teach at Junior
High School 113 in the Bronx. Again she was working with
a good principal. Between what she had learned from Green-
berg and the principal at Public School 113, she was handling

her schoolwork smoothly enough to carry on with painting after hours at home. Faith could draw well. But she could not make a picture that suited her, particularly when she left watercolor and ventured into oils. She knew that she needed more study, so in the summer of 1961 she gathered up her young daughters and her mother and set out for Europe.

Paris, Rome, Florence, Switzerland! She looked at all the great art she could find in those places. David, Titian, Caravaggio, and Picasso were particular targets. She didn't attempt to do any work, but first looked, and studied what she saw. Upon returning to school in the fall she resolved she would have to do some creative work during the school year. This time she had help. "By now I had married again, a musician, Burdette Ringgold, a man who understood what I was trying to do. He not only encouraged me—he pushed me—even goaded me into producing works in oil on canvas!" Two years later and Faith Ringgold was well into painting. Moreover, she was mentally formulating what she wanted her paintings to say about black people.

The summer of 1963 was a turning point for her as a painter. Faith packed her canvases and oils that year and went, of all places, to Oak Bluffs, Massachusetts. Oak Bluffs is a popular summer retreat for middle-class blacks who play poker and consume quantities of brand-name liquors. It is hardly a spot where one would expect to find a serious artist.

"I was well aware of the superficial social activities that go on up there," Faith says, "but that posed no problem for me. Along with my painting equipment I took Baldwin's *Notes of a Native Son* and during the summer weeks I began this present style of painting I had been wanting to do."

What Faith Ringgold wanted to do was to paint black faces and black bodies in a manner that was positive and full of meaning to blacks. However, her arrival at that kind of statement was, in the beginning, torturous and roundabout. Out of those efforts came her American People paintings,

begun after the summer at Oak Bluffs. They were dominated by the satirical paintings of white Americans that she refers to as "my paintings of Charley." Included also in the series are interpretations of middle-class blacks, like those at Oak Bluffs, and interpretations of black men who prefer white women. Faith painted those between 1963 and 1967. Then she stopped short.

"I found that 'Charley' was upsetting me terribly," she says. "Then it occurred to me that I didn't need to paint Charley and hang him up in my studio so that his image could be constantly intimidating me. What did I need to do that for?"

She then began to see that it was important for black people not to continue accepting the white image as one of glory and supreme beauteous grandeur. Nor should she, as an artist, paint black people being brutalized and burdened down by the problems of white people. And even as she was arriving at those conclusions, Faith noted that black reaction to her satire on white people was not positive but crucially negative.

It was as if black viewers regarded even her bitterest statements on "Charley" as undeserved approval of whites. In verbalizing the group's feeling in the area, Faith astutely reasons that "We know what white people look like, because we're constantly watching them. They pay little attention to us and they're not at all sure what we look like. But we know them inside out. Only by knowing them so well is it possible for us to live with them and in spite of them." Again the artist was readjusting her point of focus.

Faith Ringgold presently addresses herself as a painter primarily to black people. Indeed she finds that her "black paintings," in which white never appears, are upsetting to many whites. She laughs. "In our society people are geared to think that what one sees easily is more to be trusted than that which is more difficult to see. White people are more highly visible than black, and because our details are more subtle

and require more study than theirs, this annoys and frightens them." But Faith regards that as the white man's problem that he must solve for himself. She, a black artist, assumes the task of dealing positively with the blackness of her people.

The "blackness" of today's Afro-American, particularly the Afro-American youth, is far more than skin deep. Indeed it need be that way since we black Americans at large and en masse are no longer the *skin*-black race of our forebears. That was altered when the first slavemasters fathered the children of their black slave women. And as those children became the slaves of their white fathers, they never ceased to be the sons of their black mothers and the half brothers of their mothers' black children. In short, they too were black. So today the blackness of Afro-Americans is not a matter of pigmentation but one of a condition and an experience. It is to that blackness especially that many black artists and writers seek conscientiously to give expression in their uniquely personal ways.

Faith Ringgold's "black paintings" are no new approach to modern expression. The late Ad Rinehart used a low-keyed palette, so also at one point did Jackson Pollock. After working for more than two years in her new manner, Faith felt she was ready to show.

"I got all the reactions as I painted with black that white people must get in trying to deal directly with us—the fear, the uncertainty—the inability to handle the details of it with ease . . . *because it is hard to see!*"

She feels that her last show, America Black, was disturbing to a number of whites because, as Faith puts it, "those paintings are dealing with black people and that excludes them. White people, not used to being excluded, find that hard to take."

Still, the artist discovered that white patrons were buying her black paintings. Moreover she was learning that she and many other artists were being victimized by other kinds of

prejudices within the community of black artists itself. The least important of these was the attitude of those who want to be in the mainstream of American painting. They regard "message painting" and "ethnic painting" as irrelevant to aesthetics. So when they assemble shows they don't bother to invite message painters like Faith Ringgold and Benny Andrews or ethnic painters like Charlotte Amévor and Ernest Crichlow to participate. But the mainstream black painters are not, in Faith Ringgold's view, the real menace.

It is that group of male black artists and directors of black shows who, in her opinion, systematically exclude black women, who must be called to task. Noting what she and many others consider a not-too-accidental dearth of black women participants in many of the shows, Faith concluded that someone would have to start "pushing."

"We have learned from experience," she declares, "that you can be a nice acceptable person who speaks in modulated tones and who produces good work and nobody will let you into things for those qualities alone. You have got to push. You've got to make a statement."

During the summer of 1970 Faith and a few others formed their own group, Women Students and Artists for Black Art Liberation. The organization of activist students, supported by women artists, seeks to make certain that black art shows of the future have a 50 percent representation of women in them. New York City's museums in particular are being closely scrutinized by this and other black artist groups seeking fair representation in exhibitions.

Faith Ringgold has been seen on New York television programs and quoted in the New York press with recurring frequency during 1971. Statements of hers that seem harsh and inflammatory to some are but reflective images of her own searing experiences. Doubtless she would remind critics that the conditions forcing her own mother to push her and the others into the best available grammar schools were also

harsh. Nor has she forgotten how it feels to be assured there was a job waiting at a given school only to be told later, when appearing to claim it, that "a mistake" had been made. What the Faith Ringgolds of America are, America has made them. It is as simple and as indisputable as that. So Faith continues to stage her personal forms of protest and to handle her classroom duties at Brandeis High School.

In addition to her work as a public-school teacher, she lectures on contemporary black art at Wagner College and conducts her aforementioned workshop and lecture course for teachers at New York's Bank Street College. A woman of tremendous physical energy, she continues also to paint.

Four years ago Faith made the following statement about her art:

My painting is a comment on truth and observation. As James Baldwin wrote, in *Notes of a Native Son:* "The artist is the only member of a society who can afford to tell the truth about it." As an American Negro painter I am involved with the truths of this great American scene, which is predominantly black and white and powerful.

The statement is simple and direct. It is also an apt description of the best of Faith Ringgold's creations on canvas.

Chapter XIII

EARL HOOKS

> Baltimore, where Carroll flourished
> And the fame of Calvert grew.
> Here the Old Defenders conquered
> As their valiant swords they drew. . . .
>
> . . . Here the hearts that beat forever
> O'er the city we adore.
> Here the love of men and brother—
> Baltimore, Our Baltimore!

Those are the opening and closing lines of an anthem thoroughly familiar to all Baltimoreans of middle age and over. Perhaps Baltimoreans still sing it, I don't know. But fifty years ago many public meetings in the monumental city were not considered properly opened until its participants had first dutifully stood and sung, "Baltimore, Our Baltimore."

Obviously the lyrics had great meaning to the majority of my fellow townsmen, for they identified with "the city we adore." They firmly believed that here existed "the love of men and brother." I didn't. I am not sure if Earl Hooks did or not. But I am sure that as a black fellow Baltimorean he knows full well that "Baltimore, Our Baltimore" could not have been seriously written for its black citizens.

Its flaws and limitations notwithstanding, Baltimore has virtues and commendable traditions too. And they have been nourished and kept alive by its unusual citizens. One of the latter was James Cardinal Gibbons, a native of the city, who became one of the outstanding princes of the Church. From 1886, when he became Cardinal, until his death in 1921, Cardinal Gibbons maintained unusually cordial relations with Protestants. Moreover, his successful defense of the Knights of Labor, condemned in Canada as detrimental to the confessional, is well known to historians of American labor.

The Pratt Free Library, founded in Baltimore by Enoch Pratt, a New England-born merchant, was for many years one of the city's few nonsegregated public municipal services. Nonwhites have always had free access to its facilities on an equal footing with whites. Gibbons and Pratt and many other less widely known but no less dedicated persons have performed admirably in Baltimore. Their presence, as shall be shown, made it possible for Earl Hooks and others like him to move ahead into areas where they could make contributions to human betterment.

Earl Hooks was born in Baltimore on the second day of August 1927. It was on that very day, out in the Black Hills of South Dakota, that taciturn Calvin Coolidge shocked the nation with the announcement, "I do not choose to run for President in 1928." A few months earlier, March to be exact, The Associated Negro Press released a statement in Washington that read:

Not a single measure which might be construed as of special benefit to the race group was passed in the Sixty-ninth Congress, according to an analysis made of its proceedings this week.

Maryland's governor, Albert C. Ritchie, was asked by the *Baltimore Afro-American* newspaper if he would approve funds for a training school for mentally handicapped black children. He replied: "I doubt very much if there are a

sufficient number of mentally deficient colored children in
the state to justify the building of a separate institution for
them."

The year had just begun. The same newspaper, dated
January 1, 1927, editorially hailed the advent of a new deal
for Baltimore's black secondary-school teachers. They were,
quoting from the editorial,

 . . . to receive the same stipend paid other secondary teachers
in the city. Thus ends an effort begun nine years ago to improve
secondary education in the city by removing one of the sore spots
annoying the teaching force.

Earl Hooks speaks quietly as he recalls his parents and the
area of town the family lived in.

My mother was a native of Baltimore and my father was a
North Carolinian. We lived in a little street very few people re-
member now, China Street. It was a very tiny street in South
Baltimore and all of its residents, like us, were very, very poor. I
was the oldest of my parents' seven boys and four girls.

Baltimore had three or four "colored sections" spread out
over various parts of the city. Northwest Baltimore's black
middle-class of the late 1920's liked to think of itself as living
in the "best section of the city." They were, however, roundly
disputed in this by a few black residents of venerable East
Baltimore. But the section of town known as South Baltimore
never figured in such rivalry. True, South Baltimore, like
East Baltimore, was settled in the early days of the city's
history. But whereas the latter is thought of as "venerable,"
the former is regarded simply as "old" and poor. For many
years Baltimore's poorest whites have lived in South Balti-
more. It was the illiterate and economically oppressed whites
of that section who contributed heavily to the city's reputa-
tion that earned it the unsavory nickname, "Mobtown."

South Baltimore was the city's waterfront section and it
was also where the Baltimore and Ohio Railroad maintained

one of its two passenger stations. Transients of South Balti-
more, mixed in with its permanent residents, lent the area an
interesting ethnic face. Italian, German, Russian, Irish, and
Afro-American inhabitants created there a miniature version
of the legendary American melting pot. No other section of
town was quite like it.

Poverty was only one of South Baltimore's afflictions. Fear
and massive ignorance were equally formidable companions
of the poor. Blacks, especially, who lived in other areas of the
city, were loath to venture into South Baltimore because
they could count upon having to fight or run their way out
of it. At the same time the dreaded section had its own small
pocket of black citizens. If their white neighbors were poor,
the blacks were superpoor. If the whites lived in poor, run-
down houses, the blacks lived in dilapidated shacks. Their
streets were narrow and dark and with few exceptions their
existence consisted of one crisis followed by another.

The South Baltimoreans' penchant for rough deportment
did not confine itself to its poor white residents. Black school-
boys of the 1920's have vivid memories of the fist fights and
brick battles they found themselves embroiled in with their
"brothers" from South Baltimore. These occurred regularly
following all intersectional athletic contests. Indeed it was
axiomatic that if you won the game you'd surely lose the
battle. And it mattered not if you were the hosts or the
guests. When your opposition lived below Baltimore Street,
the dividing line separating north and south sections of the
city, you were in for a rough session. Such was the tone of
the area of Baltimore Earl Hooks grew up in.

When he was a boy in grammar school Earl's mother was
delighted to discover his love of drawing. She, too, had
always drawn and had entertained dreams of becoming an
artist before she married. Now, with a husband and eleven
children, she could only hope that, through Earl, success and

happiness in creative art would still touch her family in a meaningful way.

Earl was barely eight years old when an elementary school teacher spoke to his mother about a special art program at Baltimore's dignified Walter's Art Gallery. There classes for children were conducted on Saturdays. And there were a few scholarships available to those especially talented children, too poor to pay the fee. Earl and his mother were excited about the news, and she saw to it that her son and his work were seen at the gallery. Their joy was complete when Earl was given a scholarship and admitted to the class. He was getting a rare opportunity to begin the study of art at so early an age.

Before he was ready for high school Earl Hooks had a familiarity with art completely unknown to the majority of poor slum youngsters. Moreover, by the time he reached the seventh grade he was adept at building model airplanes. Through a teacher who had stimulated interested boys to form a club of plane model builders, Earl had met another boy whose love of planes was as keen as his own. Ralph Matthews, Jr., was that other boy.

Ralph lived uptown in Northwest Baltimore. His father was a well-known reporter and columnist for the *Baltimore Afro-American* and his mother was a teacher. Ralph and Earl liked and respected each other immensely. Their mutual interest in planes, along with membership in the club, crystallized a friendship that still exists. So when Earl entered high school the Matthews family invited him to live in their home.

The original Frederick Douglass High School, built in northwest Baltimore between 1925 and 1926, was for many years the city's only secondary school for black students. The latter had to get there from all sections of town. Earl's mother, conscious of the great distance her son would have to travel from home to school each day, consented to his

moving uptown with the Matthews family. It proved to be a sane and a mutually beneficial maneuver.

As a small boy Earl Hooks had learned the value of work and frugality. Like thousands of American boys, he sold newspapers and did other odd jobs that brought in enough money to be of significant help to his big family. Now with his skill in making model planes he could cast about for more lucrative work. But where? The downtown stores of Baltimore where his services would be needed certainly hired black youths as after-school part-time employees. But they were porters and stockroom boys, safely inconspicuous in their traditional roles. Never had any white customer threatened to take his business elsewhere because of the presence of black boys mopping floors and toting bundles. But who would hire a skilled black demonstrator in a downtown department store?

There was such a man, however, with sufficient acumen and courage, and he hired both boys at once. Earl Hooks and Ralph Matthews worked for him after school and on Saturday selling plane models and demonstrating the building of them. Most of the models they built were put on display in the lobbies of movie houses around the city. They were particularly useful in attracting moviegoers to films treating aerial warfare themes.

Earl was a high-school freshman when the Japanese attacked Pearl Harbor. "Because of my experience with model building and selling at the store downtown, I was given the task of demonstrating the craft up at the high school," he says.

In fact I taught the class in plane model-building there as part of the program of civilian defense. This was meant to teach others how to spot quickly Japanese and German planes that might launch an air attack against the country. The models Ralph and I made measured from twelve to fifteen inches across the wings. It was a very exciting experience for me then to be doing that sort of thing so early in life.

But Earl Hooks, meanwhile, had by no means abandoned drawing and painting, even though the high-school art program was a disappointment. A plan to establish an art major program at Douglass High School never materialized, since registration for it was not sufficiently large to warrant it. Earl went along with what was offered. With the encouragement of art teacher Pendleton Parrott, he was able to keep his interest alive right up to graduation in 1945. Since he had been working after school as a toolroom boy in a local defense plant, Earl went on full time at the plant as soon as he finished high school. His mother was struggling with the younger children and he went to her aid.

With the end of the war, cutbacks in defense plant industries forced Earl to look for new work. He found it in the office of the Supreme Liberty Life Insurance Company, where for a year he sold insurance. By this time he was his family's sole dependable male support. He even became a permanent substitute postal clerk, and while he was doing a great deal to help his family, nothing was happening with his art. The pressing need for money had taken him forty miles from home to Washington, where he was employed by Howard University. Something had to give. The drain on Earl's energies was too great and he fell seriously ill.

Friends he had made along the way, however, had not forgotten him, and the Matthews family were solid friends. Mrs. Matthews saw to it that he was promptly admitted to Freedman's Hospital, an affiliate of the Howard University Medical School. There, after ten months of the best available medical care, Earl was discharged, a far healthier young man than when he had entered.

He soon discovered that he was eligible for scholarship aid that would train him in the skill to which he was best adapted. To determine what that skill was Earl was tested and the results clearly showed his aptitude for art. Since it was standard practice, however, to place most black appli-

cants in training for the least skilled occupations, Earl found himself being railroaded. Again Mrs. Matthews, with her contacts, interceded on his behalf. The officials conceded that Earl's skills were in the area of art. But since they did not consider art a "practical" course, they finally ruled that he could study to be an art teacher. "So in 1949," Earl recalls, "I elected to do my study at Howard University. There my teachers in the studio courses were James A. Porter, James L. Wells, and Lois Jones. Of course the whole art program was under the leadership of James V. Herring."

Remembering the months he had been a patient at Freedman's Hospital, Earl Hooks, still studying at Howard, also did volunteer work in Freedman's division of occupational therapy. He had come to know Catherine Pitchford and Naomi Wright, who opened the facilities of the pottery studio to him. The hospital was so well stocked with equipment for throwing and firing clay that Earl's interest in pottery grew rapidly. He wasted no time or opportunity in developing the potter's skill. For his entire period of study at Howard, Earl worked at the potter's wheel after his other classes were over. The same enthusiasm and intensity of study he had formerly devoted to the building of model planes now went into this newly discovered art form.

I began to do well enough with it to be represented as a potter in a show of work by Howard teachers and students which I myself had organized. Then I went to work nights, after my studies at the University, as a crafts instructor for the Department of Recreation for the District of Columbia.

Upon Hooks's graduation from Howard he was invited to teach at Shaw University in Raleigh, North Carolina. Samuel Green, who was handling the art there, had to be away for a year and Earl was his replacement. It was during that year that one of those unplanned and completely unexpected experiences took place. It was the kind of occurrence that

happen in the life of every creative person if he is to have any measure of success.

Harold Brennan, administrator for the School for American Craftsmen, happened to see some of the work Earl Hooks was doing. Mr. Brennan was traveling about the country stimulating interest in the crafts movement among schools and colleges. While in Raleigh he stopped by Shaw and there he met Hooks. Earl will never forget the meeting.

I was quite surprised to find the man interested enough in what I was doing to invite me to his school in Rochester, New York. So at the end of my year at Shaw I went on to Rochester where I spent a year studying in the graduate division of the School for American Craftsmen. It was immediately after that experience that I headed for the Midwest, landing in Gary, Indiana.

The year was 1955. Earl Hooks had visions of accomplishing great things in Gary, little aware at first of the city's relatively brief and troubled history. But he was soon to learn that the interest in his work that he found among the affluent residents of nearby Hyde Park, Illinois, did not obtain in Gary. The rough-hewn Indiana city so close to Chicago was made of entirely different stuff indeed.

Gary, named for Illinois lawyer and industrialist Elbert Henry Gary, in 1906, actually was born in 1905. That was the year its land area was bought by the United States Steel Corporation. Located at the southern end of Lake Michigan and not more than twenty-five miles from Chicago, Gary has become this nation's number one steel center. During its earliest days United States Steel relied upon the work force of illiterate and semiliterate Hungarians, Serbs, Poles, Czechs, Slovaks, Croats, Greeks, and Italians, whom it had imported. For a while all went well. Then the laborers decided they deserved more for their work and when they hadn't received it by the end of World War I they struck. The steel corporation responded by hiring hungry, poorly paid, black migrant farmworkers recently arrived from the Deep South.

United States Steel had scored a coup. Not only had it broken the back of the strike, it had simultaneously created a rift between the white and black labor groups. The possibility of their combining forces and creating a confrontation with the powerful company had been rendered remote and unlikely. Indeed, the suspicion and hatred between black and white engendered by that strikebreaking action have never been eliminated from the Gary scene.

In addition to that, Gary's political history has been notoriously sordid. Its very first mayor, Thomas Knotts, was arrested fourteen times for corruption during his two years in office. At a later time Mayor Daryl Johnson served four years in prison, and came out only to be returned to office! In the two decades that followed, Gary, with corruption oozing from every city department, had more than earned its nickname, Sin City of the Midwest.

Gary's black citizens, meanwhile, were faring badly. Of the city's 135,000 population for 1950, half were black. They held the lower-paying jobs, and less than one fourth of all city employees were black. While the city covers an area of fifty-six square miles, its black residents were compelled to live cramped into a tiny space approximately *one ninth* of the land area! What it took a report of an Indiana state civil rights commission to bring to the attention of Gary's municipal authorities, any black Garyite could have told them, had they been willing to listen.

It came as no surprise to anyone in Gary who could see and hear, when, in September 1954, trouble erupted in the predominantly white secondary schools. It started at the biracial Froebel High School. Nearly one thousand white students, egged on by their parents, walked out of school in protest to the presence of the schools eight hundred black students. Within three days four other white high-school groups staged protests. They demanded that all black students be sent to the all-black Roosevelt High School—an impossible

demand inasmuch as Roosevelt was already bursting its en-
rollment seams.

To the credit of Gary's school superintendent, as well as
the principals and teachers involved, black parents were
urged not to give way to the racist-inspired demonstrations
instigated by outside adults. And Gary's black students re-
mained in the schools they were attending. A few months
later, Earl Hooks became a teacher and an art consultant in
the Gary public-school system. His duties were to establish
him in that Midwest city for the next twelve years.

During his first year in Gary, Earl upset the city's provin-
cial tranquility by opening the Studio "A" Gallery. He speaks
reflectively now of that initial contact with Gary's white
artists.

It didn't take me long to learn that the white artists of Gary
were provincial and therefore fearful of any intrusion. In my
case the intrusion was doubly feared. So I didn't want to be
bothered at first when I saw how personal their attitudes were and
how upset they were as they faced the prospect of dealing with
a black man at a professional level. But whatever else I lacked,
I had by then developed a sense of inner security that helped
me properly evaluate them and then evaluate myself. So I cast
aside my personal misgivings and went to work at the job I had
resolved to accomplish.

Ignoring the petty slights of the others, Hooks personally
helped with the manual labor involved in readying the
gallery workshop for use. Meanwhile, the news media, par-
ticularly television, alerted the public as much to the petty
character of the opposition as to what Earl was trying to
establish. "I suppose that forced a move on the part of the
whites," Earl says. "I finally signed the deed, became a mem-
ber of the board of trustees, and was recognized as one of the
prime movers of the group."

Hooks then attempted, without much success, to get other
local black artists and craftsmen to join the group. Again the

maturity he had begun to develop early in life as the partial family breadwinner enabled him to bear with his less certain black brothers and sisters in Gary. "Even though I assured them that they could have been voted in without trouble, I realize how much easier it is to shun anything that could be unpleasant. After all, our experiences have been quite rugged in such things."

The Studio "A" Gallery closed after a year of valiantly struggling to stay alive. Obviously, while Earl Hooks was quite ready for Gary, the city was by no means ready for him.

Another group, however, was. They were the Midwest Designer Craftsmen, an organization encompassing thirteen states. Their broader base had brought Earl's skills as a potter well within their orbit. The artist had already shown at the Smithsonian Institute, the Miami National Exhibition, the Rochester Memorial Art Gallery, and America House in New York, before he arrived in Gary. Once there he took second prize at a show at Indiana University's John Herron Art School, and he was represented in another show at the Washington Art Center at South Bend, Indiana. In 1957 the Midwest Designer Craftsmen's show at the Chicago Art Institute exhibited Earl Hooks. So it was natural that the thirteen-state professional organization would welcome Hooks into its membership. It went even further than that, as Earl humorously recalls.

To this day it is a joke between my wife and me that M.D.C. elected me to the office of treasurer rather than to the office of president. You see, certain members of that interstate body traveled quite frequently. And there were hotels and private clubs that didn't relish the idea of accepting black guests. Had I been made president of the group, as a few had suggested, I would have doubtless been denied certain accommodations in certain places. But, I was the treasurer, man! I held control of the money, and nobody was going to mess with me as long as I was writing the checks! So because I had to be on hand at all times and in all

places where the group's money was being spent, nobody with whom we were dealing was about to haggle over my color.

He does not hesitate to add that there were members of the black community who were suspicious of the apparent ease with which he seemed to be moving in "white art circles." As the great novelist Thomas Hardy made so clear in his works, human beings, when they can't understand, choose to—indeed prefer to—believe the worst of another's actions. Earl never let the unpleasant and inaccurate whispers and speculations of his own people bother him any more than he had been deterred from his objective by fearful whites. "I knew exactly where I was going and I kept moving," he says.

In his twelve years in Gary, Earl Hooks gathered honors as he taught and worked at his craft. The Northwest Campus of the University of Indiana employed him as a teacher of ceramics and drawing. During 1960 alone he won three awards. One (the first prize) at Indiana University; another (the third prize) at De Pauw University; and the third (a purchase prize) at the South Bend Art Center. Moreover he was elected vice-president of the Gary Artists' League. He has been accepted in three Syracuse biennial shows between 1961 and 1966, and has taken five additional Indiana prizes between 1964 and 1965. Then, in 1967 Earl Hooks, following the invitation of David Driskell to join the fine arts faculty at Fisk University, ended his stay in Gary.

The nation was in racial turmoil. A riot in Detroit, Michigan, during the summer of 1967 lasted for five days and resulted in forty-three deaths and hundreds of injuries. Sections of the riot area were burned to the ground. At almost the same time, rioting and burning in Newark, New Jersey, occasioned by the city's indifference to its black ghetto, brought death to twenty-three and destruction of property amounting to ten million dollars. Many Americans, conceding that race relations in their country were not good, insisted that South Africa's apartheid was far worse. They

were disputed by a talented young black south African who spoke his mind to a writer for *The New York Times*.

Ernest Cole is more than a photographer. An artist with the camera, he is the author of *House of Bondage*, a searing exposé of apartheid. His uncensored tour of virtually every area of the United States was made possible by a grant of six thousand dollars from the Ford Foundation. When Cole talked later to reporter Alden Whitman of *The New York Times*, he was quoted in the December 11, 1967, issue as having said the following:

I was very much surprised to find bitter white racism in America. I had been told that being colored didn't matter at all in the United States—outside of the South, that is. But everywhere I saw racial attitudes that were very much like those I know from South Africa! Harlem [he declared] hasn't been much of a surprise to me. After all I know the Harlems of Pretoria, where I was born, and of Johannesburg. The only difference is that there are automobiles in the New York slum.

Mr. Cole had significant thoughts on his tour of the rural South.

I was more scared there than I ever was in South Africa. In South Africa I was afraid of being arrested; in your South, when I was taking pictures, I was terribly frightened of being lynched. I was told to expect discrimination, but the actuality was worse than I had imagined possible.

The young South African artist was speaking of the same general area to which Earl Hooks had recently moved with his family. The century-old Fisk University in which Earl was now working had fully earned its reputation for venerable and respectable American middle-class conservatism. Fraternity and sorority life and activity in the old traditions are still much alive on the campus. Fisk women, many of them strikingly beautiful, still cast hopeful eyes at the young men laboring away next door at Meharry Medical College. Students wearing Afro hair styles and clothing were noticeably

in the minority in the late 1960's. There was, nevertheless, a small group of students there who were mature, serious, and aware of what was happening in the world. It came as no shock to them to find that in spite of the Fisk façade of traditionally correct and acceptable deportment, its grounds and its students were not immune from police harassment.

In March of 1967, neighboring Vanderbilt University had invited Martin Luther King, Jr., and Stokely Carmichael to join white speakers in one of its Impact Symposiums. The local news media set up a dismal howl. Chaos, they grimly predicted, would result if those two, especially Carmichael, were allowed to speak at Vanderbilt. Special police security measures would be necessary, it was said, and Vanderbilt was urged by the press and outside officials to call off its plans. But Vanderbilt stood firm. Meanwhile, both Fisk and Tennessee Agricultural and Industrial prevailed upon Carmichael to address their student bodies while he was in the city. Stokely consented.

The local prophets of disaster were beside themselves. They repeated their warnings with embellishments. When Carmichael did address the two black student groups before appearing at Vanderbilt, and nothing untoward happened, the gloom forecasters were beside themselves with frustration. Carmichael then fulfilled his engagement at Vanderbilt without incident.

The following night an incident on the Fisk campus gave the alerted police and the news media the chance they had been awaiting. The police were called to the University Dinner Club to eject an unwelcome guest. Others, feeling that the action was unjust, began to picket the club and the police called in their riot squad. Hundreds of helmeted officers rushed in and a melee ensued.

Luckily there were no fatalities, though fifty were injured and ninety arrested. All but six were students. Bottles, bricks, tear gas, and bullets flew furiously, and the disturbance

quickly spread to the campus of Tennessee A. and I. The following night a renewal of the fighting spread to nearby sections of town. It subsided only after Mayor Briley withdrew police from the campus areas and they were roped off to outsiders. Although municipal authorities blamed the rioting on the presence of Stokely Carmichael, no evidence of Carmichael's presence on or near either campus at the time was ever established.

Events of that year and of the four that have since come and gone have not diminished the commitment of Earl Hooks to his work at Fisk. He meets with his classes and he gives students the best he can offer. And when they have left, he gets back to his clay bins, his wheel, and his kiln. A careful study of his work reveals his love of, and respect for, the forms in African carving, of which he has a splendid collection. And when Hooks talks with you about his craft he speaks in simple nontechnical terms.

"Pottery provides all the ways in which a person may express himself. Here you have form, design, color, balance, rhythm, harmony, all in one. For me, the sculptural aspects of pottery have always been the overriding thing." He warms to his subject as he talks. "Pottery, unlike painting, is constant in that the materials are basic. Pottery is earthy. It has undergone few changes. And it has not been invaded and bombarded by modern chemical changes."

Earl Hooks is an earthy man. The responsibility he assumed in aiding his family while still a mere schoolboy would not allow him to be anything less. And Earl Hooks is a remarkable artist who has been sensitive enough to discover his metier. That he is so able and willing to make that discovery meaningful to others is an added testimonial to his artistry and to his manhood.

Chapter XIV

JAMES E. LEWIS

JAMES AND PEARLEAN LEWIS were Virginia sharecroppers. They worked the land of a large farm in a tiny place called Phenix, a hamlet you will have trouble finding on the average road map. Small as it was, however, Phenix was too formidable for the Lewises. After their son, James, was born in 1923, the elder Lewis decided he could no longer endure existence as a sharecropper. He confided a plan for change to his wife and closest relatives, and with no word whatsoever to the landowner, took swift and silent leave. Within a few months he sent for his wife and son.

It was 1925 when the family was reunited in Baltimore. That was the year a gangling youth named Thurgood Marshall was graduated from Baltimore's Douglass High School. And it was two years before Mrs. Annie Hooks would give birth to Earl, the first of her eleven children.

The Lewis family lived for a while with relatives before finding a place of their own. But within three years they moved into a house on Durham Street in East Baltimore. James Lewis recalls his early childhood there.

Although we were in the Depression I can never recall that my father was without work for more than a few days. With his multifaceted abilities he was always able to find some work he could do

to keep us alive. He could be, and at one time was, simultaneously mechanic, laborer, custodian. Eventually he found a job as mail handler in the post office where he was at the time he died in 1943.

The house in Durham Street where James grew up was a small four-room affair with a shed kitchen and a dirt back yard. The alley behind the house was too narrow for any sizable vehicle to pass through, so Durham Street residents had to set their garbage out front for collection. Durham Street was small, and because everyone knew his neighbors a closeness developed among them. Famed Johns Hopkins Hospital was four blocks away, and the police station was even closer. As James puts it: "So we lived in the shadow of medical help and the forces of law and order. The law was not always orderly and though the hospital was strictly segregated, it did have a way of looking after sick black folks fairly well."

As was indicated in the chapter on Earl Hooks, East Baltimore and South Baltimore were the older sections of the city. Both had a reputation for toughness, particularly among its poorer citizens. The roughhewn character of Durham Street and its environs was more than matched, however, by the devotion many of its residents had to their churches. And the Lewises were a churchgoing family. "My mother belonged to the Faith Baptist Church and she is still loyal to it," the artist asserts.

Both my parents, in fact, devoted their entire Sundays to church activities and they made me go with them. Because the church is the focal point of much of the black community's social life, they often devoted many of their evenings during the week to church activities. You know, as I think about it now, the really rough kids of our neighborhood were those whose parents were not churchgoers.

School was fifteen blocks away and James walked the distance each day because Public School 101 was the single ele-

mentary school for black children of East Baltimore. Its principal was a stern, old-fashioned disciplinarian who had no qualms about using corporal punishment where it could be seen by other youngsters. Boys and girls who used foul language were given doses of castor oil to swallow. Such disciplinary measures, however, did not prevent them from harassing others. They formed gangs and they terrorized non-gang members like James Lewis. "Many a time I never ate my lunch at all," he says.

The gangs ate it for me. But I found that after a time the gang kids—and there were some bad gangs in East Baltimore—would cease to annoy those who wouldn't join them. Those who had the greatest trouble with gangs were the ones who vacillated between hanging out with them and not hanging out with them.

Although Baltimore was a racially segregated city, the whites who shared the immediate area of little Durham Street were not overtly hostile. James played with the children of the Jewish grocer from whom his parents and all the other black families bought much of what they needed. Especially friendly also were the children of the white bar-owner. Not only did their mother earn her living from the drinking members of the neighborhood but she, herself, had a black sweetheart. Such relationships, added to the fact that black and white gangs of that section were seldom in confrontation, meant that James Lewis's childhood was relatively free of the most violent aspects of Southern racism. But he was never allowed to escape its less violent aspects.

Naturally, as an elementary-school child, James was not seriously contemplating a career. He did love to draw, as do many youngsters. But he probably would never have been inspired to develop in it had there not been an unusual man placed in charge of art education in Baltimore's schools. He was Leon Winslow, a gentle and thoroughly humane pioneer in his field. James Lewis will never forget him, as the following comment reveals.

In a separately administered black and white public-school system where the black system was answerable to the white, Dr. Winslow was a welcome spirit. He gave a lot of time to talent wherever he found it. And he gave a lot of time to the teacher who did likewise. I distinctly remember his coming to Public School 101 and providing encouragement and art materials to those who wanted and needed it.

James was about to enter the fifth grade when he was sent from Public School 101 to Public School 102, just one block away. Public School 102 housed fifth and sixth grades and it was trying out a platoon system of teaching. Instead of remaining exclusively with one teacher, children were shifted to specialists in particular areas of study. This gave James Lewis the advantage of a distinct art experience. So between the ages of nine and eleven, he was in a special class conducted by a Miss Williams under Dr. Winslow's direction. There he discovered how the art program was being wisely used to reinforce the work done in other teachers' classes. For instance, as students pursued the course in civics, those with special art skills made posters. The study of city topography was made meaningful by augmented work in clay. Art, therefore, was made to bear a definite relationship to other studies, and James was a standout pupil.

At the same time he found himself functioning between one art form and other, for he was a good singer. Dunbar High School right next door to Public School 102 provided bountiful inspiration in both pursuits. Whatever the system of segregated schools deprived Baltimore's black youngsters of, it never prevented them from coming under the influence of some of the most dedicated and memorable black teachers found anywhere. Unsung and unheralded outside of the local setting, this writer recalls such stalwarts as Fannie Barbour, Gough McDaniels, Llewellyn Wilson, Glenford Pennington, Leonard Gibson, and Meta Redding. Such were the teachers who helped lay the groundwork for Thurgood Marshall, Cab

Calloway, Anne Wiggins Brown, and Avon Long, who went
on to distinguish themselves in law and theater. A few years
later James Lewis was to feel the influence of Pauline Whar-
ton, his music teacher; Ruth Taylor, his art teacher; and
Lee Davis, his teacher of industrial arts.

Mrs. Wharton, a strikingly handsome lady, was responsible
for changing the attitude among the misinformed boys that
music was for girls only. Ghetto boys, as Roy De Carava
pointed out, are inclined to look askance at the member of
their sex who chooses any cultural pursuit. The cult of
machismo they embrace—and misinterpret—leads them to
believe that dancing, singing, and acting are not masculine.
It takes teaching and training by strong well-prepared adults
to correct this false impression, and nobody was better pre-
pared for that task than Pauline Wharton. Under her direc-
tion James Lewis began to take part in school musicals.

Mrs. Wharton trained her students to sing the standard
European classics as well as the famous Negro spirituals.
Under her tutelage James sang the title role in *The Mikado,*
and did it so well his teacher began to think of him as a
future music major. Meanwhile, she heard something else
she felt her gifted young pupil should try. What Pauline
Wharton had in mind was a selection that had been written
and performed in the first revue offered by the W.P.A.
Federal Theatre in New York. The revue was titled, *Sing for
Your Supper,* and it was a musical history of the United States
of America.

During 1939 this production, like many other federally
sponsored artistic endeavors, was ridiculed and sabotaged by
congressmen more intent upon playing partisan politics than
in promoting cultural pursuits approved by the Roosevelt
administration. Thus, *Sing for Your Supper* was short lived
even as was the Federal Theatre Project that produced it.
But its great finale number, "Ballad for Americans," written
by Earl Robinson and John LaTouche, did not die with it.

C.B.S. radio's daring program director, Norman Corwin, presented it on Sunday, November 5, 1939, on his weekly program, Pursuit of Happiness.

Paul Robeson, just back from a European tour, was engaged to sing it. He was ably supported by the American People's Chorus and Nathaniel Shilkret's Victor Symphony Orchestra. The chorus, made up of New York City working people, was made to order for the lyrics and the music. Robeson was superb. Here, in part, is what *Time* reported in its issue of November 20, 1939.

In the studio, an audience of 600 stamped, shouted, bravoed for two minutes while the show was still on the air and for fifteen minutes later. In the next half hour 150 telephone calls managed to get through C.B.S.'s jammed Manhattan switchboard. The Hollywood switchboard was jammed for two hours. In the next few days bales of letters demanded words, music, recordings, another time at bat for "Ballad for Americans."

A great song about the nation's people began to be sung by them. And Pauline Wharton trained James Lewis and the Dunbar High School chorus to add their tribute to this stirring work by Robinson and LaTouche. It appeared that young Lewis was headed for a career in music until an unexpected opportunity came from another area.

At Dunbar High, James had been doing outstanding work in the art class of Ruth Taylor. Miss Taylor encouraged individual effort on the part of her students, and that suited boys and girls like James Lewis who knew how to work without strict supervision. Then there was the related work in the class of Lee Davis, a veteran teacher of industrial arts. James had the greatest admiration for Mr. Davis. A slight, quick man, with small but strong and steady hands, Lee Davis was the perfect teacher. To begin with, he was a fine craftsman in wood and he demanded seriousness of his students, even

as he commanded their respect. Though hardly more than five feet tall he stood giantlike in his shoproom.

Lewis recalls his former teacher with great warmth.

It was Lee Davis who sharpened my love of fine craftsmanship, and it was he who gave me reason to know where my talents really lay. And what a human being! He was a sharp dresser and a collector of the fine jazz records. When he invited me, along with other boys, over to his home to listen to his music, I was in my glory.

Meanwhile, Leon Winslow, who had remembered James since first seeing him in elementary school, was still interested in his progress.

Dr. Winslow used to invite me to his home. His four children, two boys and two girls, had been reared to accept people of all races on their merits as individuals. Social contact with them became an easy and natural thing. So the closeness of the Winslows to art and my closeness to them made me quite certain before I finished high school that art would be my career.

Another thing that made James so certain of his choice of a career was a Carnegie grant that he has awarded in his sophomore year in high school. The grant continued for the remaining time he was at Dunbar and it provided for special evening study. But he faced a problem. Where was a black student going to study art in jim-crow Baltimore? The Maryland Art Institute, the best and most logical place, did not at that time accept black students. So the white folks had to get together and work out a plan. They had to find some way of letting a black youth improve his mind through the courtesy of Carnegie money without violating the city's code of strict segregation. Finally they came up with a solution.

A young white man from the Maryland Institute was found who was willing to give James private instruction. He was Charles Cross, a thoroughly engaging person, who was interested in helping James as much as he could. Little did

either of them realize how their positions would be so completely reversed by the ironic caprices of time, chance, and circumstance.

It was 1942, the year of James Lewis's graduation from high school. Early in January heavyweight champion Joe Louis told the press that his impending fight with Buddy Baer would mark the twentieth defense of his title. "I'm fightin' for nothin' so I don't want to fight too long," he announced in his terse manner. The black press was critical—not of Joe Louis, but of those for whom he was fighting for nothing. *The Baltimore Afro-American* was particularly caustic. It carried the following item in its issue of January 10:

NAVY MEN TICKLED TO GET CASH FROM JOE'S BENEFIT FIGHT

But the U.S. Navy will not enlist Joe Louis, Congressman Arthur Mitchell, Judge Rainey, State Senator Diggs, City Councilman Adam Powell, Walter White, or any other colored man, except as a flunkie; that is, a valet, a cook, or a waiter.

Louis won the fight and donated his share of the purse, $47,100, to the United States Navy fund. In April he fought Abe Simon and again he donated his earnings to the Navy. This time it was $36,146. Simultaneously it was announced in Baltimore that the Baltimore Trust Building, the city's largest office building, had refused to allow Furman L. Templeton to occupy space there. Mr. Templeton, a black man, was regional racial relations staff advisor to the Office of Civilian Defense. The government agency that hired him was concerned, it said, with the building of civilian morale.

In June of 1942 ten survivors of a torpedoed merchant vessel arrived in Baltimore after having been picked up a few miles off the Virginia coast by the United States Coast Guard. Three crewmen had gone down with the torpedoed ship. Two of them were black. The three nonwhite members of the surviving group were Alvano Ortez, thirty-four; Don-

ald Russell, seventeen; and Richard Powell, thirty-five. Russell and Powell were Baltimoreans. The trio told of having helped rescue their seven white fellow merchantmen. But once aboard the Coast Guard rescue vessel, they were not permitted to eat in the mess hall with the others. They had to eat what they purchased on the open deck. Likewise, because they were denied staterooms, they slept on the open deck. Baltimore's black citizens did not find such news stories consistent with Washington's declarations of concern for the dignity of those overseas threatened by "Nazi and Japanese imperialist aggressors."

A few days later James Lewis was graduated from Dunbar High. Along with his diploma he brought home the faculty medal for the highest average in the arts at the school. The nation was well into World War II and work was plentiful, what with the feverish effort to catch up with the well-mobilized forces of the opportunistic Japanese foe. Defense plants opened all over the country. And they were rapidly filled with workers, male and female, who had been the victims of twelve years of economic depression. Men who had held what civilian jobs existed were called into the service and their places were taken by women and draft-ineligible males. James Lewis faced a small personal dilemma.

His studies to that point had indicated the career he wanted to follow and his parents, particularly his mother, were pleased with the promise he showed. His father had definite reservations, however. A man who had done hard manual labor all his life, he was not at all sure of the "practical" value of a career in art. He suggested to James that it might be wise for him to go to work for a while, now that he had completed high school. Then, after a year or so, perhaps he would see his future in a different way. There was no rancor in the family about it, though James and his mother held to views that differed.

The summer of 1942 therefore was pleasant to all con-

cerned when James, following his custom of summers past, took a job at manual labor. He went to work at the Calvert Distillery. It was there on that summer job that he began in earnest to map the course of his future education.

"I had been aware for some little time of a kind of poetic justice that was coming to those advocating a system of racial segregation in Maryland," he recalls.

Things had come to the place in this regard that proved downright advantageous and delightful to black people seeking higher education. If a black student wanted to pursue courses not offered at any of the state's black colleges, then the state was obliged to bear the expense of his tuition, travel, and some room and board at any nonsegregated out-of-state college or university of his choosing.

What Lewis refers to is the legal pressure applied to discriminating states by the N.A.A.C.P. Thurgood Marshall and his assistants had been successful in forcing through the federal courts some measure of justice from recalcitrant jim-crow states and their schools. The Lewis laughter booms with glee as he recalls what took place in Baltimore.

I imagine many whites were somewhat relieved that the law was being enforced since it served to get a number of "uppity" blacks out of town and out of their hair at the same time. And it got to the place where some of the blacks had figured a way of combining travel and vacation with an education. Man, I'm telling you a few of them deliberately selected courses of study offered only at such out-of-the-way places as the University of California! As for me I was content to settle for study in Philadelphia. The Philadelphia College of Art offered more than the University of Maryland, that would not admit me. So for one year, from 1942 until 1943, I studied in the City of Brotherly Love. Then came my letter of greetings from the United States Government, soliciting my participation in World War II. Though it interrupted what I had begun, I thought I might as well go along with the suggestion.

Lewis was drafted and he went into the Navy. At the time of his induction Marine losses in the Pacific were so great that the Marine Corps, contrary to its tradition, actively sought enlistments. An arrangement was effected with the Navy. Young men who wanted to go into the Marine Corps could first be drafted into the Navy. After receiving an immediate and official discharge from that service they were led a few feet into a nearby room and enrolled in the marines.

"I don't know why I chose the Marine Corps," James says in retrospect.

It may have been the attractive blue dress uniform. It was more likely my inability to resist certain kinds of challenge. The Marine Corps had just announced its new policy of bringing black recruits into its ranks and I saw that as the kind of challenge I should respond to. So I went on into the "colored Marine Corps."

James may or may not have known that the Marine Corps' promises were due in no small part to agitation by black leadership—not to mention the dreadful losses in the Pacific. Only a year before, several black leaders had staged an impressive rally in Chicago. A. Philip Randolph, President of the National Brotherhood Of Sleeping Car Porters, and Walter White of the N.A.A.C.P. were among those who addressed twenty thousand wildly cheering listeners at the Chicago Coliseum. Their meeting was a follow-up on a similar one held two weeks previously at New York's Madison Square Garden. But it was left to the Reverend Archibald Carey of Chicago's Woodlawn A.M.E. Church to bring the audience to its feet and to cause the more than two thousand standing outside to stop traffic in the streets. Here in part is what Mr. Carey shouted to America.

I believe that *now* is the time for us to demand fairness in job dispositions and equal rights in citizenship. I believe that now is the time to demand it, and to demand it for now, not for tomorrow or after the war, but *now!*

Now, while the grass is still green on the grave of the first American to fall in defense of his country's flag in the Pacific, a colored boy. *Now*—while the ink is still wet on President Roosevelt's order honoring Dorie Miller. *Now*—while there still remains some of the $125,000 contributed by Joe Louis to armed services relief funds.

Now is the time for the government and industrial America to set aside the Hitlerism which exists here while professing to be opposed to it elsewhere. *Now* is the time for this country to appreciate the words of Abe Lincoln in 1858 when he declared, "A house divided against itself must fall!"

If the words stirred Marine Corps officials to issue reassuring press releases on their new policies, they obviously had little effect elsewhere. On the way from Baltimore to Camp Le Jeune, North Carolina, James Lewis and other black Marine recruits were herded into a jim-crow railroad coach. One recruit was literally kicked off the train by an irate conductor who resented having a nigger ask him if he would change a twenty-dollar bill!

Conditions at the camp itself were abominable. Black recruits were housed by themselves in cardboard huts. Their white counterparts occupied the newly built brick quarters, and black-white relations in and out of camp were terrible. Things grew so bad that even the National Urban League's far from militant Lester Granger felt constrained to make an investigative visit to Le Jeune. But it was soon discovered that hard-hitting criticism of racism yielded more positive results than the conciliatory moderation of officially recognized black leadership. Harsher condemnation of official armed-forces discrimination again forced the Marine Corps to issue a new policy statement. They would now establish one black combat unit.

Then James Lewis received a wire from home. His father, overworked, underpaid, and still a young man, was dead. The Corps would allow James to go home for the funeral.

"What a fool I was," he reflects.

Had I known anything at all I could have gotten out right then and there, for I was my mother's sole means of support. But because I was young and too stupid at the time to know what to do, I dutifully returned to camp to find that most of my unit was being shipped out to the Pacific with a work battalion. Black Marines were issued no arms and word trickled back to us in the States of how they were hitting the beaches with cases of live ammunition on their shoulders!

James may have been green but he was far from being a fool. Without hesitation he shocked immediate superiors by demanding to see his commanding officer. He calmly told the C.O. that he felt his talents would be wasted in a work unit when he could be doing so much more for the boys in an antiaircraft or an intelligence unit. The C.O. immediately transferred him to another area of the camp where a few blacks were issued weapons. And Lewis found himself in the Fifty-first Defense Battalion, the Marine Corps' first fighting black unit.

We were hitting targets five miles out to sea with such accuracy the authorities quickly disbanded us. And when hostile white Marines challenged us and we were about to fight them out in California, we were quickly shipped to the Easter Islands. I served in gunnery and later in intelligence before getting out in 1946.

James returned immediately to his studies in Philadelphia, married Jacqueline Adams, and resolved initially to become an illustrator. Though he is an excellent draftsman and was promising as an illustrator, he quickly saw that white students less skilled were getting the best jobs. The Philadelphia College of Art hired him to teach drawing and it occurred to James that his future lay in the field of art education. He discovered also that in Philadelphia the best jobs in that area went to his fellow white students. So he began to look elsewhere.

The first offer came, interestingly enough, from Morgan

State College in Baltimore. Accepting it would mean that Lewis would be returning home to teach in a black school. The surroundings were familiar. His mother, to whom he has always been close, was there. Actually there were a few good reasons to give the offer serious consideration.

But James Lewis did not leap at it. After all, his wife, Jacqueline, was gainfully employed and he had the G.I. Bill that provided for further study. Temple University was right at hand. Why not go after the master's degree and cast about, meanwhile, for further offers? Another year of work at Temple's Tyler School of Art and James had his master's degree at the end of the summer of 1950. Then came another job offer from Jackson, Mississippi. Lawrence Jones, who had been at Jackson State Teachers' College since 1949, wanted Lewis to join him. The Lewises liked the offer and were within three days of leaving Philadelphia for Jackson when Morgan's president, Martin D. Jenkins, called again. Dr. Jenkins obviously is a most persuasive man, for instead of going to Mississippi, the Lewises settled in Baltimore.

When I arrived here at Morgan, Charles Stallings and I were the only two in the department. A third person, Samella Lewis, was away on leave. At the end of my first year I was asked to serve as chairman of the department in 1951. Miss Lewis left shortly thereafter and I restructured the department, establishing the program leading to the degree in art education. Meanwhile, I had previously begun to work in three-dimensional forms. Sculpture would be my metier whenever the school's program permitted the time for that phase of my work.

For the past two decades James Lewis has managed to work successfully as the director of an art education program and as a sculptor. He regards both as creative. If in his earlier years the studio work was academic, and the approach to art education more experimental, he found a way of balancing the two. Between 1954 and 1955, as the recipient of a Ford Foundation Fellowship, he studied at Yale University with

Josef Albers and Robert Scott. Lewis shares Jacob Law-
rence's respect for the Bauhaus concept of art promulgated
by Albers.

"With Albers," he asserts, "my previous concepts were
completely shaken up and I had to begin to think of art in a
much broader sense than I had ever done before. And on the
heels of that was a new and a growing interest in art by black
Americans and a new awareness and interest in traditional
African art."

Morgan did afford opportunities for creative work outside
the office of the art chairman. Lewis executed sculptor por-
traits of Dwight O. W. Holmes, a former president of the
college; of Frederick Douglass; Maryland Governor Theo-
dore McKeldin; and Carl Murphy of the *Afro-American*
newspaper. The Maryland Educational Association commis-
sioned an eight-foot figure of Frederick Douglass for install-
ment on the Morgan campus.

One day a letter came from an artist in California seeking
a job. There was nothing unusual in such requests from white
artists, except that this was from someone well known to the
addressee. The writer was Charles Cross, who had been as-
signed several years before as a private tutor for James Lewis.
Lewis gladly found a place at Morgan for his former mentor
but not before Cross had already accepted another offer. The
struggle of artists for survival in America frequently all but
erases lines of class, caste, and color discrimination that seek
to divide them.

Lewis's initial contact with African artists began in 1965.
The American Society of African Culture then commissioned
him to give a series of lectures at cultural centers and uni-
versities of West Africa. The following year, as area director
for the same organization, he was responsible for the largest
single group of persons attending the Dakar Art Festival.
Those and subsequent visits to West Africa, the cradle of

the great traditional art of the African continent, have left their indelible mark upon his own recent sculptures.

The first of these "newly conceived" pieces was commissioned in 1968 for the Cherry Hill Junior High School in Baltimore. A forty-foot by three-foot constructed sculptural relief, the work spans the entrance door of the school. The second of these African-inspired works was commissioned by the city of Baltimore in 1969. It is a fountain piece designed for the median strip in a section of East Baltimore's Broadway. The surrounding community is predominantly black.

"I was initially hesitant to bring black-oriented designs to this community in which I grew up," says Lewis.

Actually, the people are not that black oriented. Had I gone in to meet with their committee looking exotic in a dashiki and all the trappings worn by the young black activists who have no knowledge of African aesthetics, my ideas would have been promptly rejected. But they accepted what I proposed because it seemed to them that I myself was quite within their norm, and they assumed that what I was proposing had to be sound, whether or not they fully understood it.

The artist's conception for that sculpture was inspired by the geometric design of the Ashanti gold weights from upper Ghana. James Lewis was given a group of forty-two gold weights to add to the Morgan art treasures. They were a gift from the personal collection of Franklin W. Williams, a former United States Ambassador to Ghana, and some of them date back to the sixteenth century.

"I do not copy the Ashanti designs," says Lewis. "Rather I adapt them to my own work in the hope that the black community here will derive from them a sense of pride in their cultural heritage as seen through my adaptations."

At forty-eight James Lewis continues to probe and study even as he lectures and carries on his work as a sculptor. Early in 1971 he was invited to Nigeria by Ekpoo Eyo, Director of Antiquities of the Nigerian National Museum, to participate

in an archaeological expedition. At Owo the expedition party unearthed classical life-sized terra cottas and Benin variants. These finds fill an ancient void in Nigerian history, some of them coming from a shrine predating the twelfth century.

That the son of Virginia sharecroppers would be so involved in the ancient culture of his African ancestors is no fluke. Indeed it can be, paradoxically enough, attributed to both the best and the worst in the sensitive black man's experience in America.

Chapter XV

BENNY ANDREWS

THERE IS LITTLE to be envied in the life of the Southern sharecropper. He toils and scratches for an existence on someone else's land, and the bulk of what he cultivates and harvests belongs to the landlord. Like all other farmers, this tenant farmer is at the mercy of nature's caprices and whims. The sharecropper handles little or no cash. He usually buys his needs on credit from the store owned by the man he works for. He never gets ahead and rarely does he break even. Most of the time he is behind—way behind.

White sharecroppers live in hell. Black sharecroppers live in hell's jim-crow section and have to stoke its fires. That is why James and Pearlean Lewis left the hell of Virginia share-cropping after their son was born. George and Viola Andrews sharecropped, meanwhile, in Morgan County, Georgia; and when their son Benny was born in 1930, James Lewis was already attracting attention with his grade-school drawings. Art was the furthest thing from the lives of the Andrews family.

"I came from a family of ten children," Benny says.

I was the second child and we lived in a two-room house. There was no such thing as a bathroom and a kitchen. Everything was cramped in together. The younger children slept in one room

and the rest of the family in the other—three in a bed and all
that sort of thing. It is difficult for one in an urban situation to
visualize a sharecropper family of ten. You see, we were never all
together. My mother and father never saw all of their children
together. When the younger ones came along the older ones were
away.

The farm the Andrews family lived on was near the town
of Madison where, luckily, the weather was generally mild
and residents did not have to endure the rigors of Northern
winters. Working outdoors in autumn, early winter, and
spring was tolerable. The summers, however, were ghastly.
Benny's school year began in September and ended in April
or May. But that formal schedule was not something to which
sharecroppers could adhere. To begin with, they never fin-
ished picking cotton until the end of November. Then toward
the latter part of March they had to prepare the ground for
the next crop and that was the end of school for the children,
who were compelled to work along with their elders. Finally
the county authorities decided to open the schools around
"lay away time" in July, and that gave the kids an extra
month. Still their schooling was inadequate. Benny Andrews
puts it this way: "I suffered in courses like math and science.
You see, when I came into the school at the latter part of
November, classes had been in session for two and a half
months and I was always in the middle, unable to grasp any-
thing."

The school was a log cabin built by the members of the
church Benny's family attended. Members of the black local
secret order society raised money for building materials by
saving fifty cents per month. Then the men got together and
put up the cabin, while the state of Georgia furnished a
teacher and books. Benny's teacher, Bertha Douglass, handled
the first seven grades daily from 9 to 11 A.M. Then she would
have to stop and cook so that by 12 noon they could all eat.
After the dishes were washed and dried the children would

return to their studies until 3 p.m. From then on they were free until the following day. What made it possible for some children to learn in spite of such an extremely limited school program was what took place in their homes. Benny's mother helped him.

"Though she, herself, only finished the ninth grade, my mother helped me all the way into high school," he recalls. "Our high school was a two-story frame building located in town."

When black children of Madison, Georgia, became old enough to go to high school, most of them didn't. It wasn't that they and their families didn't want them to. They were discouraged by the order of things and by those who profited most from that order. The landlords were the profiteers and Benny Andrews vividly remembers the tug-of-war between his mother and the man for whom the family worked.

My mother was determined that I'd go to school. I was the first person in my family—uncles, cousins, and all—to get to high school. And it wouldn't have happened without my mother's help. . . . Now the plantation owner didn't like this at all. He would find a lot of weeds in the cotton—any excuse at all—to keep us kids working the land instead of going to school. I can hear him now storming at my parents, "You'd better keep that boy at home if y'all know what's good for you!"

So this battle—this *game*—took place between my mother and the plantation owner. My father kept out of it—playing the role of the subservient black male. They could put the screws on *him*, you know. So my father would complain to the boss about how headstrong his wife was and how unable he was to cope with her. By passing the buck he didn't have to confront the man, and I went on to school.

Confronting "the man" was a thing black men in rural Georgia did at the risk of life and limb. Black women stood a better chance of getting away with it, but even they had to be careful. In 1946, when Andrews was a high school sopho-

more, a band of twenty unmasked Georgia white men drama-
tized that grim truth with a brutal lynching. They seized a
pair of black men, Roger Malcolm and George Dorsey, from
an automobile driven by a white man who had just hired
them. The mob accused the pair of having murdered a white
former employer, and led them down a side road. When the
men's wives, who were with them, screamed in fright, the
mob seized them also. The four victims were so viciously
riddled with gunfire that close relatives were afraid to attend
their funeral.

Such was the character of "cracker" opposition faced by
black Georgia sharecroppers. That was what Mrs. Andrews
defied as she urged and pushed her second-born child into
high school. And that wasn't all. She also faced the ire of other
black sharecroppers who, out of fear, refused to buck the
landlord. So their fear took the form of envy of the Andrews
family, whom they accused of being "favored" by the white
man while they were forced to conform to his rules.

At best, however, there was no escaping the grueling, hum-
drum routine of the sharecropper's existence—except when,
during the planting and picking seasons, it rained. Benny
Andrews still loves the sound of rain falling on the roof and
beating against the windows.

Man, I used to lie up in bed at night just *praying* to hear the
rain on that old tin roof. There never has been a sound any
sweeter to my ears, for there was no way for me to get to school
during cotton planting and cotton picking times except when it
rained. Going to school was for me almost like an unattainable
thing that became so needed and so desired.

Benny had always liked to draw. His father used to draw
and paint scenes on barns, a common practice years ago in
rural areas. He made brushes out of hogs' hair and squeezed
many of his pigments from berries. With these Benny would
paint on brown paper bags. During the holiday seasons,
Thanksgiving and Christmas, Benny and a schoolmate, who

also could draw, did the appropriate decorations. Their abilities afforded them a kind of special status, and in Andrews' case that status was to follow him into high school. For four years, between 1944 and 1948, he was to learn how fortunate it was for him that he continued to draw. Along with that he discovered something wonderfully reassuring about teachers in his rural black community.

In high school Benny Andrews learned to his dismay how inadequate his elementary schooling had been. He was especially deficient in math and in science, and had his teachers not encouraged him to pursue the drawing he is certain he would never gotten through. Teachers would take Benny's drawings of airplanes, or whatever they were, from class to class to let others see that he was capable of doing *something* well. "My drawing skill and, more important, the recognition those teachers gave me for it, served to keep my morale alive," he recalls.

Even now as I go around to schools and colleges lecturing and having people heap praise upon me, I tell them I wasn't one of the top students in my school. They should have seen some of those who were really tops. This gives you some idea of the price that some paid for being black in Georgia and getting no breaks.

I go back home now and see some of my classmates, and I see how their lives have been messed up by racism. One of the big accomplishments among us was to get a job in the post office after graduation. There was nothing else for most of us to do—unless we left Georgia. I regard it as something of a fluke that I got into college, for there were a lot of breaks involved in that, too.

Another source of assistance came to Benny Andrews through his association with farming. The county in which the Andrews family lived appointed a black agent to help poor farmers, of whom Benny's father was one. With one cow, four chickens, and a hog comprising the sum total of his sharecropper family's property, George Andrews was a very poor farmer. Each fall they butchered that year's hog

for meat to last until the following season. Benny joined the
4-H Club whose purpose was to improve one's rural situation.
But, as he puts it, "There was little or nothing to improve.
Our garden was grubby and wormy and it yielded little.
There was never any money, or any prospect of getting any.
You were always behind, and just surviving was an accom-
plishment."

As a 4-H Club boy, Benny Andrews knew how to "candle"
eggs. Indeed, he had become a specialist in the art of grading
eggs by looking at them against a strong light. And he worked
hard in the hope that he would be one of the four or five kids
of the club to make the annual trip to Savannah. Benny had
never been out of Morgan County, until, at the age of four-
teen, he left home to make the coveted excursion. "I'll never
forget it," he says. "It was my first trip to the big city and I
was so excited I almost jumped out of the car going down
Victory Boulevard. The sight of the ships tied up at the pier
and a plane crash in which the pilot bailed out to safety made
that day the most memorable one of my life—up to that
point."

Lloyd Trawick was the 4-H Club agent for Morgan
County's black youngsters and he was the key man in Benny
Andrews' club life. Mr. Trawick encouraged young Andrews
to keep up his 4-H Club records and to stick with his studies.
That, however, was a big chore for the boy who had grown
to hate the farm on which he and his family existed. Visions
of plodding behind the mule and guiding the plow in the
hot sun with sweat rolling over the heat pimples have never
left him. He still recalls the steamy air and the flopping brim
of the discolored straw hat as he made the torturous journey
back and forth to nowhere through the sandy furrows.

Still, there was, as Benny expresses it today: "That black
experience, bringing with it a closeness and a matchless love
among us. It was a beautiful thing, not perfect, but so com-
plete and so isolated from anything we'd ever see in *Life*

magazine or in pictures of the country as enjoyed by the 'haves.' "

Relief from the drudgery of life on the tenant farm came on weekends. At twelve noon on Saturday all work stopped and the field hands dressed and went to Madison to shop and relax. The town belonged to black folks with money to spend, the only whites visible being the merchants and the police. If you were twelve or thirteen you would dress in your best and take your little allowance and hope to see your favorite girl. Contrary to city-made jokes about country folks, maturity comes early to rural youngsters. Andrews puts it simply: "There's plenty of room to mature in when you live in the country. I found out about life—birth and death— when I was five or six. We were way ahead of other youngsters in such things, living as we did so close to nature."

The boys and girls would meet and the older ones would slip off to the Dew Drop Inn. That was where the action took place, as churchgoers were reminded on the following Sunday morning, when the frock-coated minister delivered a searing denouncement of that den of sin. Benny and his pals were duly impressed. Gazing openmouthed at the vigorously sweating black preacher, they could scarcely wait until they were old enough to steal into the Dew Drop Inn and sample those iniquitous goodies, so temptingly described from the pulpit. "Today all that has disappeared," Andrews muses,

what with the freeways and superhighways that enable folks from Madison to make the sixty miles to Atlanta in little or no time at all. But I still incorporate some of it in my work, for it has to do with the kind of pride that makes up the music—the way we walk and talk. It has to do with our entire makeup, our ability to tie people—especially white people—up in games. We know how to do that, all right. We had to learn it in order to survive.

Benny Andrews recalls his uncles, who were migrant farm-workers. They would go to New Jersey and Long Island to pick tomatoes and potatoes and then in the winter they would

go to Florida. There wasn't enough work to keep them busy in Madison. Besides, as migrant workers, they at least had the satisfaction of having money pass through their hands. But it was when they returned home that the family would have such memorable times together.

They'd come back in a new car equipped with mud flaps spangled with red light reflectors, fox tails flying from the radio antenna, and whitewall tires. They wore the latest styles in clothes and for two weeks they partied and balled like you've never seen in any Broadway production. Then the bottom fell out. The cars were repossessed, and there was no work, for they were between jobs. So they existed from that total wipeout until it was time to go to Florida.

Benny has since visited New Jersey and seen the shacks and lean-tos occupied by his relatives and their fellow migrant farmworkers. Looking at them he understood the why of those two weeks of splurging in Madison, Georgia.

I realize now that they weren't paid until it was time for them to go. Nobody could have kept them there to make the harvest under such conditions without holding out their pay. So, with their few hundred dollars in lump sums, more money than they had ever before held in their hands, the workers were fair game for cynical car dealers. The latter knew full well that they'd soon be repossessing—and reselling!

Because Benny's parents were avid readers of whatever they could find to read, the family proceeded with its educational program at home. Benny and other youngsters furnished the reading material from the neighboring fairgrounds where a white Boy Scout troop had stashed a quantity of current periodicals. At night, when all was quiet, the black youngsters would slip over to the grounds and steal as many magazines as they could carry. From these, they and their families would learn what was happening in other areas of the country and the world. Benny, meanwhile, got through high school and went off to Atlanta to work for the summer.

Following the tradition of his older brother, who had pre-
ceded him to Atlanta, Benny took a room at the colored
Y.M.C.A. He worked as a busboy in one of Atlanta's hotels.
Most of the young black men working there were, like him-
self, from small communities. Their aim was to earn a few
dollars, buy new clothes, and on weekends visit their home
towns where they could be envied and admired by those still
on the farms. Young Andrews, however, had distinguished
himself in Atlanta by doing a mural for a restaurant. Then,
as the summer drew to a close, a letter came from his old
friend Lloyd Trawick.

Mr. Trawick was pleased to announce that Benny Andrews
had been awarded a two-term scholarship amounting to $400.
It was good for any one of Georgia's three state colleges for
black students. Benny chose Fort Valley State College, re-
putedly the best of the trio. Another friend, Warren R.
Cochrane, who headed the Atlanta colored "Y" and who also
had taught at Fort Valley, came through with Benny's train
fare to the college. Andrews laughs every time he recalls his
arrival on campus. "Man, they even met me at the train
station, because I didn't know bottom from up."

With $200 for the first term in scholarship money and an
agreement that he would be paid $125 for working in the art
department of the school, Benny was assured of $325. The
total cost of $605 left a balance of $280 and the artist will
never forget how he obtained it.

My mother took in washing as an extra chore so I could have
what I needed. She did that with the burden she bore back home,
for they were just managing to make it. And my mother didn't
have a washing machine. She washed white folks clothes with
water heated in the big black iron pot with an outdoor wood fire
under it. And she hand scrubbed those clothes on a washboard
placed in a tub. So lots of times when my mother appears (sym-
bolically) in my paintings, that is my way of recognizing the
strength and goodness of the strong black woman.

The art department at Fort Valley was but an embryo in 1948. Lawrence Jones was there and he was Benny Andrews' teacher for one year until he left in 1949 to head the art department at Mississippi's Jackson State Teachers' College. Andrews soon discovered that whatever was lacking at Fort Valley in the way of technical know-how in art was more than made up for by sympathetic and cooperative faculty attitudes.

"A very basic thing existed there that shows how the black experience worked for me," he recalls.

My teachers in other classes let me do art. For instance, my shop woodwork teacher let me do what I could do best. They accommodated and made a way for me to make it. And they did this in order to make up for what the school could not offer. That was my black, rural, Georgia experience. The white people in that area—even the poor whites—had nothing like it going for them.

After two years at Fort Valley State College, Benny joined the Air Force, a move that he describes as "my salvation." Like many other young black American males, he learned that the armed services were the only route they could find to an education. Moreover, with the raw, abrasive, official armed forces segregation now a thing of the past, the venture seemed as attractive as it was profitable. So Andrews, after training in Texas, serving in Korea, and emerging with the rank of staff sergeant, had indeed found his direction. Any studying he would pursue would be paid for by the United States Government. Ex-sergeant Andrews was going to be a professional artist.

He was twenty-four when he entered the Art Institute of Chicago, and Benny recalls that during his four years as a student, Abstract Expressionism was the big thing. The Institute had lecturers come in from New York, and few of them said anything to which Andrews could honestly relate. Jack Levine, with his commentaries on Jewish life, was an exception. Boris Margo was another. While the staff and students at the Institute ridiculed Andrews' efforts as those of the

"message painter" and the "social realist," Margo encouraged him.

He was the only person who urged me to keep on drawing and painting the people from the South. I was very unpopular as a student because I wasn't doing what was in vogue. I never qualified for anything, never made any of the student shows. Why, I never even made the veteran's show, and that convinced me that I'd never meet their approval with anything I did.

They didn't deter Benny, however. His independence of spirit was matched by a measure of financial independence inasmuch as he had found lucrative work outside the classroom as an illustrator for record companies. The album covers he designed were for discs by Duke Ellington, the Ramsey Lewis Trio, George Shearing, and Dakota Staton. The Blue Note Recording Company bought his work regularly, and Benny Andrews was a member of the Chicago Artists' Guild. With the contacts he had made in the popular-music field he was also preparing advertising drawings for the legitimate theater.

They gave me three seats in the theater. One was in the balcony, one in the orchestra, and a box seat. They had an usher walk around with me. I learned to sketch in the semidarkness, and people around me found what I was doing as fascinating as what was happening on stage. Again, I was playing the game and I was making good money at it. They never knew I was studying at the Art Institute.

When Andrews went out to sketch for his paintings the approach was entirely different. During his last year at the Institute he found that he could relate in no way to what was happening there. Discarding the fashionable trends they were teaching, Andrews went to Chicago's Madison Avenue where he stood in line with the derelicts at the beanery. On the city's South Side he was with the musicians. He sat in the parks where the real people were and he visited his former sharecropper relatives who had come north. And Benny

Andrews sketched in all those earthy places—concentrating particularly on human heads and hands. "In that way I was able," he says, "to retain my identity." When Andrews speaks of his identity he invariably calls to mind some poignant memory of his Georgia childhood. He was especially reminded during 1970 of one such recollection not long ago as he read of ex-heavyweight boxing champion Joe Louis's being committed to a mental hospital.

Nobody will ever know how many black people Joe Louis pulled through when there was no other hope for them. We'd sit around those little battery radios in our shacks and listen to the fight broadcasts. And the hope of a whole people was riding on that man's defeating whoever he was fighting. The next day people went back to those terrible jobs they were doing. And they broke dry cornbread and ate dry beans with a pride you couldn't have bought with a banquet or a pocketful of money.

The artist's painting "Champion" was doubtless inspired by both the glorious and the inglorious aspects of Louis's life.

Because of his success as an advertising artist in Chicago, Andrews and his bride, Mary Ellen, thought seriously of settling in New York. The famed metropolis was not only the nation's commercial center, it was the hub of the nation's art activities. And Benny also intended to paint. It was 1958 when they arrived in New York. The first of their two sons was born one week later.

New York is notoriously tough for anyone trying to break into any topflight area of any of the arts. All of his previous experiences notwithstanding, Benny found the going slow and torturous. He did get to illustrate a story for Nat Hentoff and he designed a few record album covers. And he tried to paint between commercial assignments. It didn't work. Mary Ellen, a stenographer, took office employment, leaving her husband at home to take care of their son—and to paint. Within a couple of years or so their second son was born.

Hard times settled in on the Andrews family, as Benny's description attests.

We lived on the lower East Side in dire poverty. It was quite a contrast to the Chicago setting, roaches, rats—the whole bit. For six or seven years I took care of the children. I'd take them to Saint Vincent's clinic at Fourteenth Street and Seventh Avenue. We were so poor I'd have to wrap that baby in a beach cloth because we had no clothing for him. And I'd walk from Suffolk Street to the hospital and sit with those women and their children until we could be seen by the doctor. They called me "Mother Andrews" but it didn't matter, for I was determined to paint and Mary Ellen was behind me.

There was the time when they needed milk for their baby and Benny walked all the way uptown through a downpour of rain to get a loan from a pawnshop near the Port Authority Bus Terminal. He arrived at the pawnbroker's only to find the shop closed. Returning back downtown, he went into a little neighborhood store where the owner spoke only Spanish. Benny, without a single word of Spanish in his vocabulary, managed to get the storekeeper to give him some milk on credit.

Trying to get some of his work in the big shows uptown was, he found, infinitely more difficult. Museums, like the Whitney and the Museum of Modern Art, were impregnable fortresses to the unknown outsider, no matter how talented he might be. Andrews tried however. He'd get up early, tie his canvases together with rope, and head up Second Avenue. It would take a whole day to make the trip. Having trudged the furrows of a Georgia plantation under the pressure of the hot sun had conditioned him for trudging from lower Manhattan to Eighty-ninth Street under a load of paintings. Not once was it ever more than he could do. "I walked," Andrews says, "because I couldn't afford to have them carried any other way. Never was I accepted for any of those shows!"

Benny Andrews did, however, show in the Village Art Fair

during his first year in New York. He had his first one-man
show in Paul Koester's gallery in Provincetown, Massachu-
setts, in 1960. The year prior to that a painting he had sub-
mitted to the Philadelphia Academy Show was selected and
hung. Then the Forum Gallery in New York presented three
one-man shows of Andrews' paintings. The first was in 1962,
the second in 1964, and the third in 1966. The artist began to
detect a pattern in those showings.

I noticed that the work that was less definitive of my black
background was the work selected by that gallery for showing.
That disturbed me, for I began to wonder at first if it was because
the quality of my work was not up to par. I resolved to find out.
In the summer of 1966 I took the family down to Georgia.
There I did a series of paintings about my home—a complete
autobiography. When they were ready for showing I took them
in to the Forum Gallery. I had the show all right, though it was
over the protest of the gallery owner. The woman who runs things
there was so opposed to my show that she sat in her quarters be-
hind the gallery during the formal opening. Raphael Soyer had
helped me put it over, though the gallery swore it wouldn't sell.
They were right. It didn't. And one reason why it didn't was
because the gallery wasn't keen on it and didn't push it.
So I came to know right then and there that I couldn't exist
with the gallery system in this city. I pulled out, and started work-
ing the way I wanted. *I* select what I want to show. When I am
seen in gallery shows it is through work of which I have approved
and the gallery selects to exhibit. Never do I permit a gallery to
dictate what I may or may not paint. That is why at this mo-
ment I have no gallery affiliation.

It was during 1959 that Andrews met and became friendly
with big, flamboyant, talented Bob Thompson. An articulate
young black painter, and in his case the term "black" was
accurately descriptive, Thompson was well ahead of his time.
As Benny puts it, "Bob knew the game inside out."
Thompson managed to penetrate the white social world
and to exist in it independent of his blackness. He would

make an entrance at gallery openings surrounded by an entourage of followers, mostly white, and they clung to him like bees to a honeycomb. Thompson's paintings reflected his refusal to see people as anything other than people. And Benny took careful note of how his friend used green, purple, pink, blue figures as he painted his interpretations of human beings on canvas. Thompson's wild and heady style of life that resulted in an early death still distresses Andrews. "The tragic side of Bob's life—that was another thing. Yet I know his Kentucky background and his New York experience had to be tinged with some form of racism. One will never know to what extent."

Benny Andrews shares a mannerism in common with Betty Catlett Mora. He, too, has been reminded that when he portrays nonblack people they have a way of coming out black. The comment doesn't disturb either artist. It rather pleases and gratifies Andrews, who recalls an especially comforting experience as his autobiographical paintings were exhibited in East Harlem. A black couple visiting from the South happened to see them and immediately were encouraged to make an inquiry. They were seeking a safe place for their daughter to live while she studied in New York, and the Andrews' paintings indicated to them that someone close by would understand that particular concern of black Southern parents.

"The fact that they felt from what they saw—that they could make such an inquiry—made me feel I hadn't missed. And that was reassuring, for, God knows, I've failed so often!"

Between 1960 and 1970 Benny Andrews was seen in ten one-man shows. He participated in twice that number of group shows during the same period. Doubtless the most memorable of the latter, for him at least, was the one seen at the Boston Museum Of Fine Arts, during the spring of 1970. It was titled Afro-American Artists: New York and Boston. Organized by Edmund "Barry" Gaither and Barnet Ruben-

stein and mounted by the Boston Museum, the show of 158
exhibits by seventy artists attracted thousands of viewers.
Benny Andrews was invited to Boston to speak about the
show. Following that he wrote his impressions of that visit,
his first to Boston, in a piece published in *The New York
Times* for June 21, 1970.

His essay served also as a reply to *Times* critic Hilton
Kramer. Mr. Kramer felt that certain mainstream black
modernists were good artists, but that the show was more
political and propagandistic than aesthetic. Andrews felt that
Kramer was ill-qualified by his particular kind of condition-
ing to honestly, fairly, and knowledgeably evaluate most of
the work in the show.

Black people at the show looked at "Champion," and upon
being introduced to me would give me the black power salute
and say, "Right on, Brother!"

"Champion," mentioned previously, was inspired not only
by the fistic achievements of men like Joe Louis and Muham-
mad Ali, but also by what those achievements have meant to
black masses at large. The painting also seeks to express
something of the torture imposed upon black men who are
champions. That, simply, is what Benny Andrews tried to
symbolize in that lonely hulking figure.

In 1971 the paintings that Andrews carried on his shoulder
as he trudged vainly in search of showings are being received
with greater respect, if not with all-out enthusiasm. He is being
included now in major shows. But that alone does not placate
him. He is active with the Black Emergency Cultural Coalition
in seeking recognition by the nation's leading museums of
black artists and black art specialists. B.E.C.C. is dissatisfied
that able and fully qualified black art historians and curators,
like Barry Gaither, and black art specialists, like Gregory
Ridley and David Driskell of Fisk University, Dr. Samella
Lewis of the Los Angeles County Museum, and Evangeline
Montgomery of the Oakland Museum are not consulted more

often by the big museums. A particular target of B.E.C.C. is the Whitney Museum, which the group accuses of treating black artists in an insensitive and humiliating manner. It is the kind of battle one is inclined to believe Benny Andrews wages with relish.

His forays obviously receive serious attention. During early March of 1971, Andrews won a grant from the Creative Artist Service Program of the New York State Council on the Arts. The grant will allow him to carry on any project of his own choosing that involves public participation in the arts.

Now, to his great satisfaction, Andrews is also teaching and lecturing with regularity. His students do not have to wonder where he stands on art schools and their function. Andrews is quick to tell them that if they can survive art instruction and most other education as it is presently ladled out, they have a chance of making something positive out of the experience. He likens the learning process to that of going to the pool for a swim. There is water in the shower one steps into en route to the pool. But the shower water is not the objective, merely the stopover en route to the deep pool water in which one swims.

The thing I tell all my students is that they shouldn't ever worry about whether or not they can do it. My aim is to get them going at the business of *doing* it. We'll worry later about whether or not they can.

The strident evangelistic Andrews' tone then gives way to a softer one.

You know, there's only one really important thing in my approach. If I can continue to reach humanity both through my paintings and through my missionary kind of teaching, then I will have made some small contribution.

That Benny Andrews is sincere in his hope is evident in the work he does in both studio and classroom. With his kind of early sharecropper's experiences, how could it ever be otherwise?

Chapter XVI

NORMA MORGAN

THERE ARE FEW contemporary black American artists of any distinction who do not know and respect the work of Norma Morgan. As a child Miss Morgan never saw a cotton field or had to skip her way through the refuse of a fetid slum. As an adult she does not join protest movements, walk picket lines, or otherwise publicly rail against the establishment. The paintings and prints that bear her signature are never charged with overt black frustration and recrimination against "whitey." Yet they emerge as strong and moving statements of man, his environment, and her reaction to both. No one who sees them ever doubts that Norma Morgan is an artist. No one who ever sees her doubts that she is, in her own highly individualistic way, a strong and attractive black woman.

Norma Morgan was born in New Haven, Connecticut. She was just a tot when her young mother, Ethel, went to work for the Means family in her native New Haven. The collapse of the stock market and the death of the child's father demanded that Ethel Morgan find work wherever she could get it. An elderly couple, the Reverend and Mrs. Stuart Means, hired Ethel. Both husband and wife were in retirement, he from the Saint John's Church and she from her work with girls

and young women. Not only were the five members of the Means family pleased with Ethel Morgan's work, but they were completely charmed by precocious and articulate little Norma, who shared their home with her mother. Ethel Morgan was talented and adaptable. She could sew, cook, drive a car, and take care of a house, all with better-than-average skill. She was a rare "find," even during the Depression, and Mrs. Means knew it.

Norma, like most preadolescent children, liked to draw. "From about the age of seven I began to draw, beginning with filling in coloring books," she says.

Those of us with outstanding ability were given colored chalks with which to draw designs on the blackboard. The art we did in school was rather dull—you know the type of thing they do in most classes—the railroad tracks and telephone poles in perspective. Ugh! What I liked to do was use my imagination, and I well remember my passion for drawing sailboats. How I loved the feeling of being free to sail away in my imagination to all sorts of strange places that drawing those boats gave me!

Little Norma was doubtless giving early indication of her intention to break away from the dull routines that life and circumstances impose upon most people.

Ethel Morgan watched and encouraged her daughter. Because she regretted not finishing school, Ethel was determined that Norma would have every opportunity to go as far as her abilities would take her. So she worked hard, and at the end of seven years was completely exhausted from doing all the housework and the driving for the elderly Means couple and their three daughters. Mrs. Means herself was becoming a difficult and demanding invalid. Young and strong as she was, Ethel Morgan had reached the breaking point. So with the illness of exhaustion upon her, she had to give up working for the family.

In a short time, however, Ethel had recovered well enough to return to work, and taking Norma with her, she went with

a family in New Rochelle, New York. There she found the work requirements far less demanding. At the end of a year the family decided to return to their native Texas and they wanted Ethel and Norma to accompany them. But Ethel wanted no part of the South, especially with a growing child whose education had to be a prime consideration in any moves she made. Meanwhile, a more attractive offer came from another New Rochelle family and Ethel took it. The year was 1936.

Norma, eight years old and obviously sensitive to the changes that had been necessitated in the life she had come to know and love in her home with the Means family, began to have trouble in school.

I had been enrolled in the Lincoln School in New Rochelle and I guess the trouble began with my being a new kid in the school—and a kid who carried a violin, at that. I began to swear at the teachers and I was made to sit outside the principal's office. Finally I was expelled for fighting. As I think about it now I'm sure I rebelled at what I could see as the unfairness of adults. But after going through that period of being a brat for a couple of years, I got into another school and there, in an entirely different atmosphere, I began to settle down. To tell the truth, even though I fought like a demon I never liked the idea of hurting anyone. I was always so overwhelmed with sorrow afterward.

Norma was now attending New Rochelle's Trinity School, a one-time private institution. She loved it. At Trinity she was encouraged to pursue her penchant for drawing and painting. One classroom project called for the painting of a mural whose theme was communication. The painting had to depict the progress of transportation over the period of a century. When the teacher saw what thirteen-year-old Norma could do, she took the other children off the project and let her carry it alone. Norma vividly recalls the experience: "For four months I had no other assignment in the school but to complete that ten-by-three-foot mural. My design called for

a switchboard operator in the center flanked on her left with
old waterways, boats, and early trains, and on her right by
the modern means of transportation."

Shortly after the completion of that mural, Mrs. Means,
her health in a state of steady decline, induced Mrs. Morgan
to return to her employ. Norma, never separated for long
from Ethel, returned with her to New Haven. Norma com-
pleted the eighth grade and entered New Haven's Hill House
High School where she found a fairly large number of black
students in attendance. Many of them came from the city's
Dixwell Avenue area. Although the Means family lived three
miles from the black district, Norma covered the distance
easily on her bike when she went to visit friends there. Never
did she feel alien to either end of town.

"I must say that the Means family," she recalls, "did regard
and treat my mother and me as members of the family in the
truest sense of that overused cliché. One or two of my friends
had parents who lived on the job as we did, and we experi-
enced no rift with the other black kids because of that circum-
stance."

The opportunities for self-expression the school offered its
gifted students by no means excluded those who were black.
One of Norma's classmates, Levi Jackson, went on to become
a fine student and star football player at Yale. For Norma,
the school's magazine, *The Hill House Gleam,* was particu-
larly meaningful. Any student who showed an inclination
toward writing and drawing was encouraged to submit ma-
terial to that publication. Norma, a good all-around student,
was welcomed to its art staff. In her junior year she was its
associate art editor and became art editor during her last year.

Sensitive and talented as Norma was, she by no means re-
treated from the usual youthful activities. A good-looking,
tall, outdoor-type girl, she made both the swimming and
skating teams at Hill House High. Even today she skiis,
hikes, and camps out. This love of, and lack of fear of, the

outdoors was to stand her in good stead a little later in her experience as a professional artist.

Norma's progress in art was being carefully noted, meanwhile, by one of Mrs. Mean's daughters. Glen Means had studied art in New York at the Art Students League as well as with Hans Hoffman. She invited Norma to join her in exhibiting at the New Haven Y.W.C.A. Norma was a junior in high school. The following year Norma was given a one-woman show at the New Haven Public Library. "The press," she says with a smile, "was kind to me. They especially mentioned one illustration I had done of one of Edgar Allen Poe's stories and an arrangement of magnolias in a glass bottle."

It is significant that those two particular pieces of Norma's earliest works would be cited. Later creations that would assure her a niche among the finest engravers and printmakers here and abroad would be imbued with the characteristics of both. In them one finds the lonely mood of Poe's writing, as well as the abstract patterns of light and dark that constantly and mysteriously play over the surface of highly polished metal or glass. In those early days, Norma painted in tempera and on large surfaces. The young artist had not yet begun to explore the possibilities of painting in oils.

That Norma Morgan would further her education beyond high school was a foregone conclusion. Her home environment had certainly been conducive to it. Most of her immediate adult associates had been to college, and their children had either done likewise or were planning to do so. The only question was *where* she would pursue her studies. At first Norma was all for attending the Fine Arts School at Yale. Two black students, Oliver Wendell Harrington and Barbara Johnson, both of New York, had been there before her and had been graduated, the former with some distinction. Glen Means, however, suggested that the Hans Hoffman school would be a better choice.

In 1947 Ethel and Norma Morgan made another move, this time to New York; they found a place to live in the West Sixties. If Ethel, a first-rate seamstress, entertained any fears that she might not be able to make it in the big city, no one saw any such evidence. She came, and almost immediately secured work, with Norma serving as her after-school assistant. Today Ethel Morgan laughs as she recalls the young woman painter who recently suggested that she should become active in the Women's Liberation Movement. "My dear," Ethel Morgan replied, "don't you know I've been liberated for over forty years? You'd better go on out and get *yourself* together!"

Norma registered as a student with Hans Hoffman. Working in his afternoon class she was able to improve her sense of picture organization—that difficult and never-ending study called "composition." In the mornings she studied at the Art Students League with Julian Levy. Hoffman, the abstractionist, was the very opposite of Levy, the romantic. While the latter held the greater emotional appeal for Norma, she was no less attentive to her work with Hoffman. After all, she needed to strengthen her sense of design if she hoped to do compelling things later.

Meanwhile, one of the models who posed for Julian Levy was looking over Norma's work one day and he saw possibilities she had not been exploiting. Did she know Stanley Hayter? Norma didn't. But at her first opportunity she went to his studio workshop on East Eighth Street to meet him. That meeting gave birth to an important facet of her career as an artist. The year was 1951.

Mr. Hayter, an Englishman and an engraver, had conducted a school and workshop in France before coming to New York. Norma met him six months before he returned to Paris, and worked with him until he left. She then continued in the workshop called "Atelier 17" with Carl Schragg, who took command at Hayter's departure. In working directly on

metal with a tool, Norma Morgan was exploring an art that is more than five centuries old. "Actually I taught myself," she says, "because Atelier 17 was not a formal classroom but a workshop situation. I looked at what the others were doing and I learned from them."

What Norma learned, among other things, was that engraving was an art form she could practice anywhere. It required little working space and she needed only the copperplate, cutting tools, scraper, burnisher, ink, paper, and press. No acid is required, as in etching, though the intaglio principle is the same. In intaglio engraving the image to be printed is cut into the surface of the plate. In other forms of engraving the image is formed by that part of the plate left standing after the remainder of it has been cut away. In the intaglio process, ink that seeps into the grooved image cut by hand by a sharp tool (the burin) is picked up on paper under the weight and pressure of the rollers of the printing press. The process resembles that of drypoint etching in that both require direct cutting of a design into a metal plate by hand. While many engravers have their plates inked and printed by specialists, Norma learned to print her own.

It was 1951 also when the John Hay Whitney Foundation fellowship grants came to Norma's attention. Whitney fellows had to belong to a nonwhite minority and had to be under thirty-five. Norma submitted to the committee several paintings and one engraving, together with her plan of selection, and was awarded a fellowship. Recalling what she did upon being notified of her good fortune, she says: "I immediately made my plans for visiting the setting of the novels by Hardy and Brontë. The British Information Center provided me with addresses of lodgings and farmhouses where I could stay. I went by freighter, and I went alone."

Devon was the first stop and Norma stayed with a farm family in a little village on the edge of Dartmoor. She arrived early one morning and admits she thought the family

would be surprised that she was black. If they were they never gave her the slightest notion of it, though Norma is certain they had never before seen a black person. The eagerness with which they drove her several miles to show her off to relatives, however, indicated that in a friendly way they did consider her an "unusual" guest.

Norma's arrival at the English countryside in October during the off-tourist season was fortunate for her. None of the special accommodations for foreign travelers was available and she became just another member of the family, taking her seat beside them around the fireplace. For nearly three months she lived with her family, during which time she sketched and worked with the burin on her copperplates.

Norma found that the southwest part of England was one of the last wild areas of the West Country. For the most part it is a picturesque wasteland with bare granite peaks called tors rising as high as two thousand feet above the earth's level. Grazing lands and granite quarries dominate the land, though copper, tin, and iron mines were once quite active. Famed Dartmoor Prison, built between 1806 and 1809, during the Napoleonic Wars, to house French captives is another neighboring landmark of the bleak and desolate area.

Having heard that the legendary Jamaica Inn was only forty miles distant, Norma resolved not only to see it but to spend Christmas there. Daphne Du Maurier's novel, *Jamaica Inn,* doubtless had much to do with her decision to see what it was really like. She recalls her visit.

I found that Jamaica Inn provided hotel accommodations for a very limited number of guests, and for the two weeks I was there I had a marvelous time. The parties during the holidays were really wild. When they learned I was an artist they asked that I do a few caricatures of the proprietors and the people who keep the place going. The drawings are now framed and are in the permanent collection of Jamaica Inn. To their delight I also played the recorder, which livened up our parties and made me

quite a popular guest. I did a number of engravings including the one titled "Wild." Then I moved over to the east side of the moor and remained there until Easter.

The damp, frosty climate of the moors required that Norma, working outdoors, master the technique of sketching quickly. Thus she was forced to grasp only the big essentials of the subjects she chose to interpret. Indoors she developed her watercolors and engravings from those sketches. "Moor Claimed" is an excellent example of how Norma was able to retain the monumental solidity of an old farmhouse and barren moor as she dramatically silhouetted both against a cold sky. Only by adhering to the simplicity of the quick sketch is it possible to capture such spirit in the more detailed engraving on copper.

With the passing of Easter and the coming of warmer weather, Norma went on to London, where she lived at the Y.W.C.A. Because she knew no one there, she kept a sharp eye out for any artists who might be about. Sure enough, a group came along carrying portfolios and sketch boxes. Norma followed them to the Soho district and into a little teahouse. Once inside she took out her sketch pad and began to draw, and within a short time she was one of the group. From them she learned where to have prints pulled from the plates she had engraved. Norma sold some of those prints in London and with the money was able to extend her visit another year. Most of it was spent in Stanbury, a town three miles from Wuthering Heights.

Returning to New York in 1953, she found that the Crespi Gallery was interested in giving her a show. Ethel had made the contact through someone for whom she was sewing. At the same time Norma applied for and won a Louis Comfort Tiffany Foundation grant, and with it established a studio on West Sixty-third Street. The name Norma Morgan was beginning to command attention and respect among those who collect and exhibit fine prints. That year both the Associated

American Artists and the Library of Congress commissioned prints from her plates.

It was 1955 when Norma decided it was time to enter her work in national shows, and she sent "Granite Tor" to the Annual Print Club show in Philadelphia. It won that year's First Purchase Prize for engraving, and became a part of the Philadelphia Museum's permanent collection. That marked Norma Morgan's first major prize in an open show. The following year New York's Museum of Modern Art purchased "David in the Wilderness" and "Granite Tor." At the same time the artist began to realize the relationship between her work as a printmaker and a painter.

As I proceeded with engraving I noticed how my painting improved. Having to create color values in black and white sharpened my appreciation for pigment itself, as it always does with artists. It pleased me when in 1959, *New Talent* carried a reproduction of my painting "Character Study." It is the study of what happens to the human being exposed to the cruelties of life's rigors, and I painted it in black, white, and red.

Again, submitting an engraving she had done in Scotland to the Washington Water Color Show, Norma won the Bainbridge Prize in 1959. She was once more beginning to feel the urge to return to the British Isles.

"What was happening to me," she says, "was that I found I had developed skill ahead of imagination."

By looking to nature, herself, for reminders of humanity—in trees, rocks—especially in the erosion of rocks—I could see things that reminded me of people. I had found so much of that on the moors of the British Isles and I felt the need to return and look afresh at what the area offered.

First, however, Norma was given her second one-woman show at the Bodley Galleries in New York, from which both the Boston Museum and the Spencer Collection purchased prints.

The Anna Stacey Fellowship which Norma won in 1960

afforded her the chance she wanted. Again she was off for England, this time for four years, and according to plan, she was beginning to engrave in a more imaginative way than she had done during her first visit. Fantasy human forms began to appear in the rock and tree formations of her desolate landscapes. And while she was experimenting in England, things were happening for Norma Morgan back home.

The American Artists Professional League awarded her its gold medal for graphics when she showed the conventional Yorkshire farmhouse, titled "Moor Claimed," in its annual exhibition. Simultaneously she received the bronze medal in the Audubon Artists Show. Overseas collectors were equally enthusiastic about her works. London showed "Glen in Badenoch," in 1962, and two years later London's Woodstock Gallery gave her a solo exhibition.

The professional monthly magazine *The Artist* published Norma's article titled "Engraving" in its October 1963 issue. Illustrated with reproductions of six Morgan prints—"Wild," "Fulfillment," "Granite Tor," "Moor Claimed," "Eroded Rock Formation," and "Limestone King," the essay clearly describes what engraving is. In addition, it gives a detailed description of how the plates for each study were handled. The latter is of particular benefit to artists seeking information on engraving techniques. In this case they are getting it from an expert, for Norma Morgan is presented as both draftsman and technician.

Norma's return to the United States was for the brief duration of six or seven months. The Cliff Castle Museum in Yorkshire was planning a solo exhibition of fifteen or twenty of her prints for the spring and wanted her there for the opening. She went. Then, after remaining in England until early autumn, Norma returned home to settle for a while.

Her work continued to be seen in domestic and foreign shows. "Man of the Moors" appeared along with other prints in a traveling show seen in United States Embassies through-

out the world. And in 1970 she had a solo exhibition of seventeen works at the Huntington Hartford Museum in New York, the result of her having presented a print to the Schomburg Collection of the New York Public Library.

Several years previously Norma's work had been shown in Harlem at the 135th Street Branch of the New York Public Library. Indeed, while there she had searched the files of the adjacent Schomburg Collection for information on Robert Duncanson, referred to earlier as a nineteenth-century romantic painter. It was Duncanson's travel and painting in Scotland that had much to do with motivating Norma Morgan's trips to the British Isles.

So all of it to date—the travel, honors, medals, acceptance in shows sponsored by the United States Government—was ego inflating and reassuring. Yes, reassuring. For artists as sincere as Norma Morgan never grow cocksure of their abilities. But artists must live. And they must live in the same very real crass commercial world of the butcher, baker, and landlord. Norma Morgan has not been adequately recompensed for her labors and she knows it.

I do feel there should be some compensation to the artist in the cases, say, involving our participation in traveling shows. Not only does the artist produce the work but he bears the expense of framing and photographs. Once in a while something sells and the artist is asked to replace the print sold with another. But sales are few and far between. Commercial galleries do take 33⅓ percent as a standard fee. I am not presently affiliated with any.

Norma regards herself as a modern romantic artist, and the label seems accurate enough. At the same time she is fully aware of the current movement among many black American artists to use their talents for black liberation. Early in 1971 she and Charles White jointly showed their prints at black Spelman College in Atlanta, Georgia.

That Norma Morgan does not employ the currently popular artists' methods of confronting racism does not mean that

for her there is no such thing. She knows she is black and
that she is made to pay a price for it.

"It's a pity," she says sadly, "we don't have many black
artists represented overseas. There we are regarded as Ameri-
can artists. Here we are regarded as black artists." Norma
knows there is a difference. She would be the first to agree
with black scholar-historian John Henrik Clarke that in our
racist society it is folly for the black artist to think of himself
as an artist who is incidentally a Negro. As Clarke so suc-
cinctly points out, any bigoted white ignoramus will readily
dispel all doubts such a misguided black may entertain.

So while Norma has learned through travel in less racially
disturbed areas that people have the same basic human im-
pulses and hang-ups, she also knows what being black in
America is all about. If there is nothing quite like getting
away from racism to give one a more balanced view of what
life's purposes really are, then, conversely, there is nothing
like being black and returning home to the reality of what
that entails. Both experiences have contributed to the life
and the work of this artist. Her work to date has, on the
surface of it, been reflective of her travels abroad. But Norma
Morgan deals in more than surface impressions. One is
tempted to believe that her deliberate choice of decaying,
eroding subject matter—her harsh, desolate English country-
side—and her strong handling of it are symbolic. Who is to
say that the restrictions imposed upon her as a woman who is
also black have not evoked this kind of stark creative re-
sponse?

Be that as it may, Norma by no means gives any indication
that she is through searching. She has other things she wants
to say, as suggested in her following comment.

As I grow older I am more inclined to work with subject matter
among my own people. We have such a great art heritage, you
know. Why, for instance, do I work so close to nature? If you
take African sculpture and put it out in nature you'd hardly

notice it. It belongs there. But a piece of Greek art would be quite noticeable—as though it were made indoors and stuck out in nature. The art closest to nature is the art I feel closest to.

Whatever Norma Morgan does bears, above all else, the stamp of her artistic integrity. It will be interesting indeed to see what the next revolutionary stage will bring forth from her gifted hand.

Chapter XVII

JOHN BIGGERS

No ARTIST COULD BE further removed from the modern romanticism of Norma Morgan than John Biggers. Yet, the people he draws, and the settings he puts them in are, like hers, very real, very earthy. The difference is in attitude. Where Norma Morgan treats decay and bleak erosion with a passionate truth, Biggers is equally passionate in his interpretation of a world bursting with vitality and living energy. Because John Biggers combines that approach with a sense of absolute commitment to his personal beliefs, his peak performances yield extraordinary results.

Most practicing artists who head college and university art departments fall in two general groups. Either they are good artists and poor department heads or the reverse. Biggers is a glowing exception. He excels at both. A man of average size, he seems, when you are in his presence, to be much larger. Students, attracted initially to his department because they have seen and admired his work, remain to be inspired by the man himself.

Raucous good humor, fierce anger, compassion, petulance, and calm deliberation emanate from this man, each in its own turn. He speaks with a husky softness and he roars. In either case you don't fail to hear him when he wants you to.

And when you know John Biggers well, you listen carefully, for you don't like to miss any of the rich warmth of his thoroughly human personality.

Gastonia, North Carolina, is where he was born. The year was 1924, and John was the last of Paul and Cora Biggers' seven children. Both parents had attended Lincoln Academy, an institution supported by the American Missionary Association. Paul Biggers conducted teacher certification training during the summer at Livingstone College in Salisbury, North Carolina. And he became a principal of several county elementary schools having two or three teachers.

But as Betty Catlett was to learn later in Durham, salaries for black teachers of North Carolina were very low. A black country principal with a wife and seven children to support had to supplement his salary, and Paul Biggers was not a lazy man. He was a Baptist preacher, part-time farmer, and during John's early childhood, he operated a shoe-repair shop. His wife, Cora, remained at home and took care of the children until, as John puts it, "the Depression forced her to launder white folk's clothes and work for them as a domestic to assist Papa in feeding and clothing us."

Gastonia is a small Southern mill town. Named for Judge William Gaston, it was settled in 1872 in North Carolina's Piedmont section, nineteen miles west of Charlotte. As was true of many other Southern newly industrialized communities, Gastonia's agricultural and manufacturing pursuits were closely allied. Cotton was the raw product, and cotton yarns and related items the man-made products. Most of Gastonia's twenty-three thousand citizens were white, and during the 1920's the majority of the millworkers were white. Only a relatively few black men worked in the mills. Black women worked as domestics in the homes of whites.

Gastonia's Loray Mills experienced serious labor trouble in 1929, when a violent strike erupted in which Police Chief O. F. Aderholt was killed. A sensational trial followed in

nearby Charlotte, and seven strike organizers were convicted of conspiracy to murder Chief Aderholt. They received prison sentences ranging from five to twenty-five years. Meanwhile, more ill feeling generated as a strike sympathizer, Ella May Wiggins, the mother of five, was killed when a truckload of unarmed millworkers was fired upon. John Biggers was a carefree five-year-old as that period of local violence provided the theme for several full-length novels.

John and his eight-year-old brother, Joe, used to play together in the cool area under their modest home, and John remembers one pastime in particular.

We made miniature wagons, trains, automobiles, houses, and farm animals from discarded thread spools, cigar boxes, and soft pinewood. The earth was cohesive enough to model, so we reproduced the town we lived in, street by street. We used moss for the lawns and created "live" streams with running water. Our two older brothers and Papa would encourage and help us with the intricate carving. It would take us two or three months to build the city and we'd start it all over again every spring. As I think of it now, this was my first real exercise in creativity. Certainly my appreciation for sculpture and architecture was fertilized and sensitized during that sweet, innocent period of growing up.

There were other times when John would watch his mother ironing clothes. He recalls the heavy, old-fashioned flatirons lined up on the hearth of the open fireplace, heating before the crackling fire. "They looked like a row of great toads silhouetted against a fiery judgment," he says.

Each member of the family had his chores to do and there was little cheating, for fair play and honest dealing were a part of the puritanical family code. So were family loyalty, regular churchgoing, and unfailing school attendance. The montaged, triple portrait of Frederick Douglass, Abraham Lincoln, and Booker T. Washington that hung to the left of the fireplace were vigilant reminders of the virtues—and the

possibilities. Paul and Cora Biggers taught their youngsters to believe that even poor black children of Gastonia could achieve, if they followed the precepts of that hallowed trio.

All the Biggers children attended the Highland Elementary School. One brother and a sister finished Highland Secondary School, while the remaining five completed their studies at Lincoln Academy. Gastonia's schools, along with other public institutions of the town and the state, were strictly segregated. And while North Carolina's record of race relations was not as violence studded as that of neighboring South Carolina and other hard-core Dixie states, it was badly tarnished none the less. The lynching of seven black men did occur in the Tar Heel state during the first seventeen years of John Biggers' life. They were committed as reminders that North Carolina, which had shared in the profits from slavery, was determined after 1865 to preserve as much as it could of the doctrine and practices of white supremacy.

Oddly enough, however, the majority of North Carolinians never owned slaves at any time. By 1860 only 28 percent of its people held any slaves at all. And North Carolina had more free blacks than any Southern state except Virginia and Maryland. Its Reconstruction period was not as traumatic as that of some other Southern states, nor were its troubles of the same kind as theirs. For one thing, North Carolina experienced a great increase in crime and violence during its Reconstruction. Members of The Union League, a Northern and Republican secret organization, were warmly embraced by blacks. Whites countered with the Ku Klux Klan, that first appeared in the state in 1867.

The K.K.K. and other similar white groups were formed to: "protect Southern womanhood"; "eliminate bad government"; "put the Negro in his place"; "restore white supremacy." Understandably, the activity of the Klan was most strongly felt, not in the eastern part of North Carolina, where blacks were most numerous, but in several counties of the

Piedmont area. Caswell, Alamance, Chatham, and Orange
counties were the favorite Klan haunts. K.K.K. vigilantism
and North Carolina law made social mixing and marriage
between blacks and whites a crime throughout the state.

Black resistance to white bigotry asserted itself when in
1930 President Herbert Hoover nominated John T. Parker,
a North Carolina circuit court judge, to the United States
Supreme Court. Judge Parker had previously publicly de-
scribed political activity among blacks as "a source of evil and
danger to both races." The N.A.A.C.P. became furious and
waged a campaign that blocked Judge Parker's appointment.
Significant as the N.A.A.C.P.'s victory was, it by no means
brought an end to official and unofficial racism in North
Carolina. And there was little reason to suppose that Gastonia
would deviate from the established mores of the state at large.

"The Southern Railroad tracks marked the boundary line
separating black and white Gastonians," Biggers recalls. "Two
streets in our neighborhood were paved. Those were where
the local black businesses were located—the barber shop,
undertaker's establishment, cleaning and pressing shop, drug-
store, and so on. The other paved street housed the few
families we 'looked up to.' They were our middle class."

All the rest of the town's blacks, and that included the
Biggers family, lived on unpaved, red clay streets, and in that
sense they, the meek, literally inherited the earth. As a child
John learned early that prejudices and snobbery abounded
within the black community itself. He recalls how some
elementary-school teachers gave preferential treatment to
children with light skin and straight or curly hair. "Less at-
tractive" children (and that meant not only the black and
kinky-haired, but out-of-wedlock children, too) sat in the
rear of certain classrooms. But such minor cruelties were
later submerged in the memorable experiences that came to
John following the death of his father.

Cora Biggers, with seven children to support, had to leave

home and take employment in the kitchens of local white folks. She placed John and his older brother in the nearby boarding school called Lincoln Academy. Lincoln, an all-black coeducational school, was just the place for a boy of John Biggers' temperament, leanings, and needs.

Black history was taught at Lincoln, and John recalls that eminent black personalities, Roland Hayes, Walter White, William Pickens, and Howard Thurmond appeared there during his student days.

To help their mother the Biggers boys took jobs at Lincoln. John and a schoolmate were up at 4 A.M. each morning to stoke the furnaces in the institution's eleven buildings. They received twelve cents an hour for their work. It was in the boiler rooms that John saw and read copies of *The New York Times Sunday Book Review* sections. Drawn to the many engravings in that section of the paper, he began to copy them. That exercise marked a fuzzy but significant indication of the direction young John Biggers would shortly take. There was no art department at Lincoln Academy, but the course in cabinetmaking offered a chance to grapple with the elements of basic design.

Local routines in and around Gastonia, meanwhile, remained provincial and quite predictable. There was the planting, the harvesting, the slaughtering of hogs. Corn was ground into meal, and the young were born as the old were laid to rest. There was the joy of weddings, the excitement of shopping in town, parties, hard drinking, hard cursing, hard fighting. All of Gastonia's citizens grew up with such things, and many of the younger ones looked forward to leaving them for a more varied and exciting existence elsewhere. John Biggers was graduated from Lincoln Academy in 1941. He was seventeen—and rarin' to go! At the end of the summer he left home to enter Hampton Institute in Virginia.

Hampton is one of America's most respected institutions of agricultural and industrial learning. Established in 1868

as Hampton Normal and Agricultural Institute, it was char-
tered two years later. Its founder was Major General Samuel
Chapman Armstrong, son of missionary parents. General
Armstrong had persuaded the American Missionary Associa-
tion to establish the school for blacks, though Indians were
later admitted also.

Hampton aimed at preparing its students for a life of
industrious work, frugality, and self-help through economic
independence. Its courses of study provided for careers in
agriculture and blue-collar trades. They clearly expressed the
values that made up the Armstrong philosophy. General
Armstrong's most celebrated pupil was Booker Taliaferro
Washington, who enrolled at Hampton in 1872 at the age of
sixteen. Washington went on to become the founder of
Tuskegee Institute in Alabama, often referred to as the sister
school of Hampton.

That triple portrait of Lincoln, Douglass, and Washington
that adorned the living room of the Biggers home was no bit
of casual decoration. "Mom" Biggers had kept it hanging
there for that day when John would be finishing his studies
at Lincoln Academy and would be looking toward further
training. Hampton would provide that training, and John
would follow in the tradition of Booker T. Washington.

"Mama was sending me to Hampton to become a work-
study student and to major in heating and sanitary engineer-
ing." He roars with mirth.

Man, I was on my way to becoming a plumber and Mama was
tickled to death!

During my first year at Hampton I enrolled in an additional
night drawing class taught by the late Dr. Viktor Lowenfeld. This
great educator opened new vistas to his students with his teach-
ings of self-identification and self-esteem through art expression.
At last I had found a way to deal with the life-long yearning to
speak in line, form, and color of the aspirations of the black man

I had become. Man, I'm telling you, that Lowenfeld turned me on! In my second year I became an art major.

When John told his mother of his change of course, she became upset. What had come over her son? He had always heretofore shown such good judgment. But now, suddenly and without warning, he seemed (in simple street parlance) to be playing with less than a full deck. Didn't the poor boy realize that the chances of survival in art were slim—even for white artists? But John was deep in his involvement with that new awakening that was his, and Dr. Lowenfeld was a magnetic and persuasive teacher. "Mom" Biggers finally threw in the towel and left her son in the hands of the Good Lord— and Viktor Lowenfeld.

At Lincoln Academy, John had been inspired by the leadership of Principal Henry McDowell. Mr. McDowell had previously spent some time in Angola as a missionary educator. His experiences there had engendered in him such a feeling for the Angolan people as to make him particularly sensitive to the problems of poor struggling black Gastonians. Mr. McDowell had found striking similarities in both experiences. And as he made those similarities known to his students, John Biggers was a careful listener. Now at Hampton with Viktor Lowenfeld, he was learning again that the black man's struggle for dignity in America does not take place in a vacuum.

Viktor Lowenfeld was an Austrian Jew who, in fleeing the wrath of Hitler, had found a haven at Hampton. An artist, who had also been a pupil of Sigmund Freud, he had come to Hampton as a psychologist. When he asked the administration if he could also offer a course in art, he met the same kind of response James V. Herring had encountered at Howard University a generation before. "Negroes," he was told, "didn't give a damn about art." Biggers' account of what followed is revealing.

Lowenfeld put a notice on the bulletin board announcing one course in the evening without credit. There were 800 in the student body and about 750 came for this course. . . . The next year they let him set up a major in art there.

Biggers freely admits that when he entered Lowenfeld's class he had no understanding of the creative aspects of art. True, he had a love of drawing but he had formulated no philosophy that he could relate to his drawing. He hadn't arrived at knowing that one could draw his hopes and demands just as one writes, sings, or dances them. "I didn't know a thing about art history," he says, "or I would have known that. Now I know that almost anything can be overcome with art, with self-expression through art. That is what Viktor Lowenfeld revealed to me."

Before Viktor Lowenfeld left Hampton his influence had touched the lives and work of Charles White and Elizabeth Catlett, who worked briefly at Hampton before going to Mexico City. When Lowenfeld left Virginia to teach at Pennsylvania State University, John Biggers followed him. There he not only learned more about the purpose and use of art but was able to secure strong academic credentials. It was in the autumn of 1949 that Biggers was offered the chance to establish an art department at the then two-year-old Texas Southern University at Houston. Texas Southern University was, and still is, predominantly black.

That same year several news items of particular interest to black Americans occupied prominent space in the pages of the nation's press. *The Pittsburgh Courier,* an eminent black news weekly, in its issue of April 30, 1949, castigated Paul Robeson editorially with the following rebuke:

The overwhelming majority of colored Americans are convinced that they will have all the rights and privileges enjoyed by other citizens of this country, and they are ready to fight for them abroad and at home, but they do not have the slightest intention

to aid in any way the enemies of this Nation, regardless of what Mr. Robeson may say.

Columnist Joel A. Rogers, writing one week later in the May 7th issue of the same paper, was less harsh with Robeson:

When Paul Robeson says (allegedly) that Negroes would not fight Russia, he is certainly not speaking for the majority of them. They will do any and everything most white Americans do. However, those leaders and others who rushed to declare Robeson wrong, since they themselves were not being accused of disloyalty, showed very poor strategy. The Negro gets so little because those keeping him down are so darn sure of him. Once he was a Republican addict, as the Southern whites are Democratic addicts, and he got nothing. Then he switched to the Democrats and the latter, knowing he was already in the bag, continue to give him nothing. Negroes are jim-crowed through fear and greed, hence they have nothing to lose by keeping the enemy guessing.

Later in May it was learned that Dr. Ralph J. Bunche had been the focal point of a hassle between the Middle East Institute and Washington's Wardman Park Hotel. The hotel had refused the use of one of its banquet rooms to the Middle East Institute when it learned that Dr. Bunche was to be the principal speaker at the meeting for which the banquet room was engaged. Bunche himself scored Washington's racist attitudes, citing that not only was he barred from speaking at the Wardman Park Hotel but from living at the Mayflower Hotel and attending a performance at the National Theater.

Singer Nat (King) Cole instituted a twenty-five-thousand-dollar lawsuit against the Mayfair Hotel in Pittsburgh for its refusal to register him and his wife as guests. Two white members of Mr. Cole's entourage, however, were given accommodations at the same time. And out in Saint Louis, day and night clashes between black and white citizens kept police busy in late June when the city-owned swimming pools were opened to blacks. The realities of American life for her black citizens was something John Biggers was beginning to feel

able to do something about. And he could do it in two ways, as an artist and as a teacher.

There were certain advantages to be derived from going to work in a newly founded school. Establishing the art department at brand-new Texas Southern University required that one go out and find talented students, then lure them into the school. That is exactly what John Biggers had to do. Then, in addition to convincing students of the significance art bears to their lives, he also had to convince the administration and his fellow teachers of the relationship of his department to the rest of the institution. That, at best, was no easy job, when one considers the stereotyped notions held about art and artists by many otherwise intelligent scholars.

Biggers had to convince them that the serious artist is not a person one calls upon to do all the show-card writing one wants, or all the charts and graphs one needs. Each of those is as specialized a division of graphic arts as are the many facets of the medical profession. And even if the artist happens to have a working knowledge of any of the aforementioned skills, it is an affront to ask him to do such professional work without pay.

John Biggers was also obliged in his early months at Texas Southern University to explain that the ability to draw an acceptable head and figure did not make him a portrait painter. To this day he refuses to execute formal portraits on commission, though few artists draw the human head with greater sensitivity. Laymen find it difficult to understand that there is a difference in making an interpretive character study and making a traditional portrait designed to please the sitter and his immediate family. All of these things Biggers had to educate students, fellow teachers, and towns-folk to understand. Some, after twenty years of exposure to the teaching, still have not caught on.

But eager, honest young students as well as seasoned artists and art lovers have. Between the time of his arrival and 1957,

Biggers was well known throughout the state. In 1950 he was awarded a purchase prize by the Houston Museum for his drawing, "The Cradle," though because of local patterns of racial segregation at public socials, he was not allowed to attend the reception. The following year he won the Neiman-Marcus Purchase Prize at a show held in the Dallas Museum. Two years later (1953) he took the Atlanta University Purchase Prize for sculpture. And in 1955 he was awarded honorable mention for a Negro Education Mural by the National Mural Painters' Society of New York.

Biggers meanwhile had studied printmaking at the University of Southern California during the summer of 1952. And in 1954 he had received his doctorate in education from Pennsylvania State University. Moreover, as part of his program of making art meaningful to the black community of Houston, he and fellow staff member, Joseph Mack, painted murals for the Eliza Johnson Home for the Aged. All they asked for was wall space and working materials.

A long-time admirer of Charles White, whose mural had impressed him as a student at Hampton, Biggers painted yet another mural in Houston. It is installed in the black branch of the Y.W.C.A. and is powerful enough to have drawn visitors from Washington, whose mission will be described later in this chapter.

Concurrent with painting the "Y" mural, Biggers had illustrated a book of folktales by J. Mason Brewer. The *Aunt Dicy Tales* are a group of folk stories not intended to represent actual happenings, but to comment slyly and humorously on snuff-dipping in south central Texas. Aunt Dicy, the central figure, is an ageless, rustic, black woman with a passion for snuff, and the tales focus upon her addiction to it.

Brewer's tales needed illustrations, and he could not have chosen a better artist for the job. John's crayon drawings are magnificent in the same sense as are Jacob Lawrence's paintings for *Harriet and the Promised Land*. They are solid works

of art and they are quite in the spirit of the tales and the earthy humans who inspired them. Middle-class blacks don't like Aunt Dicy and they find it difficult to see anything worthy (and certainly nothing beautiful) in Biggers' portrayals of her. Most of them cannot understand why any artist, especially a black artist, would want to interpret people they describe as "ignorant, ugly, old niggers and crackers." Art, they insist, should be "beautiful"—that is, pleasant, idealistic, and never reflective of human imperfection. John Biggers doesn't agree.

He had previously made his convictions quite clear in the design for the Y.W.C.A. mural. Bearing the title "The Contribution of Negro Women to American Life and Education," the painting portrays its heroines in bold and uncompromising terms. The women are not only strong but formidable. One does not doubt that if pushed they would make effective use of the torch, the musket, and the assorted implements they carry. At the same time they are warm and loving to the men and the children in their lives.

When John applied in 1957 for a UNESCO Fellowship for travel and study in West Africa, someone in Washington took second looks at photographs of that mural and concluded quite accurately that it was hardly the conventional Y.W.C.A. wall decoration. So a committee was dispatched to Houston to see if the artist was as menacing as his painting. Were they unwittingly about to unleash something on the "dark continent" that would out-African the Africans? An interview with Biggers, however, set everyone at ease, and John and his lovely Hazel went on to Ghana early in July. There they remained for the next six months, traveling also to French Togo, Dahomey, and Nigeria.

Letters to relatives and friends describe the great beauty of the land and the warmth and hospitality of its people. In those messages, Biggers tells of the assistance provided him by Ghanaians Patrick Hulede, artist and teacher; Mary

Mensah, another teacher; and K. A. Gbedemah, Ghana's Minister of Finance. Miss Ella Griffin, a black American administrative officer of the Ghana Vernacular Literature Bureau, traveled up-country with them, serving as interpreter and advisor.

But the full force of what that initial trip to West Africa meant to John Biggers was not fully made known until 1962. He had spent many interim months preparing drawings from notes, sketches, and snapshots he had made. The result was an incredibly handsome book, *Ananse: The Web of Life in Africa,* published by the University of Texas Press.

Essentially a picture book, *Ananse*'s black-and-white captioned drawings are preceded by several pages of the artist's own text. The latter, dealing principally with the tour route, descriptions of terrain, and people in their setting, is clearly secondary to the eighty-nine drawings. Frank Wardlaw, director of the University of Texas Press, called it "one of the most beautiful books we have ever published." He added that it also had the most widespread demand from all parts of the United States of any of their books.

Few realized, as they admired John's book, that while he was laboring on it he lost temporary sight of one eye. Moreover a general physical breakdown threatened and only by forcing himself to enter a hospital for a brief period was he able to stave off serious illness. That's how hard this man drives himself—happily, it is not without its rewards.

Recognition descended quickly upon Biggers. The United States Information Agency requested an exhibit of some of the original art works, which it sent on a traveling show to African countries. White universities were beginning to make bids for his services as a teacher. And while he did spend 1966 at the University of Wisconsin, John was not about to forsake the life he had developed in Houston.

From the Biggers point of view the art department should be more than a workshop. It should also be a showcase for

what its students do. So an important part of the training and experience at Texas Southern University is that art must be displayed and installed in the surroundings where it is produced. In 1967, for instance, he presented one-man shows by three of his senior students, Fred Bragg, Kermit Oliver, and Charles Thomas. Charlotte Phelan, writing of Biggers in *The Houston Post* for Sunday, November 17, 1968, made the following accurate observation.

His art program flourishes, not only in its own modern building but all over the campus. In the art building itself one has to be careful to not trip over sculptures and ceramics, so full is an exhibition island in the main entrance foyer. Walls are hung everywhere with paintings, and glass-faced cases are filled with varying quantity and quality of student endeavors in other media. This is typical of an art building, but there are few if any classroom buildings on most university campuses that have hall walls covered with one mural after the other—on floor after floor, and in the stairwells in between. Biggers' students have been busy over the years.

The salient point made in Mrs. Phelan's observation is that John Biggers has made it known that he believes art should serve the needs of people at large. And what better place to begin than within the heterogeneous university setting itself, that miniature world where scientists and artists would not ordinarily come so closely together.

Further recognition came to Biggers in 1968 by way of color reproductions of his work in nationally and internationally distributed periodicals. *The Humble Way,* elegantly published by the Humble Oil and Refining Company, was one of the former. *Topic,* a handsome magazine distributed in Africa by the United States Information Agency, was one of the latter. Then came another opportunity to visit Africa for the last six months of 1969.

Through the Danforth Foundation he was able to travel in Egypt and to visit the Sudan, Ethiopia, Kenya, and Tanzania.

There was even time to revisit Ghana, twelve years after that initial sojourn. John Biggers has summarized his feeling about that second trip in a letter to the writer.

Our trip was wonderful. Sudan and Ethiopia as I reflect back were indeed the "capping" of the total experience. It was really good to revisit Ghana, and this I will have to write you ten pages on.

Biggers never fails to let it be known that he regards his work as a classroom educator as important as that of an artist. In this he shares much in common with James Lewis and Benny Andrews.

"I tell my students,"—he laughs—"you're all so engrossed in being black and beautiful now, but we experienced this in 1941. You weren't on this earth at that time. I learned a long time ago that self-dignity and racial pride could be consciously approached through art."

John Biggers' own creations are powerful testimonials to that statement.

Chapter XVIII

JOHN TORRES

The longer you spend working on black problems the clearer you are about where black anger comes from . . . where the black "junkie" and the black criminal come from. And when you are sensitive and you understand *that* you can only have compassion for them . . . plus the fact that *I could be wrong and they could be right!* There is a very strong possibility of that. For as I said earlier, I am not a nonviolent person.

The speaker is handsome, bearded John Torres. He is thirty-two years old, highly articulate, and a very gifted artist. Although he is a full generation behind Betty Catlett, the difference in their ages is all but nullified by their common experience as sculptors. That their common experience as black Americans unites them in many of their beliefs and functions will be seen in the following narrative.

John, the eighth of eleven children, was named for his Cuba-born father. His mother, Bentina, was a native New Yorker. As a child growing up in a racially mixed neighborhood in New York's borough of Queens, he was not a black ghetto child. All of John Torres' grade-school teachers treated him with great concern, for he was bright and sensitive. He won all kinds of academic awards and was made captain of the school's safety patrol. John was convinced that there was no experience as great as that which one has in school. In-

deed, he believed that the pleasant time he had in elementary school would be continued in junior and senior high school. He was in for a rude surprise.

His first junior high school teacher grew hostile from the moment she took note of not one but two black boys in her class. Sensing, as children can, the teacher's obvious discomfiture, John and the other youngster smiled nervously at one another. That sent her into a frenzied monologue. "What are you two up to? Stand up when I speak to you! What did you say to him? You're both nothing but a pair of trouble makers." As the two boys squirmed under the teacher's unexplained rebuke, she grew more shrill.

Calling the attention of the class to the two "disruptive" boys, she ordered them to stand at opposite ends of the room. When John took a standing place beneath the American flag, the woman's anger seemed to reach its crest. She ordered him to move away from it, with the assertion that the sacredness of the flag was being menaced by his closeness to it. With that she commanded the class to ignore "the pair of trouble makers" and open their grammar books.

"As I reflect on that teacher now, I think she saw the coming of black kids to the school as a threat," says John. She looked upon our presence as the ending of an era. And she prided herself upon being able to see a Communist before anybody else could—even if he were merely an eleven-year-old seventh-grade child. What made it so apparent was that this teacher repeated her tirade against us three or four times each week.

The inevitable began to happen. Both boys underwent a complete change of personality. The teacher had made known her expectations of trouble from them and they obliged by creating it. John was especially difficult. The teacher's command to him to move away from the flag had been particularly cutting, for it brought to mind his older brother, Waverly, who, while serving in World War II, had been

assaulted with a stick by a white officer. Waverly retaliated by disarming the officer and beating him with the weapon until he, himself, was rendered unconscious by other officers.

Reminiscences of the incident seized upon John one day as the pledge of allegiance was being taken by the class. He deliberately refused to salute the flag, and was promptly driven from the room. Fellow classmates, not unsympathetic to the two black boys, began, nevertheless, to regard them as ringleaders of trouble. And while the former enjoyed the latter's encounters with authority, they found it easier to go along with the teacher than to buck her.

Within a year John Torres had dropped from the rank of an "A" student to a failing student, and his family began to worry about him. Although their neighborhood was not elegant, neither was it a slum. But nearby South Jamaica was growing bigger, blacker, and increasingly tough. John's parents were wondering if he was beginning to run around with that crowd, and while they wanted to believe the best of him, they harbored nagging doubts. Certainly the temptations to John were heightened by changes in the attitudes of his neighborhood friends. His reflections on those changes are menacingly significant.

The children I had grown up with were getting into adolescence in junior high school. And even though we were the same kids who used to be in each other's houses every day of the week, we suddenly could no longer get along together. Parents were anxious about boy-girl relationships and their worries stirred us. We began to fight with each other—these same kids who just three years before had been such close friends. We were suddenly making racially based remarks and segregating ourselves in the cafeteria.

When the Italian kid with whom I used to play and who had lived down the street had pressure put on him by his family to break off from me, he found it awkward to do. So his family did it for him. They made me know it when I sat with my friend in front of his TV set. When anything relating to blacks came on

the screen the older family members passed remarks that were meant to tell me I was no longer welcome. And I began to draw myself into my own landscape.

Though not yet twelve years old, John Torres was perceptive enough to understand why some of the teachers at that school began to feed the division between black and white students. They felt their jobs would be altered because of having to deal with more and more blacks. Blacks were, after all, "another kind of people." All that whites had heard about them over the years convinced them of the truth of that assumption. John now doubts that there was anyone at that school astute enough to know what he and his black classmate were being made to go through. So, as he puts it, "We stumbled through it—always on the brink of disaster." The most difficult thing for him was the grim realization that not only were his friends not his friends, but that he would literally have to fight them for his survival. An unforgettable incident proved how terribly right he was.

The trouble began in the school's printing shop at the very end of the school day. One of the boys made a noise to which the teacher objected, much to the mirth of the class. Another boy tossed a handful of type in the air and as it clattered to the floor, the irate teacher detained the class. He commanded the boys to stand in complete silence. If for the next thirty minutes the silence remained unbroken the class could leave. Should there be any disturbance in the interim, however, the thirty-minute period of standing silence would begin all over again. It was tough punishment for active boys, especially in view of the softball game several of them were supposed to be playing in that afternoon.

Twenty interminable minutes passed. Then someone snickered. The sound had come from a section of the group in which one of the two black boys stood and the group, deciding that he was guilty, pounced upon him. Bedlam ensued. The teacher, with no control of the situation, began

to swear and storm and finally ordered everyone to clear the room. Everyone stampeded out except the boy who had been attacked and John Torres.

"When the room was clear, I could hear my buddy groaning from the floor," Torres recalls.

His nose was bleeding and I picked him up and helped him get straight. Oddly enough I also began to pick up the type in order to help the teacher. But he began to curse at me and to order the two of us out.

I walked the boy to the bus that he had to take in order to get home and when we got to the bus stop this is what he said to me, "John, those guys are really gonna pay for what they did today. I didn't make that noise. So tomorrow they're gonna have to look down the hood of a whole carful of rough niggers. *And they're gonna be there to whip some white heads!*" That's all the fellow said and I knew he meant every word.

John recalls the following day as one during which the entire school, except for the teachers, was a vibrating nerve. He had seen some strange young white toughs outside, loitering in a park near the school yard, and he felt there would be trouble. When the bell rang at 3 p.m., not a boy moved. The teacher, obviously surprised that he did not have to restrain the class, remarked that their good manners was a refreshing thing. "It wasn't often," he said, "that they had the courtesy to wait until formally excused." He then dismissed the class.

At that point about six boys volunteered to remain and clean the blackboards. The boy who had been beaten had already taken first place in the line leaving the room. As he did so he gave John Torres one of those wordless messages, a look that all black males under similar duress know and understand. What the look said was, "Baby, if you're scared you'd better keep it to yourself and you'd better get up here and walk beside me." Without a moment's hesitation John rose and took his place in line. With a nod from the teacher the boys proceeded out of the room and down the hallway.

It was perhaps the most harrowing walk most of them had ever taken.

As they emerged into the brilliant sunlight John blinked hard in order to focus quickly upon anything unusual. Sure enough, there across the street was a green Mercury crouching low on its springs. John saw at once that it was packed with black boys from South Jamaica. Even today, as he speaks of that instant, he grows a bit tense.

How all those guys fit in that one car I'll never know. All I knew was that since there had been no previous discussion as to choice of weapons to be used, somebody was bound to be badly hurt. It was the New York gang way to prearrange the battles— to designate the time and place and weapons. It hadn't been done in this case; and since this was an interracial rumble, I knew it was going to be a bad one.

It *was* a bad one. John still sees the kids scampering out of the way, and the two groups rushing together. They kicked, swung radio aerials, chains, and garrison belts. Each side was giving the other a lot of punishment when suddenly, from across the courtyard, a new group of white youths appeared. Their appearance added superior numbers to the whites that threatened to turn the fray into a slaughter. What followed, John Torres will not soon forget.

At that instant one of the black kids pulled out a .38 he had probably stolen from someplace. I don't know whether or not he did it just to scare people. But I can remember rolling over and seeing the gun come out of this brown leather jacket. And I can remember trying to hold back that gesture with a wish. In an instant I saw the insanity of it all—this crazy way of using human life. It was a bizarre mistake that these children should grow up together to kill each other. The gun went off. A kid let out a scream and before he could hit the ground two of his friends had caught him and were dragging him away. Then all of the fighting ceased as the boys scattered into alleyways and side streets leading from the scene of the shooting.

One of the saddest things about that affair was that the boy who had done the shooting had earlier been cited for bravery at a ceremony in the school's assembly. While delivering newspapers he had rushed into a burning building and rescued several people. Seeing such a possibility go down the drain of public indifference to the needs of its youth sickened John Torres. It sickened him even more than the personal hurts he had sustained at Schirmer Junior High School.

John was never permitted to go through the formality of graduation from junior high school. That was because he had failed to secure and hand in a note of dental approval. He didn't get the note in time because his family could not afford a dentist for him; and by the time he was finally treated at a public clinic, the certification came too late to satisfy the school administration. Petty pedagogic vindictiveness kept him out of the graduation ceremony.

I was never told I had been passed on into high school. I simply went on when the time came, and since my entry was not challenged I knew I had actually passed through junior high school. Still I have nightmares in which I imagine I must go back to that school and repeat a year with those teachers. They were masters of the art of terrifying the defenseless student.

Bentina Torres exerted a strong influence over her son. The daughter of a black Virginian and an Indian mother from New York State, she taught her children that if they hoped to become something of worth, they would first have to take pride in who and what they were. Moreover, she was unromantically realistic with all her children. She told John quite early in his life exactly what he must be in order to make it in a racist climate. The result was that before John reached adolescence he knew he would have to learn to do several things better than most whites do one. Moreover, he was prepared to expect, if not to accept, that he may not receive more than half as much for the effort. Above all else, his mother insisted upon his being his own person. "Be

directed from within at all times by your own impulses and drives. And don't you ever come in here and tell me that so-and-so made you do thus and so."

John's father held himself aloof from the day-to-day problems of his children. His family had been politically and socially conscious Cuban citizens and when he came to the United States he found himself in the position of an immigrant who was also black. John loved and respected his father. From his mother, however, he absorbed the philosophy of fidelity to one's self. His closeness to her plus the trauma that seized and held him all through junior high school made him conscious of the value and importance of personal achievement. Besides, with his older brothers away from home, he was the lone male among his six sisters. That too made him feel that he must be a contributing member of society. His sisters made him know they expected that of him.

John attended Andrew Jackson High School. Very few black students were enrolled there since the zoning system shunted most of them off to Jamaica High. In spite of the few black students in attendance, racial disorders were much in evidence at Andrew Jackson between 1953 and 1956. John remembers them well. He also remembers that unlike the scene at the junior high school there were those teachers at Jackson who discouraged racial strife. Both the track coach and the head of the band and orchestra groups worked for racial harmony and they did it without creating a fuss. Each man had a skillful way of quietly putting an individual value upon each student and placing the trouble directly with those who created it.

So, even with the many disturbances, John found high school much more meaningful as a learning experience. He again attained the rank of an 80 to 85 percent student, graduating with an academic diploma and a couple of academic honors. Through the track coach, Milton Blatt, who also taught the Honor English section, Torres was inspired

to make the championship team, as a middle-distance and
cross-country runner. He played the timpani. This kind of
success in high school convinced John Torres that he was by
no means at the end of his road. He could and would go on
to college. His own description of the change that he had
undergone is simply and eloquently stated.

I learned that with consistent effort you could change your
potential and thereby redefine that word "impossible." And with
that new definition one has his life in his own hands. One then
says, as I did later: "I cannot draw. I want to be an artist. I'll
learn how to draw. I want to be a sculptor. I cannot carve. I'll
learn how to carve." By putting that kind of daily effort into it
one does the things he wants to do. I believe that had I wanted to
I could have become a United States senator. And I learned this
from that very quiet and beautiful man, Milton Blatt. He made
you feel you had always to put out your best for him . . . and for
yourself.

Torres had gone to junior high school young because of
having "skipped" a couple of elementary-school grades. Enter-
ing his senior year at sixteen it was understandable that he
could err in deciding what he would choose to study later on.
An excellent math and science student, he chose those as
major subjects when he went off to college.

"Because I had been to mixed or predominantly white
schools all my life, I chose to attend all-black Maryland State
College at Princess Anne." John had a singular surprise
awaiting him there.

The young man with whom he was assigned to share a
room was one of the participants in that Queens rumble in
which a boy had been shot. After the incident the parish
priest had gone to the black youngster's parents and advised
them to get him out of town, otherwise he stood an excellent
chance of going to jail. The parents quickly packed their son
off to a boarding school in North Carolina, and from there he
had come to Maryland State. "He was a delightful person-

ality," John recalls, "but rough as hell . . . would cut you as soon as look at you. But if you were his friend, he'd walk through fire for you."

Once ensconced in the routine of classes, Torres was in for another surprise. Separate education, he learned, was not equal education. For instance, he found that math, through which students at Princess Anne were desperately trying to wade, was math he had been through in junior high school. He was again shocked at what he found in the history class. The level of abstract reasoning was so low that the instructor had to spend an entire period explaining that B.C. meant "Before Christ," and A.D. meant "After His Death." That disturbed John Torres, who had spent time in the library preparing a presentation on the history of Egypt with the expectation of discussing it with the class.

Meanwhile, though a math major, he had begun to wander in and out of the art class at Maryland State. But try as he did to keep his academic interests high, John had to admit to himself that the course of study was not sufficiently challenging to him. So for the sake of his own development he prepared to transfer to another school.

Applying to Michigan State University and the University of Michigan he was accepted by the engineering departments at both. Without really knowing the difference between the two he chose Michigan State. That, he considers, was another error. To earn the money he needed, John went to work at a cancer-research laboratory in Brooklyn, New York. With the end of summer he entered Michigan State University only to discover shortly that the classes there were again not sufficiently challenging. "At this point," he asserts,

I was hit by many questions. Why am I going to college? Is it to earn more money? Why is there such a fantastic machinery built around football? Why do black kids segregate themselves in the cafeteria? Is this really exploitation on the student-to-student-

teacher-to-student level that I am seeing before my very eyes? And if so what am I going to do about that?

John could see that his course of study was not answering any of those questions. He was searching through the maze of his school assignments for a meaning he could not find, and out of despair of the spirit he began to draw. The sketches began to take form on sheets of calculus paper—over the equations. Most of them were of human figures inspired by photographs of popular pinup girls. John then began to talk with art students and to read biographies of celebrated artists. The contact brought him to grips with the reality that if he wanted to know what art was all about he would have to study it—to work at it.

By this time he had met a bright young man who was having a personal problem similar to his own, and they decided to leave Michigan together. John relates what happened.

We stole his grandmother's Volkswagen and we went to the West Coast. There we rented a farm and I began reading philosophy, comparative religions, and everything I could read about art. I had been in college only up to my sophomore year. To support ourselves we worked five-day-a-week jobs. On Fridays we'd take off till we arrived at another town close enough to permit us to get back to our jobs on Monday. We covered forty thousand miles of driving, moving into the Rocky Mountains and along the coast from Canada to Mexico.

Torres recalls that they saw what surely must be the most beautiful land in the world. They saw streams that seemed to flow yellow—not from pollution—but because of the shimmering color of the rocks beneath the water. He saw trees that were almost blue, rocks that were violet. And those phenomena of nature kept telling him that he must in some way attach himself to the wondrous beauties of nature.

But when John tried to give creative expression to some of the things he had seen in his travel experiences, he failed,

and he knew why. He didn't have the necessary training. Immediately he knew that the search for his life's meaning must next lead him to a search for the competence that would enable him to express it. Leaving the West Coast, he returned to New York and study at the Art Students League.

John Hovanas was the perfect instructor for getting students started in sculpture. In addition to the Hovanas class at the League, Torres studied history and languages at the New School for Social Research. He found working with Hovanas the first schooling that completely challenged all his energies. And because he was self-supporting, John tried to find jobs that were in some way related to his development as a sculptor. Then, in the middle of his education at the Art Students League, John won a MacDowell Fellowship to the MacDowell Colony in Peterboro, New Hampshire.

The MacDowell Colony covers four hundred acres of handsome New England woodland. It was established by Marian MacDowell, wife of the American composer Edward MacDowell, shortly after his death in 1907. Providing individual studios, living accommodations, and board for limited periods, the Colony exists to assist those talented and serious individuals who would otherwise find it impossible to produce their work. Painters, sculptors, authors, and composers have used its facilities. And the list of distinguished colonists is impressive indeed. Willa Cather, Steven Vincent Benét, Dubose Heyward, Aaron Copland, Leonard Bernstein, Thornton Wilder, James Baldwin, Sara Teasdale are but a few.

One of the Colony's most advantageous features is that it allows each colonist to return a number of times. This is especially helpful to the married person who has to support a family. The married colonist can work, put money aside for his or her obligations at home, and return to the Colony to pursue whatever creative goal he has. John Torres never ceases to speak lovingly of the MacDowell Colony.

"First of all the Colony has had very few black people there and I was young—only twenty-five—when I arrived," he says.

Most of those around me were from thirty-five to sixty. It was a magic experience, because, growing up as an art student, I didn't really know what art in America was like. I had no way to gauge it. But at the Colony I began to meet with painters and others who had won major awards—Guggenheim, Fulbright, or Lowe awards.

Talking with them gave me the answer to solving the problems of further education—of fellowships—of what areas of the country seem to be great for certain kinds of materials. There were a lot of practical living things I learned just by listening to people talk. The presence also of writers and composers revealed to me not only the correlation of the arts but how each art has a certain voice of its own and how that voice seemed to be transferable from one form to the other.

That particular discovery coincided with a thought John had been harboring for some time. He was certain that most of us, including himself, use only a part of our creative energies and our mentalities. Because the voices of the arts are so similar, he believed he himself could speak in more than one. Having listened to the reading of poetry at the Colony, he began to write with seriousness and to construct his own poems. He says: "It was that kind of contact and the experience it afforded me that contributed to my interior landscape from which I work. That was 1964. I returned to the Colony in 1965 and 1966."

Torres estimates that he did at least sixty carvings in his three years at Peterboro. In one year alone he did fifty-two pieces in wood and stone. He attributes that prolific output to the fact of being left alone to work and to being held in such high esteem. Moreover, it soon became apparent to John that he could establish himself right there at the Colony. Most artists feel that to achieve "a name" and the ensuing success a name brings, one must station himself in New York

or Chicago or possibly San Francisco. Not John Torres. And he explains why.

It is more important for me to show my recent work right here in Peterboro near the Colony than it is to show in New York. The kinds of people in this area form a selective group who can pass your name around. And from this you get the most incredible invitations from museums and from magazines.

This show has been seen by one of the world's leading experts in artists' materials, Ralph Mayer. He had a birthday party here at this show. Margaret Mead has seen this show and so has Russell Lyons. This you cannot guarantee in New York, with all the people who go to art shows there. Though it is off the beaten path, showing here marks the focal point from which important things happen.

Important sales have been made by John through the Colony, and they have certainly been deserved.

Keen insights and his own youth seem to have endowed John Torres with a special feeling for other young people searching as he recently has done for life's meaning. What could he do by way of helping them find a way? A series of circumstances which he and others consciously promoted came together in the summer of 1968 to provide a unique and effective program. John speaks of it with mingled humility and pride.

The Vermont Academy Program came directly from Martin Luther King's death. I was on the streets in Harlem and Bedford Stuyvesant at the time and the anguish and despair there made it mandatory that I do something consistent with his way of life. I feel that I have a responsibility to contribute as much as possible to the black kid on the street; or the Indian kid in the pueblo; or the Puerto Rican who is pushing a cart in the garment district.

Freely admitting that he is not a nonviolent person, John acknowledges his disagreement with the nihilists in the black community. Knowing how they call upon black masses to

take the path of destruction because they firmly believe that is the only meaningful path, Torres says this:

I don't agree with them in that particular. They say the American society will give them no resources to do their own work, rendering them (they contend) impotent to help their young people. I don't know that the society will not provide resources. And because I didn't know that I designed a program to gather together resources—money, equipment, materials, people—and make those resources available to young people who wanted to go into art.

Torres went to the Ford Foundation, and through the Art Students League received a grant to run a summer program for ten weeks. The plan was to set up an art program, gather kids interested in art from various communities, and give them ten weeks of intensive training. Then what they had produced would be shown to reputable schools with a view to helping the young artist get into art schools. The place selected for the Vermont Program could not have been more wisely chosen. Vermont Academy in Saxons River is an ideal spot. Under the leadership of dynamic Michael Choukas, this boys' preparatory school provides handsome living and working accommodations in beautiful natural surroundings.

Young people recruited for the program included black, Oriental, Indian, Latin-American, and poor white boys and girls. They numbered eighty-five, 60 percent of them black. Instructional staff was made up of artists who themselves were minority group members. With each student averaging one work of art each week, John and his staff had, at the end of ten weeks, from seven hundred to eight hundred pieces to present to schools at summer's end. It required a forty-foot trailer truck to transport the output to New York.

To John's delight the quality of the work was so high that schools accepted students as late as August for enrollment in September. And of the eighty-five participants, eighty were placed in schools all over the country. Each student received

grants amounting to three thousand dollars a year for four years, totaling nearly a million dollars in scholarships. Only two of the eighty dropped out of school. The remaining seventy-eight are still studying as of this writing, a record of which Torres is justly proud. But the success of his dream was not without its price.

During the time that John was recruiting in some black communities, certain elements there felt he should let the young people drift. Their approach was to let things boil and simmer until they erupted in violence. Then out of the chaos and ruins they believed a new era would evolve. A particularly distasteful aspect of the Torres plan, from their point of view, was the free mingling of black youngsters with those of other ethnic groups. So those opposing blacks made it difficult for John Torres. They damaged his truck and at one point, in lower Manhattan, they set upon him and beat the sight out of his left eye. Yet John, in view of his experience as a black youth, readily concedes the possibility that his black opposition is right and he is wrong. Right or wrong, however, he refuses to rivet attention upon his difficulties, preferring instead to talk about his aims as a promoter of talented youth.

When I recruit a bunch of students for a particular school, what I have in mind is that those I recruit will wind up being the best students there and that the school will have to change in order to deal with those students. I try to put students in schools in groups so they won't have the negative experiences I had as the only one. In that way the group is in a position to make demands upon the structure to pay attention to their cultural roots so that they won't wind up being white-black men and women. This is my approach—my hang-up.

At the moment he is also engaged in seeking patrons for the works of black artists and he is not seeking that patronage from wealthy whites. There are many influential blacks, some of them with money for original art, who Torres believes can and will support such a move. So he is planning, with the

aid of one of New York's prestigious museums, to gather a group of prominent and art-conscious black citizens. He aims to involve them directly in the much-needed program of acquiring original works of the nation's gifted black painters, sculptors, and printmakers.

John Torres' own creations in stone and wood do not confine themselves exclusively to black subjects. "I must approach my work broadly," he asserts, "because in my own family there are black, white, and red people." Moreover, he feels he can best serve his black brothers and sisters by being, or trying to be, the best sculptor who ever touched a stone. There are certain things, he feels, that should bring people together. A fine performance is one of them. When Torres carves a woman's torso he is talking about woman, the magic being, the source of human life. So as he carves woman he honors her—all women of all colors.

Of black artists Torres believes there are not enough. That was the prime reason for his recruitment program at Saxons River. He wants to change the status quo, for he sees the need of the kind of cultural diversity black artists can bring to the society.

The late morning September sun begins to fill the artist's spacious New Hampshire studio. Shafts of light pick up the three-dimensional weight of the carved stones and the torso carved from a twisted fragment of tree trunk. On the wall behind John Torres the large figure drawing of a woman catches the reflected light. The eye travels from the simply conceived form of the thighs, torso, breasts, and up beyond the neck. The head is that of a black woman. John smiles when you express your admiration of the drawing.

"I get a great sense of satisfaction from being with black artists and black models"—he pauses—"Yes, I carve from the black experience. I have had no choice, as you can see, except to go through the black experience. My skin is dark and I carve from who I am."

INDEX

Abbott, Robert S., 64
Abernathy, Ralph, 46
Adams, Jacob, 101
Adams, Jacqueline, 231
Adams, Wayman, 7
Aden, Alonzo, 10
Aderholt, O. F., 268-269
Albers, Josef, 160, 233
Aldridge, Ira, 99
Alexander, Ernest, 93
Allen, Charles E., 193
Allen, James E., 12, 174
Allen, Richard, 3
Allen, Sam, 141
Alston, Charles H., 11, 150
Amévor, Charles, 112-113, 115, 121-122, 124, 125
Amévor, Mrs. Charles, 112, 113-114, 115, 117, 118, 119, 122, 125, 127
Amévor, Charlotte, 111, 112-127, 128, 147, 169, 201
Ammons, Albert, 22
Anderson, Charles W., 132
Anderson, Marion, 108
Andrews, Benny, 58, 201, 236-252, 282
Andrews, George, 236, 238, 239, 240
Andrews, Mary Ellen, 247, 248
Andrews, Viola, 236, 238, 239, 244
Armstrong, Louis, 108
Armstrong, Samuel Chapman, 273
Artis, William, 11

Attaway, William, 136
Attucks, Crispus, 70

Bacchus, Joan, 123
Bailey, Malcolm, 144-145
Baldwin, James, 129, 141, 198, 202, 294
Bannarn, Henry, 11, 150
Bannister, Edward N., 3, 4
Barbour, Fannie, 222
Barile, Xavier, 101
Barnes, Albert C., 12
Barnette, Claude, 56, 105
Barthé, Richmond, 11, 55
Bates, "Ad," 136
Bearden, Bessie, 129, 130, 131, 133, 135, 137, 139
Bearden, Richard, 129, 130, 133
Bearden, Romare, 12, 47, 128-145, 146, 147, 148, 158, 178
Bearden, Mrs. Romare, 142
Belafonte, Harry, 71, 181
Bellows, George, 9
Benét, Steven Vincent, 294
Bennett, Gwendolyn, 23, 101, 173
Bernstein, Leonard, 294
Biggers, Cora, 268, 269, 270, 271, 273, 274
Biggers, Hazel, 279
Biggers, Joe, 269
Biggers, John, 23, 105, 267-282
Biggers, Paul, 268, 270, 271

Index

Binga, Jesse, 83, 84
Blackburn, Robert, 12, 173
Blake, Eubie, 100
Blanco, Ramos, 11
Blatt, Milton, 290-291
Bloch, Julius, 9
Bolling, Leslie G., 11
Bontemps, Arna, 133
Bowman, Laura, 151
Boyle, Kay, 137
Brackett, Edmund, 4
Brady, Mary B., 12, 154, 155
Bragg, Fred, 281
Braque, Georges, 102-103
Brennan, Harold, 211
Brewer, J. Mason, 278
Brooks, Gwendolyn, 67, 106
Brown, Anne Wiggins, 223
Brown, John, 5, 157
Brown, Samuel, 12
Bruce, Blanche K., 59
Bunche, Ralph J., 276
Burke, Selma, 12, 173
Burnett, Calvin, 47
Burroughs, Margaret, 12

Calloway, Cab, 86, 222-223
Campbell, E. Simms, 11, 66, 82, 135
Cann, Francis, 122
Caravaggio, 198
Carey, Archibald, 229
Carmichael, Stokely, 217, 218
Carr, James D., 132
Carty, Leo, 123
Cather, Willa, 294
Catlett, Elizabeth, 14-31, 32, 44, 48,
 56, 57, 58, 71, 74, 93, 142, 171, 175,
 268, 275, 283
Carver, George Washington, 70
Cayton, Horace, 54, 63, 80, 87-88, 106
Cezanne, Paul, 140
Choukas, Michael, 297
Christmas, Walter, 71
Clark, Claude, 12
Clarke, John Henrik, 265
Clough, Inez, 99
Cobb, Montague J., 98
Cochrane, Warren R., 244
Cole, Ernest, 216
Cole, Nat "King," 106, 276

Coleman, A. D., 186
Coleman, Bessie, 82
Constant, 7
Cook, Mercer, 98
Coolidge, Calvin, 204
Copland, Aaron, 294
Corot, 90
Cortor, Eldzier, 12, 55, 67, 79-94, 95,
 105
Cortor, John, 80, 81, 82, 83, 86
Cortor, Ophelia, 80, 81, 83
Corwin, Norman, 224
Countee, Samuel, 11
Crichlow, Ernest, 12, 24, 29, 71, 104,
 123, 144, 173, 201
Croker, Richard, 131
Crosby, Caresse, 137
Crosby, Harry, 137
Cross, Charles, 225, 233
Crouse, Robert, 165
Cullen, Countée, 51, 151

Dali, Salvador, 137
Daumier, 40, 46, 135-136
David, Charles, 67
David, Jacques Louis, 90, 198
Davidson, Bruce, 185
Davis, Lee, 223, 224-225
Davis, Ossie, 71
Day, Howard, 134
DeBeck, Billy, 81
De Carava, Roy, 23, 167-187, 223
DeCoverly, Roy, 103
Dee, Ruby, 71, 194
Delacroix, 90
Delaney, Beauford, 11
Delaney, Hubert, 192
DeLauney, 102
Dent, Albert, 22
Diaz, Porfirio, 24
Dickerson, Earl B., 56
Dintenfass, Terry, 163
Donaldson, Andrew, 193
Dorsey, George, 239
Douglas, Aaron, 10, 11, 101, 133, 151
Douglass, Bertha, 237
Douglass, Frederick, 156, 233, 269, 273
Dover, Cedric, 7
Drake, St. Clair, 54, 63, 80, 106
Driskell, David, 215, 251

Index

Dubanowitz, Peter, 37, 38
DuBois, W. E. B., 51, 71, 72, 88-89
DuBois, Mrs. W. E. B., 72
Dudley, Edward, 123
Du Maurier, Daphne, 260
Duncanson, Robert, 3-4, 145, 264
Dunham, Katherine, 67
Dunn, Eugenia, 29

Eakins, Thomas, 6, 144
Ebony magazine, 77, 78
Eckstine, Billy, 141
Ellington, Edward Kennedy (Duke), 98, 246
Evers, Charles, 60
Evers, Medgar, 60
Eyo, Ekpoo, 234

Farmer, James, 90
Fauset, Jessie, 51
Fax, Elton, 12
Feelings, Tom, 123
Fernandez, Justino, 93
Fernandis, Mrs, Sarah, 155
Fisher, Rudolph, 51
Freelon, Allan, 11
Fuller, Meta Warrick, 5-6, 11

Gaither, Edmund "Barry," 47, 250, 251
Garlington, S. W. (Swig), 139
Garrienen, Aliene, 162
Garrison, William Lloyd, 4
Garvey, Marcus, 33-34, 35
Gaston, William, 268
Gbedemah, K. A., 280
Gibbons, James Cardinal, 204
Gibson, Leonard, 222
Gilpin, Charles, 99
Ginsberg, Ralph, 49
Gogh, Vincent van, 162
Gordon, Taylor, 100
Goreleigh, Henrietta, 96, 97, 98
Goreleigh, Rex, 11, 95-111
Goreleigh, Mrs. Rex, 104-105, 107, 108
Goss, Bernard, 56, 67
Goss, Margaret, 56, 67
Goss, William, 11
Gottleib, Adolph, 138

Graham, Shirley, 71, 72
Granger, Lester, 230
Green, Samuel, 210
Greenberg, Max, 197
Griffin, Miss Ella, 280
Grosz, George, 135, 144
Groz, 40

Halpert, Edith, 69, 157, 158
Halsey, Bill, 37, 38
Hansberry, Lorraine, 71
Hardwicke, John W., 11
Hardy, Thomas, 215
Harleston, Edwin A., 11
Harmon, William E., 11
Harper, William, 8
Harrington, Oliver, 101, 135, 257
Hayden, Palmer, 11, 100
Hayes, Roland, 272
Hayes, Vertis, 12
Hayter, Stanley, 258
Hobbs, G. W., 3
Hoffman, Hans, 138, 257, 258
Holiday, Billie, 22, 74
Hollingsworth, Alvin, 193
Holmes, Dwight O. W., 233
Homer, Dorothy, 178
Homer, Winslow, 7, 9
Hooks, Mrs. Annie, 219
Hooks, Earl, 203-218, 219
Hooks, Mrs. Earl, 214
Hosmer, Harriet, 5
Hovanas, John, 294
Hemingway, E., 137
Henri, Robert, 7, 9
Henson, Matt, 151
Hentoff, Nat, 247
Herring, James Vernon, 9-10, 16, 90, 210, 274
Heyward, Dubose, 294
Hoover, Herbert, 271
Hudson, Henry, 17
Hudson, Julien, 3
Hughes, Langston, 10, 51, 71, 129, 160, 180-181
Hulede, Patrick, 279

Ingram, Zell, 12, 101
Irving, Catherine, 81

Jackson, Bert, 173
Jackson, Jesse, 164
Jackson, Levi, 256
Jackson, May Howard, 5-6, 11
Jenkins, Martin D., 232
Jennings, Jenette, 61
Jesse, Eva, 151
Jett, Ruth, 71
Johnson, Barbara, 257
Johnson, Daryl, 212
Johnson, James Weldon, 10, 50-52, 151
Johnson, Malvin Gray, 11
Johnson, Pete, 22
Johnson, Sargeant, 11
Johnson, William H., 11, 137
Johnston, Joshua, 3, 145
Jones, Andrew, 189
Jones, Faith, see Ringgold, Faith
Jones, Lawrence, 48-62, 63, 97, 232, 245
Jones, Lois, 10, 11, 210
Jones, Willie Posey, 189, 190, 192, 196, 198
Julian, Hubert Fauntleroy, 82, 131

Keene, Paul, 141
Kent, Rockwell, 71
Kenzie, John, 79
Key, Vivian, 11
King, Martin Luther, Jr., 34, 46, 75, 217, 296
Klein, Emanuel, 162
Knight, Gwendolyn, 157
Knotts, Thomas, 212
Kootz, Samuel, 137, 141
Kramer, Hilton, 251

La Farge, John, 154
Lafayette Players, 51, 99
LaGuardia, Fiorello, 133, 191
Lanning, Edward, 124
LaPierre, Marie, 113
LaTouche, John, 223, 224
Laurens, 7
Lawrence, Jacob, Jr., 13, 47, 71, 123, 136, 145, 146-166, 167, 169, 178, 233, 278
Lawrence, Mrs. Jacob, Jr. (Gwen), 157, 158, 159, 161, 163

Lawrence, Jacob, Sr., 147, 156
Lawrence, Rose Lee, 147, 149, 150, 156
Ledbedder, Hudie (Leadbelly), 22
Lee, Edward E. (Chief), 132, 133
Lee-Smith, Hughie, 12, 105
Leger, Fernand, 42
Leida, Jay, 158
Lenin, Nikolai, 43
Levine, Jack, 245
Levy, Julian, 258
Lewis, Edmonia, 4-5
Lewis, Elma, 47
Lewis, James, Jr., 29, 219-235, 236, 282
Lewis, Mrs. James, Jr., 231, 232
Lewis, James, Sr., 219, 220, 227, 230, 236
Lewis, Mead Lux, 22
Lewis, Norman, 12, 23, 104, 142, 144
Lewis, Pearlean, 219, 220, 227, 231, 232, 236
Lewis, Samella, 232, 251
Lewis, Sinclair, 94
Lincoln, Abraham, 269, 273
Lincoln, Richard, 179-180
Liveright, Dorothy J., 70
Locke, Alain, 1, 2, 6, 7, 10, 65, 151, 154, 155, 156, 157, 158, 174, 178
Long, Avon, 223
Look magazine, 184
Lord, Francisco, 173
Louchheim, Aline B., 161-162
Louis, Joe, 226, 230, 247, 251
Lowenfeld, Viktor, 23, 70, 273-275
Lyles, Aubrey, 100
Lynch, Charles, 48
Lynch, John, 48, 59
Lyons, Russell, 296

McCarthy, Joseph R., 27, 73
McClendon, Rose, 151
McDaniels, Gough, 222
MacDougall, Gertrude, 134
MacDowell, Edward, 294
McDowell, Henry, 274
MacDowell, Marian, 294
Mack, Joseph, 278
McKay, Claude, 10, 51, 100, 129, 136, 151

McKeldin, Theodore, 233
Malcolm, Roger, 239
Margo, Boris, 245-246
Marshall, Thurgood, 19, 219, 222, 228
Matisse, 8
Matthews, Ralph, Jr., 207-208
Mayer, Ralph, 296
Mayhew, Richard, 142
Mead, Margaret, 296
Means, Glen, 257
Means, Mr. and Mrs. Stuart, 253-256
Mendez, Leopoldo, 71
Mensah, Mary, 279-280
Meredith, James, 61
Miller, Dorie, 230
Miller, Flournoy, 100
Miller, Kelly, 6
Mitchell, Abbie, 99
Modigliani, 8
Montgomery, Evangeline, 251
Moore, Richard B., 152
Mora, Betty Catlett see Catlett, Elizabeth
Mora, David, 30
Mora, Francisco (Pancho), 26, 27, 28, 30, 32, 44
Mora, Francisco, Jr., 30
Mora, Juan, 30
Morehead, Scipio, 3
Morgan, Ethel, 253-256, 258, 261
Morgan, Norma, 253-266, 267
Morton, Ferdinand Q., 132-133
Moten, Etta, 56, 105
Motherwell, 138
Motley, Archibald J., 11, 55, 67, 133
Motley, Willard, 67, 82, 87
Muhammad Ali, 251
Murphy, Carl, 233
Murrell, Sara, 104

Neal, Frank, 55
Nkrumah, Kwame, 121

O'Higgins, Paul (Pablo), 44, 56, 71
Ojukwu, Odumegwu, 164
Oliver, Kermit, 281
Orozco, José C., 25, 40, 41, 42, 44, 45, 57, 58, 93, 95, 158
Ortez, Alvano, 226

Osofsky, Gilbert, 130, 132
Otis, Jesse R., 60
Ottley, Roi, 138, 147, 169

Page, Homer, 177, 178
Parker, John T., 271
Parks, Gordon, 67, 150, 181
Parks, Rosa, 46
Payne, Daniel, 4
Payton, Philip A., Jr., 129-130
Pegler, Westbrook, 139
Pennington, Glenford, 222
Perkins, Marion, 11, 29, 56
Perper, Mark, 176-178
Peters, Marjorie, 106
Peyton, Dave, 86
Phelan, Charlotte, 281
Phillips, Wendell, 152
Picasso, 8, 22, 40, 198
Pickens, William, 272
Pierpont, Francis, 53
Pious, Robert, 11, 173
Pippin, Horace, 47, 145, 157
Pitchford, Catherine, 210
Poe, Edgar Allan, 257
Poitier, Sidney, 71
Pollock, Jackson, 200
Poole, Archie, 142
Porter, James A., 10, 11, 17, 210
Powell, Adam Clayton, 139
Powell, Richard, 227
Pratt, Enoch, 204
Prattis, P. L., 72-73
Prophet, Nancy, 8, 11

Quigg, L. Eli, 132

Rainey, Ma, 74
Ramsey Lewis Trio, 246
Randolph, A. Philip, 138, 229
Redding, Meta, 222
Reed, Pauline Kigh, 56
Reid, Donald, 11
Reid, O. Richard, 11
Reiss, Winold, 10
Rembrandt, 135, 141
Revels, Hiram, 59
Rhodes, Sy, 123
Ridley, Gregory, 251
Rinehart, Ad, 200

Ringgold, Burdette, 198
Ritchie, Albert C., 204
Rivera, Diego, 17, 25, 26, 40, 43-44, 57, 71, 100-101
Rivers, Bill, 141
Rivers, Pauline, 113
Robeson, Paul, 70, 71, 72-74, 224, 275-276
Robinson, Bill (Bojangles), 53
Robinson, Earl, 223, 224
Rockefeller, Nelson A., 26, 43-44
Rogers, Joel, 152, 276
Roosevelt, Franklin D., 25-26, 55, 138, 139, 150, 230
Roosevelt, Mrs. Franklin Delano, 105, 139
Roualt, 40
Rubenstein, Barnet, 47, 250-251
Ruiz, José L., 26
Russell, Donald, 226-227
Ryan, Bill, 120, 121

Saible, Jean Baptiste de, 79, 80
Salen, Peter, 70
Sanders, Samella, 23
Sargeant, Al, 193
Savage, Augusta, 11, 101, 145, 150, 151, 154, 173
Schiffman, Frank, 137
Schoener, Allon, 185-186
Schomburg, Arturo, 153-154
Schomburg, Carlos, 153
Schomburg, Mary, 153
Schragg, Carl, 258
Schuyler, George, 10, 51, 100, 151
Schuyler, Philippa, 151
Scott, Hazel, 22
Scott, Robert, 233
Scott, William E., 8, 11, 55
Sebastian, Martha, 104-105
Sebree, Charles, 12, 67, 105
Seifert, Charles, 151, 152
Shahn, Ben, 40, 101, 109
Sharpe, Gloria, 121-122
Shaw, Robert Gould, 5
Shearing, George, 246
Shepard, Dr., 19
Shilkret, Nathaniel, 224
Simpson, William, 3
Siporin, Mitchell, 67

Siqueiros, David, 25, 40, 44, 45, 57, 71, 95
Sissle, Noble, 100
Smith, Albert Alexander, 11
Smith, Bessie, 74
Soyer, Raphael, 249
Spencer, Mrs. Anne, 51-52
Spencer, Dorothy, 22
Spencer, Kenneth, 22, 71
Sports Illustrated, 183
Spriggs, Edward, 186
Stallings, Charles, 232
Staton, Dakota, 246
Steichen, Eugene, 177, 178, 180
Sternberg, Harry, 69
Sterne, Maurice, 9
Survey Graphic, The, 10

Tanner, Henry Ossawa, 6-8, 144, 145
Taylor, Ruth, 223, 224
Teasdale, Sara, 294
Templeton, Furman L., 226
Thomas, Charles, 281
Thomas, Edna, 99
Thompson, Bob, 249-250
Thurmond, Howard, 272
Thurmond, Wally, 100
Titian, 198
Torres, Bentina, 283-289
Torres, John Jr., 283-300
Torres, John Sr., 283, 290
Torres, Waverly, 284-285
Toussaint L'Ouverture, 152, 153, 154, 155, 156
Trawick, Lloyd, 241, 244
Tubman, Harriett, 156, 165
Turner, Nat, 70

Vesey, Denmark, 70

Walker, Margaret, 87
Wallace, Mrs. Faith, see Ringgold, Faith
Warbourg, Eugene, 4
Wardlaw, Frank, 280
Warfield, William, 108
Waring, Laura Wheeler, 11
Washington, Booker T., 70, 269, 273
Waters, Ethel, 86
Wells, James L., 10, 11, 17, 210

West, Sarah, 173
Wharton, Pauline, 223-224
Whipper, Leigh, 151
White, Charles, Jr., 12, 24, 26, 47, 55, 63-78, 86, 105, 264, 275, 278
White, Charles, Sr., 64, 65, 68
White, Ethel Gary, 64, 65, 68
White, Frances, 74, 75
White, Josh, 22
White, Walter, 51, 229, 272
Whitman, Alden, 216
Wiggins, Ella May, 269
Wilder, Thornton, 294
Willard, Frank, 81
Williams, Franklin W., 234
Williams, Harrison, 110
Williams, Mary Lou, 22
Wilson, Becky, 46
Wilson, Edwin, 29
Wilson, Ellis, 11, 105
Wilson, Frank, 99

Wilson, John, 32-47, 48, 57, 58, 74, 191
Wilson, Julie, 32, 45, 46
Wilson, Llewellyn, 222
Wilson, Reginald, 32, 33, 34, 35, 38
Wilson, Teddy, 22
Wilson, Violet, 32, 33, 38
Wilson, Woodrow, 53, 106
Winslow, Leon, 222, 225
Winslow, Vernon, 21
Wolf, Bertram, 43
Wood, Grant, 19, 20
Wood, L. Hollingsworth, 153
Woodruff, Hale A., 11, 23, 47, 100
Wright, Naomi, 210
Wright, Richard, 41, 42, 67, 87, 106, 141

Yeargan, Max, 70

Zadkina, Ossip, 23
Zerbe, Carl, 39, 40